THE BIG BOOK OF GREEN DESIGN

THE BiG BOOK OF GREEN DESIGN

INTRODUCTION BY
ERIC BENSON

EDITED BY
SUZANNA MW STEPHENS
ANTHONY B STEPHENS

COLLINS DESIGN
An Imprint of HarperCollins*Publishers*

HarperCollins books may be purchased for educational, business, or sales promotional use.
For information, please write: Special Markets Department, HarperCollins*Publishers*,
10 East 53rd Street, New York, NY 10022.

First Edition

First published in 2009 by:
Collins Design
An Imprint of HarperCollins*Publishers*
10 East 53rd Street
New York, NY 10022
Tel: (212) 207-7000
Fax: (212) 207-7654
collinsdesign@harpercollins.com
www.harpercollins.com

Distributed throughout the world by:
HarperCollins*Publishers*
10 East 53rd Street
New York, NY 10022
Fax: (212) 207-7654

Jacket and book design by Anderson Design Group, Nashville, TN
www.AndersonDesignGroup.com

Production and additional photography by

Designs
on You!

Anthony & Suzanna Stephens
www.designs-on-you.net

Library of Congress Control Number: 2009927514

ISBN: 978-0-06-175799-0

Produced by Crescent Hill Books, Louisville, KY.
www.CrescentHillBooks.com

Printed in China by Everbest Printing Company, an FSC certified printer. Pages are FSC certified Korean Shin
Moorin matt paper. Soy based inks were used throughout.

First Printing, 2009

TABLE OF CONTENTS

THE BiG BOOK OF GREEN DESIGN

Introduction
by Eric Benson

Every designer who spends time seriously rethinking the design process from a "green" perspective—one that considers the wellbeing of the environment—tells a similar story. The story begins with a vague notion of wastefulness and progresses to a profound moment of awareness when we realize the negative impact our profession has on our water, air, and land. When we share our stories—with our friends, classmates, and colleagues; at school, at work, over coffee—we spread awareness throughout the design profession. That awareness is the seed of change that has led an increasing number of designers to greener design processes.

But what exactly is "green"? And what does it look like in the work of the graphic designer?

Simply defined, the practice of green design conserves natural resources, reduces energy consumption, cuts solid waste, and minimizes the ecological footprint of a project. Green design is a better way of creating. By itself, it cannot solve the environmental issues facing our civilization, but it is an effective first step toward changing habits,

behaviors, and the means with which we imagine ourselves and the economy. It is not an exact science, but it grows daily in terms of innovation and opportunity. By the simple act of choosing, say, a recycled or non-toxic, renewable material, we inspire other designers to improve the outcomes and the impact of our profession.

Historically, artifacts that are beautiful and satisfy the client's criteria have been deemed "good graphic design." But it has become painfully clear that the standards defining good design must be updated. For instance, the design community must consider the environmental footprint of the poster announcing last summer's big blockbuster. How much water is contaminated to print a fashion magazine? How many tons of carbon dioxide are emitted clear-cutting trees so a company can distribute a brochure at a conference? These timely questions must be considered—as well as the beauty and function of a thing—as fair, logical, crucial ways to judge good design in light of the dire environmental issues facing the planet. A new dialogue must begin—and continue—that demands of us a more appropriate

answer to the question, "What is good graphic design?"

Nearly everything we currently create will eventually end up incinerated and polluting the atmosphere, or buried and clogging a landfill. Centuries from now, will society view the city dump as a monument to the wastefulness of our profession? Or instead, will the landfill be a grave marker heralding the successful conquest of over-consumption and bad design processes?

As utopian as green design sounds, designers must be proactively practical. We must ask ourselves how we can take effective steps to follow a greener path. How do we convince clients that green design is a smarter, more economical option? Which printing methods are more environmentally friendly?

For starters, read and digest this book. *The Big Book of Green Design* tells you how you can do more, by showcasing projects that encourage the intentional reuse of packaging and providing practical environmental actions that minimize ecological damage. Pay close attention to the *What's Green About This* sections: They detail the processes and materials which have been used (or minimized) to create a greener artifact.

This book is itself a journey. It explains how aware designers create green, proactive solutions in order to improve the long-term environmental impact of design. This book is the seed that can encourage you to avoid the wasteful, damaging mistakes of the past; help you create new, sustainable outcomes for your design process; and inspire you—reader, designer, creator—to act, to innovate, and in turn to inspire a growing community of green designers.

Eric Benson (www.re-nourish.com) is Assistant Professor at the University of Illinois Urbana-Champaign.

From the Editors

At its most ambitious, the goal of this book is to help eliminate the need for a book like this.

The "green design" movement is very hot now. Global sustainability issues are at the forefront of public attention and everyone wants to be associated with ecological responsibility. We all know we should *Reduce, Reuse, Recycle*, but some of us aren't really sure how to apply specific action to the vagueness of this mandate. Additionally, transferring that practice from a personal to professional level may seem daunting and, after all, can it possibly make much difference?

When one becomes aware that the pulp and paper industry is the third largest air, land, and water polluter in both America and Canada, it becomes very clear what a hugely positive impact designers can have! Graphic designers, by the very nature of their business, are necessarily "married" to the printing/paper industry and are in a position to make good, earth-healthy choices.

If you're not sure where to start, *The Big Book of*

Green Design can help! It is full of ideas showing how you can integrate sustainable practices into your design process.

There are three important ways in which those who work in the field of graphics can contribute to a more environmentally friendly industry. Two of them are the focus of this book.

One aspect of sustainable design, relative to a graphic designer, is producing work which helps promote a green industry. This is when the client is involved in a business that is ecologically oriented and contributes to a better earth. Samples of this kind of design are showcased in the first section of this book, "Greener Image," which includes a Products chapter and Companies chapter.

Another facet of green graphics involves offering information as well as using sustainable materials within the design itself. Examples employing these kinds of work are the subject of the second section, "Green in Action," including Repurposed Design, Anti-Packaging, Materials, Events, and Education chapters.

Finally, while not shown in *The Big Book of Green Design*, a third and very important part of being a green designer is promoting green office practices. Most are simple changes that not only contribute to a more stable environment but save money as well. A basic but inexhaustive list includes:

- printing only when necessary and using both sides of the paper;
- separating recyclables from the regular trash and taking them to the recycling center;
- using compact fluorescent lighting;
- keeping the thermostat set at a reasonable level—it's OKAY to wear a sweater in the winter months;
- drinking from glass or ceramic vessels instead of paper or Styrofoam, being even more responsible by choosing not to use a minimum of 10 gallons of water to clean your cup;
- doing business with local vendors whenever possible;
- turning off computers and printers when not in use.

There will necessarily come a day when "green design" will not be the aberration. It will be the norm—and may well be the law. There won't be a perceived choice between money and environment, between short term convenience and the health of humanity. That time must come soon! In the meanwhile, look through these pages and see how it's being done now. And in that context, the ambitious goal of this book is to help eliminate the need for a book like this.

• • •

Much thanks to Eric Benson for his insightful Introduction. His Web site, http://re-nourish.com, is immeasurably helpful for any designer interested in practicing sustainable design. It hosts scads of helpful and important information with articles, blogs, definitions, and techniques to aim any designer in a green direction. Printers and design firms who are successfully running their businesses in eco-friendly fashion are also highlighted there.

Thanks also to Kim Sarka Lake of MUG & PIA in Huntington, West Virginia, for her gracious manner and good information about specialty paper vendors—including Mr. Ellie Pooh.

Suzanna
&
Anthony

Greener Image

Products

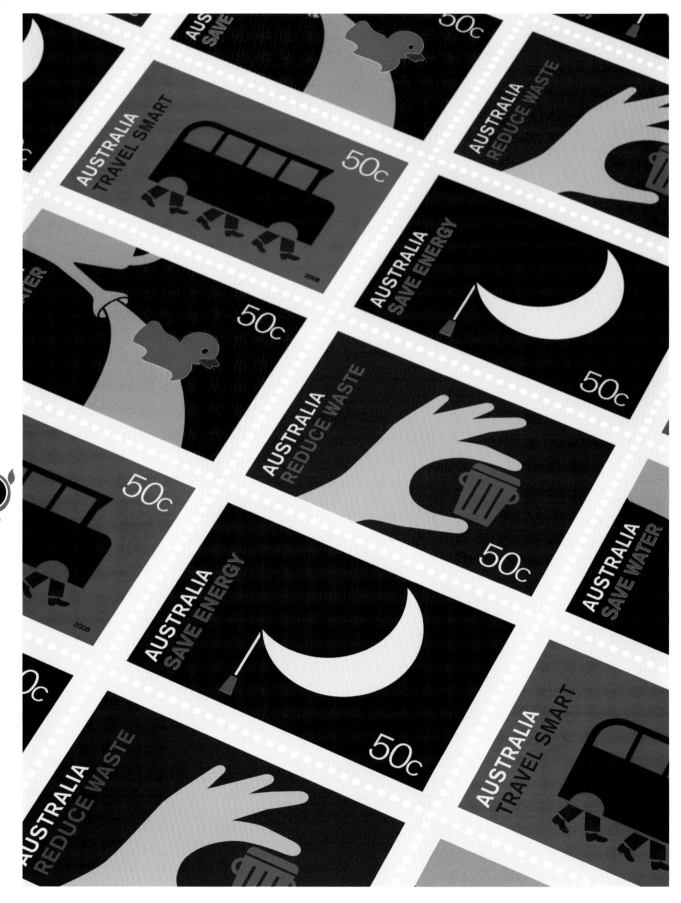

12

WHAT'S GREEN ABOUT THIS — This series of four postage stamps for Australia Post illustrates the simple ways individuals, rather than governments, can help tackle climate change. They empower people by focusing on four practical areas where they can reduce their carbon footprint: Walking, cycling or using public transport; reusing or recycling water; reducing waste; turning off lights and appliances.

HOYNE DESIGN — MELBOURNE, AUSTRALIA
Creatives : Dan Johnson, Sam Hughes, Walter Ochoa, Jim O'Neill
Client : Australia Post

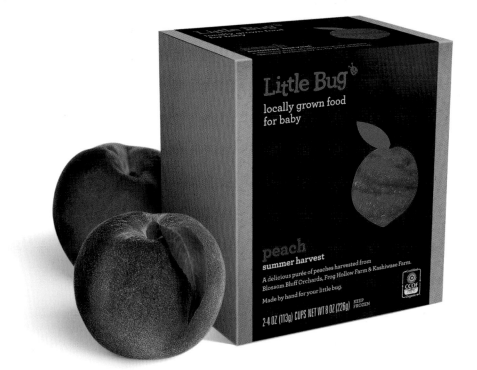

BRAND ENGINE — SAUSALITO, CALIFORNIA
Creatives : Meegan Peery, Meghan Zodrow, Bill Kerr, Bob Hullinger
Client : Little Bug

WHAT'S GREEN ABOUT THIS — Little Bug Baby Food uses only seasonal produce grown by local farmers using sustainable, pesticide-free practices. Shortening the distance from farm to table ensures maximum nutrition and taste while respecting the land.

13

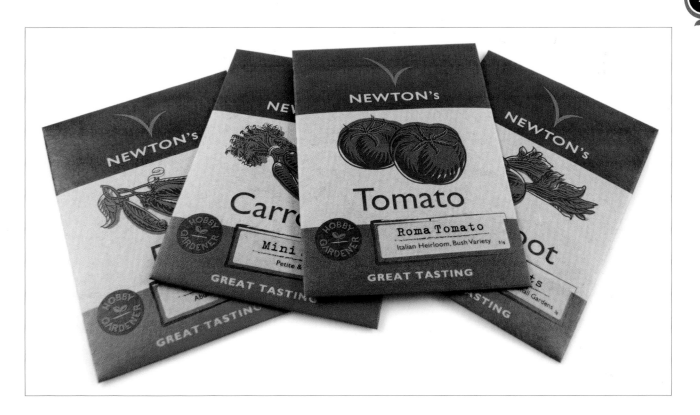

CURIOUS DESIGN CONSULTANTS LIMITED —
AUCKLAND, NEW ZEALAND
Creatives : Monique Pilley, Nigel Kuzimski
Client : Newton Seed

WHAT'S GREEN ABOUT THIS — Increased demand for their lawn and bird seed products prompted Newton Seed to launch a retail range of vegetable seeds. They wanted to reflect an environmental responsibility as well as get away from traditional seed packaging with its customary photos of impossible-to-achieve results. They used woodcut-style illustrations and specified a natural recycled stock and bio-inks to maintain the integrity of the packs.

14

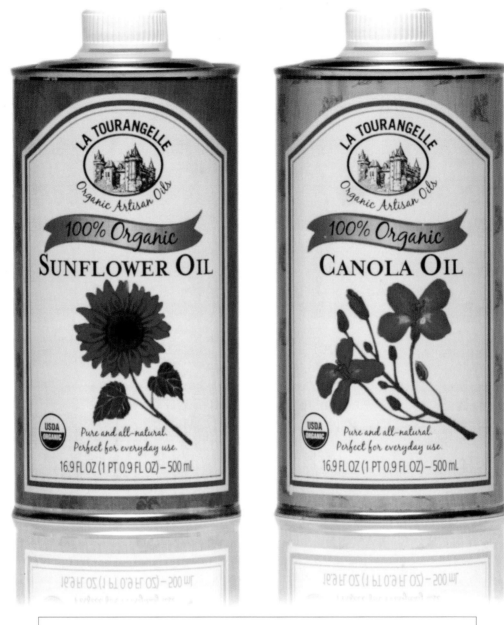

WHAT'S GREEN ABOUT THIS — Located in Woodland, California, La Tourangelle produces and distributes an exclusive line of hand-crafted, premium-quality oils in the tradition of French artisanal oil mills. La Tourangelle released these two 100% organic oils and Jenn David Design adapted the classic look of their packaging design (shown in insert) to fit the part.

JENN DAVID DESIGN — SAN DIEGO, CALIFORNIA
Creatives : Jenn David Connolly, Joan Bogart
Client : La Tourangelle

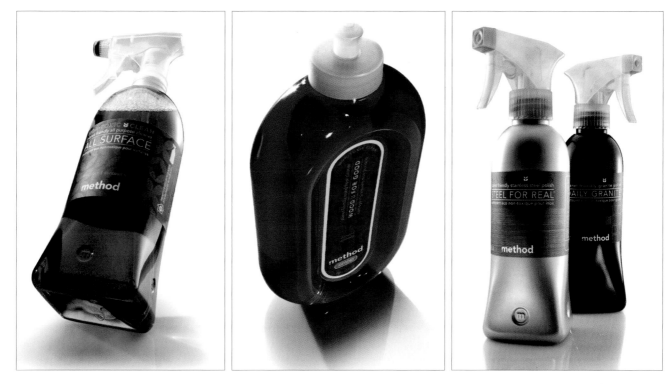

AMCOR PET PACKAGING — MANCHESTER, MICHIGAN
Creatives : Damien Moyal, Josh Handy
Client : Method Home

WHAT'S GREEN ABOUT THIS — A 100% post-consumer recycled PET spray bottle designed by Karim Rashid for Method Home. Amcor PET Packaging worked to maximize the clarity and brilliance of the container, which is a challenge with post-consumer recycled PET.

15

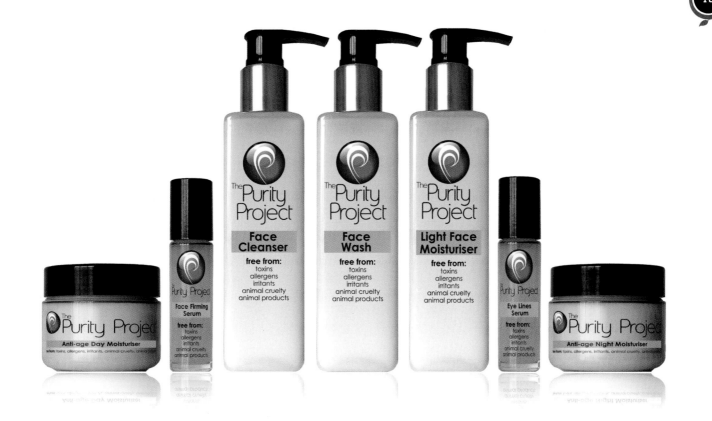

SCAMPER LTD. — KENILWORTH, WARWICKSHIRE, UNITED KINGDOM
Creatives : Tom Greenwood, Vineeta Greenwood
Client : The Purity Project

WHAT'S GREEN ABOUT THIS — The Purity Project is a new cosmetics company in the UK founded upon strong environmental and social principles. The aim of the brand is to create safe cosmetics which have a low environmental impact, with no toxins or allergens.

How They Did It
Jo Wood Organics

When she was recovering from serious illness some 20 years ago, Jo Wood, wife of Rolling Stone guitarist Ron Wood, pledged to make her family's home organic. She was unable to find high-quality organic body care products so she decided to create her own. Now, The Jo Wood Organics Bath & Body Diffusion Range, Everyday, reflects her determination to maintain a natural, healthy home as well as her own distinctive tastes and passions.

"The brand's design influences stem from Jo's eclectic rock n' roll edge, her love of 1970's, Biba, and the Art Nouveau movement," says Sam Aloof, creative director for Aloof Branding/Design Consultancy. "Her product names are influenced by Jo's passion for Africa. Fragrances have Swahili and Xhosa names like Amka, Usiku, Tula and Langa."

The design brief for Jo's Everyday range called for a new, more accessible masstige range that would sit next to her existing ultra-premium range in stores. "The new range would need to complement the existing range but also be sufficiently different because its price points would be significantly lower," Aloof says. "It needed to appeal to existing customers, as well as younger and less affluent women who are interested in organic lifestyle products and organic skin care."

Aloof set out to create naming, brand identity design, packaging design, promotional literature, and POS design.

"The Everyday range is ECOCERT certified," Aloof says. "To achieve this certification, containers and labels must be 100 percent recyclable. The selection of ECOCERT-approved bottles, caps, applicators, and label types at the time was incredibly limited."

Aloof at first presented a wide variety of creative concepts to Jo Wood. The firms worked together to pare them down to find a single direction that best fit the brand profile. Again, options were presented within that framework and Aloof and Jo Wood continued to work closely until they reached a final design decision.

Jo Wood had found a kindred spirit in Aloof. "Over the last decade our design philosophy has been to make the most of the inherent structural, visual and tactile qualities of materials," Aloof says. "We aim to minimize the number of production processes specified, often designing paper based packaging that doesn't require gluing or additional fastening, and graphically uses a minimum number of print and production processes."

In addition to recyclable packaging, Everyday supporting promotional literature is printed on chlorine-free paper and produced by a CarbonNeutral printer using 100% vegetable based inks.

The final design meshes well with Jo Wood's strong brand, cementing her dedication to a natural, earth-friendly lifestyle. Jo herself has become a noted advocate for organic living.

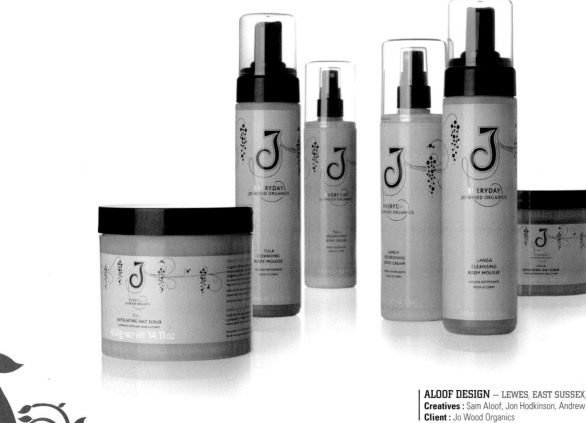

ALOOF DESIGN — LEWES, EAST SUSSEX, UNITED KINGDOM
Creatives : Sam Aloof, Jon Hodkinson, Andrew Scrase
Client : Jo Wood Organics

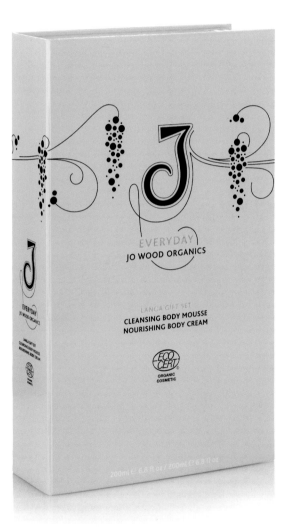

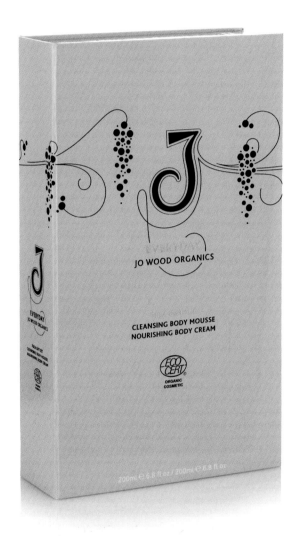

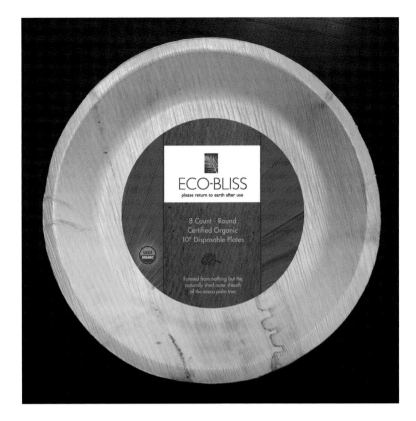

WHAT'S GREEN ABOUT THIS — These Certified Organic disposable plates are manufactured solely from the naturally shed outer sheath of the areca palm tree and are printed with the instructions, "please return to earth after use."

WHITNEY EDWARDS LLC — EASTON, MARYLAND
Creatives : Charlene Whitney Edwards, Barbara J. Christopher
Client : Maryland Plastics, Inc.

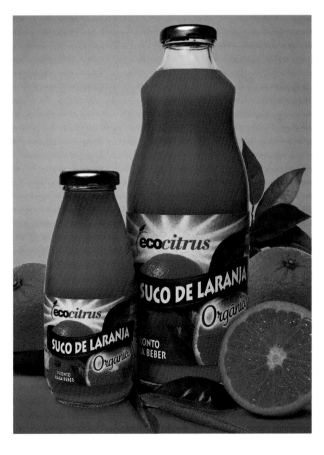

WHAT'S GREEN ABOUT THIS — This organic orange juice is produced by a cooperative whose philosophy is concerned with preserving the environment. The label is made from recycled paper and the bottle is recycled glass.

BHZ DESIGN — PORTO ALEGRE, RIO GRANDE DO SUL, BRAZIL
Creatives : Euler Silva, André Reinke
Client : Cooperative of Ecological Citrus Growers Vale Do Cai

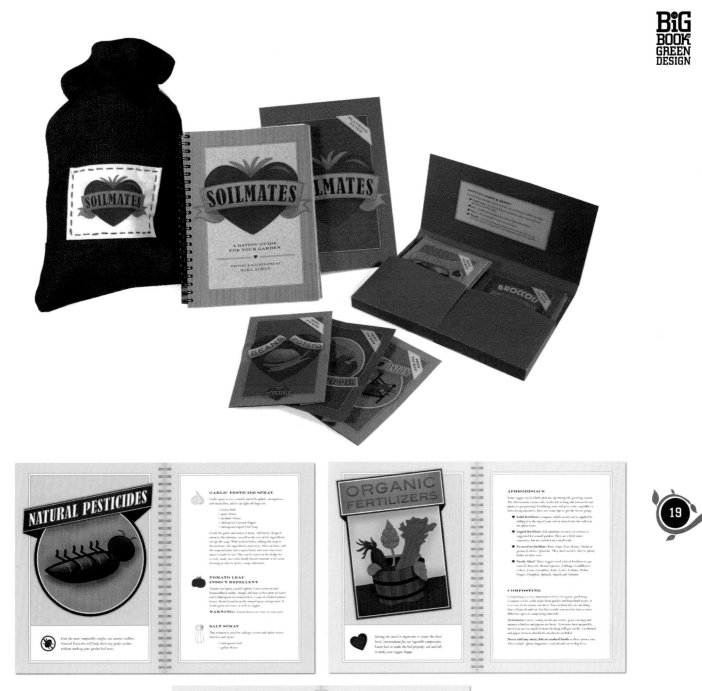

SARA ALWAY DESIGN — PHILADELPHIA, PENNSYLVANIA
Creatives : Sara Alway
Client : Quirk Books

WHAT'S GREEN ABOUT THIS — This book teaches companion planting, an organic gardening method, using the analogy that vegetables have perfect garden mates to ward off pests and disease.

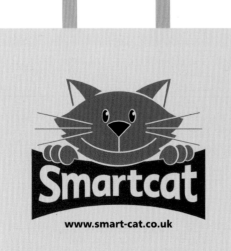

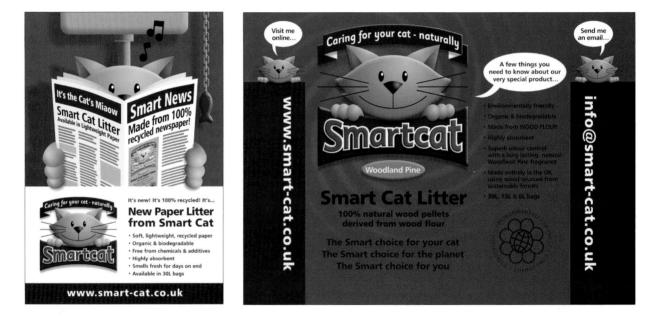

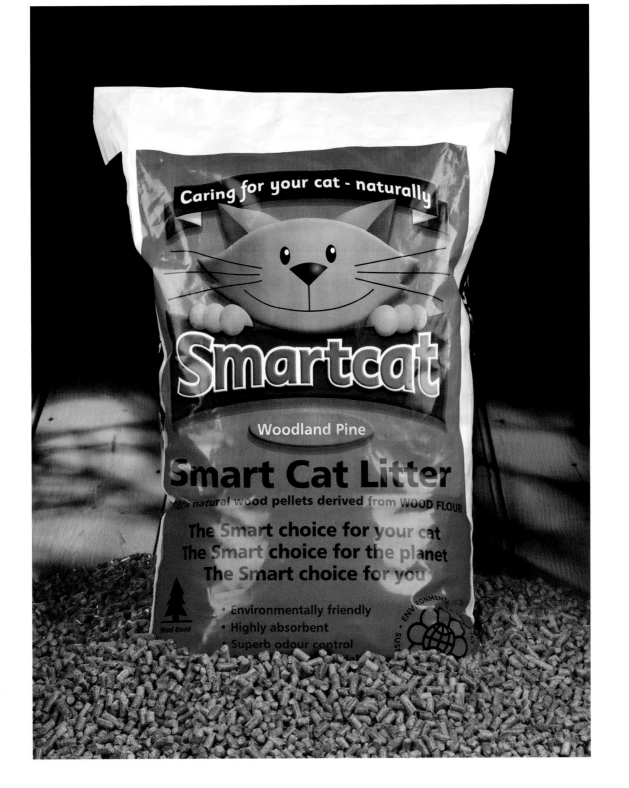

21

IMAGINE — MANCHESTER, UNITED KINGDOM
Creatives : David Caunce, Erin Portsmouth
Client : Fido PR/WTL International

WHAT'S GREEN ABOUT THIS — Smart Cat Wood-Based Cat Litter is an environmentally friendly alternative to traditional mineral cat litters, made from wood flour, a waste by-product of a local timber mill. Smart Cat Paper-Based Cat Litter is an environmentally friendly litter made from 100% recycled newspaper.

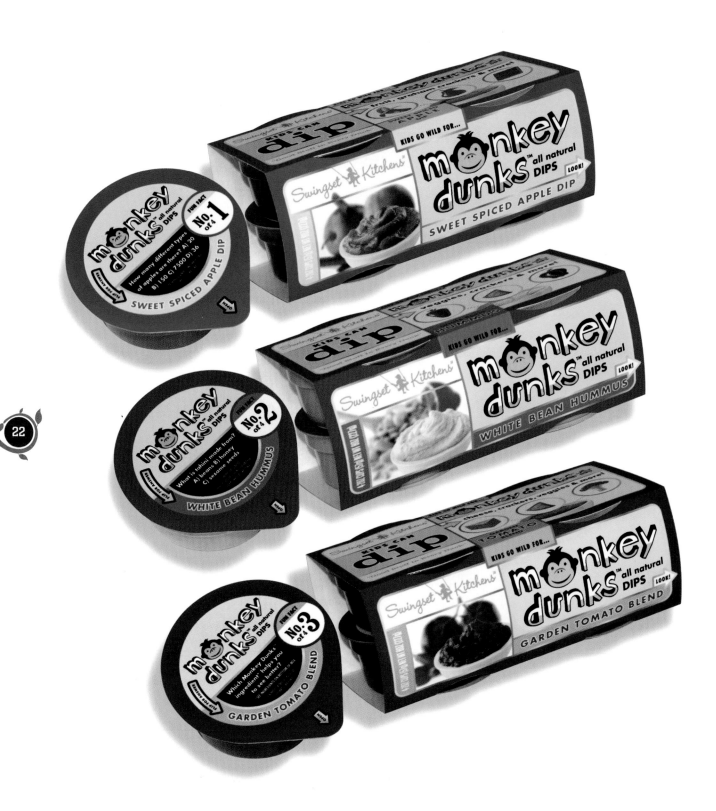

WHAT'S GREEN ABOUT THIS — Monkey Dunks is the first offering from Swingset Kitchens, a company that aspires to create healthier eating habits in children by introducing them to healthy new foods presented in fun and interesting ways. They used a vegetable-based polymer for the cups themselves, and recycled stock for the paperboard. Printed on the underside of the paperboard are ideas on how to recycle the packaging itself.

SUDDUTH DESIGN CO. — AUSTIN, TEXAS
Creatives : Toby Sudduth, Cheryl Moreno, Quentin Bacon
Client : Swingset Kitchens

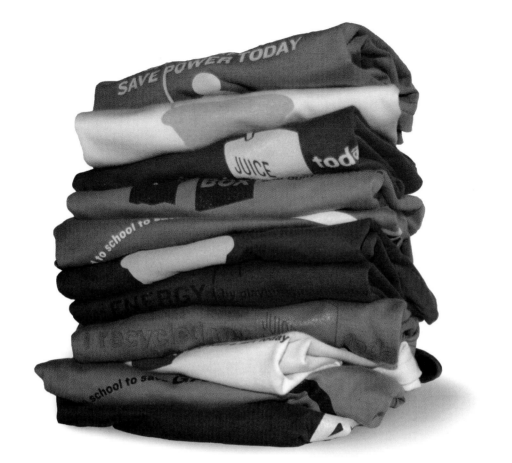

RIZCO DESIGN — MANASQUAN, NEW JERSEY
Creatives : Keith Rizzi, Patrick Keslar
Client : Beleaf

WHAT'S GREEN ABOUT THIS — Beleaf Kids makes sustainable, organic, eco-educational T-shirts that empower and inspire kids and their parents to practice sustainability through simple changes made TODAY, with Earth-friendly statements like "i recycled my JUICE BOX today," and "i didn't take a BATH to save water today." 1% of every Beleaf clothing sale is donated to the non-profit organization 1% For the Planet, which is an alliance of companies that recognize the true cost of doing business and donate one percent of their sales to environmental organizations worldwide. Beleaf Kids organic t-shirts are made 100% in the USA and are screen-printed with compostable inks.

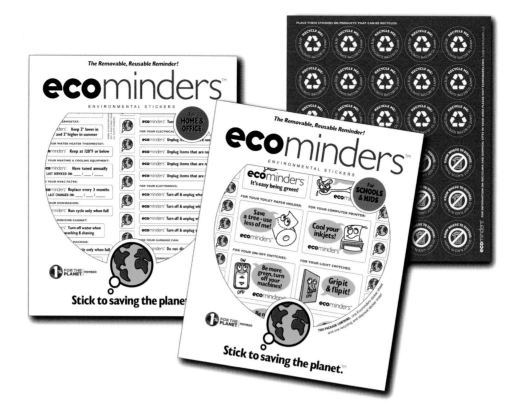

WHAT'S GREEN ABOUT THIS — Ecominders are easy-to-use, removable, reusable stickers that help us all remember the little things we can do every day that make a big environmental difference—like turning off the water when we brush, printing less, and unplugging an appliance when we're not using it. Ecominders can be stuck on on anything, anywhere, helping to reduce carbon emissions, lighten the impact on the planet, and save money. Ecominders are printed green on clear, repositionable stock.

Z FACTORY — CHICAGO, ILLINOIS
Creatives : Cary Zartman
Client : Allison Shaewitz Creator of Ecominders

24

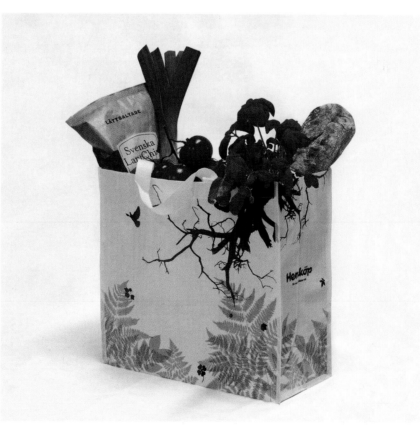

WHAT'S GREEN ABOUT THIS — Hemköp is a Swedish food-store chain with an expressed health and environmental profile. Recently they introduced their own ecological line of food products, and they wanted to offer their customers an ecological alternative for carrying their groceries home. J.Design created a reusable carrier bag with a graphic motif that represents green values and evokes nature.

J. DESIGN KOMMUNIKATION — SWEDEN
Creatives : Johan Ahström, Magnus Rubenman, Daniel Larsson
Client : Hemköp

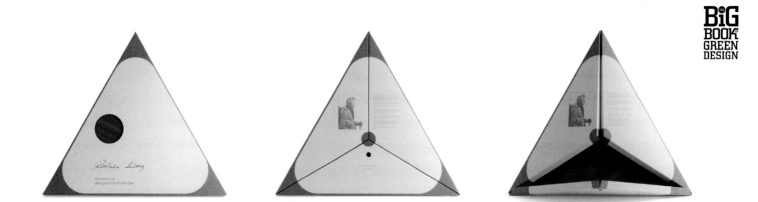

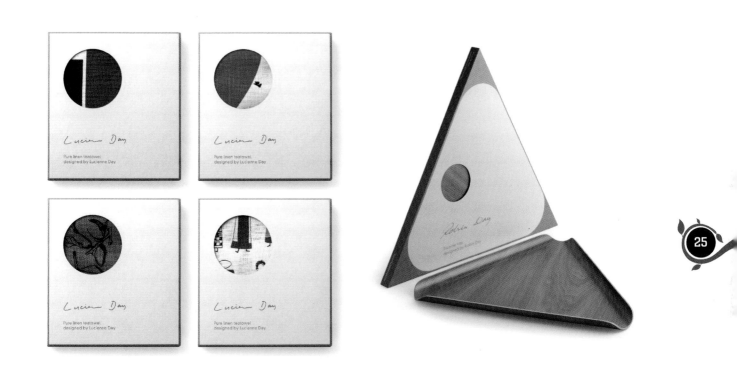

25

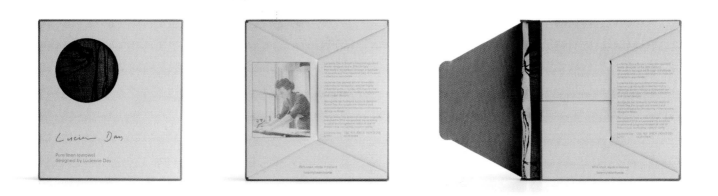

ALOOF DESIGN — LEWES, EAST SUSSEX,
UNITED KINGDOM
Creatives : Sam Aloof, Jon Hodkinson, Andrew Scrase
Client : Twentytwentyone

WHAT'S GREEN ABOUT THIS — The natural materials of linen and wood are complemented by recycled Kraft packaging, hand-printed with silk-screened graphics. The pack designs are carefully detailed constructions, assembled without the use of glue. Packs were designed with a low target unit cost in mind, which was achieved by keeping print and production processes as minimal as possible, making these designs both affordable and eco-friendly.

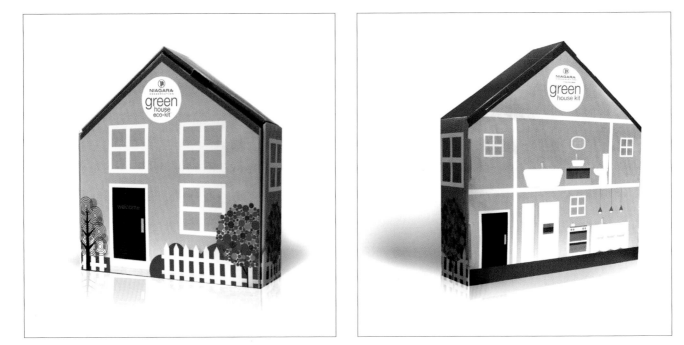

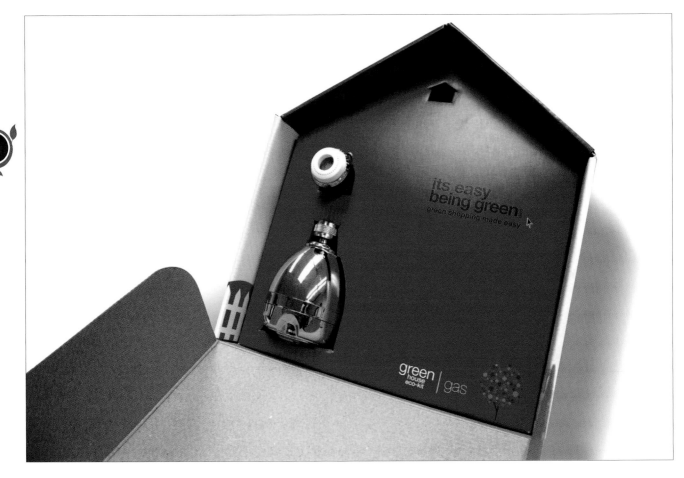

WHAT'S GREEN ABOUT THIS — Niagara's Green House EcoKit™ was designed to house water conservation products in a fun, environmentally friendly way. Not only are the packaging and the products themselves eco-friendly, but they were envisioned as a step towards growing the consumer's commitment to the environment, much like plants would grow in a greenhouse. The packaging was printed on recycled paperboard with soy-based inks, and what comes in the kit saves approximately 300,000 gallons of water over the life of the product. The box was also designed to be reused for storing small items that need a home.

NIAGARA CONSERVATION — CEDAR KNOLLS, NEW JERSEY
Creatives : Scott Kim, Donille Massa
Client : Niagara Conservation

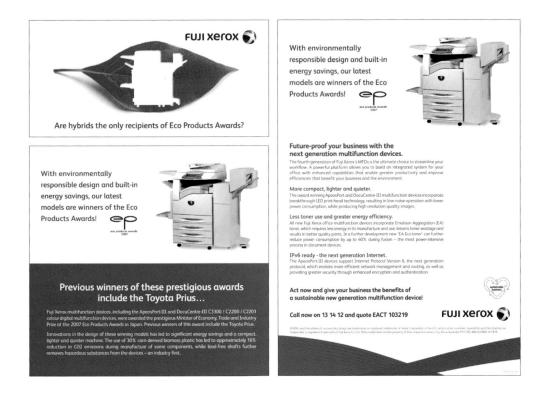

BOOMERANG INTEGRATED MARKETING –
ULTIMO, NSW, AUSTRALIA
Creatives : Jaime Teoh, Peter Kawerau,
Melissa Warland, Chris George
Client : Fuji Xerox Australia

WHAT'S GREEN ABOUT THIS – To visually illustrate Fuji Xerox's commitment to sustainability, the designer developed a three-colored graphic of a heart with three curved arrows. Each color and arrow symbolizes a single element of sustainability, and together they illustrate the interdependent and ongoing nature of Fuji Xerox's commitment to economic, social and environmental responsibility.

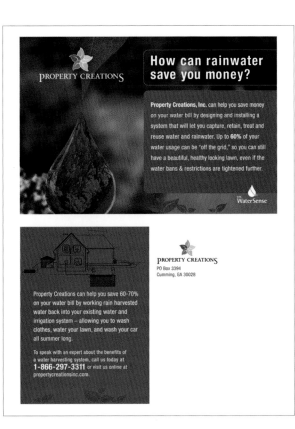

KELSEY ADVERTISING & DESIGN –
LAGRANGE, GEORGIA
Creatives : Brant Kelsey, Niki Studdard
Client : Property Creations, Inc.

WHAT'S GREEN ABOUT THIS – Property Creations specializes in creating green (in every sense of the word) landscapes and stylish hardscapes expressly designed to make the most efficient use of water in order to help conserve water and energy resources. Their rainwater-harvesting installations can supply up to 60% of a household's water needs from rainwater.

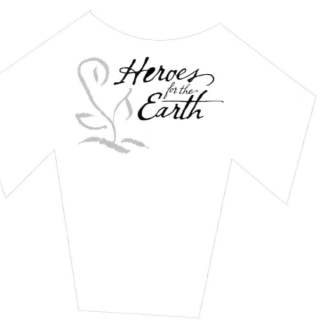

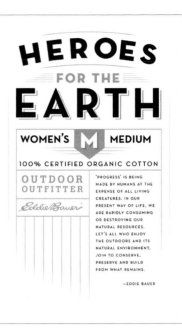

WHAT'S GREEN ABOUT THIS — T-shirt label screen for "Heroes for the Earth," a line of clothing produced by Eddie Bauer and made from organic fabrics. A portion of the proceeds goes to support green causes.

WEATHER CONTROL — SEATTLE, WASHINGTON
Creatives : Josh Oakley
Client : Eddie Bauer

28

BACK

FRONT

WHAT'S GREEN ABOUT THIS — These organic cotton shirts were printed with soy-based inks and sold at the One Earth/One Dream Festival in Laguna Beach, California in 2008.

BILL ATKINS DESIGN & ILLUSTRATION — LAGUNA BEACH, CALIFORNIA
Creatives : Bill Atkins, Bonnie Macmillan, Charles Michael Murray
Client : Endangered Planet Gallery

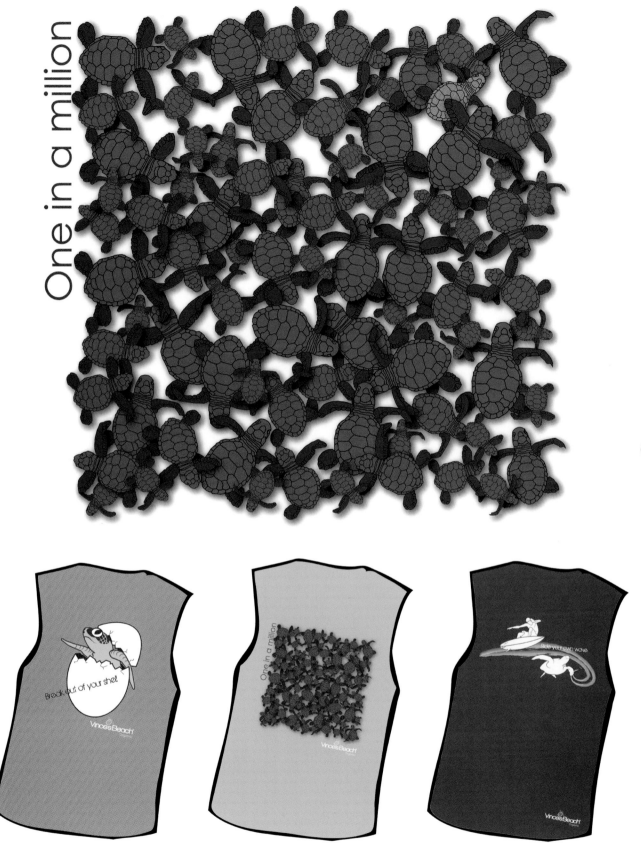

One in a million

SCAMPER LTD. — KENILWORTH, WARWICKSHIRE, UNITED KINGDOM
Creatives : Tom Greenwood, Vineeta Greenwood
Client : Vince's Beach

WHAT'S GREEN ABOUT THIS — Vince's Beach is a start-up clothing company with an exclusive, eco-friendly range of casual surf and beach wear offering great surf designs in organic cotton with vegetable-based inks. The t-shirt designs intentionally avoid blatant eco-messaging in order to avoid limiting its appeal and preaching to the converted. Instead, they aim to show that eco-friendly clothing can be fashionable, using more subtle messages in the graphic design that celebrate individuality and respect for each other and the environment. The brand's turtle emblem is used in all designs to highlight the company's passion and support for turtle and ocean protection, an issue of great significance for beach lovers.

WHAT'S GREEN ABOUT THIS — These buttons were handed out to clients as a self-promotional item to promote Jason Hill Design and the green causes they believe in.

| **JASON HILL DESIGN** — PHOENIX, ARIZONA
| **Creatives :** Jasonn Hill
| **Client :** Prickie.com

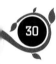

WHAT'S GREEN ABOUT THIS — Shaklee, a wellness company, re-launched their line of environmentally friendly cleaning supplies under a new name. The "Get Clean" packaging system allows consumers to create their own dilutions from the concentrated products, with re-usable bottles and a sticker system. This saves on packaging and transportation waste.

| **TURNER DUCKWORTH** — LONDON & SAN FRANCISCO
| **Creatives :** David Turner, Bruce Duckworth,
| Shawn Rosenberger, Danny Smyth
| **Client :** Shaklee

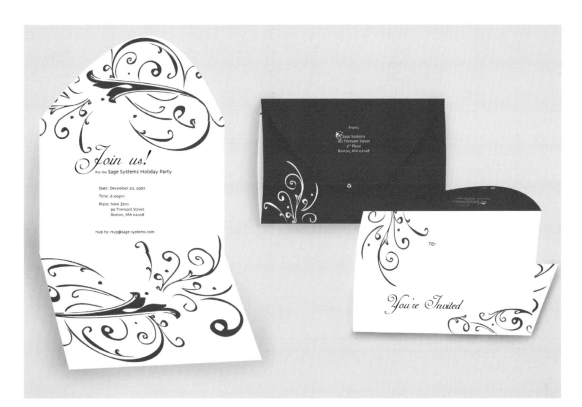

SAGE SYSTEMS — MASSACHUSETTS
Creatives : Yvette Perullo, Sahba Fanaian, Boyds Direct
Client : Sage Systems

WHAT'S GREEN ABOUT THIS — In-house invitation design for the Sage Systems annual holiday party. The goal was to reduce the environmental impact of this piece by designing the invitation as a self-mailer to minimize paper use. RSVPs were requested via email instead of a reply card to further eliminate the use of paper. This was a small two-color print run printed digitally for less waste during proofing. The paper is 30% post-consumer waste recycled stock.

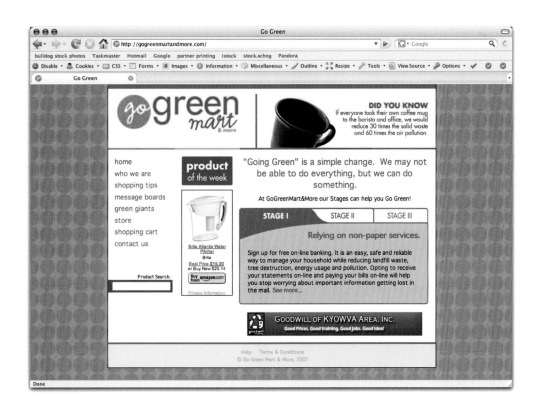

BULLDOG CREATIVE SERVICES — HUNTINGTON, WEST VIRGINIA
Creatives : Christine Borders, Megan Ramey-Keelin, Ashleigh Graham-Smith, Nick Niebaum
Client : Go Green Mart and More

WHAT'S GREEN ABOUT THIS — The Go Green Mart is a website for purchasing eco-friendly or green products.

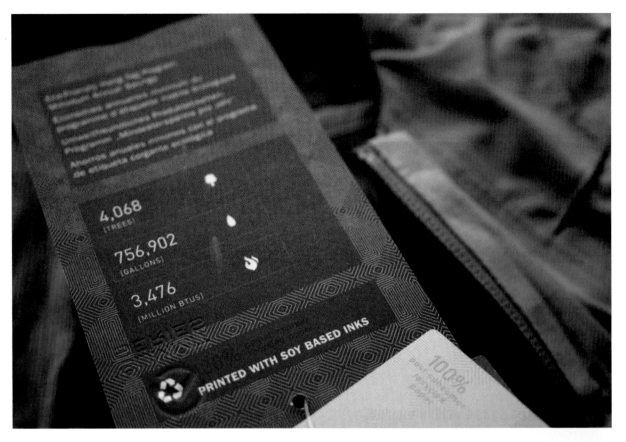

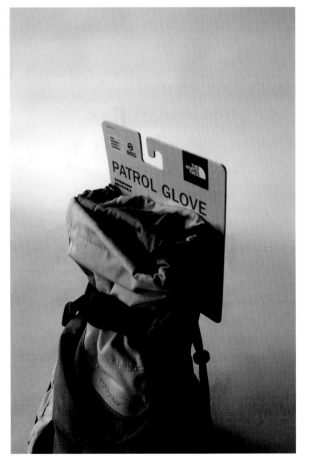

WHAT'S GREEN ABOUT THIS — The North Face launched a global redesign of its product hang-tag and packaging system that demonstrates the company's efforts toward greater environmental sustainability in its business practices. The new system utilizes high percentages of post-consumer content and environmentally-friendly inks. One feature displays an annual audit highlighting the minimum yearly savings from North Face's greener methods.

CHEN DESIGN ASSOCIATES — SAN FRANCISCO, CALIFORNIA
Creatives : Joshua Chen, Laurie Carrigan,Kathrin Blatter
Client : The North Face

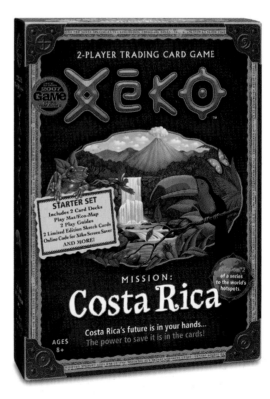

33

MARKETABILITY GROUP — KIRKLAND, WASHINGTON
Creatives : Mark Tolleshaug, Carolyn Goodwin
Client : Matter Group

WHAT'S GREEN ABOUT THIS — A children's trading card game designed to introduce kids to endangered animals and plants from around the world and to concepts of sustainability and ecology. The client requirements called for a unique format for each installment, using only sustainable materials. From FSC-certified wood to 100% recycled paperboard.

How They Did It
eConscious Market

"I don't care how good a design is," says Leif Steiner, creative director and founder of Moxie Sozo design and advertising agency, "if it's not effective, you're just doing art. You've got to sell the product, promote the service, or build the brand."

That doesn't mean Moxie Sozo skimps on great design—only that it had better satisfy the client's needs. "First and foremost, our job is to make money for our clients," Steiner says. "Then we want to minimize our impact on the Earth."

With those aims in mind, Steiner launched Moxie Sozo in Boulder, Colorado a decade ago. "All of our projects are green-oriented in one way or another," he says. Steiner touts Moxie as the first agency in the world to operate with zero-waste and be renewable-energy-powered and carbon-neutral.

That reputation naturally draws green-oriented clients. In 2006, eConscious Market was a start-up on a limited budget looking for a kindred marketing agency. Steiner recalls founder Mathew Gerson initiating the relationship by saying, "This is our idea. You look like the company that'll get us going. This is how much money we have to spend on marketing—can you do it?"

eConscious Market is an internet commerce site, a digital shop for people who are earth-aware. Think of it as an online superstore with a plus: a percentage of each sale goes to designated green-oriented and socially responsible organizations. Users may purchase anything from clothing, outdoor and recreation gear, and body care products, to a wide variety of recycled and fair trade goods. "We were hired to develop the website and drive traffic to it," Steiner says. The agency was to handle all aspects of strategy and brand development as well. Then, in order to support the growth of eco-friendly companies including eConscious Market and its partner suppliers, Moxie Sozo donated most of its services for the project.

Steiner prides himself on working closely with his clients, making sure they are in sync with his ideas every step of the way. "Creative design is equal portions of talent and the ability to walk clients through the process and have them buy off on it," Steiner says. "As crazy as this sounds, I don't remember ever having a disagreement with a client over what we were doing." So it went with eConscious Marketing. "The first project is critical," Steiner says. "If we hit a home run the first time out, the client will trust us after that. In ten years of business, we haven't lost a single account."

eConscious Marketing is planning a European rollout for its site. Moxie will create that website from the ground up. The client's mission in Europe will be the same as it is in the U.S. "eConscious is trying to provide a marketplace for people who want to give back," Steiner says. "It's tapping into a certain culture of giving and personal responsibility."

The U.S. site's slogan is "Giving. It's the new getting." eConscious only does business with companies that reflect its worldview. For every product bought on the site, eConscious makes a donation of up to 10 percent to one of its 125 "Social-Profit partners."

"Our business was created to benefit society—to give back rather than merely extract," the website explains.

It's an outlook Steiner buys into. "I've been all over the world. When crossing the Sahara, you occasionally see black plastic bags blowing across the sand. Sometimes they come from come from 300 miles away. We have to minimize our impact on Earth," he says.

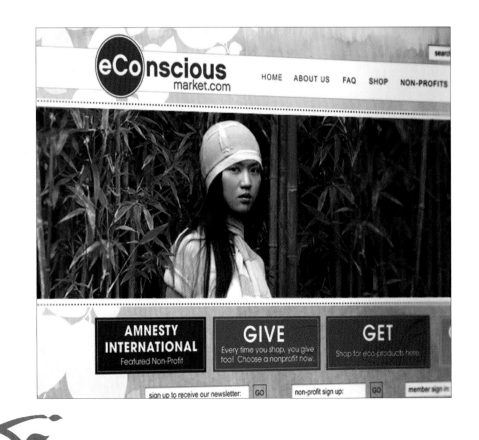

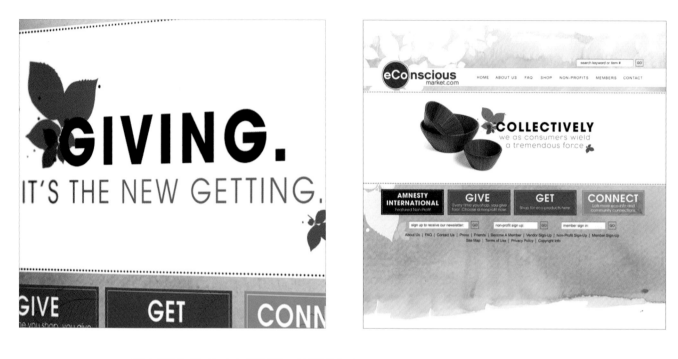

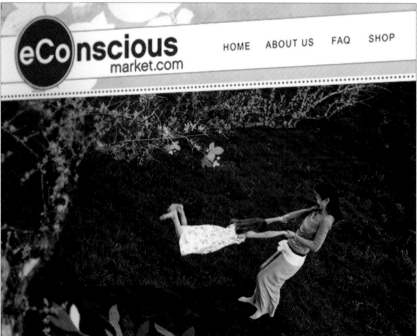

MOXIE SOZO — BOULDER, COLORADO
Creatives : Leif Steiner, Sarah Layland, Teri Gosse
Client : Econscious Market

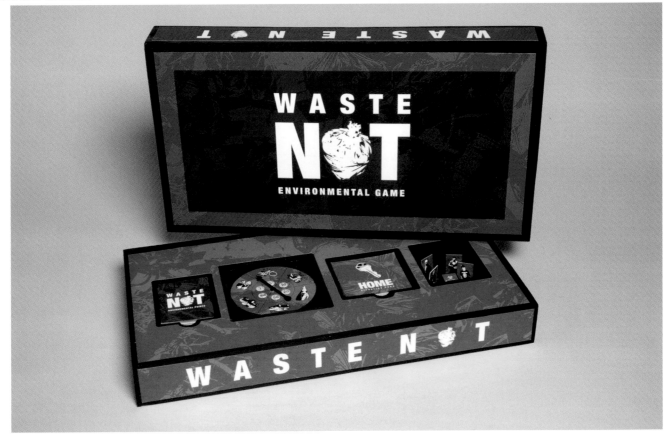

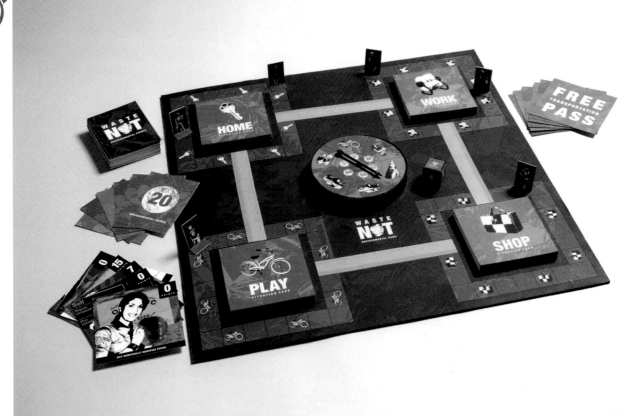

WHAT'S GREEN ABOUT THIS — This environmentally friendly game is printed on recycled paper using soy-based ink. The game teaches people small things they can change to help the environment by awarding points to environmentally friendly decisions like riding a bike instead of driving a car, or bringing canvas bags to the grocery store.

CALAGRAPHIC DESIGN — ELKINS PARK, PENNSYLVANIA
Creatives : Joe Scorsone, Ronald J. Cala II
Client : Tyler School of Art, Temple University

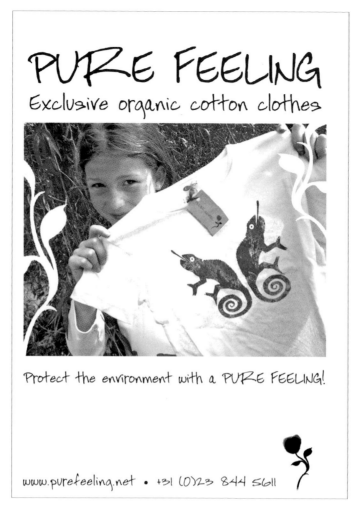

VKP DESIGN — HAARLEM, THE NETHERLANDS
Creatives : Vanessa Paterson
Client : Pure Feeling

WHAT'S GREEN ABOUT THIS — Pure Feeling sells fair-trade organic cotton clothing for children and adults, both online and in a successful shop in Haarlem, the Netherlands, which started as a simple market stall.

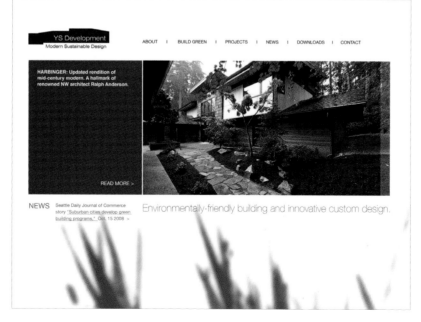

NETRA NEI — SEATTLE, WASHINGTON
Creatives : Netra Nei, Mik Nei, Iris Guy Sofer
Client : YS Development

WHAT'S GREEN ABOUT THIS — The company's goal is to build innovative and thoughtful developments, that are designed by the best local architects, and that meet or exceed the high standards of BUILT GREEN, LEED and ENERGY STAR HOME, while allowing for relative affordability.

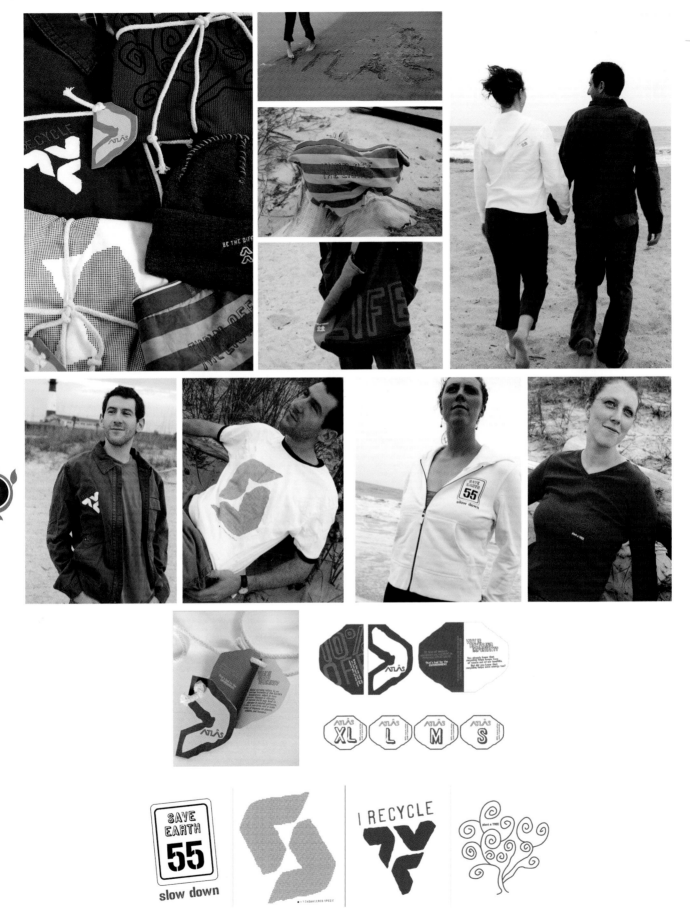

WHAT'S GREEN ABOUT THIS — Atlas plays to pop-culture sensibility with a line of organic clothing that educates its target market about environmental issues.

THE FAMOUS STUDIO — WHITE STONE, VIRGINIA
Creatives : Ryn Bruce
Client : Atlas

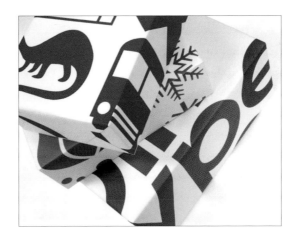

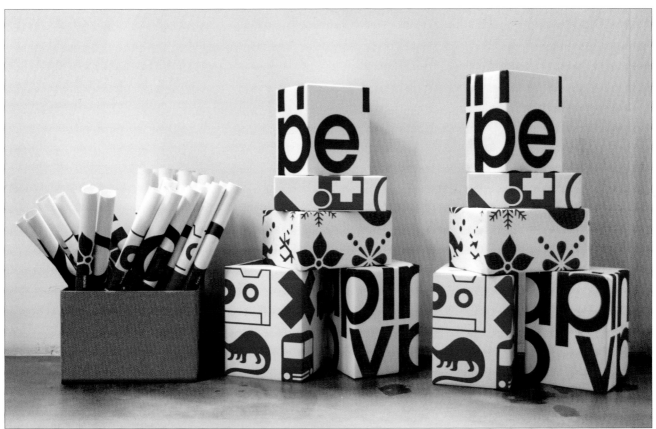

HOUSEMOUSE™ — VICTORIA, AUSTRALIA
Creatives : housemouse™
Client : Wrapped by housemouse™

WHAT'S GREEN ABOUT THIS — Wrapped by housemouse™ is a designer wrapping-paper range which doubles as poster art (sheet size: 840 x 595mm.) Wrapped by housemouse™ is printed on 100% recycled, Australian [locally]-made, acid-free, pH-neutral paper, using vegetable-based inks.

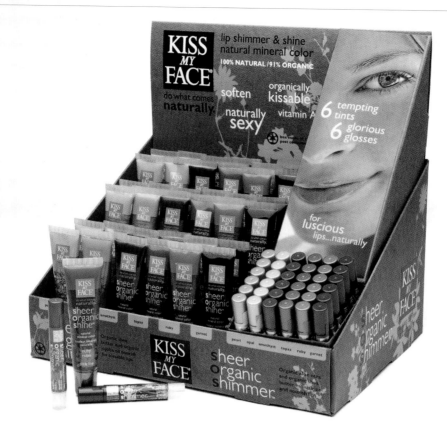

40

WHAT'S GREEN ABOUT THIS — Kiss My Face created Sheer Organic Shines and Sheer Organic Shimmers 100% natural/91% organic natural mineral lip colors. To reinforce the all-natural product ingredients, eco-friendly display materials use 100% recycled board stock to differentiate them from the mostly plastic cosmetic displays currently in the market. The display is space-saving, efficient, and eliminates the need for additional product packaging.

ALTERNATIVES — NEW YORK, NEW YORK
Creatives : Ellen Bean, Lisa D'Eila, Julie Koch-Beinke, Lynn Marfey
Client : Kiss My Face

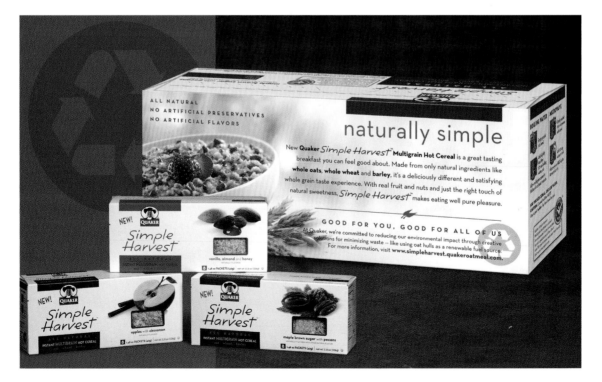

WHAT'S GREEN ABOUT THIS — For Quaker's Simple Harvest Instant Multigrain Hot Cereal, the designer created a simple, recyclable carton that shows the cereal through a die-cut window and highlights the all-natural ingredients.

HAUGAARD CREATIVE GROUP — CHICAGO, ILLINOIS
Creatives : Jose Parado, Ed Griffin
Client : Quaker Oats

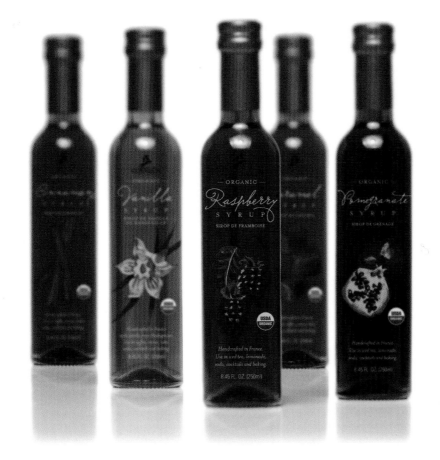

JENN DAVID DESIGN — SAN DIEGO, CALIFORNIA
Creatives : Jenn David Connolly, Julie Delton
Client : Combier

WHAT'S GREEN ABOUT THIS — Combier, a French artisan distillery, developed a line of 100% organic syrups for introduction into the American gourmet retail market. Combier is the oldest distillery that is still active in the Loire Valley in France.

41

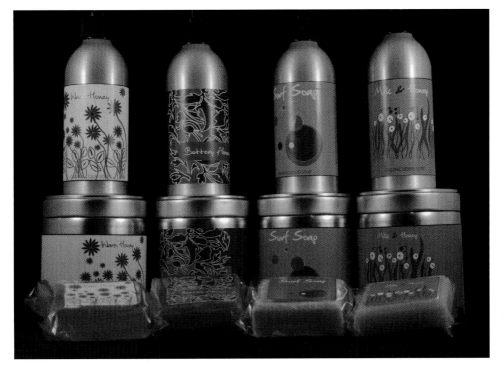

LAF, INC. — FORT MYERS, FLORIDA
Creatives : Stephanie Battista
Client : Happy Body Soap Co.

WHAT'S GREEN ABOUT THIS — Happy Body Soap Company uses at least 80% post-consumer content for all its labels and boxes, cello wrap made from vegetable fiber instead of petroleum, and aluminum for its ease of recycling. All beauty products within their range are completely organic and natural.

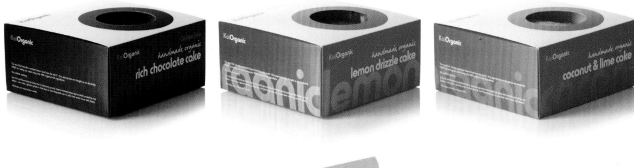

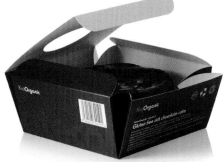

WHAT'S GREEN ABOUT THIS — Kai Organics' cakes were originally sold in stock, vacuum-formed plastic cake boxes with home-produced graphics applied to sticky labels, which was neither aesthetically appealing nor in sync with their organic image. The designer created a new pack with an innovative structural design that is environmentally sound, easy to recycle, and requires a minimum number of production processes to keep costs low. The packaging is produced locally to the bakery using just two-color litho print with vegetable-based inks and a single die-cutting process. The folding box board is a white, chlorine-free board made with wood pulp sourced from sustainable forests. The packaging can be transported and stored flat, and is assembled as required.

ALOOF DESIGN — LEWES, EAST SUSSEX, UNITED KINGDOM
Creatives : Sam Aloof, Jon Hodkinson, Andrew Scrase
Client : Kai Organic

42

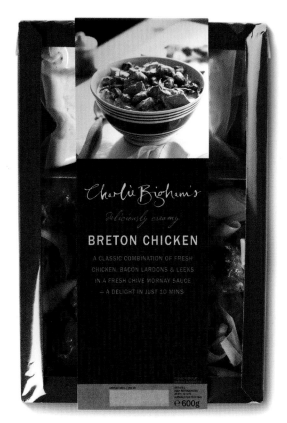

WHAT'S GREEN ABOUT THIS — Bigham's new branding and packaging replaces its plastic trays with recyclable paper to create a more sustainable range of packaging that is both elegant and fit for the purpose. They have also reduced the amount of cardboard by creating narrower sleeves on most packs.

BIG FISH DESIGN LTD. — LONDON, UNITED KINGDOM
Creatives : Perry Haydn Taylor, Ruth Brooker
Client : Charlie Bigham's

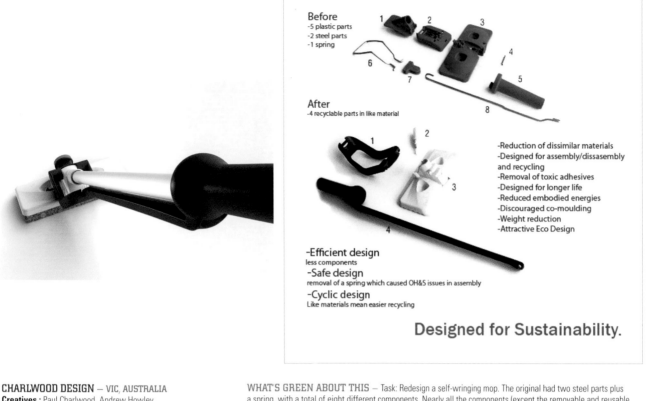

Before
-5 plastic parts
-2 steel parts
-1 spring

After
-4 recyclable parts in like material

-Reduction of dissimilar materials
-Designed for assembly/dissasembly
 and recycling
-Removal of toxic adhesives
-Designed for longer life
-Reduced embodied energies
-Discouraged co-moulding
-Weight reduction
-Attractive Eco Design

-Efficient design
less components
-Safe design
removal of a spring which caused OH&S issues in assembly
-Cyclic design
Like materials mean easier recycling

Designed for Sustainability.

CHARLWOOD DESIGN — VIC, AUSTRALIA
Creatives : Paul Charlwood, Andrew Howley
Client : Oates

WHAT'S GREEN ABOUT THIS — Task: Redesign a self-wringing mop. The original had two steel parts plus a spring, with a total of eight different components. Nearly all the components (except the removable and reusable handle) are now recyclable plastic. At the end of its useful life, most parts are easily disassembled for recycling. The aluminum handle pole can simply be unscrewed from the head. The wringing mechanism is driven by a flexible plastic strut intstead of a galvanized spring. The mop now has fewer parts, is designed for easy disassembly and recycling, is free of toxic adhesives, has been reduced in weight for transport, and is designed for a longer life.

43

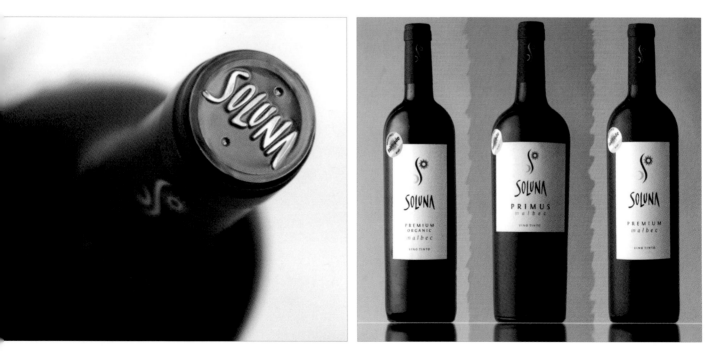

KENNETH DISEÑO — URUAPAN, MICHOACAN, MEXICO
Creatives : Kenneth Treviño
Client : Soluna Wines

WHAT'S GREEN ABOUT THIS — Soluna is the first fair-trade wine of Argentina, produced with conventional and organic malbec grapes.

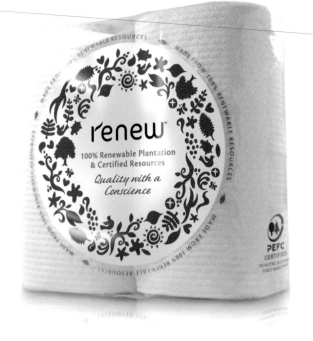

WHAT'S GREEN ABOUT THIS — Renew makes sustainable, eco-friendly toilet tissue sourced from 100% renewable plantations from a certified environmentally managed company that shares the client's concerns and responsibilities not only for the environment, but for the social and economic impact on local communities.

CURIOS DESIGN CONSULTANTS LIMITED —
AUCKLAND, NEW ZEALAND
Creatives : Monique Pilley, Nigel Kuzimski
Client : Paperforce

44

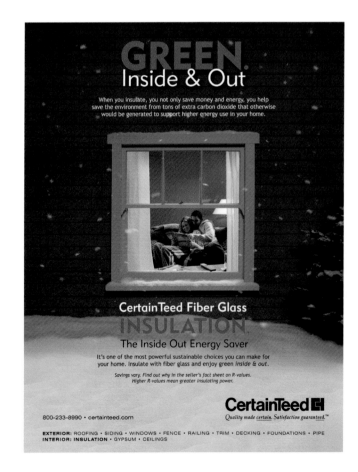

WHAT'S GREEN ABOUT THIS — Green ad for energy-efficient CertainTeed insulation, which is made in energy-conscious plants, using sand and recycled glass. CertainTeed's environmental commitment is: From the design and manufacture of our building products, to how they perform in our world, CertainTeed leads by example. It's our commitment to energy efficiency, innovative recycling, and sustainable design and construction.

ELIAS SAVION ADVERTISING —
PITTSBURGH, PENNSYLVANIA
Creatives : Ronnie Savion, Jim Kashak
Client : Certainteed Insulation

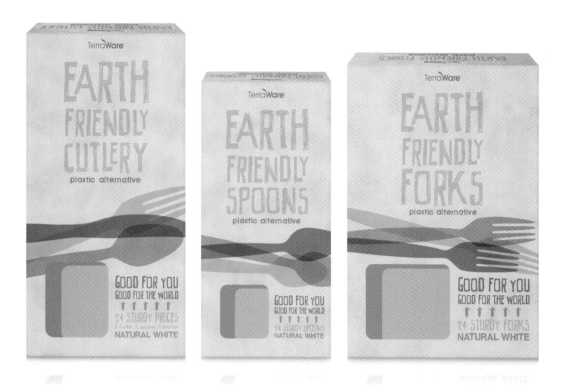

AFTER HOURS CREATIVE — PHOENIX, ARIZONA
Creatives : Aaron Thompson, Brad Smith, Trevor Hill, Russ Haan
Client : Terraware

WHAT'S GREEN ABOUT THIS — TerraWare makes biodegradable spoons, forks, and knives from corn byproducts—a superb alternative to non-degrading plastic. Ink on packaging is biodegradable, as is the paperboard on which it is printed.

45

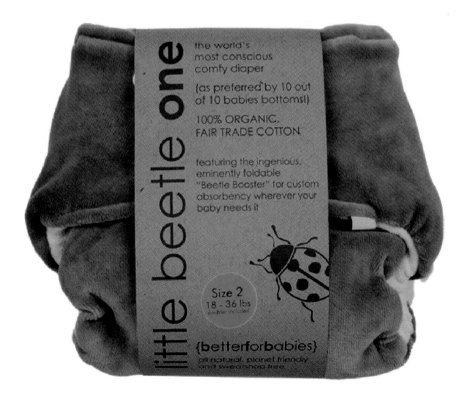

THE CHANGE — NORTH CAROLINA
Creatives : Jerry Stifelman, Chelsea Bay Wills
Client : Better for Babies

WHAT'S GREEN ABOUT THIS — Better for Babies offers products to make responsible, sustainable parenting hassle-free, from organic, fair-trade, reusable diapers to co-sleepers made from natural rubber.

46

WHAT'S GREEN ABOUT THIS — A natural solution for an environmentally responsible brand. OrangeCup's "Orange is Green" program is based on the re-usable bags given to customers who buy two cups of yogurt. Each time they bring the bag back and fill it with two cups, they get a sticker. After all stickers are collected, it spells "Orange is Green." The reward for a full set of stickers is an organic "Orange is Green" t-shirt.

RANGE DESIGN — DALLAS, TEXAS
Creatives : John Swieter, Garrett Owen
Client : Orangecup Natural Frozen Yogurt

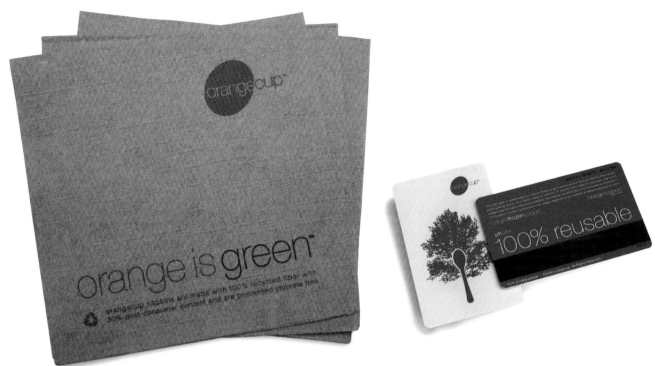

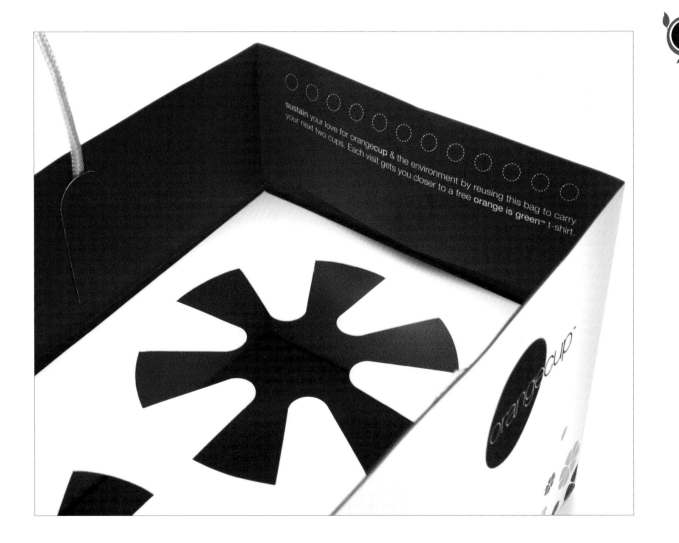

orange is green™

orangecup napkins are made with 100% recycled fiber with 30% post-consumer content and are processed chlorine free.

100% reusable

sustain your love for orangecup & the environment by reusing this bag to carry your next two cups. Each visit gets you closer to a free **orange is green™** t-shirt.

47

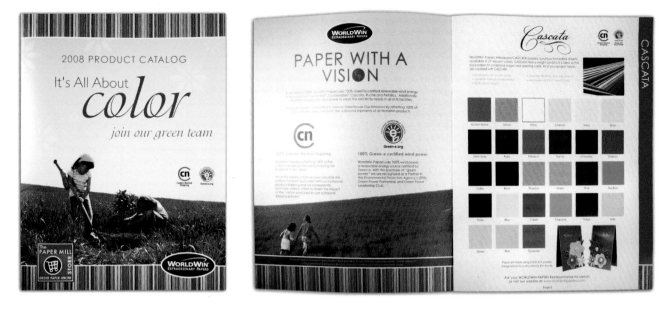

WHAT'S GREEN ABOUT THIS — WorldWin Papers and The Paper Mill Store .com offer "Paper with a Vision" by using 100% carbon-neutral shipping and 100% Green-e certified wind power. They are FSC-, CoC-, and SFI-certified. The Paper Mill Store .com is one of the largest purchasers of renewable energy certificates among online paper stores and is recognized as a Partner of the EPA's Green Power Partnership and Green Power Leadership Club. Materials were printed on recycled paper using soy inks.

GREENLEAF MEDIA — WISCONSIN
Creatives : Mary Walsh, Jen Baker, Erica Hess
Client : Worldwin Papers

48

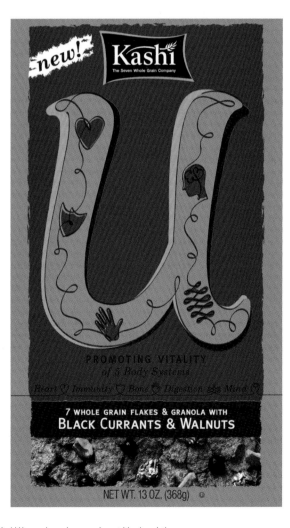

WHAT'S GREEN ABOUT THIS — To establish Kashi U as a pioneering, superior nutrition brand, the designer emphasized the idea of connectivity: of our body systems to each other; of the food we eat to our health and vitality; and of our actions and food choices to the health and vitality of the planet. The use of kraft paper, wind power, and soy-based inks supports the integrity of the product and brand.

ADDIS CRESON — BERKELEY, CALIFORNIA
Creatives : Joanne Hom, Traci Clark
Client : Kashi

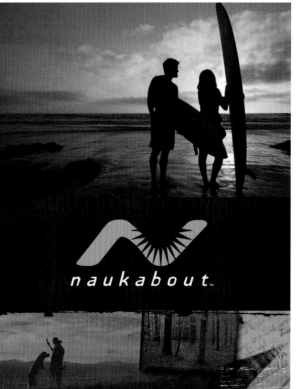

Our Partnerships

The Conservation Alliance
Outdoor Business Giving Back to the Outdoors

The Conservation Alliance
www.conservationalliance.com

Elias

Elias Fund
www.eliasfund.org

25 YEARS HOCKEY EAST 1984-2009

Hockey East
www.hockeyeastonline.com

Surfrider Foundation

Surfrider Foundation
www.surfrider.org

naukabout

Naukabout LLC
Cape Cod, Massachusetts | Ponte Vedra Beach, Florida

(866) 869-3257 www.naukabout.com

Printed on 100% recycled content, 100% post-consumer waste, processed chlorine-free paper.

naukabout

WHERE DO YOU NAUKABOUT?

Naukabout is a clothing company, a concept and a lifestyle
dedicated to the preservation and pursuit of one's most memorable moments, places and life adventures.

(nok'a-bout')

Verb: to find, capture and preserve one's most memorable moments, places and life adventures.

Noun: a clothing company offering casual, active and outdoor apparel for men, women and children. A comfortable, casual article of clothing.

STUDIO 22 — THURMONT, MARYLAND
Creatives : Eryn Willard, Adam Conley
Client : Naukabout

WHAT'S GREEN ABOUT THIS — Naukabout founders' commitment to preserving our past while creating a sustainable outdoor future was a good fit for Studio 22's commitment to sustainability and the environment. All Naukabout apparel is manufactured using 100% organic cotton. Naukabout's commitment to conservation and preservation also manifests itself in alliances with a number of environmental, charitable, and social organizations. Reflective of both companies' beliefs, this piece was printed on 100% recycled/100% PCW stock at a certified green printer and shipped via climate-neutral delivery.

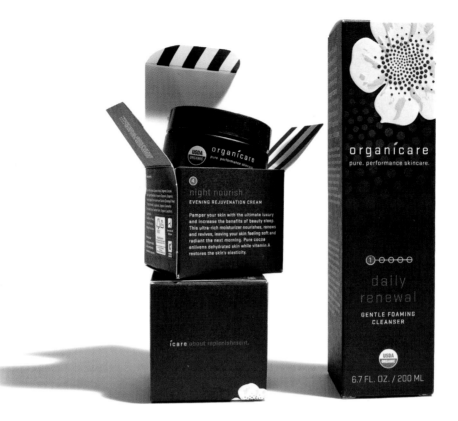

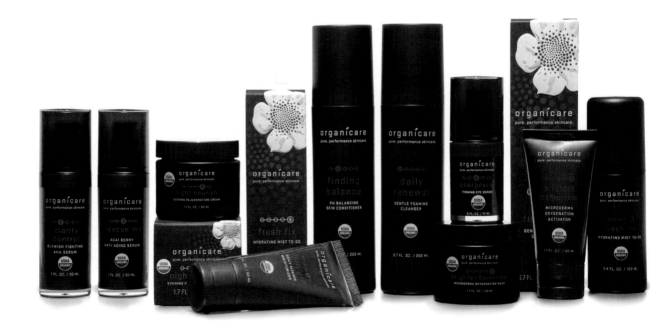

WHAT'S GREEN ABOUT THIS — Organicare is the first completely USDA-certified line of organic skincare products. The Organicare brand and packaging system remains true to the products' earth-friendly values. Both products and packaging are made from completely renewable resources. The carton is made from 80% post-consumer, FSC-certified recycled fiber. Paperboard and carton were manufactured in a carbon-neutral facility using only wind power or hydropower.

WILLOUGHBY DESIGN — KANSAS CITY, MISSOURI
Creatives : Ann Willoughby, Megan Semrick, Nate Hardin, Stephanie Lee
Client : Organicare

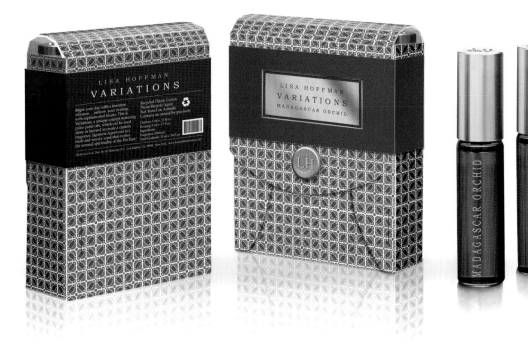

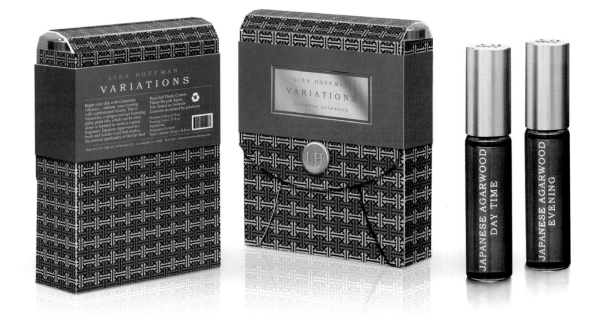

STRINE PRINTING — YORK, PENNSYLVANIA
Creatives : Kathryn Culley, Becky Hoffman
Kathleen Allen, Sharon Coakley
Client : Lisa Hoffman Beauty

WHAT'S GREEN ABOUT THIS — Lisa Hoffman (wife of actor Dustin Hoffman) wanted green packaging for her portable perfume line that could stand up to the wear and tear of travel. It was important that the product be recyclable and, if possible, made from recycled material. Strine made a printed package and sleeve out of PE PCR (70% recycled content from recycled milk-jug material) and recycled paper. This is a major development in the digital print industry; until this time, there were no plastic materials available for the Indigo Press that were environmentally friendly and recycled.

WHAT'S GREEN ABOUT THIS — Typographic patterns for Aladdin, a manufacturer of drinkware. These patterns are for use on coffee tumblers. Disposable coffee cups generate about 253 million lbs. of waste in the U.S. alone, so reusable coffee mugs and tumblers can have a huge impact on our environment.

WEATHER CONTROL — SEATTLE, WASHINGTON
Creatives : Josh Oakley
Client : Drinkware

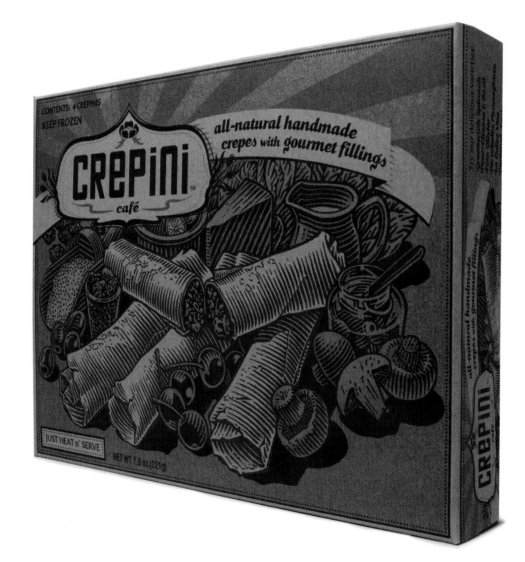

WHAT'S GREEN ABOUT THIS — Crepini wanted to update their packaging to look more gourmet and incorporate as many green qualities as a frozen food package would allow. The options for material choices that stand up in a freezer case were very limited. The final product uses a SFI (Sustainable Forestry Initiative) certified kraft paper, as well as a bagasse (sugar cane pulp) paper tray inside the box.

MILLER CREATIVE LLC — LAKEWOOD, NEW JERSEY
Creatives : Yael Miller, Roger Xavier
Client : Crepini Café

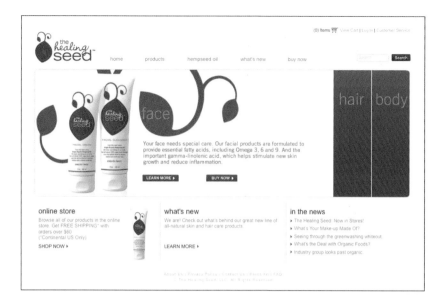

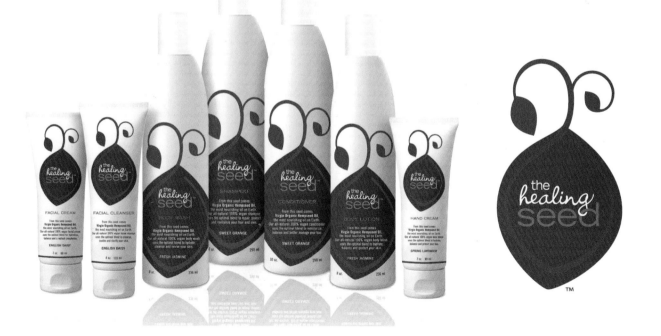

53

THE PHELPS GROUP — SANTA MONICA, CALIFORNIA
Creatives : Shelly Walker, Kent Land, Jason Yoffy, Kate Scherer
Client : Richmond Nature—The Healing Seed

WHAT'S GREEN ABOUT THIS — These products are made with cold-pressed, organic virgin hempseed oil in all-natural formulas.

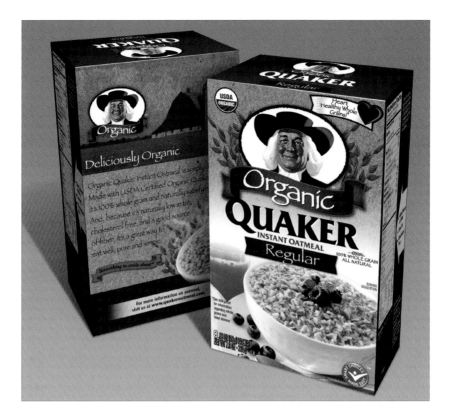

WHAT'S GREEN ABOUT THIS — Quaker Organic Instant Oatmeal is a new organic offering from Quaker Oats, and is produced and processed according to "USDA standards, which means that at least 95 percent of the food's ingredients are organically produced".

HAUGAARD CREATIVE GROUP — CHICAGO, ILLINOIS
Creatives : Tony Cesare
Client : Quaker Oats

54

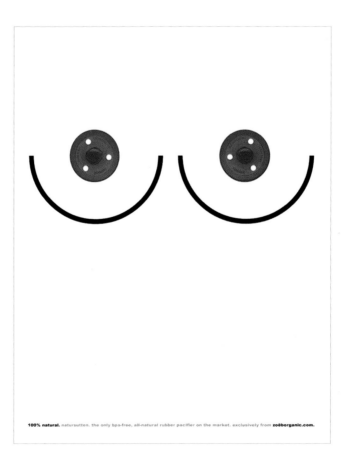

100% natural. natursutten. the only bpa-free, all-natural rubber pacifier on the market. exclusively from zoëborganic.com.

WHAT'S GREEN ABOUT THIS — An advertisement for the only bpa-free, 100% natural rubber pacifier on the market.

BB CREATIVE PARTNERS — WINSTON SALEM, NORTH CAROLINA
Creatives : Beth Kosuk, John Brockenbrough
Client : Zoe b Organic

The highest quality. The greatest good.
Natural Products From the Most Pristine Regions of the Planet

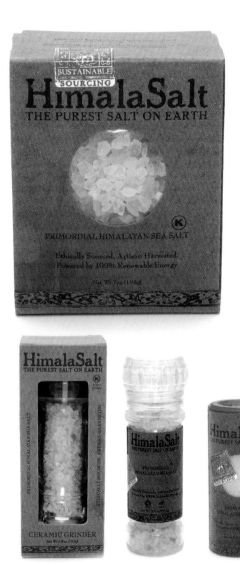

55

THE CHANGE — NORTH CAROLINA
Creatives : Jerry Stifelman, Chelsea Bay Wills
Client : Sustainable Sourcing

WHAT'S GREEN ABOUT THIS — Sustainable Sourcing offers artisan-produced gourmet salt from the Himalayas, some of the purest salt on earth. The company's founder goes to great lengths to ensure fair wages for producers, culturally appropriate business models, and environmental sustainability; she also offsets all emissions and uses recycled cardboard packaging.

MOHAWK FINE PAPERS

eco*guide

*Practicing energy conservation and purchasing emission-free energy are fundamental to Mohawk's environmental stewardship program.

Fall 2008

Beckett Cambric
Beckett Cambric's refined linen finish is sophisticated and totally fresh with an energized color palette. A polished and calendered surface lends to extraordinary results for offset, digital, and specialty printing techniques.
- subtle linen finish
- made carbon neutral
- FSC certified
- Green-e certified
- 30% and 100% pcw shades

Beckett Concept
Beckett Concept's luxurious vellum finish and dense formation result in unparalleled printability. New heavier covers and rich colors make Concept an elegant choice for business and social communications.
- luxurious vellum finish
- made carbon neutral
- FSC certified
- Green-e certified
- 100% pcw shades

Beckett Expression
High-performance Beckett Expression is an essential tool for demanding jobs that require print and environmental performance. The super-smooth surface gives images extra snap and brilliance on offset and digital presses.
- super-smooth surface
- made carbon neutral
- FSC certified
- Green-e certified
- 30% pcw shades

Strathmore Writing and Script
Strathmore papers have been made to the highest quality standards since 1892 and offer elegance and technical performance. Wove, laid, smooth, and pinstripe finishes are guaranteed to perform in offset, laser, and inkjet printers.
- beautiful writing, text, and cover
- made carbon neutral
- FSC certified choices
- Green-e certified
- 30% and 100% pcw shades
- rapidly-renewable cotton

Mohawk Superfine
Mohawk Superfine serves as the benchmark for premium papers and inspires great design. A highly refined text and cover paper, Superfine is chosen for its superb formation, archival quality, and timeless appeal.
- traditional writing, text, and cover
- 30% pcw shades
- Green-e certified

Mohawk Options
Made with our patented Inxwell process, Mohawk Options features unusually high ink holdout and exceptional opacity for four-color photos that reproduce precise, vivid images with clean highlights and stunning contrast.
- high-performance paper with Inxwell
- FSC certified choices
- Green-e certified
- 30% and 100% pcw shades

Mohawk Via
The Via portfolio is comprehensive and economical, offering a variety of finishes—smooth, linen, felt, vellum, satin, and laid—and a fresh color palette as well as outstanding print quality. Cotton writing and textured digital papers made with i-Tone make Via ideal for a range of business communications.
- comprehensive writing, text, and cover
- FSC certified choices
- Green-e certified
- 30% and 100% pcw shades

Mohawk Renewal Folding Board *(new Fall 2008)*
Mohawk Renewal is a premium folding board for luxury packaging. With 80% postconsumer waste and two textures, it is a perfect choice for companies who want to project their commitment to sustainable design.
- 18 point single-ply
- smooth and vellum
- Green-e certified
- FSC-certified and made carbon neutral
- 80% pcw
- excellent scoring and folding

Mohawk 50/10
Mohawk 50/10 was one of the first coated papers made with postconsumer fiber. In Matte, gloss, and cast coated finishes, Mohawk 50/10 is a value sheet with excellent printability in both the offset and digital pressroom.
- matte, gloss, and cast coated paper
- Green-e certified
- 15% pcw

Mohawk Color Copy
Mohawk Color Copy is a collection of high-performance papers for digital color printers and copiers. Featuring Mohawk's Digital Imaging Surface, these papers offer enhanced print fidelity, brilliant color and unparalleled value.
- brilliant digital printing
- FSC certified choices
- Green-e certified
- 15%, 30%, and 100% pcw shades

These premium Mohawk grades contain postconsumer fiber and are made with windpower:
Strathmore Elements 20% pcw choices	Beckett Ridge 30% pcw choices	Mohawk BriteHue 30% pcw choices
Strathmore Grandee 20% pcw choices	Mohawk Navajo 20% pcw	Mohawk Opaque 10% and 20% pcw
Beckett Enhance 30% pcw choices	Mohawk Ultrafelt 30% pcw	

56

WHAT'S GREEN ABOUT THIS — The eco*guide is Mohawk's first attempt at promoting their environmental attributes across grade lines. The guide explains overall environmental properties--the entire product line is made with windpower--as well as grade-specific qualities (including carbon neutral, postconsumer waste, etc.). The at-a-glance guide enables customers to see the entire range of environmental offerings and make choices that are most consistent with their project goals.

AURORA DESIGN — NISKAYUNA, NEW YORK
Creatives : Jennifer Wilkerson, Laurel Saville
Client : Mohawk Fine Papers

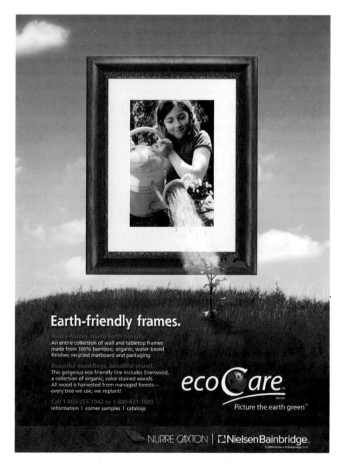

Earth-friendly frames.

Already-Made, made Earth-friendly
An entire collection of wall and tabletop frames made from 100% bamboo; organic, water-based finishes; recycled matboard and packaging.

Beautiful mouldings, beautiful planet.
This gorgeous eco-friendly line includes Sherwood, a collection of organic, color-stained woods. All wood is harvested from managed forests— every tree we use, we replant!

Call 1-800-255-1942 or 1-800-631-1603
information | corner samples | catalogs

ecoCare
Picture the earth green

NURRE CAXTON | Nielsen Bainbridge

WHAT'S GREEN ABOUT THIS — Nielsen Bainbridge has introduced an entire collection of wall and tabletop frames made from 100% bamboo with organic, water-based finishes and recycled matboard and packaging. They have also introduced a new custom, eco-friendly moulding line called Sherwoods, a collection of organic, color-stained woods. All wood is harvested from managed forests—every tree used is replanted.

R&J GROUP — PARSIPPANY, NEW JERSEY
Creatives : Andrew Badalamenti, Dale Sutphen
Client : Nielsen Bainbridge

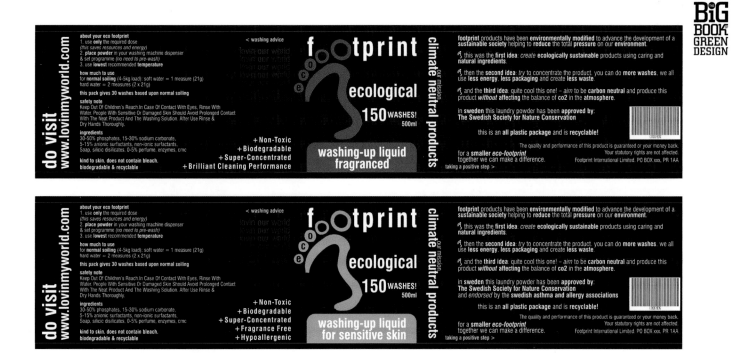

about your eco footprint
1. use **only** the required dose
(this saves resources and energy)
2. **place powder** in your washing machine dispenser
& set programme *(no need to pre-wash)*
3. use **lowest** recommended **temperature**

how much to use
for **normal soiling** (4-5kg load): soft water = 1 measure (21g)
hard water = 2 measures (2 x 21g)
this pack gives 30 washes based upon normal soiling

safety note
Keep Out Of Children's Reach.In Case Of Contact With Eyes, Rinse With
Water. People With Sensitive Or Damaged Skin Should Avoid Prolonged Contact
With The Neat Product And The Washing Solution. After Use Rinse &
Dry Hands Thoroughly.

ingredients
30-50% phosphates, 15-30% sodium carbonate,
5-15% anionic surfactants, non-ionic surfactants,
Soap, silicic disilicates. 0-5% perfume, enzymes, cmc

**kind to skin. does not contain bleach.
biodegradable & recyclable**

**do visit
www.lovinmyworld.com**

< washing advice

f ˚otprint

ecological

150 WASHES!
500ml

washing-up liquid fragranced

+Non-Toxic
+Biodegradable
+Super-Concentrated
+Brilliant Cleaning Performance

climate neutral products
our mission

footprint products have been **environmentally modified** to advance the development of a **sustainable society** helping to **reduce** the total **pressure** on our **environment.**

this was the **first idea**: *create* **ecologically sustainable** products using caring and **natural ingredients.**

then the **second idea**: *try* to concentrate the product. you can do **more washes**. we all use **less energy, less packaging** and create **less waste.**

and the **third idea**: quite cool this one! – *aim* to be **carbon neutral** and produce this product *without* **affecting** the balance of **co2** in the **atmosphere.**

in **sweden** this laundry powder has been **approved by:**
The Swedish Society for Nature Conservation

this is an **all plastic package** and is **recyclable!**

The quality and performance of this product is guaranteed or your money back.
for a **smaller eco-footprint** Your statutory rights are not affected.
together we can make a difference. Footprint International Limited. PO BOX xxx, PR 1AA
taking a positive step >

about your eco footprint
1. use **only** the required dose
(this saves resources and energy)
2. **place powder** in your washing machine dispenser
& set programme *(no need to pre-wash)*
3. use **lowest** recommended **temperature**

how much to use
for **normal soiling** (4-5kg load); soft water = 1 measure (21g)
hard water = 2 measures (2 x 21g)
this pack gives 30 washes based upon normal soiling

safety note
Keep Out Of Children's Reach.In Case Of Contact With Eyes, Rinse With
Water. People With Sensitive Or Damaged Skin Should Avoid Prolonged Contact
With The Neat Product And The Washing Solution. After Use Rinse &
Dry Hands Thoroughly.

ingredients
30-50% phosphates, 15-30% sodium carbonate,
5-15% anionic surfactants, non-ionic surfactants,
Soap, silicic disilicates. 0-5% perfume, enzymes, cmc

**kind to skin. does not contain bleach.
biodegradable & recyclable**

**do visit
www.lovinmyworld.com**

< washing advice

f ˚otprint

ecological

150 WASHES!
500ml

washing-up liquid for sensitive skin

+Non-Toxic
+Biodegradable
+Super-Concentrated
+Fragrance Free
+Hypoallergenic

climate neutral products
our mission

footprint products have been **environmentally modified** to advance the development of a **sustainable society** helping to **reduce** the total **pressure** on our **environment.**

this was the **first idea**: *create* **ecologically sustainable** products using caring and **natural ingredients.**

then the **second idea**: *try* to concentrate the product. you can do **more washes**. we all use **less energy, less packaging** and create **less waste.**

and the **third idea**: quite cool this one! – *aim* to be **carbon neutral** and produce this product *without* **affecting** the balance of **co2** in the **atmosphere.**

in **sweden** this laundry powder has been **approved by:**
The Swedish Society for Nature Conservation
and **endorsed** by the **swedish asthma and allergy associations**

this is an **all plastic package** and is **recyclable!**

The quality and performance of this product is guaranteed or your money back.
for a **smaller eco-footprint** Your statutory rights are not affected.
together we can make a difference. Footprint International Limited. PO BOX xxx, PR 1AA
taking a positive step >

THE GRAFIOSI — NEW DELHI, INDIA
Creatives : Pushkar Thakur
Client : Footprint International, UK

WHAT'S GREEN ABOUT THIS — The brand is household cleaners and the target audience are ABC1 Ethical Consumers. That means they deliberately look for and buy Green products that are better for the environment than mainstream cleaners.

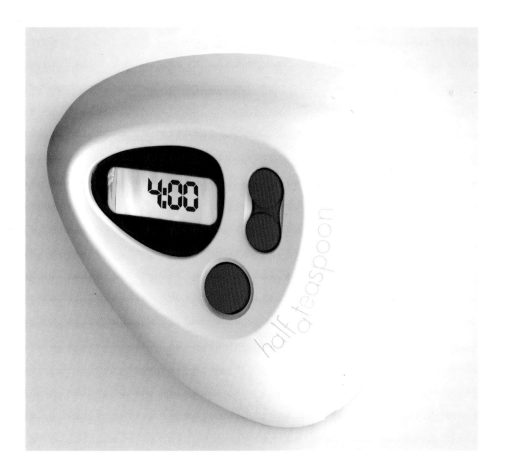

57

CHARLWOOD DESIGN — VICTORIA, AUSTRALIA
Creatives : Paul Charlwood, Gretha Oost, Andrew Howley
Client : Half a Teaspoon

WHAT'S GREEN ABOUT THIS — Most home water use is in the bathroom, and the average shower takes eight minutes. The ShowerWatch is a 4-minute shower timer which creates awareness of time spent in the shower to stimulate consciousness about water use. It makes use of like materials without the need for screws or metal fastenings and has an easily replaceable battery. The ShowerWatch is designed for easy dissasembly for recycling at the end of its useful life.

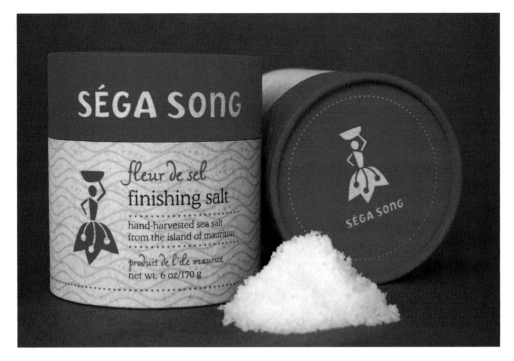

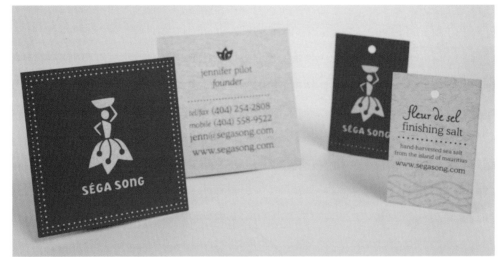

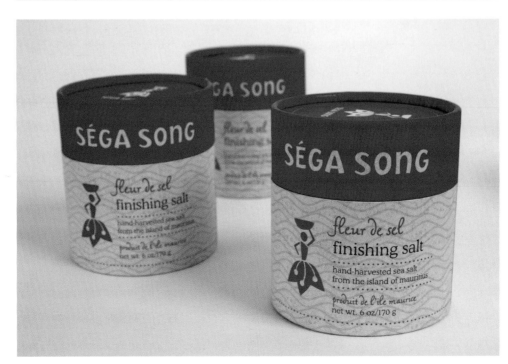

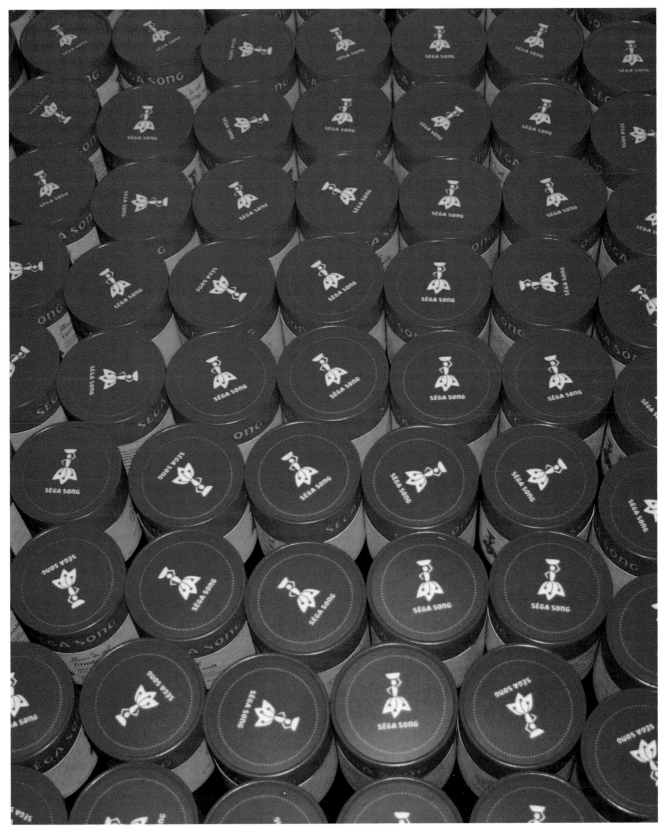

CITIZEN STUDIO — ATLANTA, GEORGIA
Creatives : Linda Doherty
Client : Séga Song

WHAT'S GREEN ABOUT THIS — High-end green branding on a start-up budget: Séga Song celebrates the preparing and sharing of meals with the tag line, "Make every meal a natural celebration." Their debut product is fleur de sel finishing salt from a family-owned farm in Mauritius, the founder's home country. The owner and designers opted for existing environmentally preferable materials. The two-color business card is printed on Domtar EarthChoice paper (minimum 30% post-consumer waste) at a local, FSC-certified printer. Sample tags for the company's first product were added to the business card press sheet so the client could offer vendors and customers samples along with her contact information. They printed 2,500 labels and created a small quantity (250) of packages for the marketing introduction. When the client needs new packaging, the preprinted labels are ready to go.

WHAT'S GREEN ABOUT THIS — T-shirts that explore new ways of commenting on sustainability and American culture with tongue-in-cheek environmental messages ("I [heart] gridlock") were created for a clothing line called Commute>Work>Commute>Sleep. The shirts were sold in retail stores throughout Arizona (U.S) and on Etsy.com.

JASON HILL DESIGN — PHOENIX, ARIZONA
Creatives : Jason Hill, Nick Lehmans
Client : Commute Work Commute Sleep

60

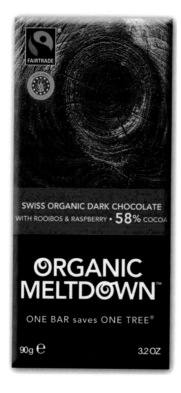

WHAT'S GREEN ABOUT THIS — Organic Meltdown chocolate is 100% organic and fair-trade. Their slogan is "ONE BAR saves ONE TREE". Working with the World Land Trust, for every bar sold they will save a tree in Ecuador.

BRAND STAND LIMITED — ZUG, AL, SWITZERLAND
Creatives : Matt Hunt
Client : Brand Stand Limited

BiG BOOK GREEN DESIGN

Financing the Stewardship of Global Biodiversity

Table of Contents *continued*

Looking Ahead:
What is Next for GEF

section 5

DESIGN NUT, LLC — KENSINGTON, MARYLAND
Creatives : Brent M. Almond, Polina Pinchevsky,
Susan Chenoweth
Client : Global Environment Facility

WHAT'S GREEN ABOUT THIS — This book was distributed at the International Environmental Conference in Bonn, Germany. It combined the organization's policies and progress with environmental photography to create an annual report/coffee-table book. Eco-friendly manufacturing processes were used.

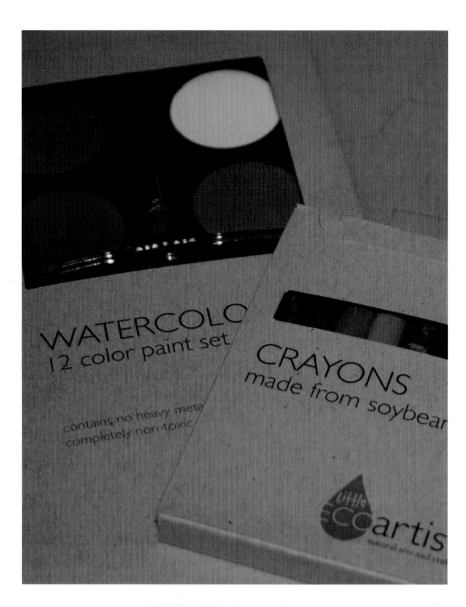

62

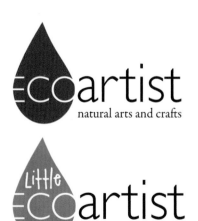

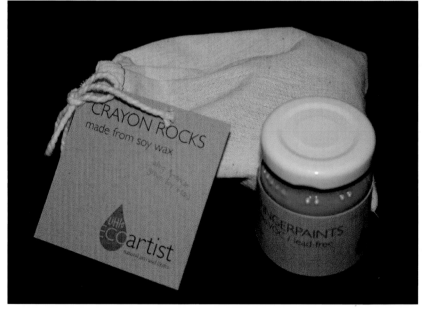

DESIGN BY TEVA — MOSCOW, IDAHO
Creatives : Teva Hopper
Client : ECOartist

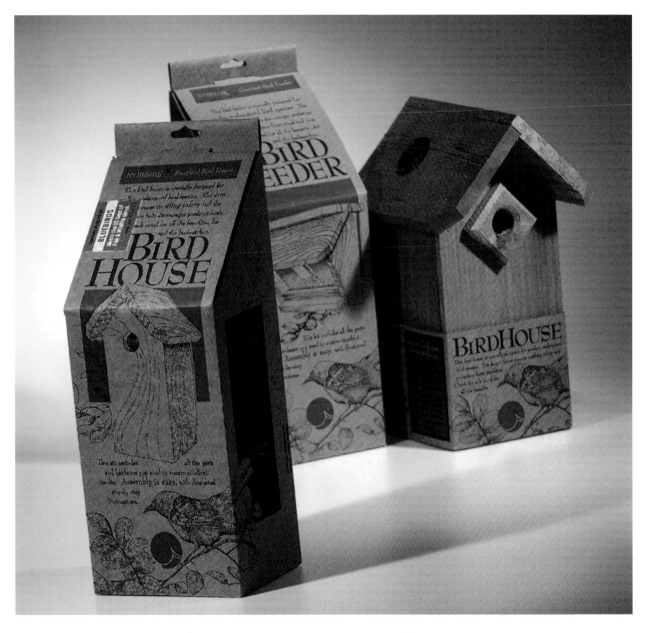

SIEVERS DESIGN — LAKE OSWEGO, OREGON
Creatives : David Sievers
Client : Green Elephant, Inc.

WHAT'S GREEN ABOUT THIS — The organic and eco-friendly nature of their bird feeder and birdhouse kits (also sold assembled) informed the name, the identity, and the packaging of Green Elephant wildlife products.

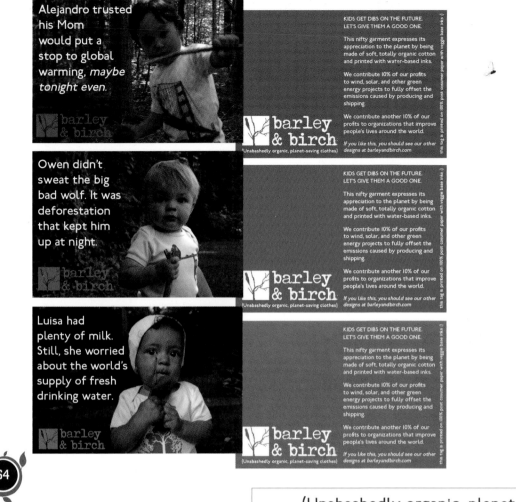

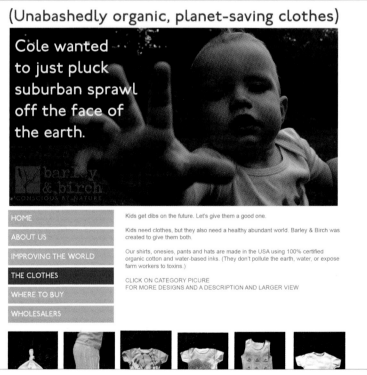

WHAT'S GREEN ABOUT THIS — Barley and Birch is a young company offering 100% organic baby and children's clothing. The company offsets its power use and donates a portion of its income to development and environmental charities. Branding was designed to appeal to parents' sense of responsibility and inter-generational as a key tenet of sustainability, yet avoiding the usual guilt trips so common in sustainability communications.

THE CHANGE — NORTH CAROLINA
Creatives : Jerry Stifelman, Chelsea Bay Wills
Client : Barley and Birch

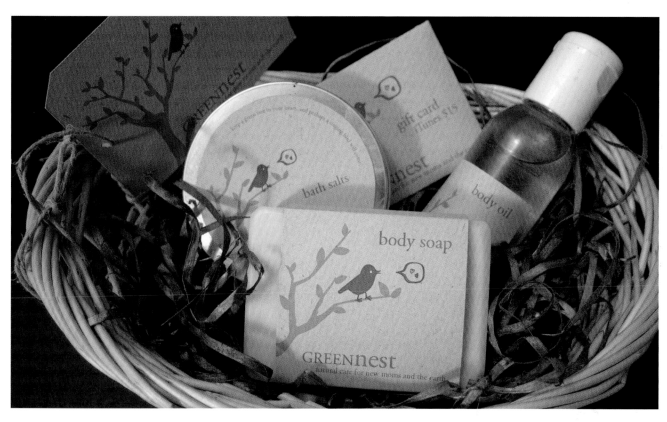

DESIGN BY TEVA — MOSCOW, IDAHO
Creatives : Teva Hopper
Client : Greennest

WHAT'S GREEN ABOUT THIS — Designer Teva Hopper used the proverb, "Keep a green tree in your heart, and perhaps a singing bird will come" as the foundation of this packaging project. It became the basis for the company name, GREENnest, and for the artwork displayed on the product labels. Printed on recycled paper, this eco-friendly care package was designed for new moms.

65

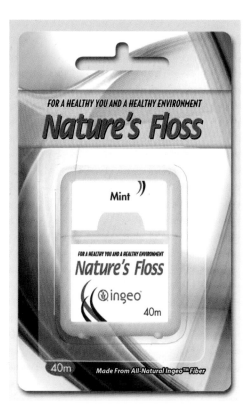

SK ADVERTISING+DESIGN — POTTSTOWN, PENNSYLVANIA
Creatives : Paul Kennedy, Janice Icenhour,Steve Goggins
Client : Gudebrod, Inc.

WHAT'S GREEN ABOUT THIS — Nature's Floss is the first dental floss on the market that are made to be fully bio-degradable. Everything about Nature's Floss—the floss, case, and blister pack—are made using Ingeo, a corn-based resin. The backer card is recycled paper.

WHAT'S GREEN ABOUT THIS — The people at Compostable Goods believe that the health of people and the health of the environment are intimately connected. They are dedicated to increasing the knowledge and availability of compostable and biodegradable products in order to reduce waste and its harmful effects on people, the environment, and the climate while replenishing the soil.

OFF THE PAGE CREATIONS — ESSEX JUNCTION, VERMONT
Creatives : Stephanie Raccine, Michael Raccine
Client : Compostable Goods

WHAT'S GREEN ABOUT THIS — The GreenSmartGifts website showcases its wide variety of green gifts, like handmade handbags, Pure Enchantment brown sugar body scrub, handmade accessories, Vermont lemongrass soap, organic teas, beeswax candles, Sweet Pea Tear-Free Baby Wash, and many more, many of them handmade by local and global artisans. Up to 100% of the proceeds from certain products is earmarked for charities.

PARALLEL PRACTIC LLC — LAKEWOOD, OHIO
Creatives : Brian Frolo, Karen Frolo
Client : Greensmartgifts

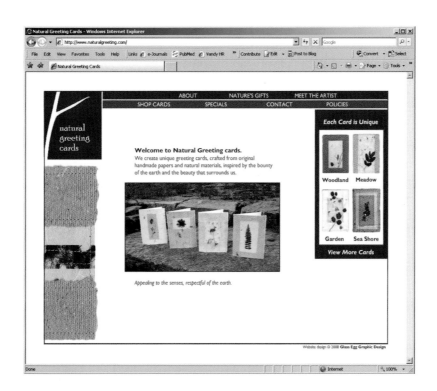

natural greeting cards

Natural Greeting cards are inspired by the bounty of the earth and the beauty that surrounds us.

Composed of stitched layers of original handmade papers and plant fibers, our unique cards are embellished with gifts from the natural world.

The stitched cover is attached to a blank card and packaged with a matching envelope, both of 100% recycled paper. The card and envelope are protected in a resealable biodegradable clear cellophane sleeve.

We not only respect and support the earth, we also strive to make the world a better place. For each Natural Greeting card sold, we donate twenty-five cents to KIVA to help support craftspeople and entrepreneurs in developing nations.

Please visit our website today to place an order. **www.naturalgreeting.com**

4x5 cards	5x7 cards
$4.50 direct	$5.50 direct
$5.50 retail	$6.50 retail

Appealing to the senses, respectful of the earth.

www.naturalgreeting.com

Meet Anna Saterstrom
The Artist Behind Natural Greeting Cards

I created Natural Greeting cards as a result of experiments using natural materials in my artwork. By restricting my colors and textures to those that occur in the natural world, I found that my work became calmer and more restful. Like most of us, I am seeking ways to live with less complication and fewer needs, and my artwork was reflecting that impulse. I found that as my art work became simpler and less cluttered, it evoked a natural serenity.

Like most of us, I am also eager to find ways of walking more gently on the earth. I began to recycle my own paper, creating an endless variety of textures and incorporating many of the gifts of nature in the process. I located a source for card blanks and envelopes that uses 100% post consumer paper in its production, and Natural Greeting cards came into being.

I love what I do, and I am grateful to have the opportunity to give back to those who live under more challenging circumstances. To support and encourage craftspeople who are seeking to establish their own businesses in Third World Countries, twenty-five cents from each Natural Greeting card sold is invested in small business loans through KIVA. Please visit our website for additional photos and information, and we hope you will visit often as we continue to evolve and develop new ideas and products.

Anna

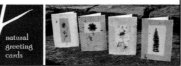

natural greeting cards

Anna Saterstrom
www.naturalgreeting.com
info@naturalgreeting.com • phone: 203-426-4277

natural
greeting
cards

GLASS EGG GRAPHIC DESIGN — NASHVILLE, TENNESSEE
Creatives : Jessica Eichman
Client : Natural Greeting Cards

WHAT'S GREEN ABOUT THIS — Natural Greeting Cards creates unique greeting cards crafted from original handmade papers and natural materials. All excess paper is recycled into new greeting cards so there is no waste. Packaging is biodegradable. For each card purchased, they donate 25 cents to KIVA to support craftspeople and entrepreneurs in developing nations.

Greener Image
Companies

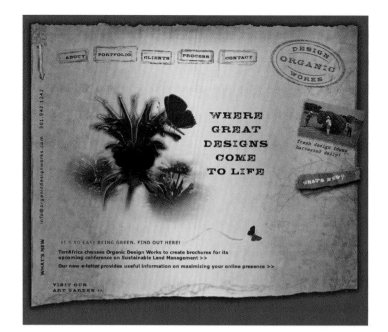

70

WHAT'S GREEN ABOUT THIS — The goal of Organic Design Works is to connect on a personal level with their clients, to use great design to promote environmental sustainability, and to cultivate the quality and detail inherent in hand-hewn objects, which underscores their commitment to being a truly eco-friendly design studio. The Organic Design Works letterhead system was printed on recycled paper at a small, locally-owned print shop that uses soy-based, waterless inks. They also work with a larger printer that is triple-certified (FSC, SFI, and PEFC) for their high-volume jobs.

ORGANIC DESIGN WORKS — SILVER SPRING, MARYLAND
Creatives : Moira Ratchford
Client : Organic Design Works

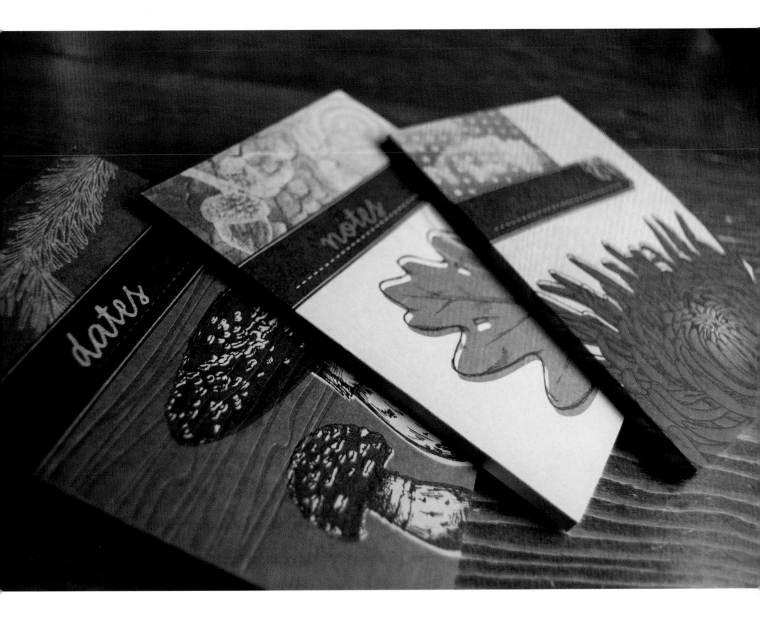

DEFTELING DESIGN — PORTLAND, OREGON
Creatives : Alex Wijnen
Client : (collaborative) Defteling Design, Brown Printing,
West Coast Paper, Rose City Bindery

WHAT'S GREEN ABOUT THIS — Four companies collaborated to create a cost-effective yet impactful client gift for the 2008 holiday season, each company contributing labor and/or materials. The result is a stunning yet functional set of note book, address book, and date book, all printed on recycled, FSC-certified paper.

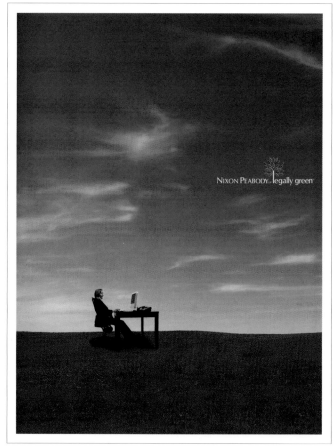

go green

Sustainable technologies have become essential to your business. An old saying describes how an idea gets accepted: first it is ridiculed, then it is rejected, and finally it is seen as self-evident. Because we understand the future depends on decisions made now, our "legally green" initiative supports legal needs in this new environment.

Our "legally green" commitment:

• Provide integrated services to clients focused on sustainable technologies, products, and solutions
• Pursue a thought leadership role in the community
• Practice responsible citizenship where we work and live.

While many law firms have separate practices that occasionally handle sustainability issues, at Nixon Peabody we've integrated our league-leading practices as very few others can. Whether a matter concerns private equity, public finance, real estate, tax credits, intellectual property, or environmental regulation, our attorneys understand the issues that arise in the context of emerging industries such as Cleantech, renewable energy, and green building, and we are developing innovative solutions.

Within our offices, Nixon Peabody is embracing sustainable building practices and reducing our own environmental impact. While there is still a long way to go, each of our offices has an action plan in place, and we are dedicated to being the leader among law firms in sustainable practices and operations.

cleantech
private equity & venture capital
intellectual property protection
litigation & arbitration

green building and sustainable development
public financing
tax incentives
project acquisition, development & finance
historical preservation
affordable housing

renewable energy
siting
tax credits
project finance
bonds
mergers & acquisitions
transmission & interconnection
power purchase agreements
regulatory
pilot agreements

environmental and land use
permitting
transactional due diligence
brownfields
environmental impact review
code compliance

climate change
corporate and institutional policies,
protocols & practices
SEC reporting & disclosure

green investing
fund structuring, formation
& implementation

practice green

Take the lead. Nixon Peabody has the experience and the ability to identify opportunities and provide solutions in all sectors of the economy. Our public finance lawyers helped develop the legislation that created Clean Renewable Energy Bonds. Throughout the United States, our private equity and venture capital, energy, environmental, project finance, real estate, regulatory, tax credit syndication, and intellectual property teams have given critical assistance to innovative renewable energy projects, including land-based and offshore wind, solar, and geothermal.

"As the legal profession begins to take on climate change issues...Nixon Peabody has gone a step further..."

—*Lawyers USA, 2007*

WHAT'S GREEN ABOUT THIS — In 2007, Nixon Peabody became the first law firm in the nation to embrace sustainable building practices for its offices and the first law firm in the country to appoint a Chief Sustainability Officer. Nixon Peabody attorneys are well versed in the substance of green issues, including cleantech, renewable energy, and green buildings. They worked with DC-based design firm Greenfield/Belser Ltd. to put together an integrated cleantech practice brochure.

GREENFIELD/BELSER LTD. — WASHINGTON, DC
Creatives : Erika Ritzer, Tae Jeong, Margo Howard, Burkey Belser
Client : Nixon Peabody LLP

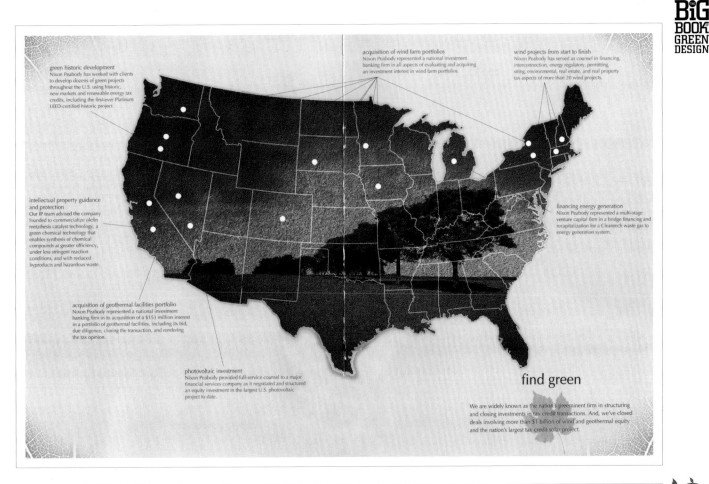

green historic development
Nixon Peabody has worked with clients to develop dozens of green projects throughout the U.S. using historic, new markets and renewable energy tax credits, including the first-ever Platinum LEED-certified historic project.

acquisition of wind farm portfolios
Nixon Peabody represented a national investment banking firm in all aspects of evaluating and acquiring an investment interest in wind farm portfolios.

wind projects from start to finish
Nixon Peabody has served as counsel in financing, interconnection, energy regulatory, permitting, siting, environmental, real estate, and real property tax aspects of more than 20 wind projects.

intellectual property guidance and protection
Our IP team advised the company founded to commercialize olefin metathesis catalyst technology, a green chemical technology that enables synthesis of chemical compounds at greater efficiency, under less stringent reaction conditions, and with reduced byproducts and hazardous waste.

financing energy generation
Nixon Peabody represented a multi-stage venture capital firm in a bridge financing and recapitalization for a Cleantech waste gas to energy generation system.

acquisition of geothermal facilities portfolio
Nixon Peabody represented a national investment banking firm in its acquisition of a $153 million interest in a portfolio of geothermal facilities, including its bid, due diligence, closing the transaction, and rendering the tax opinion.

photovoltaic investment
Nixon Peabody provided full-service counsel to a major financial services company as it negotiated and structured an equity investment in the largest U.S. photovoltaic project to date.

find green

We are widely known as the nation's preeminent firm in structuring and closing investments in tax credit transactions. And, we've closed deals involving more than $1 billion of wind and geothermal equity and the nation's largest tax credit solar project.

think green

At conferences across the nation. We have addressed audiences on the issues of financing for solar and wind power, environmental citizenship for educational institutions, preserving and greening affordable housing and historic structures, renewable energy, project siting and permitting, and building green homes and sustainable communities.

partnerships

Our attorneys are actively involved as members and speakers with these national organizations:

- American Council on Renewable Energy
- American Wind Energy Association
- Design Standards Drafting Committee (LEED)
- Enterprise Community Partners
- Global Green USA
- National Wind Coordinating Collaborative
- Solar Energy Industries Association (SEIA)
- The Cleantech Venture Network
- U.S. Green Building Council

be green

In our own offices. Legally green is more than a slogan—it is an increasing element of the Nixon Peabody culture. One example is securing LEED certification for our new San Francisco office—a showcase of our support for sustainable building practices and a healthy work environment. Across the country we are putting sustainability plans into action with large and small steps—from improving recycling practices to greening our supply chain.

"'Going green demonstrated to clients that the firm walked the walk...'"
—Lawyers USA, 2007

practice green

- 700 lawyers
- 17 offices nationwide
- 75+ lawyers with green experience across practices and nationwide
- 3 certified hazardous materials managers
- 40 syndication lawyers
- 25 energy and environment lawyers
- 90 intellectual property lawyers
- 8 patent agents and other specialists

Counsel for waste-to-energy bonds totaling more than $5 billion in issuance

Dozens of green projects throughout the U.S., with equity in the billions of dollars, including the largest solar project in the country

Assistance to developers in siting, permitting, and acquiring more than 20 wind power projects

Counsel to the first-ever Platinum LEED-certified historic project

#1 most active underwriters' counsel in public finance (Thomson Financial, 2006)

#8 most active bond counsel in public finance (Thomson Financial, 2006)

#4 firm for private equity/venture capital funds formed (Dow Jones, 2006)

Among the leading patent procurement law firms in the U.S. (IP Today, 2007)

Among the top trademark law firms in the U.S. (IP Today, 2007)

Top 25 for IP Litigation (IP Law & Business, 2005)

One of the FORTUNE 100 Best Companies to Work For® in 2006 and 2007

"Global 100" firm (American Lawyer, 2007)

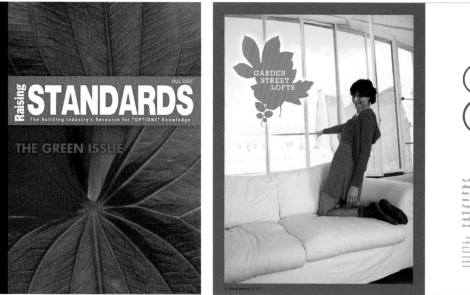

WHAT'S GREEN ABOUT THIS — "Raising Standards is a magazine for the United States home-building industry. This redesigned green issue and all subsequent issues were printed on recycled paper with soy-based inks.

DESIGN 446 — MANASQUAN, NEW JERSEY
Creatives : Brian Stern, Taryn de los Reyes, Ralph McGeehan, Caryn Bennington
Client : Monarch Media

74

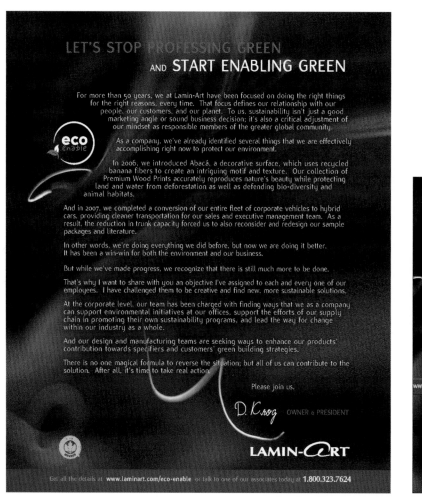

WHAT'S GREEN ABOUT THIS — Lamin-Art, Inc. supplies the commercial interior design and architectural professions with innovative design-statement laminates. In 2007, I Imagine Studio worked with Lamin-Art on a major "Green" campaign which took on the name and visual identity "Eco-Enable." Following the visual identity, IIS created a series of print and online ads which challenge the reader to make a greener world possible—to "enable green."

I IMAGINE — EVANSTON, ILLINOIS
Creatives : Alena Tsimis, Olga Weiss, Laurence Minsky, Kateryna Wolf
Client : Lamin-Art

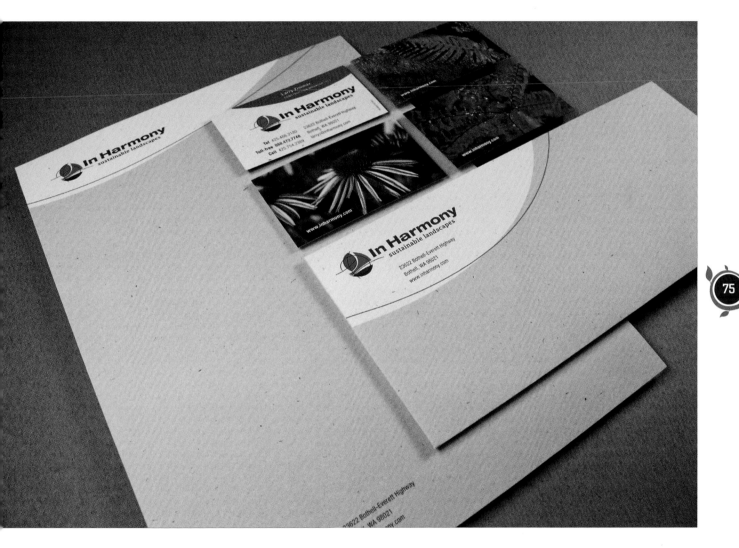

BELYEA — SEATTLE, WASHINGTON
Creatives : Ron Lars Hansen, Patricia Belyea, Aaron Clifford
Client : In Harmony

WHAT'S GREEN ABOUT THIS — In Harmony is a pioneer in organic landscaping. The logo motif includes the sun and a green leaf, plus the all-important ingredient of healthy growth: good dirt. The business cards, with a series of photos on the back, are printed on recycled paper.

WHAT'S GREEN ABOUT THIS — Olympus Press, an FSC-certified printing facility, wanted to give its clients a fun and useful end-of-the-year thank-you. The result: A small folder holding a flip book that can be used as a note pad. The promotion was printed on FSC-certified and Green-e certified paper with soy inks. This is a dual-purpose promotional item, in that it is both a flip book and note pad.

BELYEA — SEATTLE, WASHINGTON
Creatives : Ron Lars Hansen, Nicholas Johnson, Michael Barbre
Client : Olympus Press

WHAT'S GREEN ABOUT THIS — Every summer Wallace Church throws a Tuna Party where they grill fresh tuna for clients and friends. "Eat a Fish, Feed a Fish," this year's invitation and tuna party theme, took on a hot topic: sustainability. The "susTUNAbility" invitation featured a new take on the familiar recycle icon. Aluminum, bamboo, and fish food—recyclable and ingestible—all played a part in creating the unique invitation. For good measure, a donation was made to SPAT, Cornell University's Aquaculture Training program, devoted to shellfish restoration efforts.

WALLACE CHURCH, INC. — NEW YORK, NEW YORK
Creatives : Stan Church, Tom Davidson
Client : Wallace Church, Inc.

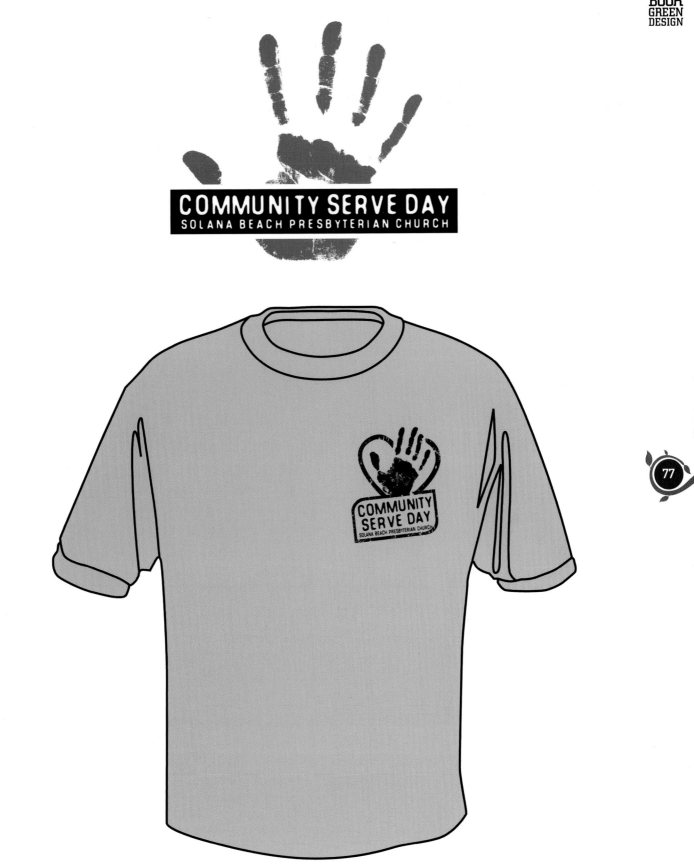

COMMUNITY SERVE DAY
SOLANA BEACH PRESBYTERIAN CHURCH

77

CHURCH LOGO GALLERY — OCEANSIDE, CALIFORNIA
Creatives : Michael Kern
Client : Solana Beach Presbyterian Church

WHAT'S GREEN ABOUT THIS — Solana Beach Presbyterian Church plans to mobilize 1500 members to do community service work instead of holding their Sunday worship service. The plan is to clean parks and lagoons, help with local school landscaping, and do a variety of work projects to benefit the community. These are proposed logos for the event.

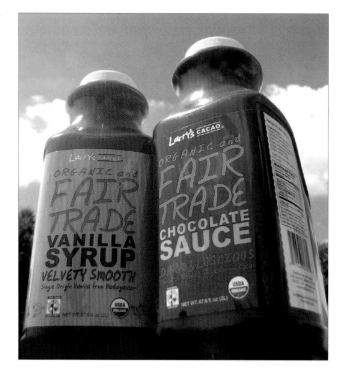

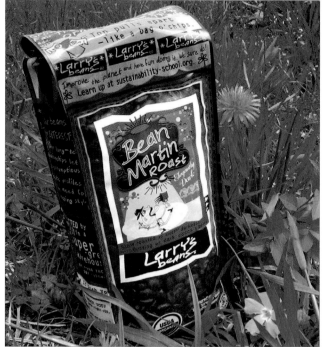

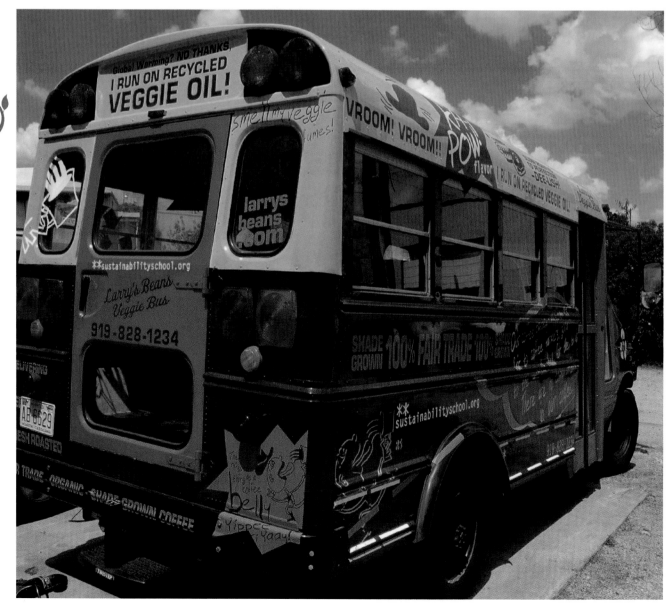

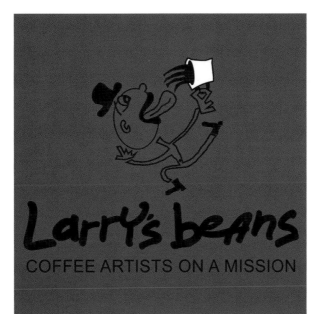

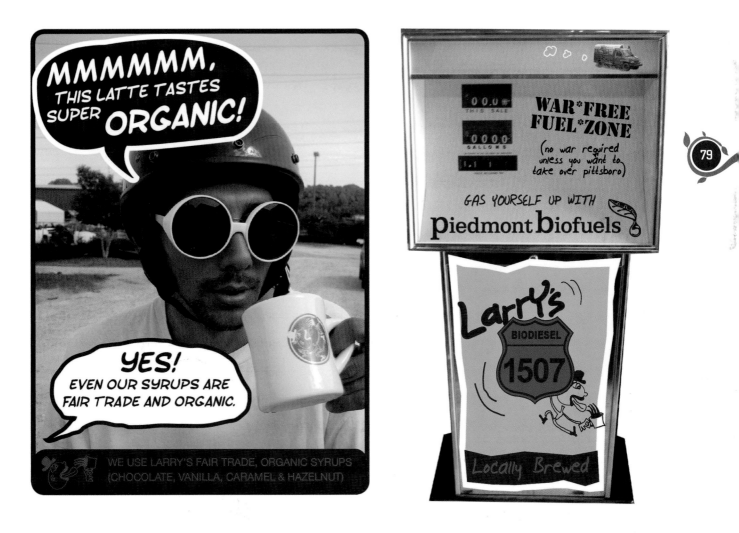

THE CHANGE — NORTH CAROLINA
Creatives : Jerry Stifelman, Larry Larson, Brian Owenby, Patrick Short
Client : Larry's Beans

WHAT'S GREEN ABOUT THIS — Larry's Beans is an aggressively sustainable fair-trade, organic coffee roaster from Raleigh, North Carolina. Their coffee is all about aiming for 100% sustainability. Lest someone might buy a fair-trade, organic latte sweetened with syrups made from conventionally grown sugars, they developed a line of fair-trade, organic syrups to complement their coffees. Retail packaging was designed to celebrate the company's commitment to move beyond token measures, offering only 100% fair-trade, 100% organic coffee, roasted in a sustainably renovated warehouse, and delivered locally using waste veggie oil. They have recently started experimenting with biodegradable plastic packaging. The company runs funky, irreverent ads celebrating sustainability not as something to sacrifice for, but something to aspire to. Larry has even opened up a biodiesel filling station outside the roasting plant, so Raleigh residents can run their cars on sustainable, locally produced biodiesel.

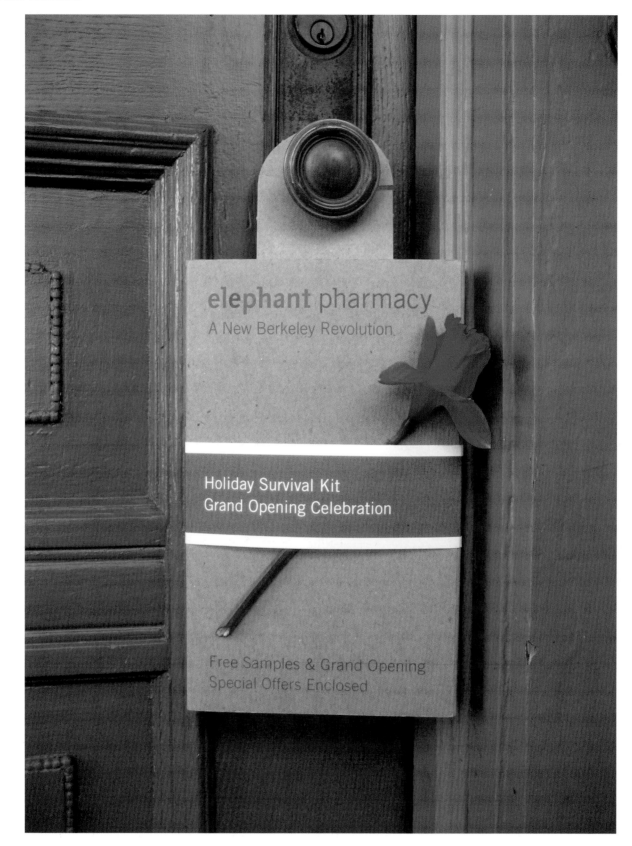

80

elephant pharmacy
A New Berkeley Revolution.

Holiday Survival Kit
Grand Opening Celebration

Free Samples & Grand Opening
Special Offers Enclosed

WHAT'S GREEN ABOUT THIS — Elephant Pharmacy is a Northern California-based retail chain that focuses on natural health and wellness products. Celery helped the company launch their first three stores with a unique direct-mail campaign. Rather than starting from the "junk-mail" paradigm of a plastic bag door-hanger stuffed with glossy coupons, they imagined the project as an opportunity to give a small gift to 30,000 people. This simple change of perspective impacted the whole project. The resulting "gift box" contained free samples of natural health and wellness products along with illustrated coupons. The mailer was constructed with recycled chip board and featured a pop-out door hanger, which made it completely recyclable. Each box was delivered with a fresh flower tucked into a paper belly-band. The flowers were the idea of Elephant's founder and CEO, who really embraced the concept of direct mail as a gift-giving opportunity. People hate junk mail, but they love flowers.

CELERY DESIGN COLLABORATIVE — BERKELEY, CALIFORNIA
Creatives : Ayako Akazawa, Brian Dougherty, Patty Katsura
Client : Elephant Pharmacy

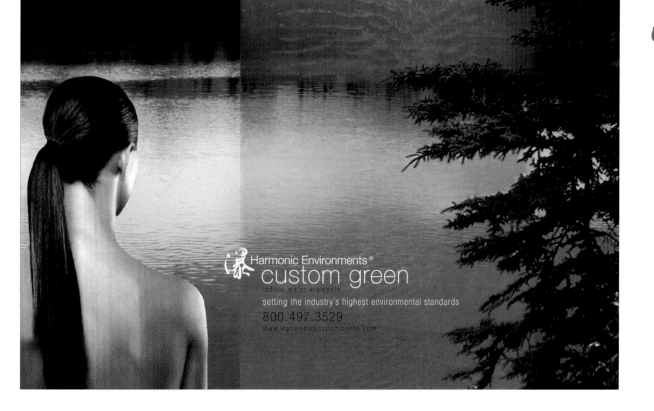

MAKING THE WORLD AROUND YOU A BETTER PLACE

Harmonic Environments®
custom green
indoor water elements
setting the industry's highest environmental standards
800.497.3529
www.HarmonicEnvironments.com

I IMAGINE — ALABAMA
Creatives : Olga Weiss, Alena Tsimis
Client : Harmonic Environment

WHAT'S GREEN ABOUT THIS — Harmonic Environments produces indoor water features such as water walls. This ad was featured in interior design magazines. The company uses very advanced, eco-conscious water filter systems, energy-efficient pumps and lighting, and sustainable materials in their products. They use no harmful chemicals in their waterfalls.

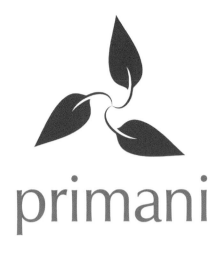

WHAT'S GREEN ABOUT THIS — Primani is a company working with renewable energy sources and its activities also include raising ecological conscience. The logo illustrates a windmill made of leaves symbolizing one of the ways to collect green energy.

BRUKETA&ZINIC OM — ZAGREB, CROATIA
Creatives : Davor Bruketa, Nikola Zinic, Imelda Ramovic, Mirel Hadzijusufovic
Client : Primani

WHAT'S GREEN ABOUT THIS — U"Seeing Green" is the name of the design seminar held by the Los Angeles AIGA to promote the use of sustainable products and practices for designers in Los Angeles.

UNIT DESIGN COLLECTIVE —SAN FRANCISCO, CALIFORNIA
Creatives : Shardul Kiri, Ann Jordan, Saral Lamont
Client : AIGA Los Angeles

WHAT'S GREEN ABOUT THIS — Abbey Hardwoods sells teak and other hardwoods from plantations grown in Sri Lanka. These plantations contribute to the world's ecological balance through increased planting of trees which take in carbon dioxide, release oxygen, and reduce the illegal deforestation of much-needed rainforests.

BOUTIQUEGRAFICA — VIÑA DEL MAR, CHILE
Creatives : Paola Leyton, Mariana Leyton
Client : Abbey Hardwoods

National Environmental Education Foundation

Knowledge to live by

National Environmental Education Week

A National Environmental Education Foundation Program

National Public Lands Day

A National Environmental Education Foundation Program

83

Earth Gauge

A National Environmental Education Foundation Program

BBMG — NEW YORK, NEW YORK
Creatives : Raphael Bemporad, Scott Ketchum
Client : National Environmental Education Foundation

WHAT'S GREEN ABOUT THIS — The National Environmental Education Foundation promotes daily environmental actions where we live, work, and play. Addressing these issues in the logo's design, BBMG created a logo that visually made a statement about the work of the organization including the full name with descriptive tagline. The logo mark and identity system similarly unifies the organization's core strategies (education, health, public lands, weather) into overlapping petals of a single flower. The colors are connected to individual strategies and reinforce an organic, optimistic, and growing whole.

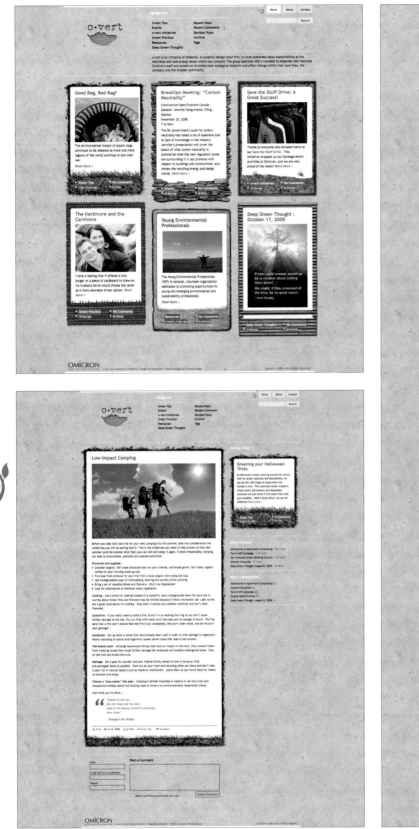

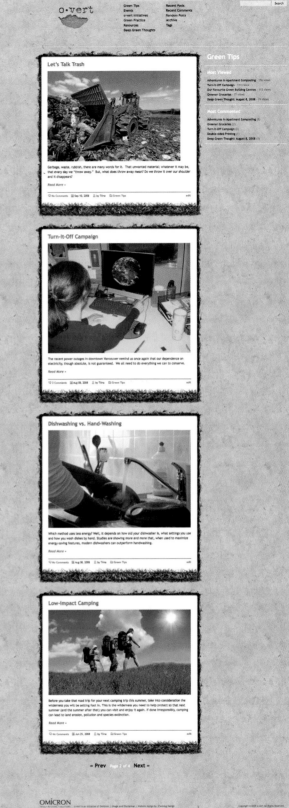

84

WHAT'S GREEN ABOUT THIS — O-vert.com is an initiative by Omicron, a Canadian design/build firm, to raise awareness about sustainability at the individual and operational levels within the company. As a companion site to Omicron's corporate website, o-vert features a blog-style format designed to house conversation and content related to sustainability.

FLEMING CREATIVE GROUP — VANCOUVER, CANADA
Creatives : Blair Pocock, Felix Heinen, Mike Dennison, Jaybe Allanson
Client : Omicron

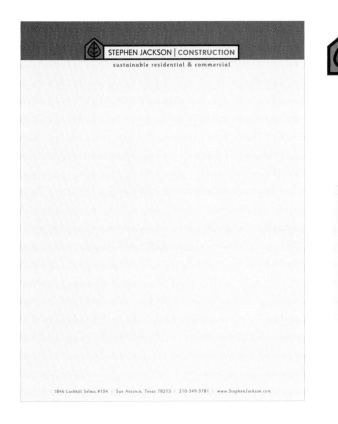

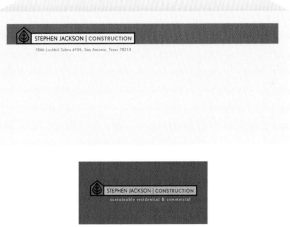

GRAPHICGRANOLA — AUSTIN, TEXAS
Creatives : Kelly Blanscet
Client : Stephen Jackson Construction

WHAT'S GREEN ABOUT THIS — Stephen Jackson is an established builder focused on the sustainable residential and commercial construction market in Austin and San Antonio. SJC requested a visibly green approach to their branded materials. Letterhead, envelopes, and business cards were developed, printed on recycled paper stocks, and printed with soy inks.

85

CAUSE AND AFFECT DESIGN LTD. — VANCOUVER, CANADA
Creatives : Steven Cox, Jane Cox, Sebastien Cantin, Becki Chan
Client : Volkswagen Canada

WHAT'S GREEN ABOUT THIS — Volkswagen Canada was releasing the new Jetta TDI Clean Diesel, their first car to enter the "green market." They wanted to break out of their standard car-show consumer experiences but were unsure how to approach the green consumer. The Green Guts Experience kept the car at center stage but featured it as another highlight rather than the only highlight of the Green Guts campaign.

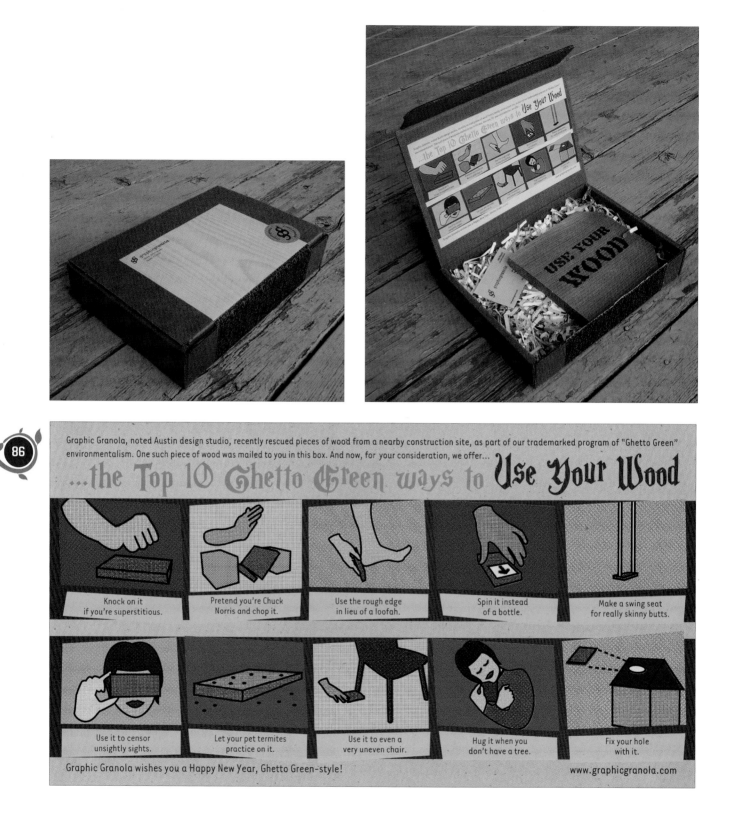

Graphic Granola, noted Austin design studio, recently rescued pieces of wood from a nearby construction site, as part of our trademarked program of "Ghetto Green" environmentalism. One such piece of wood was mailed to you in this box. And now, for your consideration, we offer...

...the Top 10 Ghetto Green ways to Use Your Wood

Knock on it if you're superstitious.

Pretend you're Chuck Norris and chop it.

Use the rough edge in lieu of a loofah.

Spin it instead of a bottle.

Make a swing seat for really skinny butts.

Use it to censor unsightly sights.

Let your pet termites practice on it.

Use it to even a very uneven chair.

Hug it when you don't have a tree.

Fix your hole with it.

Graphic Granola wishes you a Happy New Year, Ghetto Green-style!

www.graphicgranola.com

WHAT'S GREEN ABOUT THIS — This fun self-promotion highlights sustainable uses for everyday urban objects.

GRAPHICGRANOLA — AUSTIN, TEXAS
Creatives : Kelly Blanscet, Kristin Bruno, Martina Vaughn
Client : Ghetto Green

INSIGHT MARKETING DESIGN —
SIOUX FALLS, SOUTH DAKOTA
Creatives : Doug Moss, Ben Hodgins, Kari Geraets
Client : Insight Marketing Design

WHAT'S GREEN ABOUT THIS — The Eco Bag is part of a total immersion project Insight Marketing Design developed to go green and become more energy conscious and conservative. The bags are 100% recycled material and sent to clients with a "Top Ten Ways to Go Green at Work" list.

Tanya Stock

206.420.8795
vidaverdebuild@vidaverdebuild.com

www.vidaverdebuild.com
License No. VIDAVVC927CJ

WHAT'S GREEN ABOUT THIS — This branding for a Green Home consultant included logo, business card, postcard, and website.

CALL ME AMY DESIGN — SEATTLE, WASHINGTON
Creatives : Amy Reisman
Client : Vida Verde

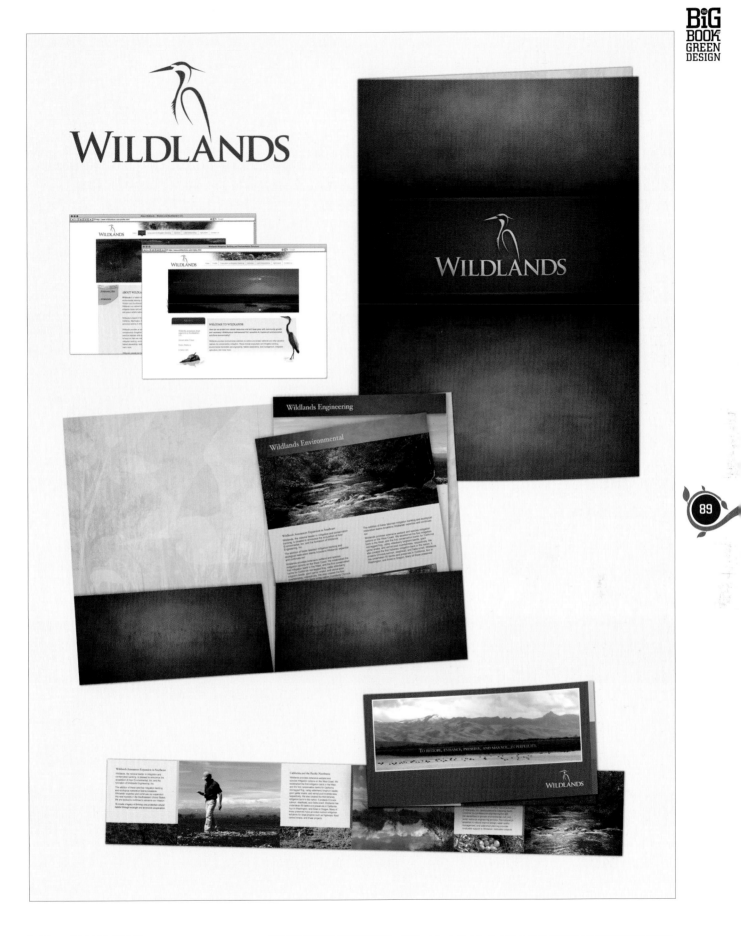

89

SPITFIRE MEDIA GROUP — BUFORD, GEORGIA
Creatives : Bradley Sherwood, Kevin Moss, Ben Davis,
Christian Shepard
Client : Wildlands Inc.

WHAT'S GREEN ABOUT THIS — Wildlands is a habitat development, land management, and environmental planning company with projects throughout the western and southeastern United States. Established in 1991, Wildlands is a national leader in establishing wetland and stream mitigation banks and conservation banks that enhance water quality and protect wildlife habitat in perpetuity. By using recycled and FSC-certified papers, Wildlands chooses to be both responsible and resourceful in their branding efforts.

WHAT'S GREEN ABOUT THIS — "20 Ideas that Changed the Way the World Does Business." All promotional materials were printed with soy inks on 100% recycled, 50% post-consumer waste, FSC-certified paper. Eco-printer is FSC-certified and powered by renewable energy.

BBMG — NEW YORK, NEW YORK
Creatives : Raphael Bemporad, Scott Ketchum, Molly Conley
Client : Social Venture Network

90

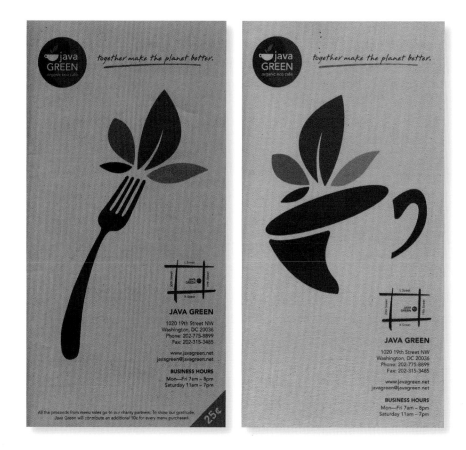

WHAT'S GREEN ABOUT THIS — Java Green serves carefully selected organic and eco-friendly foods. Menus are printed on 100% post-consumer waste paper with bright, beautifully-coordinated soy inks.

IDEAL DESIGN — WASHINGTON, DC
Creatives : Kristen C. Argenio
Client : Java Green

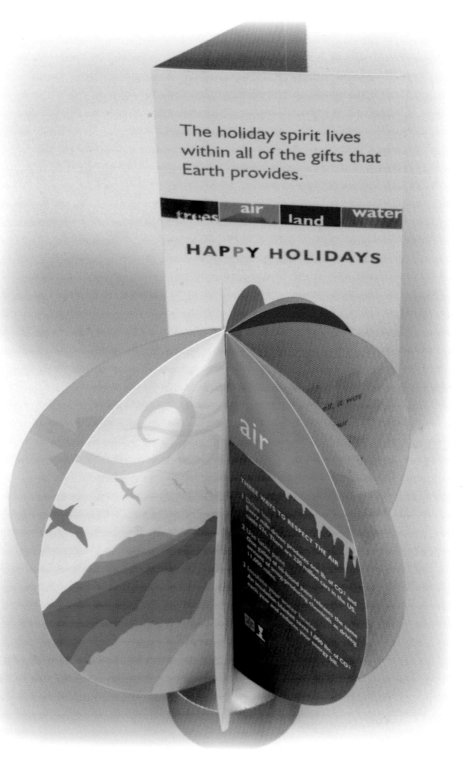

The holiday spirit lives within all of the gifts that Earth provides.

trees air land water

HAPPY HOLIDAYS

air

THREE WAYS TO RESPECT THE AIR

CRABTREE + COMPANY — FALLS CHURCH, VIRGINIA
Creatives : Susan Angrisani, Lisa Suchy, Rod Vera, Joe Valasquez
Client : Crabtree + Company

WHAT'S GREEN ABOUT THIS — Vegetable-based inks give Crabtree's holiday card its lively color palette. Inside are tips on how to respect the earth with specific suggestions regarding trees, air, land, and water.

Think!

WHAT'S GREEN ABOUT THIS — This artwork was commissioned for the Norwegian Water BA to help people think about the importance of their role in clean water.

MAGENTA— LOS ANGELES, CALIFORNIA
Creatives : Adhemas Batista
Client : Norwegian Water BA

92

WHAT'S GREEN ABOUT THIS — Kama Energy Efficient Building Systems needed a brand new web design to reflect the clean, safe, green products they supply.

FLYING COW DESIGN — CALIFORNIA
Creatives : Flying Cow Design
Client : Kama Energy Efficient Building Systems

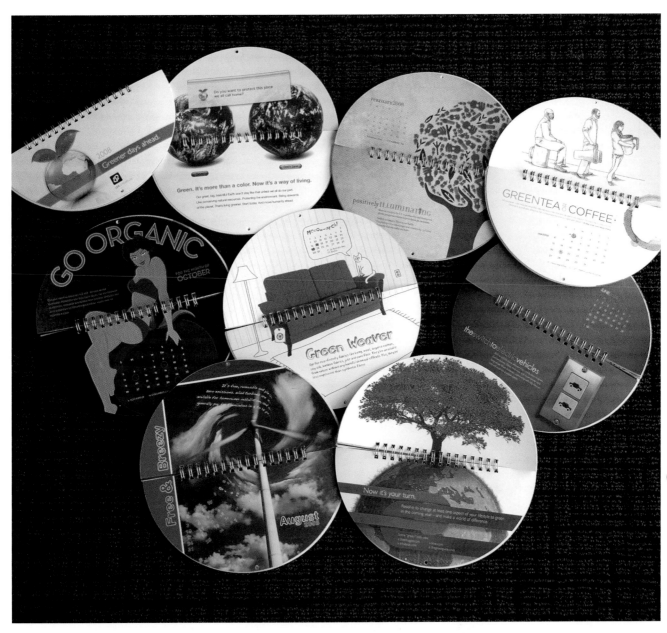

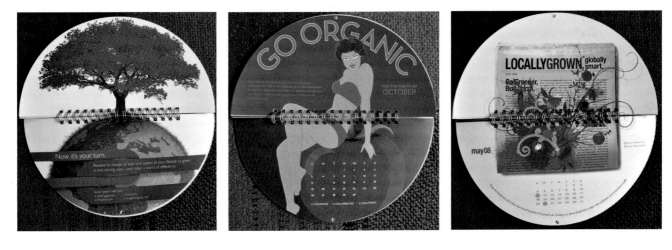

D4 CREATIVE GROUP — PHILADELPHIA, PENNSYLVANIA

Creatives : Wicky Lee, Jeff Aikens, Dennis Beerly, Allie Lefebvre, Chad Clark, Dina Cicchini, Bob Seaburt, Steven Gupton

Client : D4 Group

WHAT'S GREEN ABOUT THIS — This is a self-promotion item, printed on recycled paper with soy-based inks.

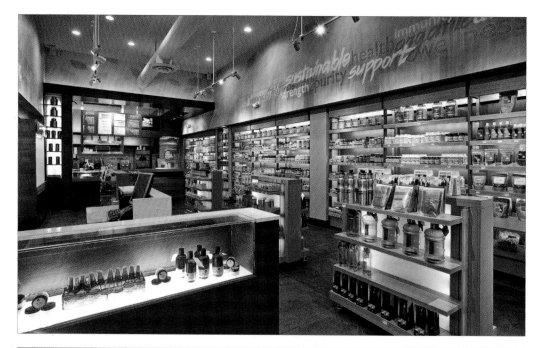

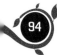

94

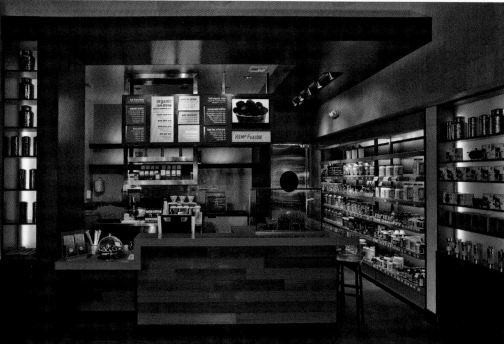

earthbar

OPEN

413

AKARSTUDIOS — SANTA MONICA, CALIFORNIA
Creatives : Sat Garg, Chris Jones, Sean Morris, Kayleigh Ditchburn
Client : EarthBar

WHAT'S GREEN ABOUT THIS — Earthbar specializes in all-natural, nutritional health products, vitamin supplements, and handcrafted organic drinks and food. Located in downtown Santa Monica, CA, the store's interior has been created entirely from sustainable and recycled materials—including the use of soy-based stains, bamboo-clad shelving, recycled MDF, and Douglas fir — as well as the latest energy-efficient lighting systems.

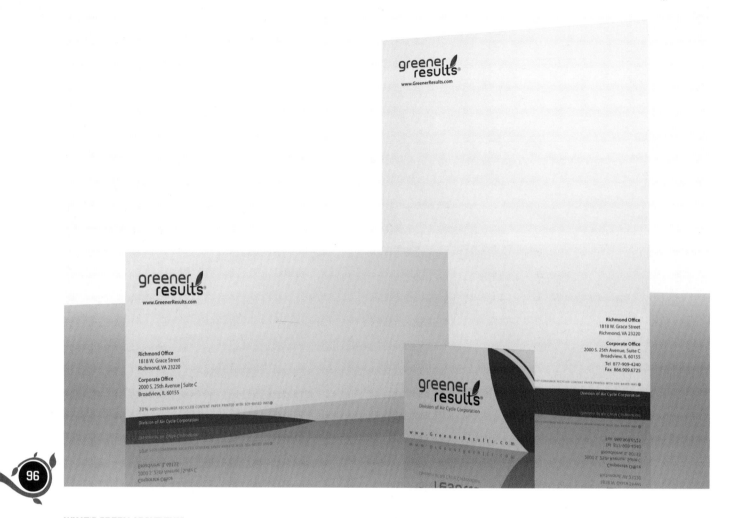

96

WHAT'S GREEN ABOUT THIS — This consulting group assists companies that want to become more green.

BOUTIQUEGRAFICA — VIÑA DEL MAR, CHILE
Creatives : BG Team
Client : Greener Results

WHAT'S GREEN ABOUT THIS — O'Neil Printing's very green brochure showcases their responsible printing practices while highlighting their in-house green initiatives.

RULE29 — ILLINOIS
Creatives : Justin Ahrens, Kara Merrick
Client : O'Neil Printing

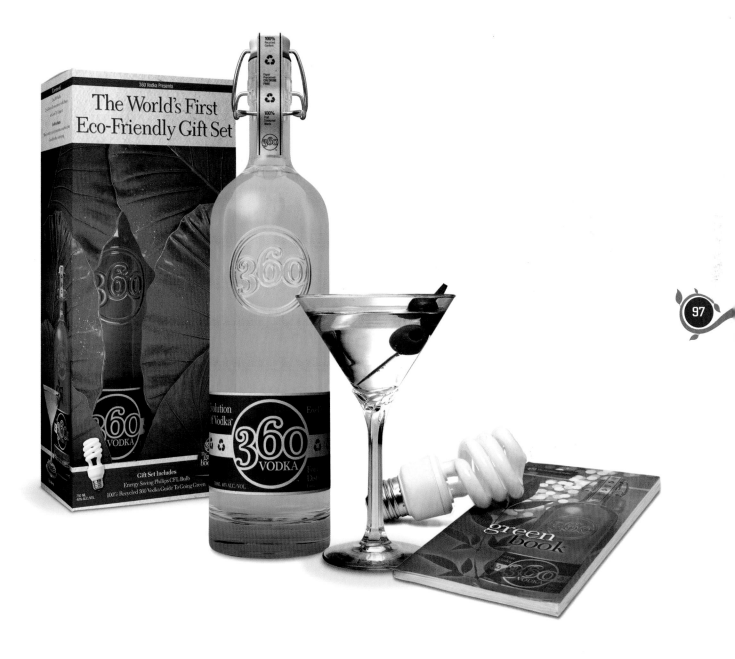

SAGON-PHIOR — LOS ANGELES, CALIFORNIA
Creatives : Glenn Sagon, Patrick Fee
Client : 360 Vodka

WHAT'S GREEN ABOUT THIS — The self-proclaimed world's first eco-friendly distilled spirit presents the world's first eco-friendly vodka gift set. 360 Vodka is quadruple-distilled using equipment that reduces the amount of fossil fuel energy by 21%. The green packaging uses chlorine-free paper and an 85%-recycled glass bottle. Gift set includes an energy-saving CFL light bulb and the 100% recycled 360 Vodka Guide to Going Green.

WHAT'S GREEN ABOUT THIS— Story Worldwide worked with UPS to consolidate three existing newsletters into Compass, a single new program with print, web, and e-mail components. A sophisticated and cost-effective versioning plan ensured that key segments of UPS's audience received the information most suited to their needs. Compass is FSC-Certified.

98

STORY WORLDWIDE— NEW YORK, NEW YORK
Creatives : Roe Intrieri, Moya McAllister, Dan Golden, Dan Durller
ClientT : UPS

WHAT'S GREEN ABOUT THIS — In partnership with the Arbor Day Foundation, USA TODAY will plant a tree for each subscriber who switches to their online EZ-PAY billing system. To promote the initiative, they created an informational splash page linked from their online subscription service website.

USA TODAY — MCLEAN, VIRGINIA
Creatives : Scott Ament
Client : Kaitlyn Jain

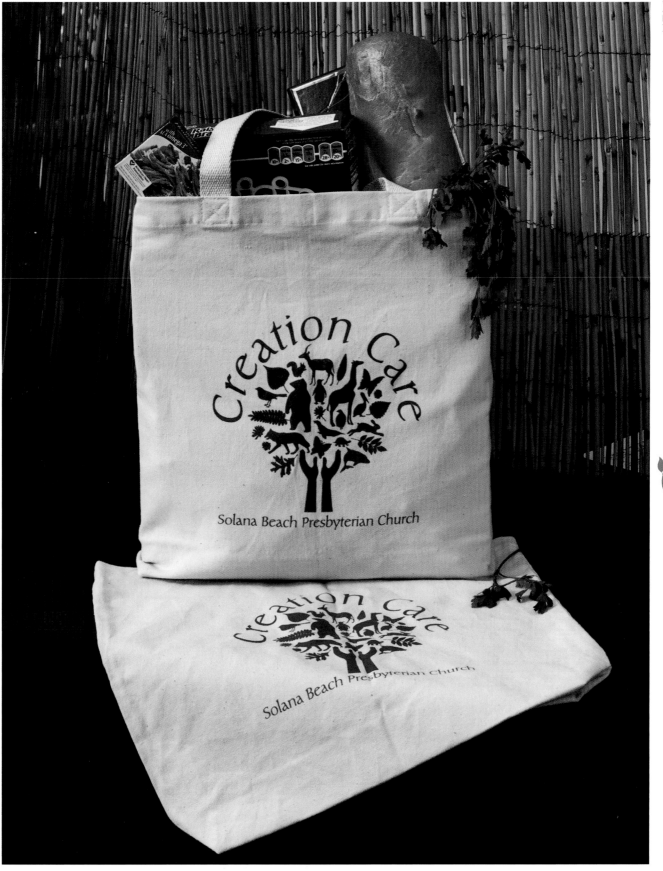

99

Creatives : Michael Kern
Client : Solana Beach Presbyterian Church

WHAT'S GREEN ABOUT THIS — Solana Beach Presbyterian Church developed a Creation Care team to educate church members about differences they can make in the environment. The team advocates using canvas bags instead of plastic bags as well as permanent beverage bottles. The church has recently begun offering green bags (with a white logo), as well as t-shirts and aluminum beverage containers. Members also participate in beach clean-up days, Earth Day, and other opportunities to educate and make a difference in environmental issues.

100

NATURE KNOWS.

The finest, most authentic wood-grained fiber cement siding made is also green.

CertainTeed's patented formula uses more than 30% pre-consumer recycled fly ash, a majority of wood fiber from sustainably managed forests, and a manufacturing process that conserves water and energy.

Shown in WeatherBoards™ Cedar Lap in Tan

building

CertainTeed ▣
Quality made certain. Satisfaction guaranteed.™

800-233-8990 • certainteed.com

EXTERIOR: ROOFING • SIDING • WINDOWS • FENCE • RAILING • TRIM • DECKING • FOUNDATIONS • PIPE
INTERIOR: INSULATION • GYPSUM • CEILINGS

WHAT'S GREEN ABOUT THIS — The client wanted to communicate that their product was the greenest in their category and was insistent that nothing be said that could not be backed up with facts and figures.

ELIAS SAVION ADVERTISING —
PITTSBURGH, PENNSYLVANIA
Creatives : Ronnie Savion, Jim Kashak
Client : CertainTeed FiberCement

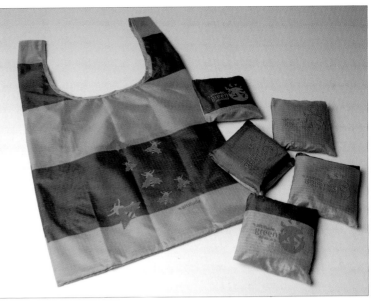

ALTITUDE, INC. — SOMERVILLE, MASSACHUSETTS
Creatives : Debra Fleury, Lilia Sanabria
Client : Altitude, Inc.

WHAT'S GREEN ABOUT THIS — Altitude, Inc. gives these re-usable nylon shopping bags to clients in an effort to not only retain customer goodwill, but to keep landfills free from plastic.

101

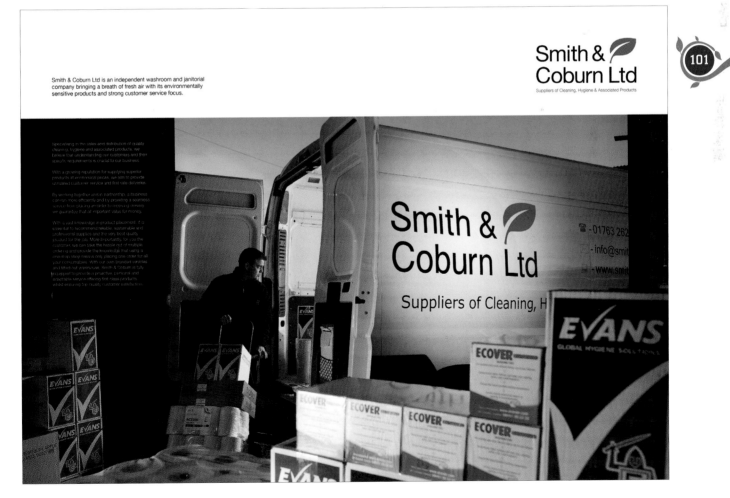

DEAN FORD CREATIVITY — LONDON, UNITED KINGDOM
Creatives : Dean Ford, Liz Graveney, Richard Dewick, Charlie Troman
Client : Smith & Coburn

WHAT'S GREEN ABOUT THIS — Smith & Coburn specializes in the sales and distribution of quality cleaning, hygiene, and associated products with a strong emphasis on customer service and environmental responsibility.

WHAT'S GREEN ABOUT THIS — Carolina Classics Catfish, of Ayden, North Carolina, produces its Natural Catfish sustainably, without land-animal by-products, pesticides, or other harmful chemicals.

KABLE DESIGN + RESEARCH — GREENVILLE, NORTH CAROLINA
Creatives : Kate Ann B. LaMere
Client : Carolina Classics Catfish

WHAT'S GREEN ABOUT THIS — The nomenclature of the company is self-explanatory of the product's attributes. In most of the options presented, a synthesis between the raw cotton bud and the sliver has been created. Several designs symbolise the fusion between the traditional and modern online trading of cotton.

GRAPHIC COMMUNICATIONS CONCEPTS — MUMBAI, INDIA
Creatives : Sudarshan Dheer
Client : Click for Cotton

WHAT'S GREEN ABOUT THIS — The industry-leading brand of high-performance/low power-consumption microchip wafers evokes the company's aspirations of intelligent energy management and closed-loop system efficiency for the world.

GEE + CHUNG DESIGN — SAN FRANCISCO, CALIFORNIA
Creatives : Earl Gee
Client : National Semiconductor Corporation

climate dialogues
SEATTLE

EWING CREATIVE, INC. — MANCHESTER, WASHINGTON
Creatives : Kristy Ewing, Phil Mitchell
Client : Climate Dialogues Organization

WHAT'S GREEN ABOUT THIS — The Greater Seattle Climate Dialogues is a campaign of community learning and discussion that begins with small-group dialogues (in neighborhoods, workplaces, schools, etc.) and will culminate in a Citizen's Climate Summit, where their informed, collective voice will be heard by local and national political leaders. Kristy Ewing provided her design services pro bono.

KiDS THiNK BiG™

103

NORA BROWN DESIGN — CHICAGO, ILLINOIS
Creatives : Nora Brown
Client : Kids Think Big

WHAT'S GREEN ABOUT THIS — This logo was developed for Jeanine Behr Getz's new company, Kids Think Big. She published her first book, *Think Green!*, under the new company in February 2008. It promotes everyday things kids can do for the environment and is printed on New Leaf Paper with soy-based inks.

PROJECT GIVE 360°

NINE TEN CREATIVE — LAKEWOOD, COLORADO
Creatives : Amanda Salazar
Client : Project Give 360

WHAT'S GREEN ABOUT THIS — Project Give 360 is a non-profit organization empowering women, children and families in emerging communities to lead self-sufficient, enriched lives through educational and vocational programs. Domestic and international volunteer opportunities supporting these programs are offered to families and individuals who want to make a difference. Project Give 360 enhances the well-being and sustainability of communities served while fostering awareness, compassion, and inspiration in those who serve. Their primary project is to help fund a vocational sewing program by selling reusable eco-friendly bags made out of flour sacks by the local children of Tegucigalpita, Honduras.

WHAT'S GREEN ABOUT THIS — Eco-Coach is an environmental sustainability consulting company that helps businesses and individuals create environmentally friendly and healthy spaces.

SUBSTANCE151 — BALTIMORE, MARYLAND
Creatives : Ida Cheinman, Rick Salzman
Client : Eco-Coach

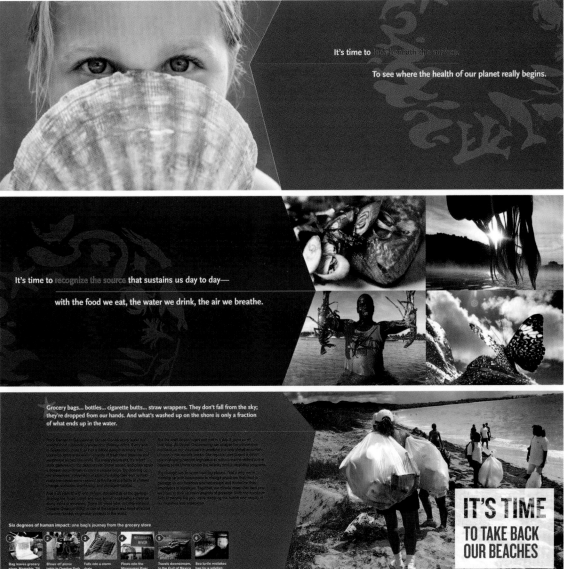

It's time to look beneath the surface.

To see where the health of our planet really begins.

It's time to recognize the source that sustains us day to day—

with the food we eat, the water we drink, the air we breathe.

Grocery bags... bottles... cigarette butts... straw wrappers. They don't fall from the sky; they're dropped from our hands. And what's washed up on the shore is only a fraction of what ends up in the water.

Six degrees of human impact: one bag's journey from the grocery store

IT'S TIME
TO TAKE BACK
OUR BEACHES

BBMG — NEW YORK, NEW YORK
Creatives : Scott Ketchum, Miriam Kriegel, Russell Feldman
Client : Ocean Conservancy

WHAT'S GREEN ABOUT THIS — The health of our entire planet begins with the oceans: Blue is the new green. In the campaign to position Ocean Conservancy—and the oceans—as an urgent conservation issue that's relevant to our daily lives, the designer specified paper that is 100% recycled, 50% post-consumer waste, FSC-certified, and printed with soy inks. Eco-printer is FSC-certified and powered by renewable energy.

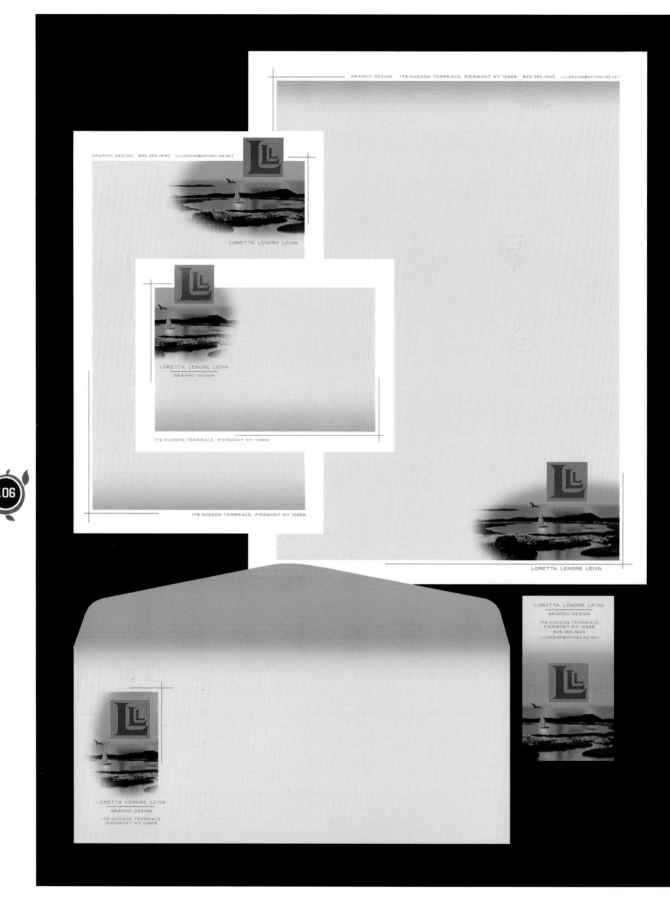

WHAT'S GREEN ABOUT THIS — Stationery system for graphic design studio that specializes in environmental projects.

JOHN SPOSATO DESIGN & ILLUSTRATION — PIERMONT, NEW YORK
Creatives : John Sposato
Client : Loretta Lenore Leiva

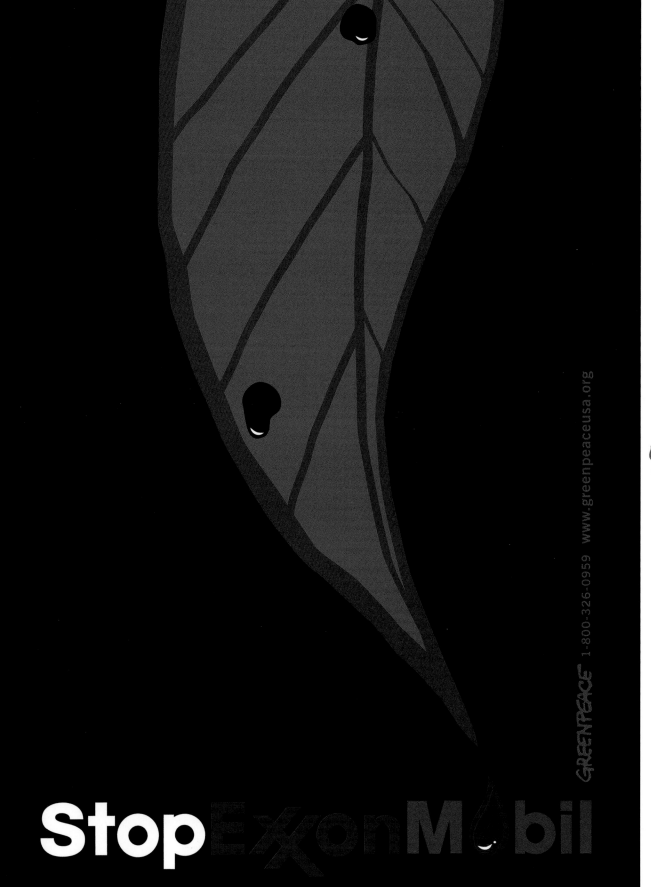

Stop ExxonMobil

GREENPEACE 1-800-326-0959 www.greenpeaceusa.org

107

TWOINTANDEM — NEW YORK
Creatives : Sanver Kanidinc, Elena Ruano Kanidinc
Client : Greenpeace

WHAT'S GREEN ABOUT THIS — This poster was created for the non-profit environmental organization Greenpeace to generate awareness of Exxon Mobil's corporate policies.

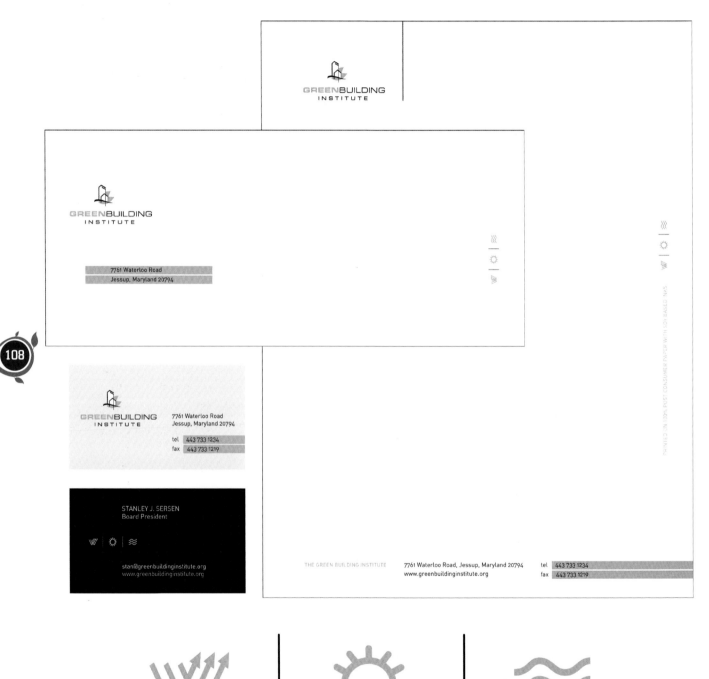

WHAT'S GREEN ABOUT THIS — The Green Building Institute is an emerging non-profit organization working to advance environmentally sustainable building practices through education and example. By designing the website as The Green Building Institute's primary marketing tool, the designer eliminated the need for a number of paper-based tools. Where print materials were used, they specified Mohawk Options White Smooth paper, 100% post-consumer waste, FSC-certified, and manufactured with renewable, non-polluting, wind-generated electricity. By choosing a local , FSC-certified printer, they minimized energy use in delivery and contributed to building a sustainable local economy.

SUBSTANCE151 — BALTIMORE, MARYLAND
Creatives : Ida Cheinman, Rick Salzman
Client : The Green Building Institute (GBI)

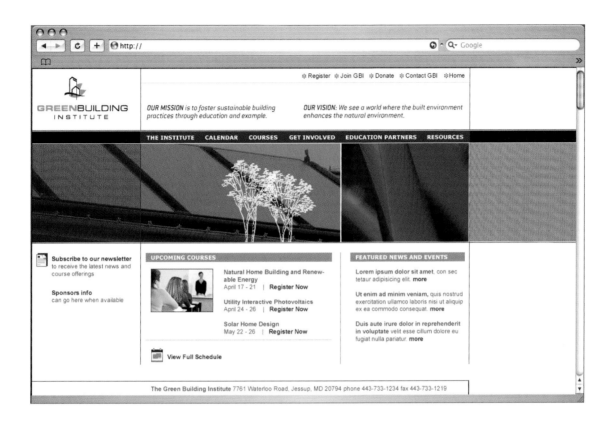

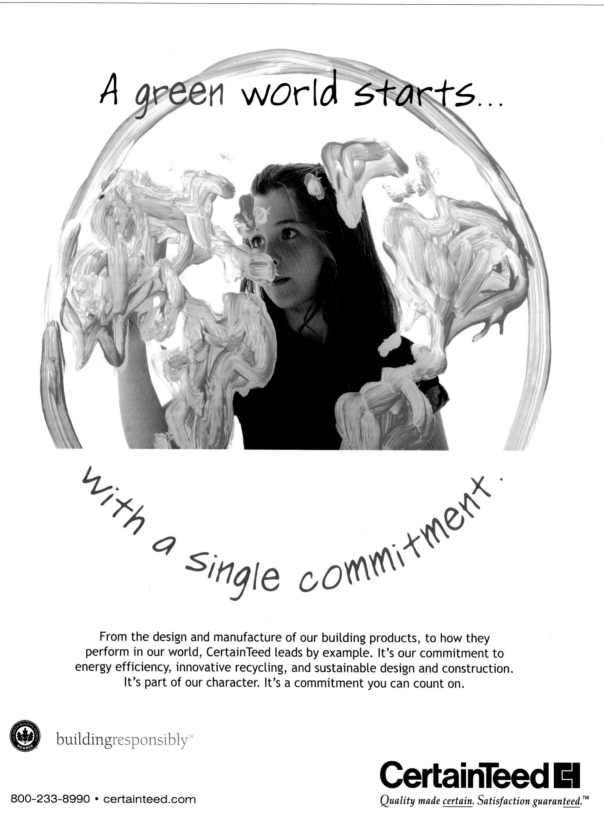

A green world starts...

with a single commitment.

From the design and manufacture of our building products, to how they perform in our world, CertainTeed leads by example. It's our commitment to energy efficiency, innovative recycling, and sustainable design and construction. It's part of our character. It's a commitment you can count on.

buildingresponsibly™

800-233-8990 • certainteed.com

CertainTeed
Quality made certain. Satisfaction guaranteed.™

EXTERIOR: ROOFING • SIDING • WINDOWS • FENCE • RAILING • TRIM • DECKING • FOUNDATIONS • PIPE
INTERIOR: INSULATION • GYPSUM • CEILINGS

WHAT'S GREEN ABOUT THIS — Green ad for energy-efficient CertainTeed insulation, which is made in energy-conscious plants, using sand and recycled glass. CertainTeed's environmental commitment is: From the design and manufacture of our building products, to how they perform in our world, CertainTeed leads by example. It's our commitment to energy efficiency, innovative recycling, and sustainable design and construction.

ELIAS SAVION ADVERTISING —
PITTSBURGH, PENNSYLVANIA
Creatives : Ronnie Savion, Jim Kashak
Client : CertainTeed

110

111

LAMBIANCE DESIGN AND MULTIMEDIA — ALABAMA
Creatives : Lili Lau
Client : Bondex Group

WHAT'S GREEN ABOUT THIS — From client's brochure, designed to project an environmentally friendly image.

2009 MEMBERSHIP BENEFITS

112

WHAT'S GREEN ABOUT THIS — The Maryland Chapter of the U.S. Green Building Council is a non-profit organization committed to transforming the way buildings and communities are designed and built. It is dedicated to sustainable practices and providing healthy places to live, work, learn, and heal, and developing ways to educate and involve more people in creating healthier, more productive businesses and communities in Maryland.

SUBSTANCE151 — BALTIMORE, MARYLAND
Creatives : Ida Cheinman, Rick Salzman
Client : U.S.Green Building Council—Maryland Chapter

unum®

(A WORLD OF BENEFITS)

2008 Corporate Social Responsibility Report

115

EYEPROJECTOR — CHATTANOOGA, TENNESSEE
Creatives : Cathi Cannon, David Bankston, Tina Paul
Client : Unum

WHAT'S GREEN ABOUT THIS — Unum's corporate social responsibility report illustrates how the company and its employees have made positive changes where they live and work—including environmentally responsible initiatives that help create sustainable communities. A limited number of reports were printed and distributed. The full report is available online as well. They chose Mohawk Options 100% PC White paper, which is manufactured entirely with Green-e certified wind-generated electricity, Rainforest Alliance-Certified and FSC-certified, containing 100% post-consumer waste fiber, and printed with low volatile organic compound (VOC) vegetable oil-based ink.

WHAT'S GREEN ABOUT THIS — Studio 22 specializes in creating sustainability communications for their clients, whether they already exist in the environmental sector or are aspiring to become a greener company. This is the first report for Evolution Markets, and it signifies the beginning of their commitment to becoming an environmentally sustainable company. Evolution Markets now has a full accounting of their impact on the environment and the communities in which they work.

STUDIO 22 — THURMONT, MARYLAND
Creatives : Eryn Willard, Jennifer Woofter, Evan Ard
Client : Evolution Markets

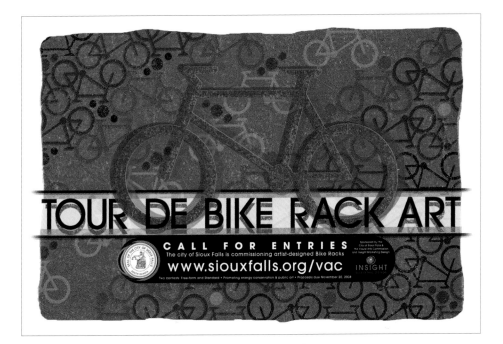

INSIGHT MARKETING DESIGN —
SIOUX FALLS, SOUTH DAKOTA
Creatives : Doug Moss, Ben Hodgins
Client : City of Sioux Falls

WHAT'S GREEN ABOUT THIS — The Bike Rack Art Call for Entries poster was the first step in a process to solicit designs for original bike rack sculpture designs that will replace the traditional bike racks throughout Sioux Falls, SD. The competition is part of the City of Sioux Falls. Visual Arts Commission's efforts to provide visually attractive elements in their community. The competition calls for the sculptures to be comprised of 50% recycled material.

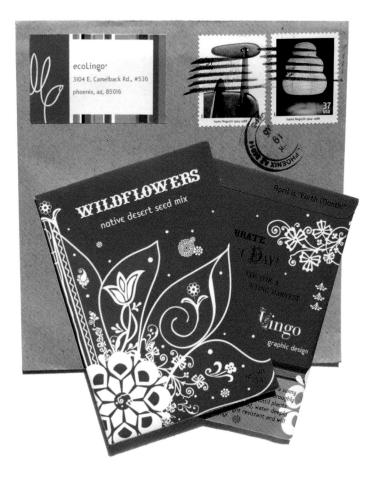

ECOLINGO — PHOENIX, ARIZONA
Creatives : Dion Zuess
Client : ecoLingo

WHAT'S GREEN ABOUT THIS — Founded on Earth Day in 2002, ecoLingo designs with sustainability in mind, applying design ecology principles to each project. The studio's electronic design and publishing is powered by the sun and wind, and the studio creates projects that have minimal impacts on the environment—for example, using agri-based or solvent-free inks and recycled, FSC-certified, chlorine-free papers made with certified renewable energy. Each year on Earth Day, the studio sends out an educational or promotional item to clients, colleagues, and friends. These colorful seed packages were created in-house, with some seeds harvested from desert wildflowers outside the studio.

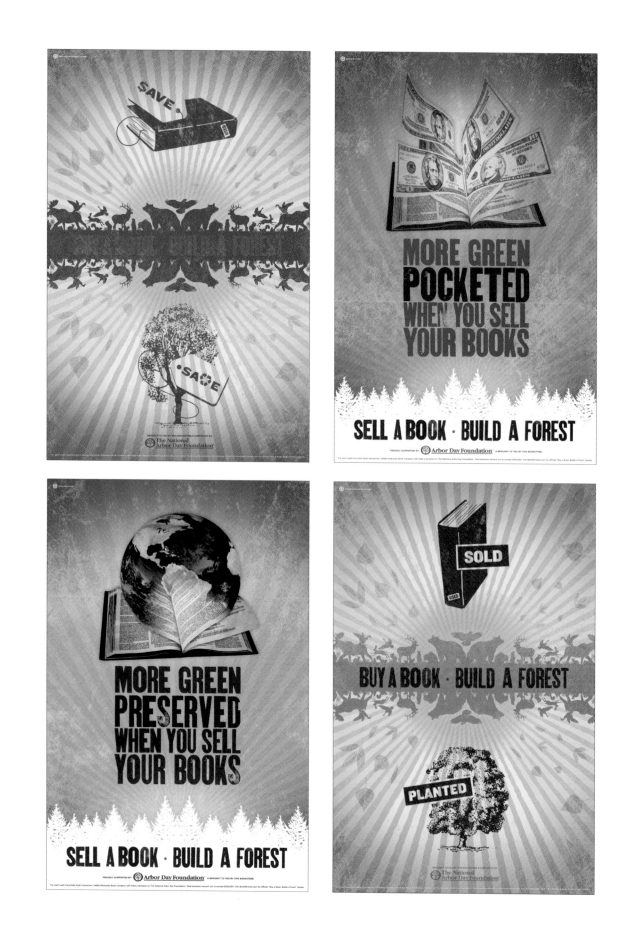

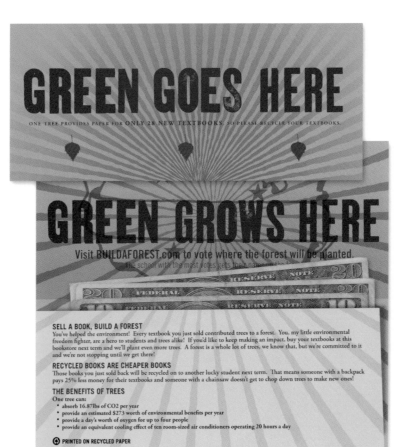

GREEN GOES HERE

ONE TREE PROVIDES PAPER FOR ONLY 28 NEW TEXTBOOKS, SO PLEASE RECYCLE YOUR TEXTBOOKS.

GREEN GROWS HERE

Visit BUILDAFOREST.com to vote where the forest will be planted.
The school with the most votes gets their name on it.

SELL A BOOK, BUILD A FOREST
You've helped the environment! Every textbook you just sold contributed trees to a forest. You, my little environmental freedom fighter, are a hero to students and trees alike! If you'd like to keep having an impact, buy your textbooks at this bookstore next term and we'll plant even more trees. A forest is a whole lot of trees, we know that, but we're committed to it and we're not stopping until we get there!

RECYCLED BOOKS ARE CHEAPER BOOKS
Those books you just sold back will be recycled on to another lucky student next term. That means someone with a backpack pays 25% less money for their textbooks and someone with a chainsaw doesn't get to chop down trees to make new ones!

THE BENEFITS OF TREES
One tree can:
* absorb 16.87lbs of CO_2 per year
* provide an estimated $273 worth of environmental benefits per year
* provide a day's worth of oxygen for up to four people
* provide an equivalent cooling effect of ten room-sized air conditioners operating 20 hours a day

♲ PRINTED ON RECYCLED PAPER

119

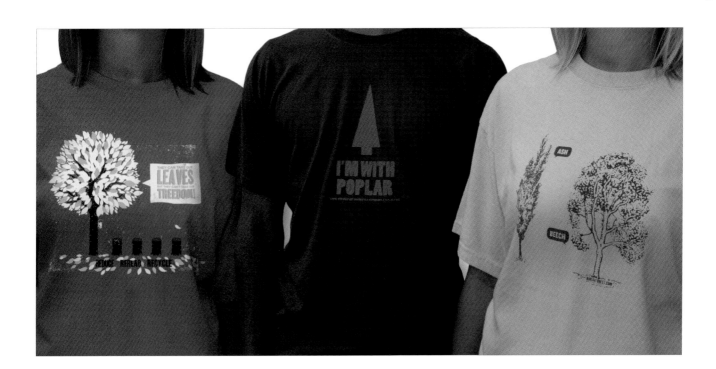

NEBRASKA BOOK COMPANY — LINCOLN, NEBRASKA
Creatives : Shane Jochum, Bennett Holzworth, Curtis Pachunka
Client : Nebraska Book Company

WHAT'S GREEN ABOUT THIS — The Build a Forest campaign was implemented in 2007 throughout Nebraska Book Company's nationwide network of 270+ college bookstores. The main thrust of the promotion is focused on planting two 100,000-tree forests through a collaborative effort with the Arbor Day Foundation. Another goal of the campaign is to show the environmental benefits of using used (recycled) textbooks instead of new textbooks. The campaign and the design have received positive reactions from students and store managers. All materials were printed on post-consumer recycled paper.

| KARL DESIGNS — CALIFORNIA
Creatives : Trudy Harrington Karl
Client : TrueGreen Investments

WHAT'S GREEN ABOUT THIS — TrueGreen Investments required a corporate identity package for its international, earth-friendly, community-driven agriculture company. Products for this company are diverse, from hardwoods to coffee and chocolate.

WHAT'S GREEN ABOUT THIS — Zero Motorcycles asked Tread Creative to design a logo for their electric motorcycle company. Although Zero's product is highly efficient, they did not want the logo to look overtly green, using earth tones, natural elements, etc., but more subtly green by simply using a clean design.

TREAD CREATIVE — LOS GATOS, CALIFORNIA
Creatives : Phil Mowery
Client : Zero Motorcycles

WHAT'S GREEN ABOUT THIS — BRING Recycling is one of the nation's oldest non-profit recyclers. They help their community keep useful items out of the landfill, find ways to use less stuff, reuse as many things as possible and recycle the rest. BRING also runs the Planet Improvement Center, a used building materials resale outlet and education center.

FUNK/LEVIS & ASSOCIATES — EUGENE, OREGON
Creatives : David Funk
Client : BRING Recycling

WHAT'S GREEN ABOUT THIS — West Penn Energy Solutions specializes in residential and commercial energy conservation. They provide performance testing and contracting as well as solar energy design and installation.

IMAGEBOX PRODUCTIONS INC. — ALABAMA
Creatives : John Mahood, David Patrick Crawford
Client : West Penn Energy Solutions

NETRA NEI — SEATTLE, WASHINGTON
Creatives : Netra Nei
Client : Green Home Contractors

WHAT'S GREEN ABOUT THIS — Green Home Contractors focuses on the use of environmentally conscious products and the re-use of existing materials.

POST CARBON
INSTITUTE

RELOCALIZATION
NETWORK

ENERGY FARMS
NETWORK

OIL DEPLETION
PROTOCOL

MINE™ — SAN FRANCISCO, CALIFORNIA
Creatives : Christopher Simmons, Tim Belonax
Client : Post Carbon Institute

WHAT'S GREEN ABOUT THIS — The Post Carbon Institute is an organization that focuses on solutions to help the public move beyond carbon consumption.

GEE + CHUNG DESIGN — SAN FRANCISCO, CALIFORNIA
Creatives : Earl Gee
Client : National Semiconductor Corporation

WHAT'S GREEN ABOUT THIS — National Semiconductor's advanced solar energy conversion technology transforms solar energy into electric current by multiplying the power of the sun.

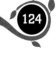

124

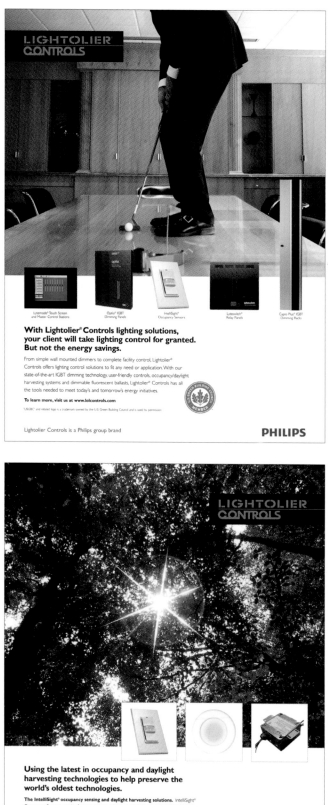

WHAT'S GREEN ABOUT THIS — This energy-efficient lighting contains a sensor that knows when humans enter a room and turns the lights on. The lights also employ automatic calibration and shut-off. They can detect how much natural light is in a room and reduce energy usage accordingly.

VANPELT CREATIVE — GARLAND, TEXAS
Creatives : Chip VanPelt, Heinz Roy
Client : Philips/Lightolier Controls

125

ELIAS SAVION ADVERTISING —
PITTSBURGH, PENNSYLVANIA
Creatives : Ronnie Savion
Client : CertainTeed Building Solutions

WHAT'S GREEN ABOUT THIS — Green ad for CertainTeed, designed to speak specifically to architects. The building used in the ad, once certified, will be the largest LEED-certified building in the U.S. CertainTeed ceilings and insulation products were used in its construction.

Como devemos actuar?

CONVERTENDO TODOS OS RESÍDUOS NOVAMENTE EM RECURSOS: FECHANDO O CICLO DOS MATERIAIS

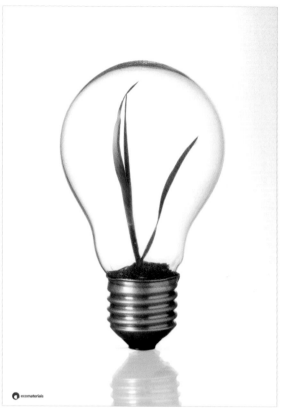

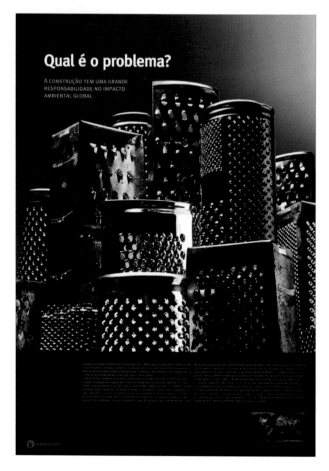

Qual é o problema?

A CONSTRUÇÃO TEM UMA GRANDE
RESPONSABILIDADE NO IMPACTO
AMBIENTAL GLOBAL

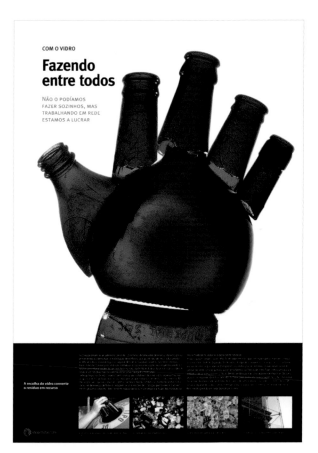

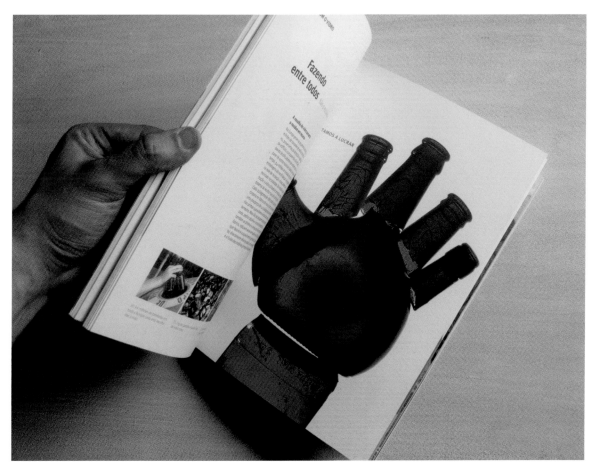

GUERRINI DESIGN ISLAND — BUENOS AIRES, ARGENTINA
Creatives : Sebastian Guerrini
Client : Concreta Fair

WHAT'S GREEN ABOUT THIS — Ecomateriais, Concreta Fair. Image and identity design.

128

WHAT'S GREEN ABOUT THIS — Promotional booklet to increase awareness of environmental issues and how small changes in daily life help combat the effect each person has on the environment.

CL GRAPHICS, INC. — CRYSTAL LAKE, ILLINOIS
Creatives : Heather Azzarello
Client : CL Graphics, Inc.

want to **lessen** your
CARBON FOOTPRINT?

ask me about
carpooling

129

AMBIENT — MILLER PLACE, NEW YORK
Creatives : Scott Mosher
Client : Louis Visconti/NYS DOT

WHAT'S GREEN ABOUT THIS — This poster is an internal marketing piece designed for the New York State
Department of Transportation to promote carpooling in their workforce.

WHAT'S GREEN ABOUT THIS — A self-promotion piece for a design firm specializing in environmentally responsible marketing and advertising options.

DESIGN 446 — MANASQUAN, NEW JERSEY
Creatives : Brian Stern
Client : Design 446

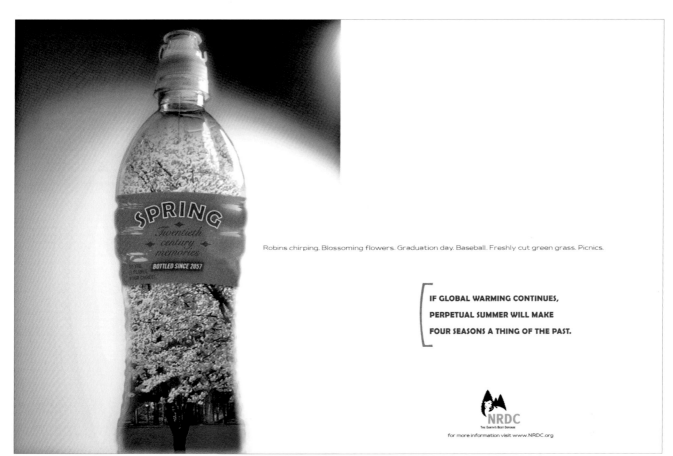

Robins chirping. Blossoming flowers. Graduation day. Baseball. Freshly cut green grass. Picnics.

IF GLOBAL WARMING CONTINUES,
PERPETUAL SUMMER WILL MAKE
FOUR SEASONS A THING OF THE PAST.

NRDC
THE EARTH'S BEST DEFENSE
for more information visit www.NRDC.org

JOHN SPOSATO DESIGN & ILLUSTRATION —
PIERMONT, NEW YORK
Creatives : Mark Sposato
Client : Tyler School of Art

WHAT'S GREEN ABOUT THIS — Anti-global-warming ad series for the Natural Resource Defense Council. The concept is that if we don't stop global warming, we will be left with perpetual summer, and the other three seasons will be extinct. The images evoke the notion of bottled, artificial seasons 50 years in the future.

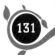

CONRY DESIGN — TOPANGA, CALIFORNIA
Creatives : Rhonda Conry
Client : PSAV Presentation Services

WHAT'S GREEN ABOUT THIS — Ads showcasing PSAV's move toward greener business applications.

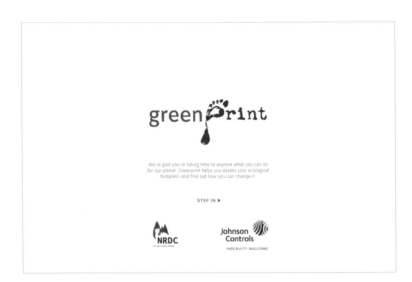

WHAT'S GREEN ABOUT THIS — Johnson Controls provides innovative, environmentally conscious automotive interiors that help make driving more comfortable, safe, and enjoyable while making use of reused and recycled materials. It offers energy-efficient products and services that make buildings efficient, safe, and sustainable. Johnson Controls also provides batteries for hybrid electric vehicles and promotes the idea of electric-powered fleets of earth-friendly trucks.

MCDILL DESIGN — MILWAUKEE, WISCONSIN
Creatives : Dave Burkle, Mike Grunwald
Client : Johnson Controls

133

WHAT'S GREEN ABOUT THIS — EarthFriendly Greetings is the new brand identity created for Earth Medicine, an established B2B greeting-card company. The new company name, logo, and positioning were created to reflect the company's recent strategic organizational shift to environmentally friendly printing practices.

GUARINO GRAPHICS DESIGN STUDIO —
EAST NORTHPORT, ALABAMA
Creatives : Jan Guarino, Michelle Molin
Client : Earth Medicine

134

WHAT'S GREEN ABOUT THIS — Freedomilk is an international certification program enabling cows to have the freedom to choose when to give their milk, living humanely within an eco-friendly, small scale farming environment that supports dairy farmers with fair-trade.

COMPASS CREATIVE STUDIO — BURLINGTON, ONTARIO, CANADA
Creatives : Jason Bouwman
Client : Freedom Dairy Inc.

WHAT'S GREEN ABOUT THIS — This logo was developed to promote the company's ongoing efforts of developing environmentally friendly products for the construction industry.

CAPERS DESIGN — MIDDLEBORO, MASSACHUSETTS
Creatives : Lauren Capers
Client : GRACE

Alameda County
SUSTAINABILITY
Local Action, Global Impact.

DK DESIGN STUDIO, INC — OAKLAND, CALIFORNIA
Creatives : Darilyn Kotzenberg, Joe Wright, Kristin Slye
Client : Alameda County General Services Agency

WHAT'S GREEN ABOUT THIS — Alameda County in California is at the forefront of many green programs and regarded as a leader by other county governments. This identity was developed for their sustainability programs.

arborwood
TREE SERVICE INC.

COMPASS CREATIVE STUDIO — BURLINGTON, ONTARIO, CANADA
Creatives : Jason Bouwman, Pierre Bourreau
Client : Arborwood Tree Service Inc.

WHAT'S GREEN ABOUT THIS — While part of their service includes heavy equipment, arborists Arborwood wanted a logo that would reflect their commitment to new organic treatments and care techniques as well as attract world-class climbing talent.

the **green** glass co.

ALR DESIGN — RICHMOND, VIRGINIA
Creatives : Noah Scalin
Client : The Green Glass Company

WHAT'S GREEN ABOUT THIS — Logo for company which makes glassware from reclaimed wine and beer bottles.

There are hundreds of things that we, as individuals, can do to be more environmentally sensitive. But what can facility managers and building owners do to green their buildings and make their organizations more sustainable? Implement any of these environmentally beneficial ideas and you can reap the financial fruits of your sustainable efforts.

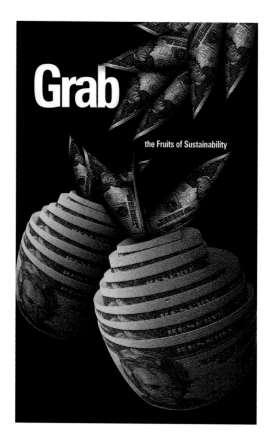

Grab
the Fruits of Sustainability

1. Conserve Energy!
Improving technology doesn't just make your cell phone thinner or your TV screen bigger. Replacing old lighting systems with energy efficient systems, installing building automation systems and tightening your building's envelope will not only reduce utility bills, they'll also reduce the greenhouse gas emissions those utilities generate.

2. Conserve Water!
The issues we face today regarding the supply and demand of oil will eventually become the same issues regarding the supply and demand of something more essential: clean water. Green cleaning programs and water efficient fixtures and faucets are just a couple of ways that your building can hedge against water scarcity.

3. Take a Deep Breath!
Volatile organic compounds (VOCs) can be a major cause of building occupant complaints, particularly in new or newly renovated office buildings. Walls, floors, ceilings, furniture and office equipment all play a part. When evaluating comparable products, look to see which are the most durable, lowest-emitting options (both during initial installation and throughout its life cycle), and which require the least maintenance.

4. Recycle!
Bottles, cans and paper are great starting points, but in the U.S., 57% of all waste is from non-residential buildings. Carpeting, wallboard, floor covering, ceiling tiles, concrete, steel, packaging, wood, bricks and shingles are all relatively easy to recycle. In fact, as much as 75% of all construction and demolition waste can be recycled and diverted from the waste stream, significantly lowering cartage costs and even generating revenue.

5. Green Your Supply Chain!
You can make your purchases do more than just satisfy your needs: use them to protect the environment and improve social conditions in your community. Speak volumes about your organization by considering the environmental and social impact of your purchases. Use these same criteria to establish relationships with like-minded vendors and suppliers.

If you're just starting to reap the benefits of sustainability, the Alliance can help you take advantage of the low hanging fruit.

If you're already well on your way, each of the Alliance members can provide you with advanced sustainable solutions that deliver significant results.

Alliance for Sustainable Built Environments

Alliance Members

JOHNSON CONTROLS · KOHLER · Forbo · PHILIPS · USG · JohnsonDiversey · MILLIKEN

www.greenerfacilities.org
866.913.9473

Reap additional benefits of sustainability by requesting information on a variety of solutions categories. Simply tell us what information you would like to receive.

Make Sense of Sustainability

Name _____ Title _____
Company _____
Address 1 _____
Address 2 _____
City _____ State/ZIP _____
Phone _____
Email _____

I'm interested in:
❏ Green cleaning programs
❏ Recyclable carpeting and fabrics
❏ Acoustical and occupant comfort
❏ Water-efficient fixtures and faucets
❏ Sustainable building materials
❏ Sustainable flooring solutions
❏ Energy efficient building systems
❏ Energy efficient lighting systems
❏ Thermal solutions
❏ Indoor environmental quality

For fast on-line requests go to: www.greenerfacilities.org/solutions

WHAT'S GREEN ABOUT THIS — This direct-mail piece was created in print and electronic format to provide leads to the individual Alliance for Sustainable Built Environments member companies. The piece promoted "grabbing the low-hanging fruit" and offered ideas to get started on a path toward sustainability. It included a tear-off return card as well as a web link for sustainability information. Leads were collected at Braun & Zurawski and disseminated to Alliance members in a spreadsheet format for their follow-up.

B&Z MARKETING — MILWAUKEE, WISCONSIN
Creatives : Al Braun, Pat Lafferty, Hayley Jacobs, Kriss Schulz
Client : Alliance for Sustainable Built Environments

GOUTHIER DESIGN — TORRINGTON, CONNECTICUT
Creatives : Jonathan Gouthier, Rich Preciose
Client : Gouthier Design: a brand collective

WHAT'S GREEN ABOUT THIS — Graft highlights recent projects and topics relevant to this designer's clients and prospects. This issue deals with sustainability and being green: how a company becomes a green company; how to implement greenness and sustainability in their communications, product design, and services. It is printed on FSC-certified paper which was manufactured with renewable energy and printed using soy-based inks.

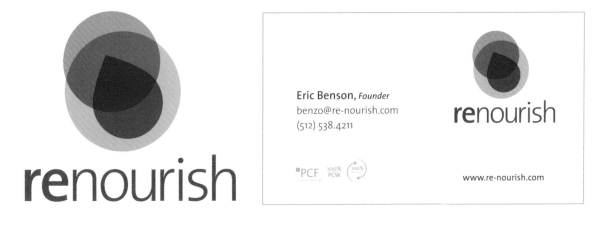

RENOURISH — CHAMPAIGN, ILLINOIS
Creatives : Eric Benson
Client : renourish

WHAT'S GREEN ABOUT THIS — Business cards are printed on 100# New Leaf Everest cover stock. The paper is FSC certified, 100% PCW, PCF, Ancient Forest Friendly, green-e certified, and manufactured by windpower. The redesign of the logo and business cards was completed in response to the relaunch of Eric Benson's research site: www.re-nourish.com. The site is a repository of facts, definitions, tips, and case studies that help the graphic designer become more sustainable in his/her studio and everyday practice.

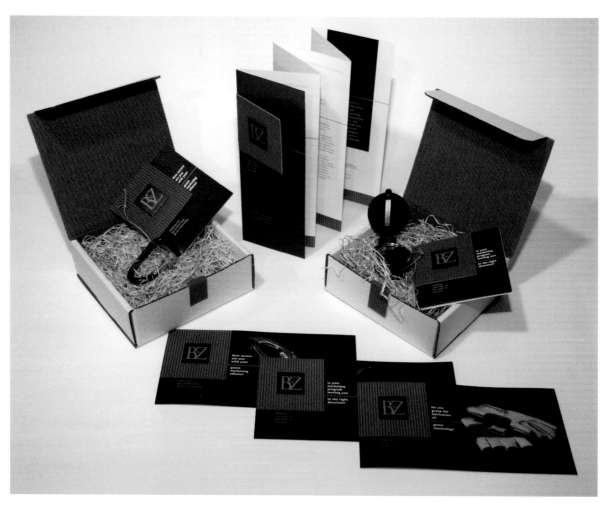

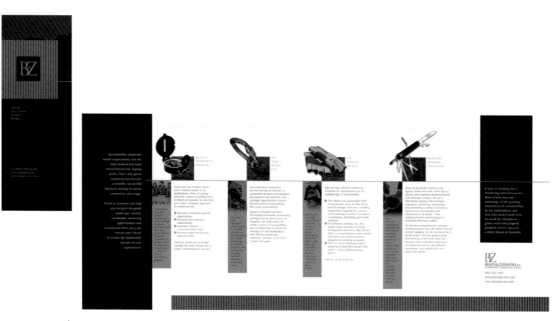

WHAT'S GREEN ABOUT THIS — The compass and carabiner were made from recyclable metals and plastics. They were packed in all-natural wood fibers and shipped in highly recyclable corrugated cardboard boxes. All materials were printed on recycled stock with soy-based, low-VOC inks, and the hanging cards were attached with unbleached, waxed hemp twine. The brochure was accordion-folded to limit waste.

B&Z MARKETING — MILWAUKEE, WISCONSIN
Creatives : Al Braun, Pat Lafferty, Craig Zurawski, Kriss Schulz
Client : Braun & Zurawski, Inc.

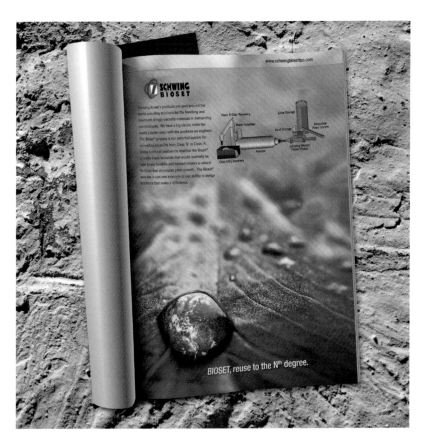

SYMBO DESIGN — HUDSON, WISCONSIN
Creatives : Melinda Johnson, Angie Wishard, Teicko Huber
Client : Schwing Bioset

WHAT'S GREEN ABOUT THIS — Schwing Bioset's Bioset Process creates reusable class A biosolids that would otherwise be dumped in a landfill. Symbo Design created an environmentally conscious image for their print and web advertising.

139

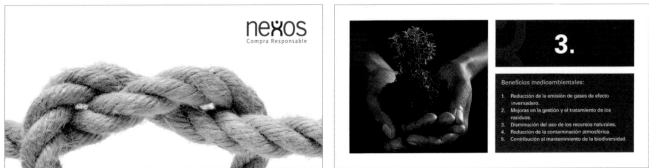

CANNONBALL STUDIO — SPAIN
Creatives : Estela Rivero, Olga Martinez
Client : Nexos

WHAT'S GREEN ABOUT THIS — NEXOS is an environmentally aware company whose services include consulting on sustainable procurement. Cannonball Studio developed and designed the name, logotype, and corporate identity for NEXOS as well as various graphic applications: presentation cards, corporate folders, and marketing brochures. All printing was done on 100% recycled paper.

How They Did It
The Lost Bean

The Lost Bean asked twoline Studio's husband-and-wife team to reinvent everything short of the coffee pot. "They wanted to portray the organic concept by redesigning all their branding and collateral pieces using modern graphics and colors," says Robert C. Newell, twoline's art director.

With wife and creative director, Charissa, Newell swept the old brand away. Lost Bean had been utilizing earthy visual cues in a painterly fashion emphasizing natural textures and fibers. The Newells aimed for more abstract images that satisfied the client's desire for a fun, edgy, unique look that was clean and sophisticated. The look, as Lost Bean envisioned it, would reflect the store's interior space.

"The new idea needed to be fresh and more abstract, with clean lines— and vector-based-as opposed to photographic—artwork," Newell says.

Newell had previous experience with Lost Bean, having helped design the store's website. The client was so pleased with his work that twoline was retained for the brand overhaul. "For the original website home page,

I used The Lost Bean concept as a navigational aid popping up throughout a sort of urban maze," Newell says. "Because of the fun detail of the imagery and animation, Lost Bean decided to keep it, so we had to adapt it somewhat to work with the new concept."

Lost Bean stresses the organic idea at every turn and encourages customers to live an eco-friendly lifestyle. The website and all collateral materials highlight the store's dedication to environmentally sound practices as well as its associations with nonprofits and community-based organizations. The Newell's design incorporated recycled and organic materials. "We even designed display cards presenting factoids about environmentally friendly living to be positioned around the store," Newell says.

With more potential clients seeking a greener image, the market is steering the Newells into producing more earth-friendly material. They've also chosen to work at home and do digital office paperwork. "Every little bit helps," he says.

TWOLINESTUDIO — DENVER, COLORADO
Creatives : Robert C. Newell III, Charissa Newell
Client : The Lost Bean

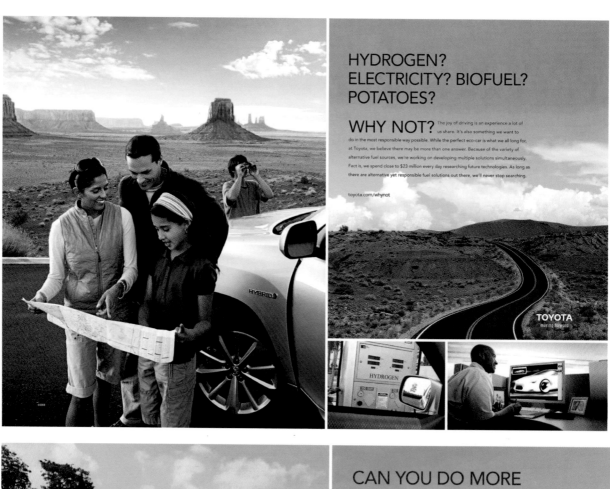

142

HYDROGEN?
ELECTRICITY? BIOFUEL?
POTATOES?

WHY NOT? The joy of driving is an experience a lot of us share. It's also something we want to do in the most responsible way possible. While the perfect eco-car is what we all long for, at Toyota, we believe there may be more than one answer. Because of the variety of alternative fuel sources, we're working on developing multiple solutions simultaneously. Fact is, we spend close to $23 million every day researching future technologies. As long as there are alternative yet responsible fuel solutions out there, we'll never stop searching.

toyota.com/whynot

TOYOTA
moving forward

CAN YOU DO MORE
FOR THE EARTH BY
PUTTING LESS INTO IT?

WHY NOT? Of all the methods we use to reduce our environmental footprint, some of the most impactful ones are at our plants. Eight of our U.S. plants have achieved zero landfill targets – which means no waste goes into landfills. To accomplish this, we've reduced raw material usage and we're recycling virtually every material, including paper, plastics, metals, even waste water. And we're constantly looking for innovative ways to further reduce waste. Because sometimes, giving back to the earth means not giving it much at all.

toyota.com/whynot

TOYOTA
moving forward

WHAT'S GREEN ABOUT THIS — This campaign for Toyota focuses on three pillars of their corporate philosophy: environmental commitment, economic impact, and social responsibility.

CCO INC – LOS ANGELES, CALIFORNIA
Creatives : Craig Cameron Olsen, Aaron Frisch, Doreen McKenney
Client : Toyota

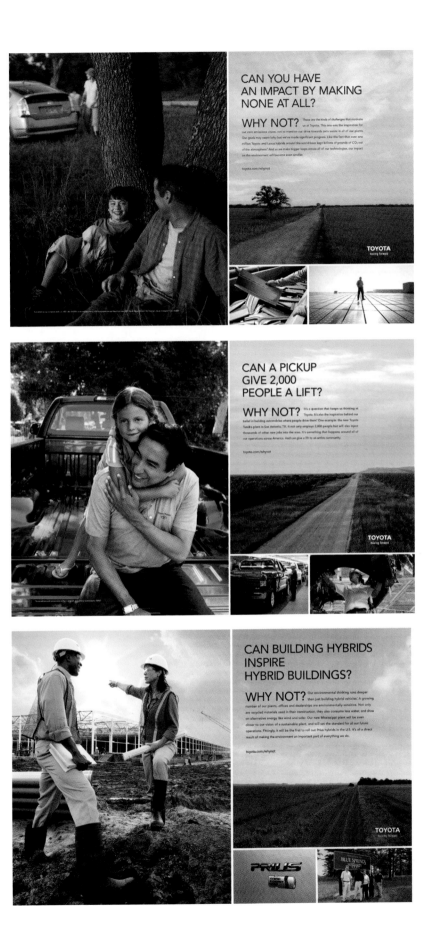

HYPHEN
GREENSTART

WHAT'S GREEN ABOUT THIS — Hyphen GreenStart, a green- friendly company.

CAMP CREATIVE GROUP — BLUE RIDGE SUMMIT, PENNSYLVANIA
Creatives : Sarah Camp
Client : Hyphen GreenStart through Hyphen Media Group

zelen

144

WHAT'S GREEN ABOUT THIS — Hrvatska Elektroprivreda (HEP Group) is a national electricity company; this logo was made to promote their green energy production. The name "zelen" is an abbrevation of "zelena energija" (meaning "green energy.") The logo combines an image of a wall power socket and a trefoil with four leaves, which is a rare natural phenomenon.

BRUKETA&ZINC OM — ZAGREB, CROATIA
Creatives : Davor Bruketa, Nikola Zinic, Imelda Ramovic, Mirel Hadzijusufovic
Client : HEP

ekko
solutions

WHAT'S GREEN ABOUT THIS — Ekko Solutions is a New Zealand company that focuses on selling eco-friendly, environmentally sustainable products. Their latest product includes reusable, biodegradable jute-fiber bags, an alternative to plastic bags, which they produce for retail clients in Australia and New Zealand.

GRAPHITE DESIGN LIMITED — AUCKLAND, NEW ZEALAND
CREATIVE TEAM : Matthew Coates
CLIENT : Ekko Solutions

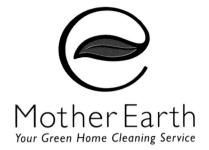

Mother Earth
Your Green Home Cleaning Service

CHAPPLE DESIGN — LOS ANGELES, CALIFORNIA
Creatives : David Harris Chapple
Client : Mother Earth

WHAT'S GREEN ABOUT THIS — Mother Earth is a green home cleaning service based in Southern California that uses all-natural products like lemon juice, vinegar, baking soda, castille soap and natural oils.

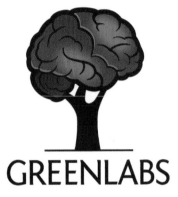

GREENLABS

DIVER LOGO DESIGN — SAINT-PETERSBURG, RUSSIA
Creatives : Yury Akulin
Client : GreenLabs

WHAT'S GREEN ABOUT THIS — GreenLabs is a web development company.

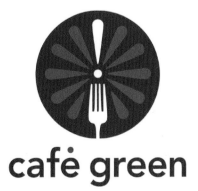

café green

IDEAL DESIGN COMPANY, LLC — WASHINGTON, D.C.
Creatives : Kristen Argenio
Client : Café Green

WHAT'S GREEN ABOUT THIS — Café Green is an organic vegan restaurant in Washington, DC. Building on the success of its award-winning sister café Java Green, Café Green will be a leader in promoting a peaceful community and eco-friendly living.

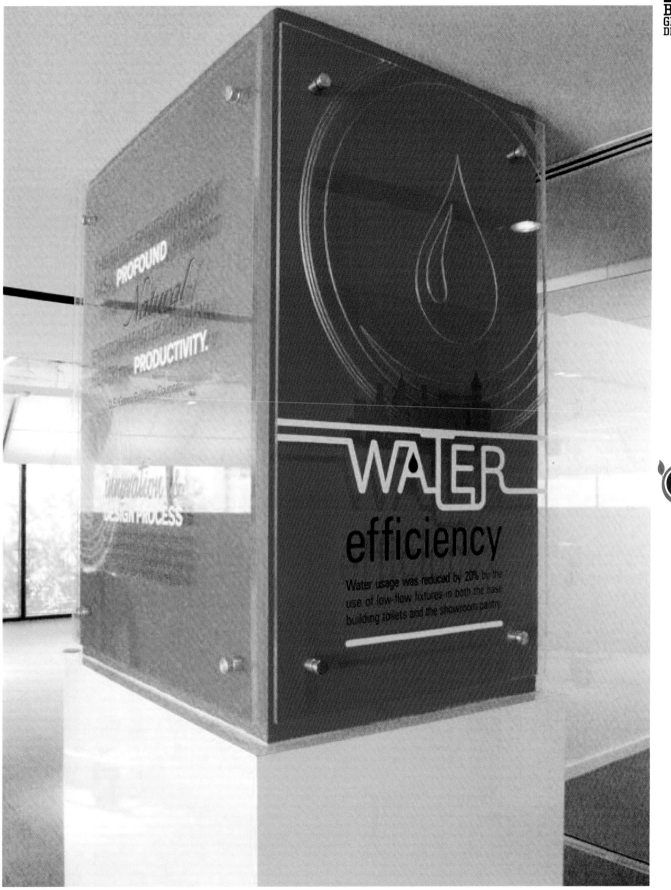

147

SKY DESIGN — ATLANTA, GEORGIA
Creatives : W. Todd Vaught, Jason Summers, LEED AP,
Masha Rastatourova
Client : Kimball Office

WHAT'S GREEN ABOUT THIS — The new Kimball showroom in Atlanta, GA was designed as a modern "blank canvas."
Modular panels allow for a constantly evolving space, and a LEED column showcases various attributes of the new showroom
that make up their commitment to the environment while contributing 1 credit to the LEED certification of the space.

perennial
is a promise of renewal

THE MORTON ARBORETUM PERENNIAL REPORT
www.mortonarb.org/perennialreport

Tree Hugger in Chief

As a strong and steadfast advocate for the importance of trees, Gerry Donnelly finds himself—and The Morton Arboretum—fulfilling a leadership role as our planet faces the effects of climate change in the twenty-first century.

This was not always the top-of-mind issue it has recently become. Now that climate change is on everyone's lips, the public's sense of urgency seems to grow with each new revelation about the precarious state of our natural environment. Gerry understands that "urgency" is not part of the natural language of trees, whose lives span generations, sometimes centuries. So he knows that any measures addressing the health and survival of trees must incorporate a very long-term approach. And the Arboretum's key initiatives, from woodland conservation to tree diversity, reflect that point of view. At the same time, we're working in the community every day addressing immediate tree concerns, inspiring individual action, and educating future stewards of the earth.

3

149

STUDIONORTH — CHICAGO, ILLINOIS
Creatives : Leah Shanholz, Julie DeNamur, Chris Cacci, Terry Jones
Client : Morton Arboretum

WHAT'S GREEN ABOUT THIS — The Morton Arboretum is an internationally recognized nonprofit organization dedicated to the planting and conservation of trees. Its 1,700 acres in Lisle, Illinois, hold collections of more than 4,000 kinds of trees, shrubs, and other plants from around the world. The Arboretum wanted to develop an alternative to their traditional printed annual report that would both support and showcase their role in promoting environmental stewardship. Since they've always been green—it's integral to their mission of creating a greener, healthier, more beautiful world—one of the Arboretum's objectives was to help their donor audience make that connection. StudioNorth created the Perennial Report, the first "hybrid" annual report. The printed Perennial Report Preview included a feature story and financial statement, along with a personalized notepad for each donor, all made from recycled materials certified by the Forest Stewardship Council (FSC). The companion website (perennialreport.mortonarb.org), utilizes a cutting-edge interactive interface with stories about the Arboretum's programs and people, video testimonials, and an easy-to-search list of donors and other supporters.

WHAT'S GREEN ABOUT THIS — In 2008, Guerrini Design Island won the competition to design the branding for Organic World Foundation (Bonn, Germany.) The brand was launched in Modena, Italy.

GUERRINI DESIGN ISLAND — BUENOS AIRES, ARGENTINA
Creatives : Sebastian Guerrini
Client : International Federation of Organic Movements

Our Nature is Organic

Organic World Foundation

IFOAM

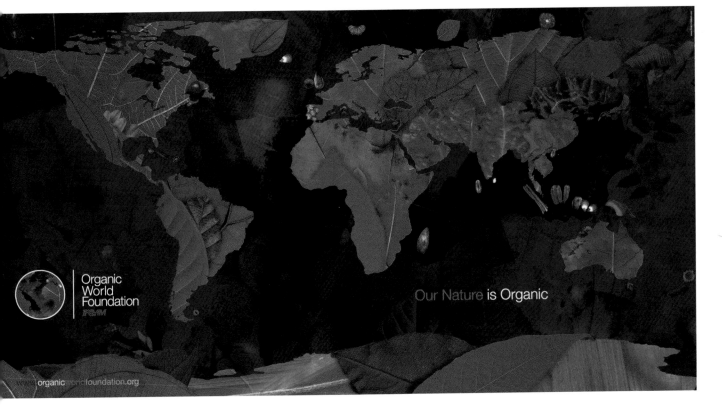

152

PAT HINKLEY CO-FOUNDER
PO BOX 22, ASHEVILLE, NC 28802 PH: 828.242.2578

WHAT'S GREEN ABOUT THIS — Winter Green is a non-profit organization focusing on sustainable food production during winter months through the use of hoop-house technology. The organization helps set up and maintain hoop-house food production for local schools, individuals, and various other groups.

828 DESIGN — ASHEVILLE, NORTH CAROLINA
Creatives : Chris Hunter
Client : Winter Green

153

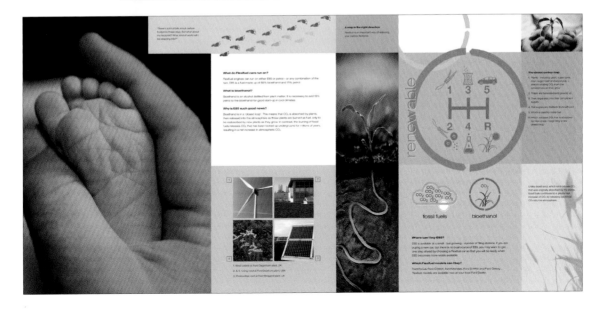

BURROWS — BRENTWOOD, ESSEX, UNITED KINGDOM
Creatives : Roydon Hearne, Phil Sutton, Steve Hallman, Mike Baker
Client : Ford Motor Company Limited

WHAT'S GREEN ABOUT THIS — Ford of Europe wanted a brochure that showcased their Flexifuel engine and Ford's commitment to the development of new technology in environmentally friendly products. Ford Flexifuel engines run on E85, a low-emissions fuel that's 85% bioethanol (an alcohol distilled from plant matter) and 15% petroleum.

WHAT'S GREEN ABOUT THIS — James Doherty, a zoological consultant, spends the year between two locations, so Citizen Studio created a versatile label system that is easily applied to any size paper, card, or envelope. The label stock by Tek Paper is 100% recycled PCW and FSC-certified.

CITIZEN STUDIO — ATLANTA, GEORGIA
Creatives : Linda Doherty, Chris Doherty
Client : James G. Doherty

154

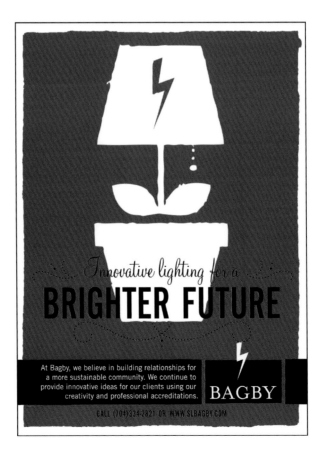

WHAT'S GREEN ABOUT THIS — Bagby Company designs commercial lighting projects with emphasis on green building, energy-efficient lighting solutions, and other sustainability-related growth.

A3 DESIGN — CHARLOTTE, NORTH CAROLINA
Creatives : Amanda Altman, Alan Altman, Reachal Giralico
Client : Bagby Lighting

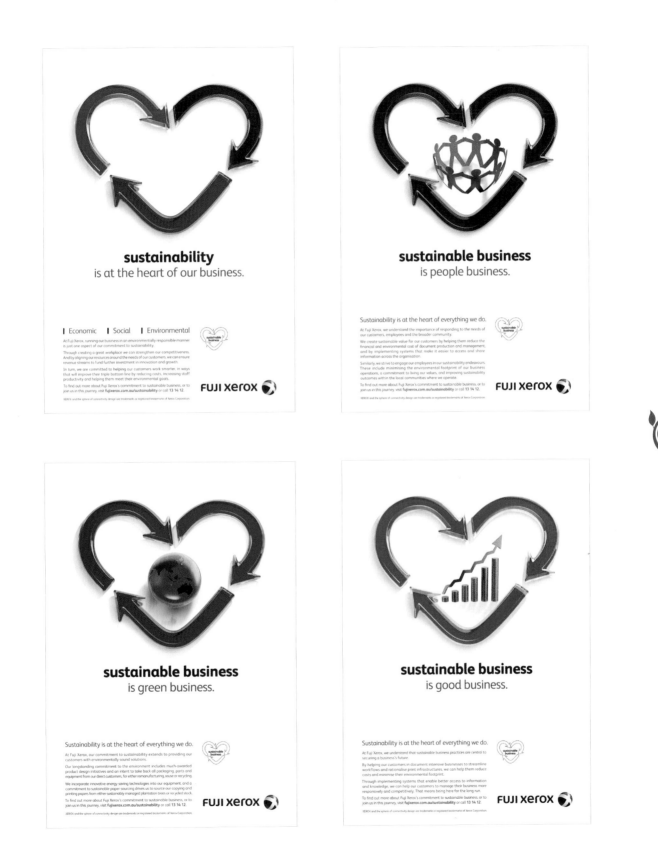

WHAT'S GREEN ABOUT THIS — To visually illustrate Fuji Xerox's commitment to sustainability, the designer developed a three-colored graphic of a heart with three curved arrows. Each color and arrow symbolizes a single element of sustainability, and together they illustrate the interdependent and ongoing nature of Fuji Xerox's commitment to economic, social, and environmental responsibility.

energy **savings** plus

WHAT'S GREEN ABOUT THIS — Energy Savings Plus provides energy audits and ratings of homes and small businesses. The company provides a detailed report on the sources of a building's energy losses and inefficiencies.

ENZO CREATIVE — SUMMIT, NEW JERSEY
Creatives : Lou Leonardis
Client : Energy Savings Plus

envivaSM

MATERIALS

156

WHAT'S GREEN ABOUT THIS — Identity for alternative recycling business which converts used tires into feedstock for alternative fuel producer. All materials were printed on 100% post-consumer waste recycled papers.

ALR DESIGN — RICHMOND, VIRGINIA
Creatives : Noah Scalin
Client : Enviva Materials

WINDROCK

ENERGY

WHAT'S GREEN ABOUT THIS — WindRock Energy LLC is a wind energy development company founded in early 2008 in Houston, Texas. The company develops utility-scale wind farms in the western United States that generate clean, renewable electricity and provide revenue to the landowners and jobs to the local communities. Their business card is printed on paper manufactured using 100% wind-generated electricity.

LEGACY DESIGN GROUP — HOCKLEY, TEXAS
Creatives : Eric Theriot
Client : WindRock Energy

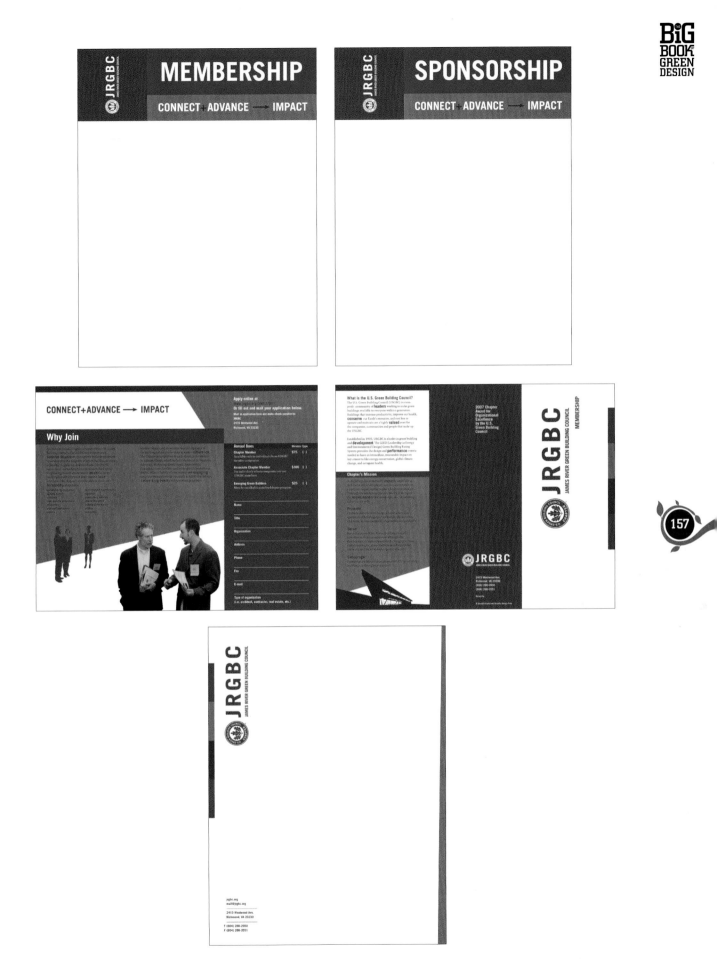

MEMBERSHIP

CONNECT + ADVANCE → IMPACT

SPONSORSHIP

CONNECT + ADVANCE → IMPACT

157

THINKHAUS, A SOCIALLY CONSCIOUS GRAPHIC DESIGN FIRM — RICHMOND, VIRGINIA

Creatives : John O'Neill
Client : The James River Green Building Council (JRGBC)

WHAT'S GREEN ABOUT THIS — The James River Green Building Council (JRGBC) is a Richmond-based nonprofit organization that promotes and educates about green activities and standards among the building and architecture community in the Central Region of Virginia.

158

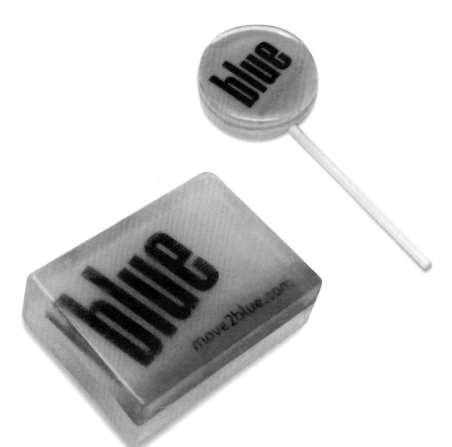

WHAT'S GREEN ABOUT THIS — Blue was Uptown Minneapolis's first LEED-certified apartment building. The entire campaign was nearly paperless: no direct mail; limited advertising; heavy PR; weekly placement on the *Blueprint for Green* syndicated TV series; online presence that provided all the content a typical direct-mail and print-collateral campaign delivers; promotional items that didn't add to landfills; and finally, an eco-friendly scavenger hunt across Uptown that awarded a year's free rent.

CARBON CREATIVE — MINNEAPOLIS, MINNESOTA
Creatives : Michele Harris, Cheryl Gordon
Client : Greco Development

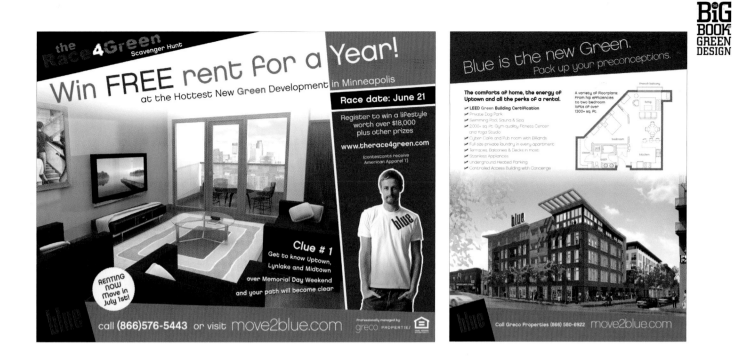

159

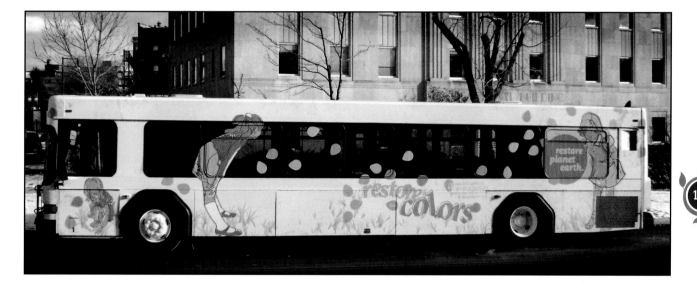

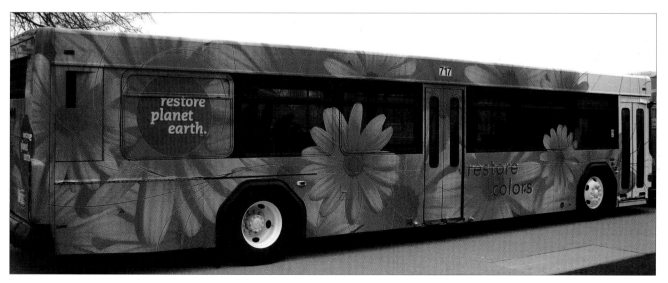

BOWLING GREEN STATE UNIVERSITY —
BOWLING GREEN, OHIO
Creatives : Amy Fidler, Mary Dawson, Garret Bodette,
Lindsy Harshe Buser, Michael Gump Jr., Ana Vasquez,
Corey Perez-Vergara, Zach Zollars
Client : Toledo Area Regional Transit Authority

WHAT'S GREEN ABOUT THIS— TARTA and the Arts Commission of Greater Toledo have partnered with representatives of Bowling Green State University to provide the opportunity for graphic designers to encourage the community's exposure and appreciation for the arts through the artistic enhancement of buses, bus shelters, and stops throughout TARTA's service area. The Art In TARTA bus wraps are graphic interpretations of poetry written by Toledo high school students, designed by Bowling Green State University graphic design students, and applied to Toledo Area Regional Transit Authority (TARTA) buses. The 2008 theme is Restore Planet Earth.

Down to earth.

Something just feels right
about being **closer** to the Earth.

Visit www.greenbank.com today
to learn how we can all get a little closer.

GREEN BANK
Save more than money.

Help the planet and get a great rate
with no fees when you choose Green.

4.00% APY Totally Green
Transaction Account™

• 4.00% Annual Percentage Yield
• No minimum balance requirement
• Use your Free Debit Card and
 Free Bill Pay for purchases and
 payments instead of writing checks
• Access your cash with NO Fees
 at any ATM
• Free Online Banking

5.00% APY Totally Green
Money Market™

• 5.00% Annual Percentage Yield
• Low opening deposit
• Free Online Banking
• Free Debit Card
• No fees at any ATM
• Requires Totally Green
 Transaction Account

Visit www.greenbank.com to learn more and apply online.

GREEN BANK
Save more than money.

* The Annual Percentage Yield (APY) is subject to change without notice and is based on monthly compounding of interest. The APY is current as of Oct. 1, 2007. Certain Restrictions Apply. Totally Green Transaction Account – A minimum balance of $25,000 is required to earn 4.00% APY. Accounts with balances less than $25,000 will earn 2.00% APY.Totally Green Money Market Account – A $5000 daily balance is required to avoid a $15.00 service charge each statement cycle. A minimum balance of $500,000 is required to earn 5.00% APY. Accounts with balances 1) $50,000- to 99,999 will earn 4.50% APY 2) $10,000- to 49,999 will earn 4.00% APY 3) $0 to $9,999 will earn 3.50% APY. Fees may reduce earnings. Transaction limits do apply.

Member FDIC

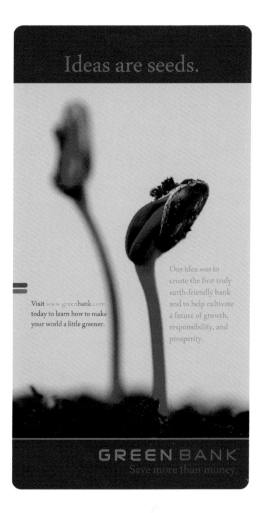

Ideas are seeds.

Our idea was to create the first truly earth-friendly bank and to help cultivate a future of growth, responsibility, and prosperity.

Visit www.greenbank.com today to learn how to make your world a little greener.

GREEN BANK
Save more than money.

163

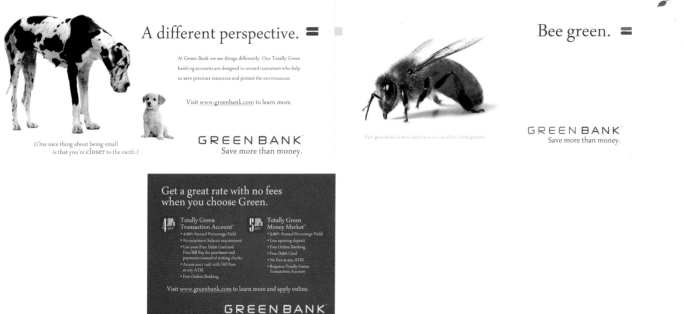

A different perspective. =

At Green Bank we see things differently. Our Totally Green banking accounts are designed to reward customers who help us save precious resources and protect the environment.

Visit www.greenbank.com to learn more.

GREEN BANK
Save more than money.

(One nice thing about being small is that you're closer to the earth.)

Bee green. =

Visit greenbank.com to learn how we can all be a little greener

GREEN BANK
Save more than money.

Get a great rate with no fees when you choose Green.

4.00% Totally Green Transaction Account
• 4.00% Annual Percentage Yield
• No minimum balance requirement
• Use your Free Debit Card and Free Bill Pay for purchases and payments instead of writing checks
• Access your cash with NO Fees at any ATM
• Free Online Banking

5.00% Totally Green Money Market
• 5.00% Annual Percentage Yield
• Low opening deposit
• Free Online Banking
• Free Debit Card
• No fees at any ATM
• Requires Totally Green Transaction Account

Visit www.greenbank.com to learn more and apply online.

GREEN BANK
Save more than money.

Member FDIC

| **PLUG MEDIA GROUP** — KINGWOOD, TEXAS
Creatives : Jeff Dietrich
Client : Green Bank

WHAT'S GREEN ABOUT THIS— Plug's new brand for Green Bank introduced a new concept in banking where customers are rewarded for being enviromentally responsible and helping to, literally, "save more than money." Everything changed. Ceramic mugs replaced styrofoam. Statements were online instead of mailed each month. Branches were rebuilt earning the highest LEED ratings possible. The CEO even traded his Lexus for a Prius. Sadly, the original campaign–titled "This is the last piece of junk mail you will ever receive from our bank"–was unceremoniously rejected by the business development guys. But at least they used soy inks and only the best recycled paper! Direct mailers used earth-friendly inks and premium recycled or renewable mixed sources.

WHAT'S GREEN ABOUT THIS — The Green Store came to Funk/Levis for a new identity for their retail store. The key word at the Green Store is "alternatives." Every item in the inventory is chosen for its potential to change the way customers live, or to lessen the environmental impact of a consumer-driven society.

FUNK/LEVIS & ASSOCIATES — EUGENE, OREGON
Creatives : Chris Berner, Claudia Villegas
Client : The Green Store

WHAT'S GREEN ABOUT THIS — Solar Communities is a solar panel manufacturer with an emphasis on solutions for apartment buildings, condominiums, and other medium-size building applications.

SABINGRAFIK, INC. — CARLSBAD, CALIFORNIA
Creatives : Mike Stivers, Vitro Robertson, Tracy Sabin
Client : Solar Communities

CHOATE
CHOATE HALL & STEWART LLP

WHAT'S GREEN ABOUT THIS — Choate Hall & Stewart launched a green campaign that has included recycling plastic and glass building-wide, switching to biodegradable paper goods and eco-friendly cleaning products, promoting double-sided printing and copying, and providing daily "green tips" to aid all employees in their efforts to "live a little greener." They recently held a special "Bring Your Mug to Work Day" and proudly report a 40% reduction in the firm's use of paper cups.

GREENFIELD/BELSER LTD. — WASHINGTON, D.C.
Creatives : Erika Ritzer, Tim Frost, Mark Ledgerwood, Burkey Belser
Client : Choate Hall & Stewart LLP

جائزة الاعلام البيئي

THE ROYAL SOCIETY FOR THE
CONSERVATION OF NATURE — AMMAN, JORDAN
Creatives : Shadi Alhroub
Client : RSCN, USAID and KIA AWARENESS Event

WHAT'S GREEN ABOUT THIS — The Royal Society for the Conservation of Nature aims to conserve the biodiversity of Jordan and integrate its conservation programs with socio-economic development, while promoting wider public support and action for the protection of the natural environment within Jordan and neighboring countries.

Green Star Group
environmentally beneficial products

165

BOUTIQUEGRAFICA — VIÑA DEL MAR, CHILE
Creatives : BG Team
Client : Green Star Group, Ltd.

WHAT'S GREEN ABOUT THIS — Green Star Group, Ltd. focuses on environmentally beneficial products across all cultures and geographies.

SMITH & DRESS LTD. — HUNTINGTON, NEW YORK
Creatives : Abby Dress, Frederick Dress
Client : National Environment Education & Training Foundation

WHAT'S GREEN ABOUT THIS — Chartered by the U.S. Congress in 1990, NEETF fosters environmental education (EE) to meet critical challenges in America. This private, nonprofit organization is dedicated to increasing public awareness of environmental issues. Abby Dress and Frederick Dress designed a logo to brand the first National Environmental Education Week.

We proudly feature in the restaurant, lounge and room service the cuisine of Chef Peter Davis from his Fresh & Honest Cookbook.

166

WHAT'S GREEN ABOUT THIS— Interstate Hotels & Resorts implemented a food and beverage initiative that works with local farmers and suppliers to utilize green and sustainable products whenever possible. Promotional items utilized recycled materials, paper produced from managed forests, and soy-based and water-soluble inks.

PATRICK HENRY CREATIVE PROMOTIONS, INC. —
STAFFORD, ALABAMA
Creatives : Jeremy Shulse, Holly Mcallister, Christy Sevier
Client : Interstate Hotels & Resorts

twointandem has gone green...and you?

TWOINTANDEM— NEW YORK
Creatives : Sanver Kanidinc, Elena Ruano Kanidinc
Client : Twointandem

WHAT'S GREEN ABOUT THIS— This is a self-promotional bookmark sent to introduce the green approach of the design firm Twointandem.

GET FRESH

MAKE A CONNECTION WITH YOUR LOCAL FARMER

Buy Local

VALDES DESIGN — SUMNER, MAINE
Creatives : Virginia Valdes
Client : Western Mountains Alliance

WHAT'S GREEN ABOUT THIS— The Eat Smart Eat Local initiative was founded in 2005 as a new sustainable agriculture program of Western Mountains Alliance (WMA). Eat Smart Eat Local strives to increase demand for local produce, thus encouraging local farmers to increase production. WMA provides technical assistance, workshops, and outreach to farmers to help them grow more, store more, extend the harvest, and market produce. Partnerships with schools, parents, health care practitioners, and the community work to incorporate more local foods into area schools, hospitals, and businesses. This design was the first part of a two-year traveling poster exhibit. Four designs were later repurposed as printed postcards and are sold online through WMA. All proceeds support sustainable agricultural projects.

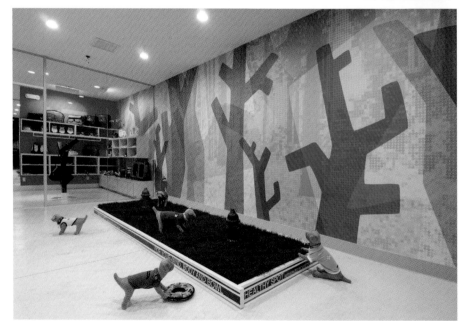

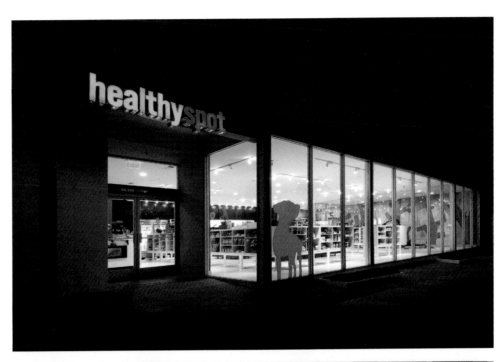

169

AKARSTUDIOS — SANTA MONICA, CALIFORNIA
Creatives : Sat Garg, Matt Lutz, Sean Morris
Client : HealthySpot

WHAT'S GREEN ABOUT THIS — Healthy Spot, located on Santa Monica, California's famous Wilshire Blvd, features specialty dog products and provides customers with an eco-friendly environment. The store breeds social awareness of compassion and canine education for the community. The entire wall around cash-wrap is recycled sharcote OSB.

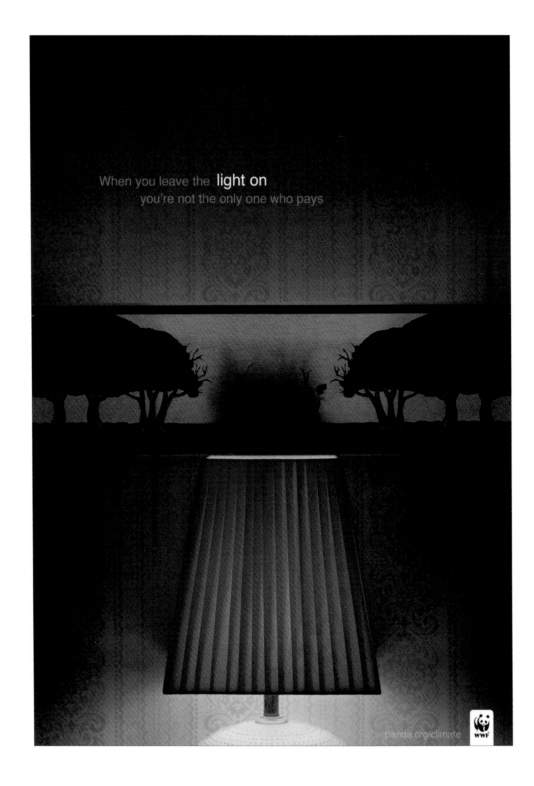

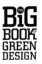

When you leave the **light on**
you're not the only one who pays

panda.org/climate

When you leave the **light on**
you're not the only one who pays

panda.org/climate

171

OGILVY GROUP — KYIV, UKRAINE
Creatives : Will Rust, Taras Dzendrovskii,
Sergey Kolos,Goran Tacevski
Client : WWF

WHAT'S GREEN ABOUT THIS — A press campaign to support the World Wildlife Fund's efforts to encourage energy conservation in the home, reducing the effects on climate change.

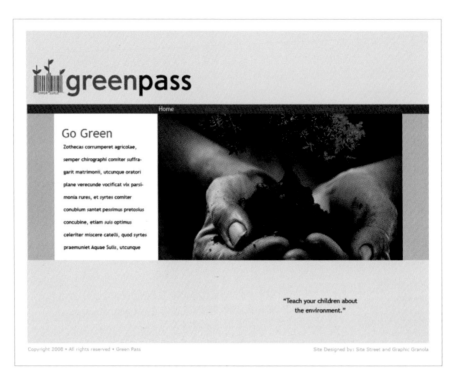

WHAT'S GREEN ABOUT THIS— This branding project included a logo, business card, and website developed for an online depository of receipts, promoting sustainability by eliminating paper receipts. Contents of the campaign include: logo, business card, email, newsletter and website.

GRAPHICGRANOLA — AUSTIN, TEXAS
Creatives : Kristin Bruno
Client : Green Pass

WHAT'S GREEN ABOUT THIS — Realizing their obligation to minimize their impact on the environment, LEROS Point to Point (a luxury transportation service) enlisted a sustainability consultant and Studio 22 to help them communicate their commitment to going green. The result was a brochure that they could provide to their clients that highlighted their actions toward sustainability, as well as an eco-friendly driving guide that was placed in each vehicle. All pieces were printed on 100% recycled/50% PCW stock with vegetable-based inks at environmentally-friendly printing companies.

STUDIO 22 — THURMONT, MARYLAND
Creatives : Eryn Willard, Jennifer Woofter
Client : LEROS Point to Point

JODESIGN LLC — FORT WORTH, TEXAS
Creatives : Jennifer Henderson, Robert George
Client : Botanical Research Institute of Texas

WHAT'S GREEN ABOUT THIS — BRIT, the Botanical Research Institute of Texas, wanted to follow their mission to conserve their natural heritage by deepening their knowledge of the plant world and achieving public understanding of the value plants bring to life. Several of their botanists are working and researching in the Andes and Amazon jungles to protect and preserve this endangered ecosystem. IRIDOS is the means by which they communicate their initiatives to friends and donors. In harmony with this initiative, BRIT is going green by printing only FSC-certified materials.

ZD STUDIOS — MADISON, WISCONSIN
Creatives : Mark Schmitz, Amy Bevler, Chris Moore,
Eric Dorgan, Kris Marconnet, Rasheid Atlas
Client : Marshall Erdman & Associates

WHAT'S GREEN ABOUT THIS — In line with the concepts and goals of Erdman Place and Marshall Erdman & Associates, incorporating sustainable design options into the office manufacture was a perfect fit. This firm specializes in design and construction for healthcare providers and believes strongly that green design yields benefits for both the environment and the healthcare organization. The program was recognized by The American Corporate Identity Awards as outstanding in the category of Sustainable Environmental Graphic Design. Some basic definitions of the design criteria are: All Items were fabricated within a 500-mile radius of installation; materials are rapidly renewable and /or biodegradable. Exhibit elements are 100% recycled and 25%-35% and 60%-70% Inherent Recycled Content Low-VOC / HAPS compliant. Glass products: Zero-VOC emission / 100% recyclable. Wallpapers are "Solvo Tex Cotton" 100% cotton/natual fiber/earth safe.

WHAT'S GREEN ABOUT THIS — An online site where green enthusiasts share ideas and suggestions about everything and anything dealing with the environment and sustainability.

NENAD DICKOV — NOVI SAD, SERBIA
Creatives : Nenad Dickov
Client : Greentelligence

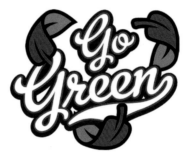

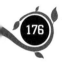

WHAT'S GREEN ABOUT THIS — Go Green is an intiative of the Sacred Heart Cathedral Preparatory School calling students and staff to be conscious of their paper consumption and to foster overall awareness of the environment. Rendered to capture students' attention, the "Go Green" tag line exudes a school-spirit enthusiasm for environmentalism that links with the school's "Fightin' Irish" heritage.

MINE™ — SAN FRANCISCO, CALIFORNIA
Creatives : Christopher Simmons, Tim Belonax
Client : Sacred Heart Cathedral Preparatory School

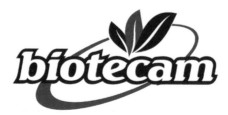

WHAT'S GREEN ABOUT THIS — Biotecam is an organic agriculture supply store located in Michoacán, Mexico. The name Biotecam comes from *bio tecnologia para el campo*.

KENNETH DISEÑO — URUAPAN, MICHOACAN, MEXICO
Creatives : Kenneth Treviño
Client : Biotecam

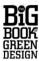

MAD DOG GRAPHX — ANCHORAGE, ALASKA
Creatives : Michael Ardaiz
Client : University of Alaska
Anchorage Sustainability Council

WHAT'S GREEN ABOUT THIS — The University of Alaska Anchorage needed a unifying mark to identify the programs and efforts of its Sustainability Council both on- and off-campus to students, faculty, and the community. The Council encourages taking social, economic, and environmental measures to meet current needs without compromising the ability of future generations to meet their own needs. Symbols of balance, growth, renewal, and stewardship are incorporated in the new logo.

VISIONARY+FLOCK — CALIFORNIA
Creatives : Menachem Krinsky
Client : EarthenCare

WHAT'S GREEN ABOUT THIS — EarthenCare produces and sells bio-degradable shopping bags and bottles.

GREEN EMPLOYER COUNCIL

ADDIS CRESON — BERKELEY, CALIFORNIA
Creatives : Traci Clark, Mily Nguyen
Client : Green Employer Council

WHAT'S GREEN ABOUT THIS — For the sustainable and social justice communities, the Green Employer Council is an alliance of engaged green businesses who advise and connect people who need work the most— underserved communities—with the work that most needs to be done in the sustainability movement.

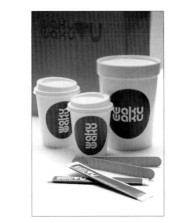

178

WHAT'S GREEN ABOUT THIS — A new fast-food restaurant aimed to provide high-quality and healthy food while respecting the environment. Located in Hamburg, Germany, Waku Waku's kitchen concept is based on foodservice solutions that can ensure best-in-class performances, low heat dispersion, and savings in terms of energy, water, and detergent.

IPPOLITO FLEITZ GROUP GMBH — STUTTGART, GERMANY
Creatives : Peter Ippolito, Gunter Fleitz
Client : Waku Waku

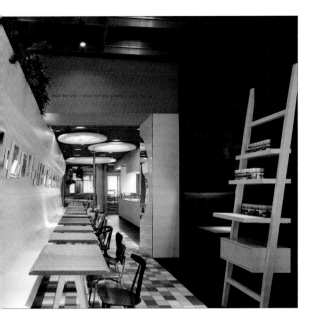
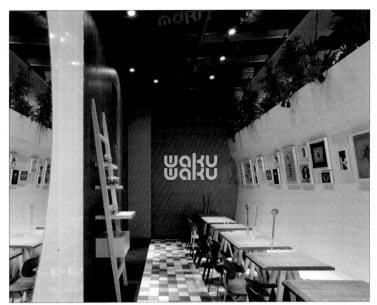

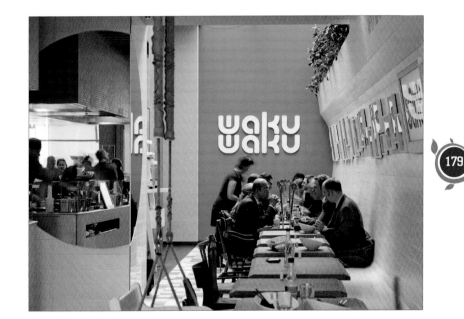

pyxsis

180

WHAT'S GREEN ABOUT THIS — Traditional outlets generate an over-abundance of power. This prototype device limits the amount of electricity generated by each outlet according to the requirements of the device that is currently plugged into it. It also works as a power adapter, offering six different plugs.

TOMODESIGNS — NEW YORK, NEW YORK
Creatives : Thomas Moon, David Ung
Client : Tomodesigns

Welcome to Green Home Contractors!

Our award-winning landscaping and home and business remodels are not only beautiful to the eye, but more importantly, provide healthy living conditions while helping to minimize environmental impact.

As a green-conscious company, we do our part to recycle unused materials from each project and will assist you in making informed eco-sensitive decisions that can save you money.

We hope our portfolio will inspire you.

181

NETRA NEI — SEATTLE, WASHINGTON
Creatives : Netra Nei, Mik Nei
Client : Green Home Contractors

WHAT'S GREEN ABOUT THIS — Green Home Contractors focuses on the use of environmentally conscious products and the re-use of existing materials.

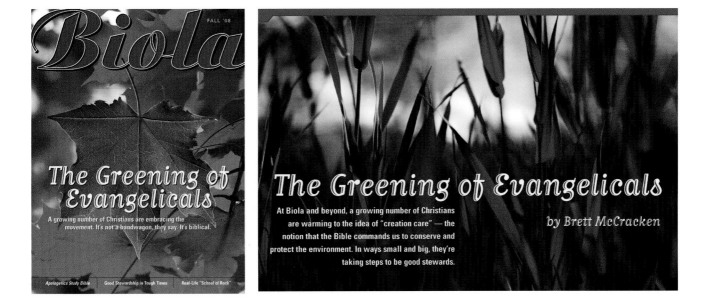

SAINT DWAYNE DESIGN — CHARLOTTE, NORTH CAROLINA
Creatives : Dwayne Cogdill, Jason Newell, Brett McCracken
Client : Biola University

WHAT'S GREEN ABOUT THIS — This issue of Biola University's magazine focuses on the growing movement among evangelical Christians to be actively involved in environmental issues. The article discusses religious programs with an emphasis on "creation care" and contains a list of institutes and links for involvement.

183

ALR DESIGN — RICHMOND, VIRGINIA
Creatives : Richard Lord
Client : Ellwood Thompson's Local Market

WHAT'S GREEN ABOUT THIS — Store sign system promoting the local farmers which supply this health food grocery store. The goal was to produce signage that was environmentally friendly while using local materials and manufacturers. All signs were printed directly on FSC-certified Purebond formaldehyde-free plywood using a low-toxic emission UV printer and coated with a water-based varnish.

WHAT'S GREEN ABOUT THIS — The Green Education Design Showcase features instructional, administrative, and service facilities for public, private, and parochial schools of all levels, up to and including technical, two-year, and four-year colleges and universities. The Green Education Design Showcase is a vehicle for sharing innovative yet practical solutions in planning, design, and construction to achieve the best possible learning environments for all students at all levels of education.

LITTLEDOGDESIGN — DAYTON, OHIO
Creatives : Matt Cole
Client : College Planning & Management

184

WHAT'S GREEN ABOUT THIS — Cepa (Center for Ecology and Alternative Projects) is a nonprofit organization that aims to control waste and promote the subsequent reuse of waste materials. This is their new corporate identity.

TOORMIX — BARCELONA, SPAIN
Creatives : Oriol Armengou, Ferran Mitjans
Client : Cepa (Center for Ecology and Alternative Projects)

WHAT'S GREEN ABOUT THIS — Sustainable Building Insulation uses a non-toxic insulation that is fireproof and double the energy efficiency of normal building insulation, yet it is a 100% green product.

AINSWORTH STUDIO.COM — TACOMA, WASHINGTON
Creatives : Josh Read, Gabe Beahler, Ben Carlson
Client : Sustainable Building Insulation

BILL ATKINS DESIGN & ILLUSTRATION —
LAGUNA BEACH, CALIFORNIA
Creatives : Bill Atkins
Client : Friends of Harbors Beaches and Parks

WHAT'S GREEN ABOUT THIS — Created for a new public park in Orange County, California, this logo emphasizes an "ecological staircase" of existing habitats.

SABRAH MAPLE DESIGN — JACKSONVILLE, OREGON
Creatives : Sabrah Maple, Kathleen Sanchez
Client : renú: a hair salon

WHAT'S GREEN ABOUT THIS — The client wanted a logo that represented not only her business and industry but also her commitment to sustainability, both in business and in life. The imagery shows one leaf as an accent mark, symbolizing the shedding of the old to support the new: renú.

URBAN INFLUENCE — SEATTLE, WASHINGTON
Creatives : Michael Mates, Jonathan Obrien, Peter Wright
Client : Ecohaus

WHAT'S GREEN ABOUT THIS — ecoHAUS is a Seattle-based, eco-friendly building supply company specializing in products made with renewable resources and sustainable manufacturing practices.

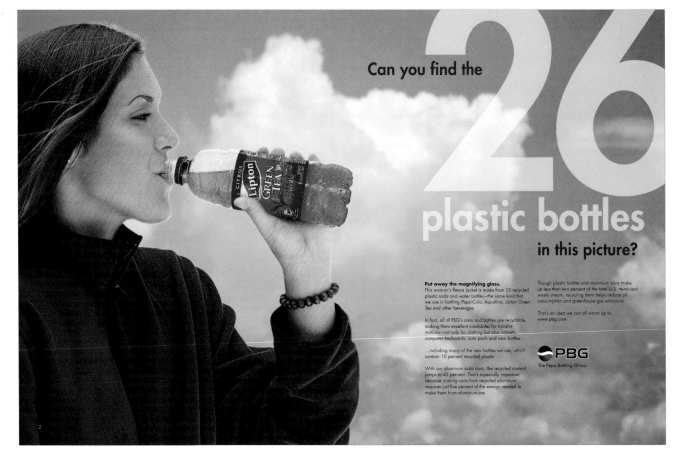

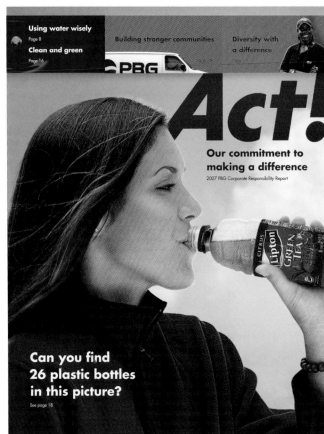

WHAT'S GREEN ABOUT THIS — In this corporate responsiblity report, Pepsi offers numerous examples of how the company's procedures are increasingly earth-friendly. The booklet itself is printed on 100% post-consumer recycled paper which is certified by Green Seal. The electricity used to manufacture the paper is matched 100% with credits from Green-e certified windpower projects.

BRANDLOGIC — WILTON, CONNECTICUT
Creatives : Wynn Medinger, Randell Holder, Brad Elliott
Client : Paula Davis, Pepsi Bottling Company

Today, people want to know more about the companies they buy from, work for and invest in. They want to know more about *how* a company operates—how it treats its employees, how it lives up to its environmental responsibilities and how it gives back to its communities.

The Pepsi Bottling Group

welcomes the chance to talk about sustainability because we have a great story to tell. And so we're delighted to be publishing our first Corporate Responsibility Report, primarily focusing on the U.S., and highlighting some of the ways that we're working to fulfill our obligations to the environment, our communities and each other.

For PBG, our path to the future guides us according to the highest business, social and environmental values. Our approach to sustainability encompasses:

• Innovating and implementing sound environmental practices

• Ensuring the long-term well-being of our employees in all aspects of their lives

• Giving back to the communities where we live, work and market our products

Add to these commitments the strengths of PBG products, people and partnerships, and you have a formula not just for success but also for *renewable and continually renewed* success. These are essential ingredients for a very bright future indeed.

PBG www.pbg.com

Recycle it!

Beverage containers like the ones PBG uses are the most recycled consumer packaging in the U.S. But those billions of bottles and cans don't find their own way into recycling bins. See how long it takes you to get this bottle through the maze and into the collection bin.

Answer key on page 48

PBG environmental responsibility word search

PBG people are working in many ways to protect the environment. How many words relating to those efforts can you find in this puzzle?

```
S Y M G X Z L E R P X I A E F R L R
W U D U N C C I L M T T N L G E I S
A E S T N I O S P A W E I C R T F K
T N P T V I S M O T N K F Y E A E C
E D D R A A M N M V O R A C E W W U
R W E Q L I F U I U C N U E N N A R
B S F G J D N R L R N S Q R H A T T
E N E R G Y O A D A R I A H O E E U
R E S P O N S I B I L I T Y U L R L
R L X J M A M U N I C S A Y S C P A
Z C L E A N A I R A L C W L E F R N
A E N E C U D E R I C I I Q G Z O D
A T E F F I C I E N C Y T T A R P F
W E D N I A T N U O M W R Y S U E I
S E L T T O B P E P S I S E R A L L
P O J G L E D G U O C O N I U K L L
J S E V R N Y K L C B I F V U S F P
G N I G A K C A P E B Y T C A C E I
```

ACT
AIRRINSING
ALUMINUM
AMP
AQUAFINA
BIN
BOTTLES
CAN
CLEANAIR
CLEANWATER
COMMUNITY
EFFICIENCY
ENERGY
ENVIRONMENT
GLASS
GREENHOUSEGAS
LANDFILL
LIFEWATER
LIPTON
MOUNTAINDEW
PACKAGING
PEPSI
PLASTIC
PROPEL
PURIFY
RECYCLE
REDUCE
RESPONSIBILITY
REUSE
SERVICE
SOBE
SUSTAINABILITY
TRUCKS
WATER

Green Fun

2 3

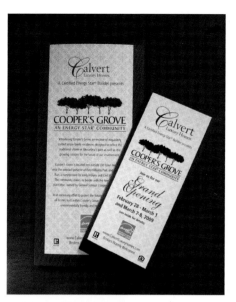

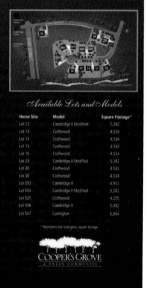

WHAT'S GREEN ABOUT THIS — Calvert Luxury Homes is one of only a few certified Energy Star builders in the Northern Virginia area. The brochure explains what it means to be green, how Calvert intends to carry out their energy-efficient efforts, and educates the consumer about the community. The brochure was printed on 100% recycled FSC-certified paper.

SIMPATICO DESIGN STUDIO — ALEXANDRIA, VIRGINIA
Creatives : Amy Simpson
Client : Calvert Luxury Homes

JULIA REICH DESIGN— SCIPIO CENTER, NEW YORK
Creatives : Julia Reich, Patrick Moroney
Client : Council on the Environment of New York City

WHAT'S GREEN ABOUT THIS— CENYC is the city agency in charge of the famous Union Square Greenmarket in New York City, along with many other environmental initiatives such as the Office of Recycling, environmental education, greening neighborhoods, and farmer training. This 24-page annual report was printed by Brooklyn, New York-based environmental printer Rolling Press, on New Leaf paper (100% recycled, 50% post-consumer waste paper; process chlorine free; Ancient forest-friendly, Green-e certified), using soy inks.

189

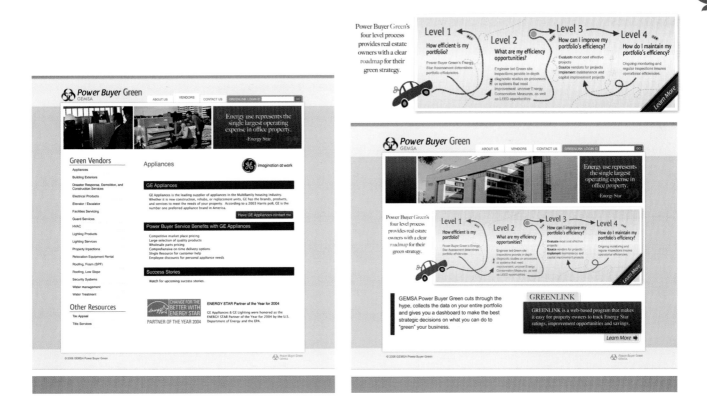

CAMP CREATIVE GROUP — BLUE RIDGE SUMMIT, PENNSYLVANIA
Creatives : Sara Camp
Client : GEMSA PowerBuyer through Hyphen Media Group

WHAT'S GREEN ABOUT THIS — The Power Buyer Green program performs Energy Star assessments on office buildings. If the Energy Star rating is low, they bring an engineer out to assess the property. Their vendors then help the owners/operators of the properties improve and maintain a higher rating.

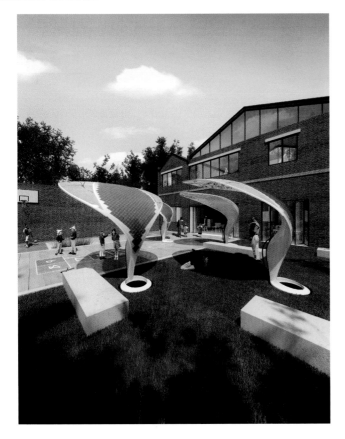

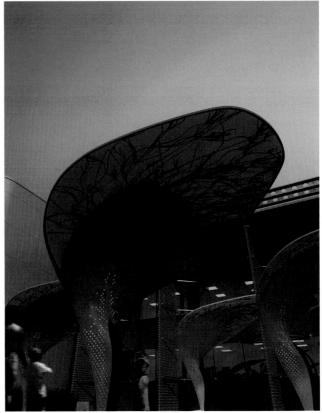

190

Solar Shade Material

A thin and flexible tensioned solar shade material creates a large translucent shade space.

Photovoltaic Array

An array of PV cells covers the face of the shade structure. The panel would be created as a custom array.

Solar tracking

To obtain the best orientation for solar power generation and playground shading, the unit pivots through 180° around the footing.

WHAT'S GREEN ABOUT THIS — Büro North was engaged by the Victorian Eco-Innovation Lab (VEIL) to help develop solar collecting shade umbrellas for installation on school grounds to help students make a visual connection between energy collection and consumption. The solar shade was designed to expose and exhibit the technology of solar light harvesting whilst providing a protective shade covering for students from the harsh Australian sun. The design informs students about the collection of electricity and how the quantity of energy harvested directly relates to the world around them and actively involves the students in the collection of electricity. As the sun moves throughout the day, the students must move the solar shade to catch more electricity and provide more shade. Markings around the circular base indicate the best direction for shade in the morning and afternoon. The underside of the shade features a dynamic visual feedback system to instantaneously indicate the quantity of energy currently being collected from the solar panels. Correct solar orientation will generate a positive visual message (LEDs glow green); incorrect orientation will indicate the low amount of power collection (LEDs glow red).

BÜRO NORTH — MELBOURNE, AUSTRALIA
Creatives : Soren Luckins, Tom Allnutt, Sarah Napier, Kathleen Turner
Client : Büro North

toto*logy*

SAVE 14,400 BATTERIES

The typical lifespan of a sensor faucet or flush valve battery in a commercial restroom is two years. But what if you didn't have to replace the battery for the entire 15-year lifespan of the restroom?

The answer lies in TOTO EcoPower® faucets and flush valves. Dedicated to their commitment to water conservation and knowledge of water as a power source, TOTO engineers developed EcoPower faucets and flush valves to utilize the incoming water flow to power its sensors. This means low maintenance and operating cost — and a better solution for the environment. Simply put, with no routine battery replacement, the benefits are substantial.

At TOTO, we believe in the intelligent use of water. It's all part of totology, which lies at the heart of everything we do to help create a more sustainable planet.

Learn more at www.whytotology.com

toto*logy*

TOTO

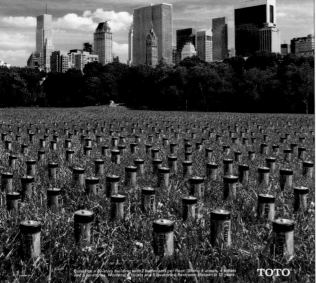

SAVE 24,665 GALLONS

If a household replaced its old toilets with TOTO® 1.28 gallon per flush High Efficiency Toilets (HETs), it would save 24,665 gallons of water a year.* That's a lot of water and a giant step forward in conserving one of our most precious natural resources. Other High Efficiency Toilets can sacrifice performance in an effort to save water, meaning that you have to flush more than once to get the job done—that's hardly efficient.

At TOTO, our engineers have perfected the art of the "single flush"—using less water with no compromise. Our advanced water technologies, responsible manufacturing processes and life enhancing products are our lasting contribution to a more sustainable planet.

We call this totology. It's our approach to everything we do. Learn more at whytotology.com

toto*logy*

TOTO

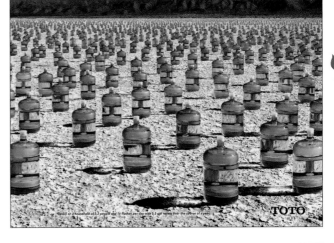

191

SKAGGS — ALABAMA
Creatives : Bradley Skaggs, Samantha Edwards,
Jonina Skaggs, Joseph Guzman
Client : TOTO

WHAT'S GREEN ABOUT THIS — TOTO's new branding and campaign reinforce their eco-initiatives and promote their high-efficiency toilets and faucets.

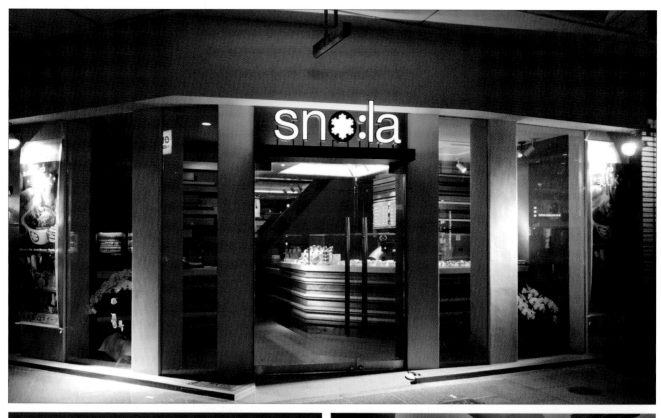

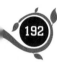
192

WHAT'S GREEN ABOUT THIS — Constructed almost entirely from recycled and natural materials, the Sno:la store uses biodegradable and compostable bagasse cups, which are made from cane fiber, for the yogurt containers. They also use biodegradable and compostable glasses (made from corn) and spoons (made from potato). Recycled woods were used for the wall decoration, counter and bench. Soy-stain was used for the wall decoration and concrete floor. Recycled computer chips created the counter top and recycled saw dust created the menu board. All drinks are served in glass bottles.

AKARSTUDIOS — SANTA MONICA, CALIFORNIA
Creatives : Sat Garg, Matt Lutz, Chris Jones, Sean Morris, Allie Piehn, Chris Jones
Client : Sno:la

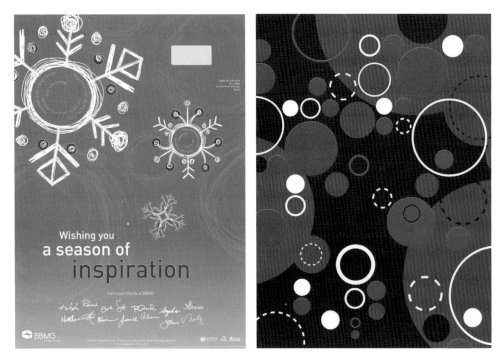

WHAT'S GREEN ABOUT THIS– BBMG wanted to created a card that embodied the holiday spirit while taking environmental concerns into account. The front displays personal notes of inspiration from the BBMG team, and the back displays custom artwork, giving the poster a second life as wrapping paper for holiday gifts. Eco-printer is FSC-certified and powered by renewable energy. Paper is 100% recycled, 100% post-consumer waste, FSC-certified, and printed with soy inks.

BBMG – NEW YORK, NEW YORK
Creatives : Scott Ketchum, Molly Conley
Client : BBMG

194

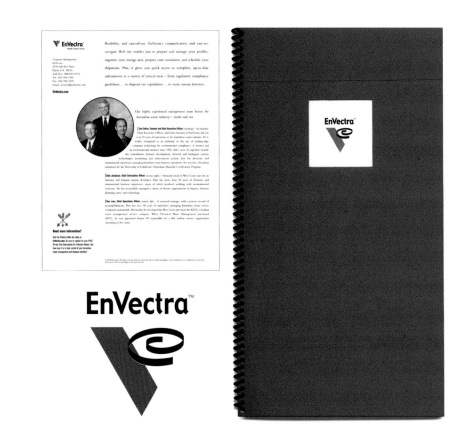

WHAT'S GREEN ABOUT THIS – Since 1987, Social Venture Network has promoted the triple bottom line, helping businesses do good by people, planet, and profit. As it approached its 20th anniversary, the organization wanted to raise awareness of its work to boost membership and meet new market opportunities. A commemorative booklet, "20 Ideas that Changed the Way the World Does Business," explains how select pioneering business leaders turn their values into action. Also, a new B2B print brochure helped increase Social Venture Network's membership 15% and continues to contribute to the fact that their conferences sell out in advance. Both brochures are printed on 100% recycled (50% PCW) stock with soy inks. The eco-printer is FSC-certified and is powered by renewable energy.

KOLLAR DESIGN | ECOCREATIVE® –
SAN FRANCISCO, CALIFORNIA
Creatives : Candice Kollar, Shannon Armstrong, Richard Levitt
Client : Clennon Associates for EnVectra

IMAGINE — MANCHESTER, UNITED KINGDOM
Creatives : David Caunce, Mike Swift, Manchester Creative
Client : DB Refurb

WHAT'S GREEN ABOUT THIS — DB Refurb specialize in refurbishing new and existing office spaces. They are committed to environmental sustainability and to creating new interiors without increasing the client's carbon footprint. Very little of what they remove from buildings goes into landfills. They work only in Manchester, thus limiting their own vehicle emissions. On completion, they issue a certificate showing the carbon emissions of the office rehab.

worldeka

worldeka

worldeka

worldeka

worldeka

worldeka

worldeka

worldeka

worldeka

worldeka

worldeka

worldeka

196

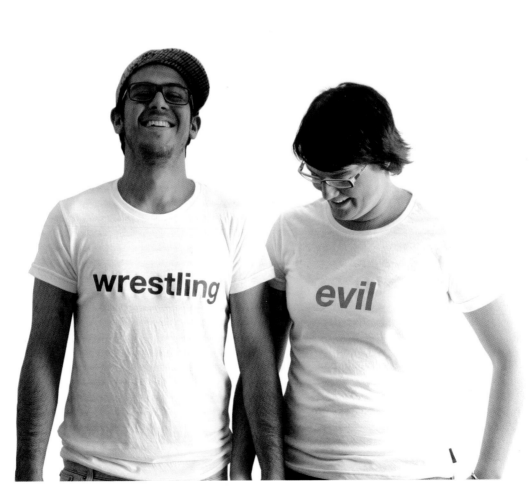

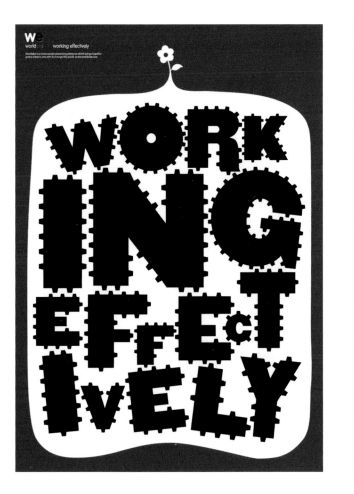

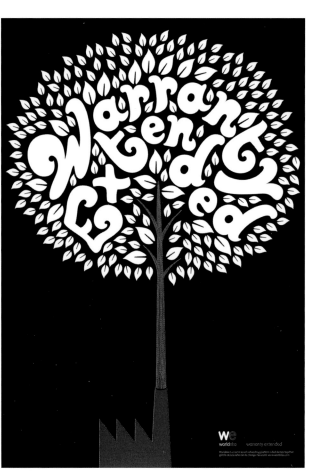

197

LANDOR ASSOCIATES — SYDNEY, AUSTRALIA
Creatives : Mike Staniford, Jason Little, Joao Peres, Serhat Ferhat
Client : Worldeka

WHAT'S GREEN ABOUT THIS — Worldeka, meaning "one world" in Sanskrit, is a niche social-networking platform which brings together global citizens who aim to change the world. The shortening of Worldeka to WE as a logo represents the collaborative nature of the brand.

WHAT'S GREEN ABOUT THIS — Eden Organix says that women put five pounds of chemicals from beauty products on their skin each year. They have a passion for sharing the power of organic skin and beauty products to heal and rejuvenate.

3RD EDGE COMMUNICATIONS — JERSEY CITY, NEW JERSEY
Creatives : Frankie Gonzalez, Nick Schmitz, Rob Monroe, Valerie Mason-Robinson
Client : Eden Organix

198

WHAT'S GREEN ABOUT THIS — This is an advertisement for an electric-powered car that shows how electricity can power this vehicle more efficiently than gasoline, diesel or any other form of energy.

CREATIVE CONCEPTS — ALABAMA
Creatives : Courtney Cordaro
Client : Chevrolet

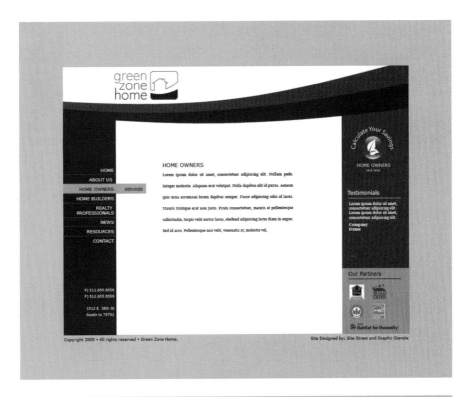

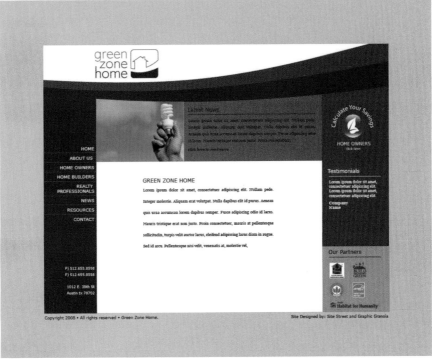

GRAPHICGRANOLA — AUSTIN, TEXAS
Creatives : Kelly Blanscet
Client : Green Home Zone

WHAT'S GREEN ABOUT THIS — Green Zone Home is a professional consulting agency that specializes in energy efficiency, green building, and conservation for residential structures.

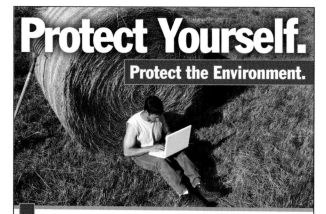

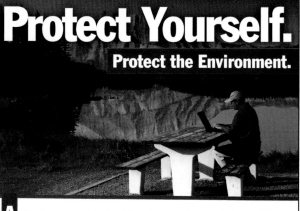

Protect Yourself.
Protect the Environment.

t Navigator Security Shredding, Inc., we destroy all types of data-carrying media and components in a secure environment — guaranteed in writing. No opportunity for your data to fall into the wrong hands. No landfill pollution. Only the peace-of-mind that comes from knowing you've made the best choice in protecting your data and the environment.

You get a secure environment. We get a cleaner one.

www.NavigatorShredding.com
NAVIGATOR SECURITY SHREDDING, INC.
PO Box 175 • Skaneateles Falls, NY 13153 • 315-663-5517

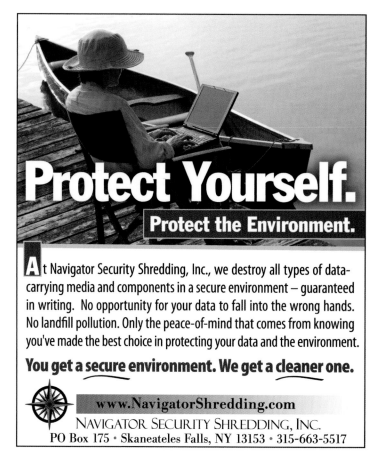

Protect Yourself.
Protect the Environment.

At Navigator Security Shredding, Inc., we destroy all types of data-carrying media and components in a secure environment — guaranteed in writing. No opportunity for your data to fall into the wrong hands. No landfill pollution. Only the peace-of-mind that comes from knowing you've made the best choice in protecting your data and the environment.

You get a secure environment. We get a cleaner one.

www.NavigatorShredding.com
NAVIGATOR SECURITY SHREDDING, INC.
PO Box 175 • Skaneateles Falls, NY 13153 • 315-663-5517

200

WHAT'S GREEN ABOUT THIS — Navigator Security Shredding, Inc. is a computer and electronic recycling service providing information resource destruction while preserving the environment through socially responsible, professional, and ethical means.

HIHO DESIGN — RIO RANCHO, NEW MEXICO
Creatives : Heidi Ames,
Joanna Jankowski, President and CEO,
Navigator Security Shredding, Inc.
Client : Navigator Security Shredding, Inc.

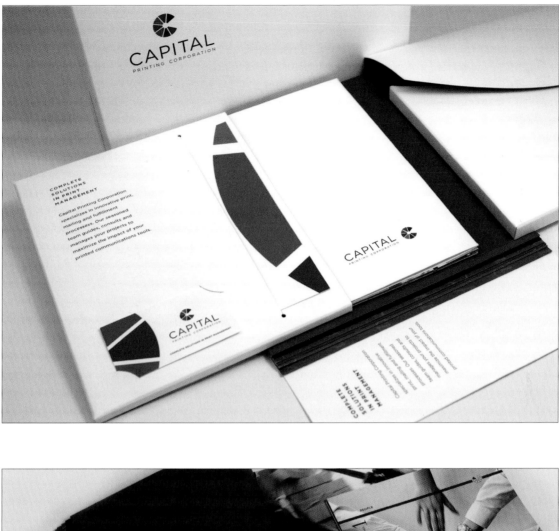

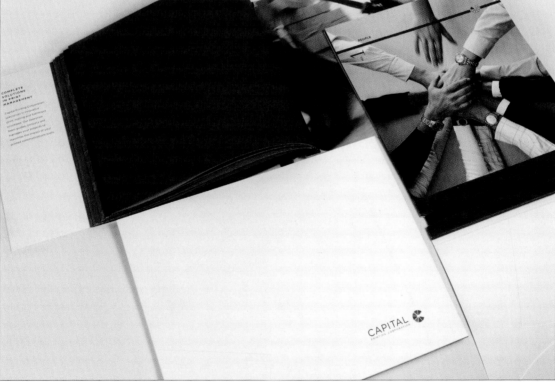

RIZCO DESIGN — MANASQUAN, NEW JERSEY
Creatives : Keith Rizzi, Lauren Sarnecky
Client : Capital Printing Corporation

WHAT'S GREEN ABOUT THIS — Capital Printing Corporation needed a marketing piece to announce that a portion of their plant had been converted over to green power and that they were now FSC- and SFI-certified. Rizco Design made sustainable design choices throughout the process, including minimizing resources, choosing FSC-certified paper stocks, and turning to vendors who utilize wind power. Lamination and UV coatings were replaced with environmentally friendly aqueous coatings and Mohawk Options FSC-certified, wind-powered, uncoated text- and cover-weight papers. Printing was done in gang runs, and reusable and recyclable dies were used for the embossing. Last, multi-process bindery that included recyclable dyes and water-based glues ensured that the end product would be recyclable.

024 print report

COLD FOILING

Some people get excited by a new Tarantino film. Some people get excited by seeing Leonard Cohen live. Some people get excited by seeing Chris Judd evade three opponents and kick for goal. The Fluoro team are designers and we're pretty excited by cold foiling.

"What's cold foiling?" I hear you ask. So here's the answer. Cold foiling is a new print process that we were fortunate enough to observe recently. It adds colour to foil and has huge upsides for people in the design world. The way of how promotional pieces can be enhanced.

you think you've heard something about this before, you're right. Back in Fluoro strated the result of a g process. Hot ative of cold fol s spectacula s. Cold foil t foil star ress pro ng is

HOUSEMOUSE™ — MELBOURNE, AUSTRALIA
Creatives : housemouse™
Client : housemouse™

WHAT'S GREEN ABOUT THIS — Named after the housemouse brand color "Fluoro Magenta," Fluoro magazine was developed by the housemouse team. It focuses on environmental sustainability within the graphic design and print industries and is always printed using eco-friendly processes on leading paper stocks.

WHAT'S GREEN ABOUT THIS — H GenCorp brings hydrogen-based alternative energy technologies to the commercial marketplace. They develop practical, real-world applications for scientific discoveries and identify and nurture laboratory breakthroughs in the field of hydrogen-based alternative energy solutions.

THE BETTER IMAGE COMPANY — SARASOTA, FLORIDA
Creatives : Charles Bird, Bennie Barton, Caroline Mendez, Laura Leeming
Client : H GenCorp

WHAT'S GREEN ABOUT THIS — Xtreme Green Products is an eco-vehicle company designing and building revolutionary, electric-powered land vehicles and personal watercraft.

BOUTIQUEGRAFICA — VIÑA DEL MAR, CHILE
Creatives : BG Team
Client : extremegreen

WHAT'S GREEN ABOUT THIS — An online shop that specializes in eco-friendly cleaning supplies and products.

ECOLOGIC DESIGN, LLC — MOUNTAIN LAKES, ALABAMA
Creatives : Marnie Vyff
Client : Fresh & Green

Sertifi

DIVER LOGO DESIGNS — SAINT-PETERSBURG, RUSSIAN FEDERATION
Creatives : Yury Akulin
Client : Sertifi

WHAT'S GREEN ABOUT THIS — Sertifi provides the leading On-Demand Electronic Signature Service enabling organizations to quickly deliver and execute business documents and contracts online. They wanted to communicate that the process of sending, signing and retrieving contracts and documents online is paperless and environmentally friendly

205

LIQUIDFLY DESIGNS — CARROLLTON, TEXAS
Creatives : Mariah Rushing
Client : EcoFencePanels.com

WHAT'S GREEN ABOUT THIS — EcoFencePanels.com is a creative new company with an innovative wood fence system which recycles cedar from post-consumer and/or post-industrial materials.

CHRIMMONS — BROOKLYN, NEW YORK
Creatives : Chris Ammons
Client : Ennovative Homes

WHAT'S GREEN ABOUT THIS — Ennovative Homes is a green home building company in Lethbridge, Alberta, Canada.

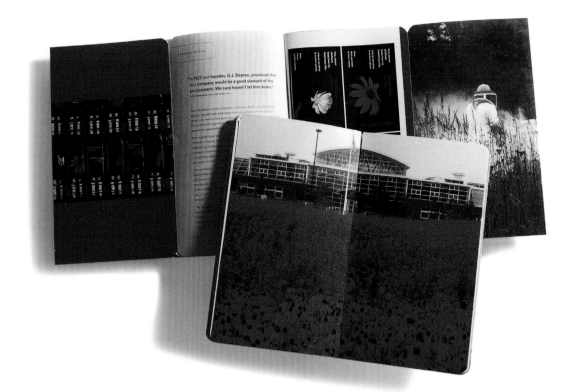

206

WHAT'S GREEN ABOUT THIS — Strathmore was introducing their newly reformulated Strathmore Writing and Script lines of responsibly-made paper for stationery systems and corporate communications. They needed a promotional paper sample. Willoughby saw an opportunity to inspire a deeper dialogue with designers about getting involved and leading initiatives at work, at home, and in communities across the country. Strathmore embraced the vision. The Strathmore Sustainability Portfolio features stories about six companies that are pioneers in environmental and social stewardship. For each of them, sustainability is a core philosophical value that permeates their company, culture and identity. The portfolio showcases the paper line as intended but, more importantly, it inspires the designers who read it to rethink design for the world around us.

WILLOUGHBY DESIGN — KANSAS CITY, MISSOURI
Creatives : Ann Willoughby, Deg Tagtalianidis, Janette Crawford, Nicole Satterwhite, Ryan Jones, Jessica McEntire
Client : Mohawk Fine Papers/Strathmore Writing & Script Paper

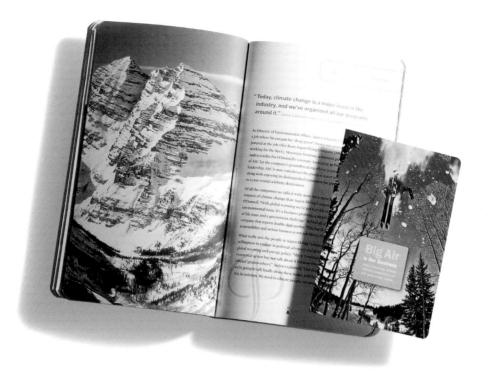

207

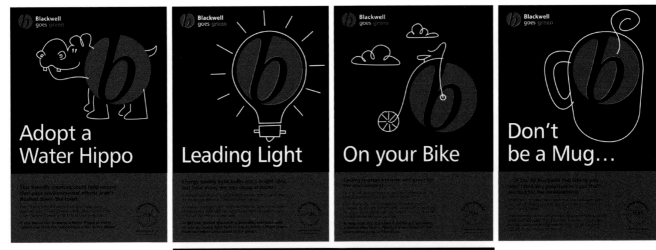

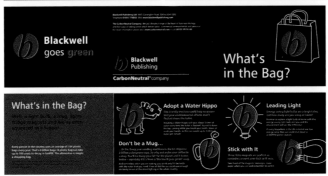

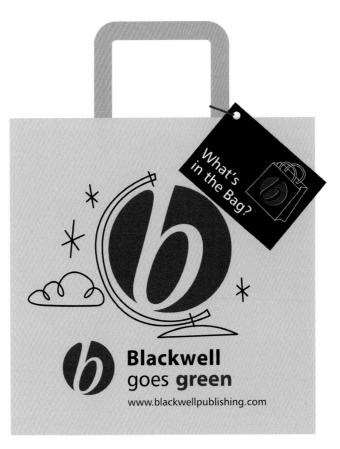

WHAT'S GREEN ABOUT THIS — Lamin-Art, Inc. supplies the commercial interior design and architectural professions with innovative design-statement laminates. In 2007, I Imagine Studio worked with Lamin-Art on a major "Green" campaign which took on the name and visual identity "Eco-Enable." Following the visual identity, IIS created a series of print and online ads which challenge the reader to make a greener world possible—to "enable green."

IMAGINE — MANCHESTER, UNITED KINGDOM
Creatives : David Caunce, Laura Sullivan
Client : Blackwell Publishing

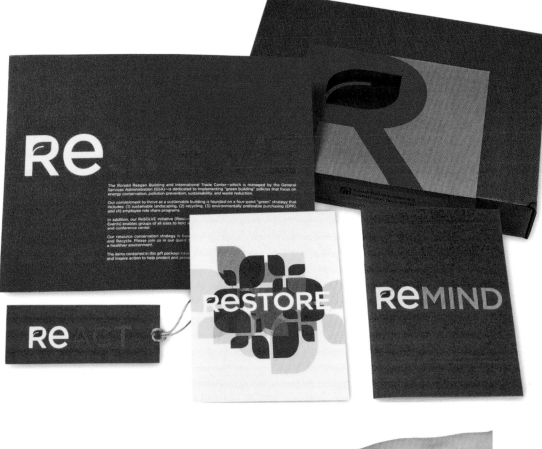

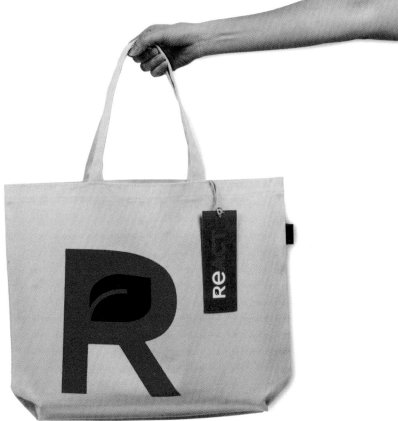

209

DESIGN ARMY — WASHINGTON, D.C.
Creatives : Jake Lefebure, Pum Lefebure, Lucas Badger
Client : Ronald Reagan Building and International Trade Center

WHAT'S GREEN ABOUT THIS — The Ronald Reagan Building and International Trade Center's holiday promotion kit to highlight green initiatives and offerings contains a 12-year calendar, a bamboo USB drive, and a 100% organic tote bag. The entire piece is FSC-certified and printed on 100% post-consumer waste stock with soy-based inks.

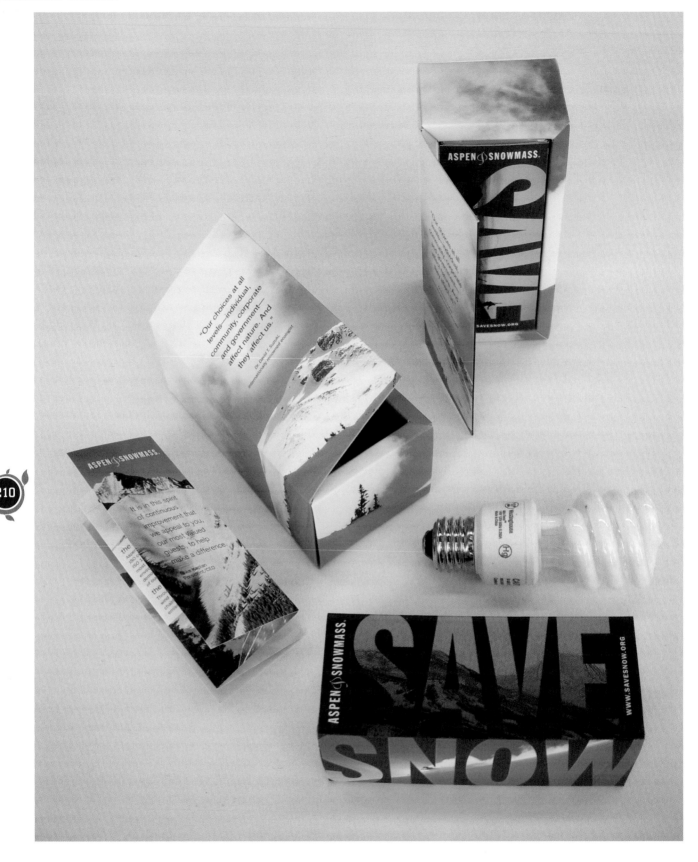

210

NATALIE KITAMURA DESIGN — SAUSALITO, CALIFORNIA
Creatives : Natalie Kitamura, Lisa Winter
Client : Aspen Skiing Company

WHAT'S GREEN ABOUT THIS — Aspen Skiing Company sends out a gift to their best guests every year. Historically they have sent journals and day planners. In 2007 they decided they wanted to send something that was good for the environment and carried a green message. So we designed packaging for 40,000 compact fluorescent light bulbs packaged with information on climate change and the energy savings associated with the bulbs. If the bulbs got used—and their sense from guest feedback was that they would— the total energy savings will be 18,400 megawatt hours, or enough power to run 20 average American homes for a year. The packaging was designed to be as nominal as possible without using a lot of paper yet still protect the bulb inside (a tricky feat in itself.) The sleeve surrounding the CFL had large letters which said "Save Snow" on each panel. There was also a three-panel letter from the President/CEO. The packaging was printed on recycled paper.

211

HORNALL ANDERSON — SEATTLE, WASHINGTON
Creatives : Larry Anderson, Jay Hilburn, Bruce Branson-Meyer, Kathleen Kennelly Ullman, Ashley Arhart, Greg Arhart
Client : Café Yumm!

WHAT'S GREEN ABOUT THIS — Hornall Anderson designed a store prototype to help the Café Yumm! develop a franchise model. Warm, eye-pleasing aesthetics set the table for the restaurant's organic fare and showcase their commitment to progressive, environmentally responsible restaurant design. Menu boards are printed on re-milled timber, flooring is made from recycled agriculture waste, tabletops are manufactured from 50% post-consumer recycled paper with water-based phenolic resin with cashew-shell binder and pigment and sit under energy-efficient, low-wattage, mercury-free lighting.

WHAT'S GREEN ABOUT THIS — This holiday promotion featured lightweight but sturdy shopping bags printed with bold graphics. The subtle reminders of "restore, reconnect, resolve, rejoice, reuse, reciprocate, repurpose, and respond" all indicate that when you "rethink your world" it involves not only action, but attitude as well.

BREMMER & GORIS COMMUNICATIONS —
ALEXANDRIA, VIRGINIA
Creatives : Nicole Hanam, Lara Dalinsky, Carolyn Belefski
Client : Bremmer & Goris Communications

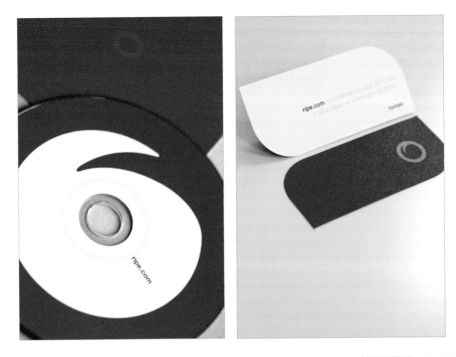

WHAT'S GREEN ABOUT THIS — In creating an identity for their business, ripe wanted a mark that could support their methodology and be consistent with their philosophy of simplicity and sustainability. The resulting ripe mark (they call it a "riple") fulfilled that requirement. Their stationery package is printed on Mohawk superfine uncoated paper with soy inks.

RIPE.COM — WASHINGTON, D.C.
Creatives : Tómas Snoreck, Ian Hamilton, Maryam Seifi
Client : ripe.com

214

WHAT'S GREEN ABOUT THIS — The Alliance for Sustainable Built Environments is a group of industry leaders who practice and are recognized for their leadership in sustainability: economic, social, and environmental responsibility. It delivers high-performance sustainable solutions for the built environment. This specific piece creates awareness among its target audience: first, of the Alliance's existence; second, of the Alliance's goals and objectives; third, of the reasons why sustainable development is important; and finally, how the Alliance can help the target audience transform the world's entire stock of buildings to high-performance green buildings.

B&Z MARKETING COMMUNICATIONS —
MILWAUKEE, WISCONSIN
Creatives : Al Braun, Pat Lafferty, Craig Zurawski, Kriss Schulz
Client : Alliance for Sustainable Built Environments

enviro print®

responsible printing for a sustainable world

215

HAMES DESIGN — MOHEGAN LAKE, NEW YORK
Creatives : Katherine Hames, Jerry Truppelli
Client : Thich Nhat Hanh's Love & Understanding Program

WHAT'S GREEN ABOUT THIS — Graphic Concepts Printing of Central New Jersey transformed themselves into a green printing company in 2007. Now they are one of a small group of printers using renewable energy and sustainable materials to reduce their impact on the environment Their enviroprint division is certified by both the Forest Stewardship Council (FSC) and Green-e certified renewable energy. Inks used in their offset printing process are made from environmentally friendly soy and vegetable oils derived from crops primarily grown in the US.

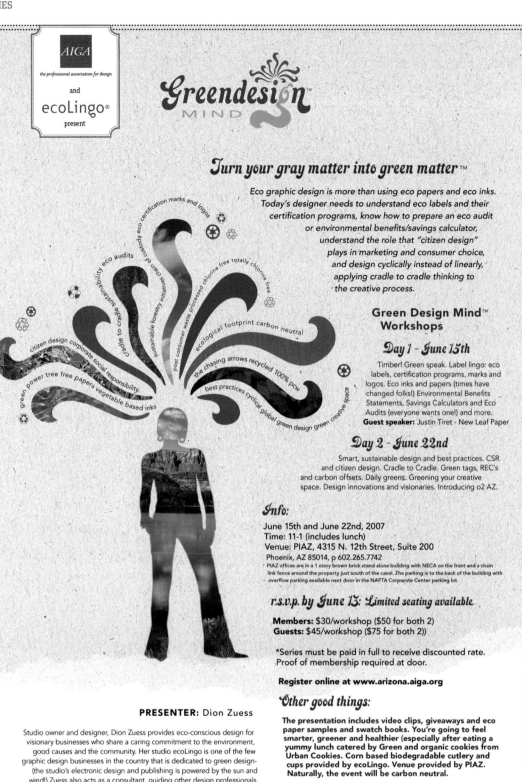

AIGA
the professional association for design

and

ecoLingo®
present

Greendesign
MIND

Turn your gray matter into green matter™

Eco graphic design is more than using eco papers and eco inks. Today's designer needs to understand eco labels and their certification programs, know how to prepare an eco audit or environmental benefits/savings calculator, understand the role that "citizen design" plays in marketing and consumer choice, and design cyclically instead of linearly, applying cradle to cradle thinking to the creative process.

Green Design Mind™ Workshops

Day 1 – June 15th

Timber! Green speak. Label lingo: eco labels, certification programs, marks and logos. Eco inks and papers {times have changed folks!} Environmental Benefits Statements, Savings Calculators and Eco Audits {everyone wants one!} and more.
Guest speaker: Justin Tiret - New Leaf Paper

Day 2 – June 22nd

Smart, sustainable design and best practices. CSR and citizen design. Cradle to Cradle. Green tags, REC's and carbon offsets. Daily greens. Greening your creative space. Design innovations and visionaries. Introducing o2 AZ.

Info:

June 15th and June 22nd, 2007
Time: 11-1 (includes lunch)
Venue: PIAZ, 4315 N. 12th Street, Suite 200
Phoenix, AZ 85014, p 602.265.7742
PIAZ offices are in a 1 story brown brick stand alone building with NECA on the front and a chain link fence around the property just south of the canal. The parking is to the back of the building with overflow parking available next door in the NAFTA Corporate Center parking lot.

r.s.v.p. by June 13: Limited seating available.

Members: $30/workshop ($50 for both 2)
Guests: $45/workshop ($75 for both 2))

*Series must be paid in full to receive discounted rate.
Proof of membership required at door.

Register online at www.arizona.aiga.org

Other good things:

The presentation includes video clips, giveaways and eco paper samples and swatch books. You're going to feel smarter, greener and healthier (especially after eating a yummy lunch catered by Green and organic cookies from Urban Cookies. Corn based biodegradable cutlery and cups provided by ecoLingo. Venue provided by PIAZ. Naturally, the event will be carbon neutral.

Reserve your seat today!

SPONSORED BY:

AIGA Arizona
ecoLingo:
earth friendly graphic design
New Leaf Paper
PIAZ
Urban Cookies

NEW LEAF
PAPER®

Urban **Cookies**

PRESENTER: Dion Zuess

Studio owner and designer, Dion Zuess provides eco-conscious design for visionary businesses who share a caring commitment to the environment, good causes and the community. Her studio ecoLingo is one of the few graphic design businesses in the country that is dedicated to green design- (the studio's electronic design and publishing is powered by the sun and wind!) Zuess also acts as a consultant, guiding other design professionals, groups and businesses with transitioning into the fast growing green market.

Green Design Mind™ and Turn Your Gray Matter into Green Matter™ names and logo © ecoLingo 2007
Design credits: © Dion Zuess/ecoLingo 2007
Photo credits: dion zuess/ecoLingo and © istockphoto.com/
Jason Verschoor, Rafa Irusta, Svetlana Prikhodko, Kushnirov Rosalia
Subeve dingbat © Sub Communications.
Additional type from MyFonts and Canada Type.

216

WHAT'S GREEN ABOUT THIS — The Green Design Mind™ workshop educates designers in ecological awareness and practice. Dion Zuess and ecoLingo partnered with AIGA Arizona to host the first educational event and used paperless communication to advertise the workshops.

ECOLINGO — PHOENIX, ARIZONA
Creatives : Dion Zuess
Client : Green Design Mind

WHAT DOES IT MEAN TO THINK GREEN, GO BLUE?

It means taking action. Moving beyond conventional thinking and finding new ways to make the world a cleaner, safer, healthier place. At Ecolab, we're developing and delivering sustainable solutions that make a dramatic difference every day. A difference you can see. A difference you can measure. A difference you can count on.

SOLUTIONS THAT GO BEYOND GREEN

Sustainability is not just about protecting the environment — it also involves economic progress and social responsibility.

We believe that success is measured by the satisfaction of our customers — as well as the contributions we make to our communities and the global economy. Advancements in all of these areas are necessary to protect needed resources and preserve quality of life for future generations.

A COMPREHENSIVE APPROACH

IT ALL ADDS UP — The Total Impact

Innovative Technology Delivers the Total Impact

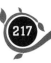

FUTURA MARKETING — EDEN PRARIE, MINNESOTA
Creatives : Heidi Derner, Gina Miraldi
Client : Ecolab

WHAT'S GREEN ABOUT THIS — Printed on 100% post-consumer paper with soy ink, this brochure is full of easy-to-understand information explaining how Ecolab helps its customers run sustainable businesses.

GREENLEAF MEDIA — WISCONSIN
Creatives : Mary Walsh, Erica Hess,
Client : Botsford EcoTech Partners

WHAT'S GREEN ABOUT THIS — WorldWin Papers and The Paper Mill Store .com offer "Paper with a Vision" by using 100% carbon-neutral shipping and 100% Green-e certified wind power. They are FSC-, CoC-, and SFI-certified. The Paper Mill Store .com is one of the largest purchasers of renewable energy certificates among online paper stores and is recognized as a Partner of the EPA's Green Power Partnership and Green Power Leadership Club.

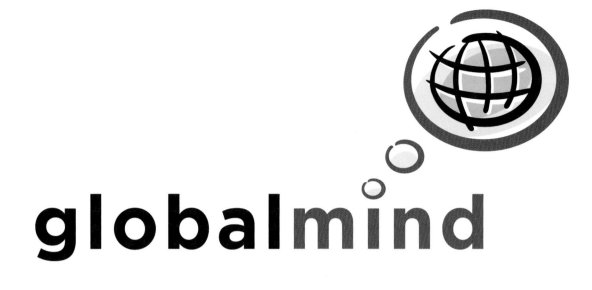

218

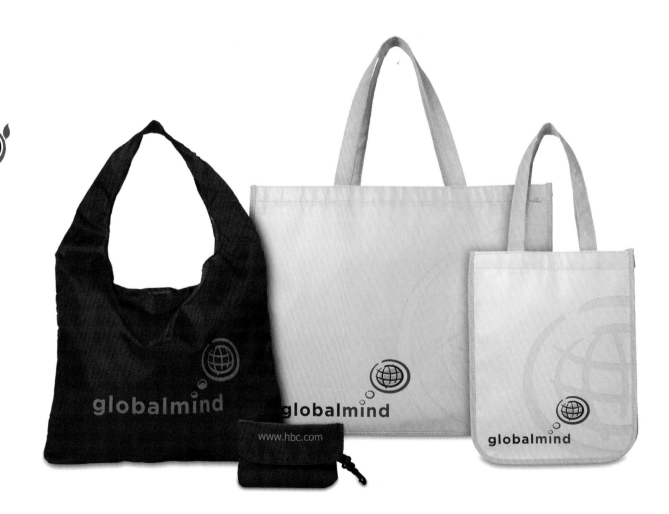

WHAT'S GREEN ABOUT THIS — The Hudson Bay Company sought to raise public awareness for their efforts in environmental programs, innovative sustainable solutions, and their "Global Mind" philosophy. Designs included reusable shopping bags and substrate recommendations for recyclable, low environmental-impact materials.

ANTHEM — SAN FRANCISCO, CALIFORNIA
Creatives : Brian Lovell, Michael D. Johnson, Rebecca Stillpass
Client : Hudson Bay Company (Hbc)

ulitho **ug** GREEN

219

PRYOR DESIGN COMPANY — ANN ARBOR, MICHIGAN
Creatives : Scott Pryor, Laura Hervey
Client : ULitho Print Services

WHAT'S GREEN ABOUT THIS — ULitho Print Services, an offset and digital printer located in Ann Arbor, Michigan, has long been devoted to diminishing their impact on the environment. To announce their recent Forestry Stewardship Council (FSC) certification, they asked Pryor Design Company to create an identity and a small booklet to inform designers and print buyers how to approach printing in a more sustainable way. They also developed a campaign of buttons worn by the sales team and other staff members in support of ULitho's "ugreen?" approach.

WHAT'S GREEN ABOUT THIS — The Air District is the public agency protecting clean air in the nine Bay Area counties. 50 Years of Progress incorporates a timeline of the Air District's achievements. Major spreads focus on Air District employees defining progress in the context of their work and the Air District's ongoing efforts to preserve air quality in the Bay Area.

GEE + CHUNG DESIGN — SAN FRANCISCO, CALIFORNIA
Creatives : Earl Gee, Fani Chung, Sharon Beals
Client : Bay Area Air Quality Management District

221

WHAT'S GREEN ABOUT THIS — Olive and Bean is an eco-friendly boutique located in Las Vegas, Nevada. The store offers a variety of organic and green products, including home goods, baby toys, and body-care products.

THE ZEN KITCHEN — WATERTOWN, MASSACHUSETTS
Creatives : Dani Nordin
Client : Olive and Bean

 223

ZERO DESIGN LIMITED— EDINBURGH, SCOTLAND,
UNITED KINGDOM
Creatives : Lisa Jelley, Ricardo Agnello,
Abel Rogers, Stuart Robins
Client : Damhead Holdings Limited

WHAT'S GREEN ABOUT THIS— Trading since 1989, Damhead Organic Farm is based just outside Edinburgh in Scotland and services the organic community across the country. This Web site and new branding gives the company a softer, "family" face, with the concept of large-enough-to-cope, small-enough-to-care as the main design ethos for the project.

THE ZEN KITCHEN — WATERTOWN, MASSACHUSETTS
Creatives : Dani Nordin, Lee Shane
Client : Botsford EcoTech Partners

WHAT'S GREEN ABOUT THIS — Botsford EcoTech Partners, formerly 5-Trees, needed a brochure that they could use to reach out to potential clients. Deciding against another paper brochure, they chose instead to do an eco-friendly PDF brochure that they could make available on their website as well as by e-mail to contacts who requested more information.

WHAT'S GREEN ABOUT THIS — Ginkgo House uses a green strategy for their design and architecture processes, examining energy use, water consumption, choices in building materials, building orientation, and landscaping.

GREENLEAF MEDIA — WISCONSIN
Creatives : Mary Walsh, Erica Hess, Jen Baker, Enid Williams
Client : Ginkgo House Architecture

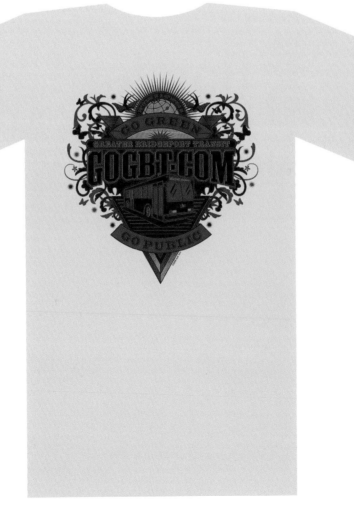

WHAT'S GREEN ABOUT THIS — In an effort to promote a greener environment and encourage the use of the public mass transportation system in the Greater Bridgeport area in Connecticut, the Greater Bridgeport Transit had this t-shirt designed. The shirts were given away in honor of Earth Day, April 22, 2009.

JACK TOM DESIGN — BRIDGEPORT, CONNECTICUT
Creatives : Jack Tom
Client : Greater Bridge Transit (GBT)

RIZCO DESIGN — MANASQUAN, NEW JERSEY
Creatives : Debra Rizzi, Keith Rizzi, Jennifer Pesce, Patrick Kesler
Client : Rizco Design

WHAT'S GREEN ABOUT THIS — In May 2007, Beleaf started as a three-tiered environmental program that encourages the elimination of deforestation. This plan of action is measured with the Beleaf On-line Report Card, which every client receives (with a "grade") at the end of each project. Point-earning initiatives include such measures as implementing paperless paychecks, analyzing shipping and supply vendors, switching to eco-friendly cleaning products, and purchasing 100% green power (50/50 split between wind and hydro). Major emphasis is placed on sustainable-paper decision-making such as specifying stocks that are FSC-Certified and/or recycled. Beleaf has since evolved into its own brand. Originally used as part of the marketing campaign, the Beleaf tote is available via the internet (www.Beleaf.com) with one percent of sales being donated to the non-profit organization 1% for the Planet.

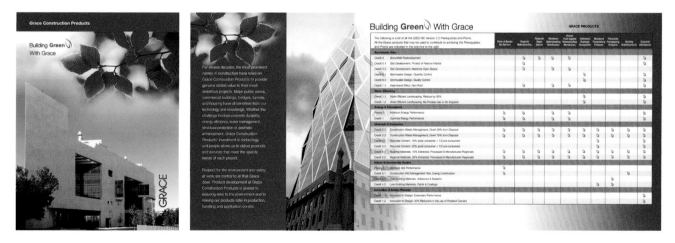

CAPERS DESIGN — MIDDLEBORO, MASSACHUSETTS
Creatives : Lauren Capers
Client : GRACE

WHAT'S GREEN ABOUT THIS — Brochure and full-page trade advertisement promote the green qualities of the company's varied building products and capabilities.

Green In Action
Repurposed Design

WHAT'S GREEN ABOUT THIS — This collaborative student project explored a more sustainable way of creating reusable grocery bags that didn't mean planting more fields of cotton (as cotton is one of the most fertilizer-intensive crops to grow.) They found that Goodwill, the Salvation Army, and other similar organizations have leftover clothing (much of it being T-shirts and jeans) that are shipped overseas, used for rags, or thrown away. They developed an easy way to use one pair of jeans and a t-shirt to create a recycled, reused, and reusable shopping bag that could be quickly constructed by the economically disadvantaged or part-time worker in local urban/rural areas.

UNIVERSITY OF ILLINOIS + RENOURISH — CHAMPAIGN, ILLINOIS
Creatives : Eric Benson, Jaladhi Pujara

228

WHAT'S GREEN ABOUT THIS — Lemnis bulbs use LED technology that is eight times more effective than CFL. Each bulb is mercury-free and lasts an average of 35 years. But they're pricey. In an effort to convince people that they will save money by spending $25 on a light bulb, they differentiated the buying experience from that of buying a plain old incandescent by packaging it in a box made from recycled paper that refolds into a stylish, modern lampshade. The solution looks innovative on shelf, adds tangible value to the purchase, and, by being reusable, honors the brand's conservation-minded ethos.

CELERY DESIGN COLLABORATIVE — BERKELEY, CALIFORNIA
Creatives : Stephanie Welter, Rod DeWeese, Brian Dougherty
Client : Lemnis Lighting

229

HOUSEMOUSE™ — MELBOURNE, AUSTRALIA
Creatives : housemouse™
Client : housemouse™

WHAT'S GREEN ABOUT THIS — The Wrap Up is housemouse's way to provide their valued stakeholders with a wrap-up of the year. The Wrap Up also follows housemouse's environmentally sustainable approach to business by printing in Australia [locally] using vegetable-based inks, 100% recycled, Australian-made, acid-free, pH-neutral paper, and doubling as a piece of wrapping paper, encouraging reuse before recycling.

WHAT'S GREEN ABOUT THIS — This husband-wife design team created green moving announcements using old pieces of their packing boxes and rubber stamps to make the self-mailing postcards.

DESIGNLAB, INC. — ST. LOUIS, MISSOURI
Creatives : Scott Gericke, Laura Gericke
Client : Scott and Laurie Gericke

230

WHAT'S GREEN ABOUT THIS — The mission of New Leaf Paper is to inspire a fundamental shift toward environmental responsibility in the paper industry by first setting a successful example themselves. Just because a notebook contains recycled paper doesn't mean it has to scream "THE WORLD WILL END IF YOU DON'T RECYCLE" across the front cover. Students just want normal notebooks that are eco-friendly. Cool designs are a bonus, but they're happy with simply different colors for each subject. New Leaf products offer quality, price, style, and a recycling message that is fun, relatable, optimistic—and subtle.

WILLOUGHBY DESIGN — KANSAS CITY, MISSOURI
Creatives : Ann Willoughby, Zack Shubkagel, Ryan Jones, Jessica McEntire, Chris Jones, Becky Ediger, Luke Lisi, Stephanie Lee, Nicole Satterwhite, Megan Semrick
Client : New Leaf Paper

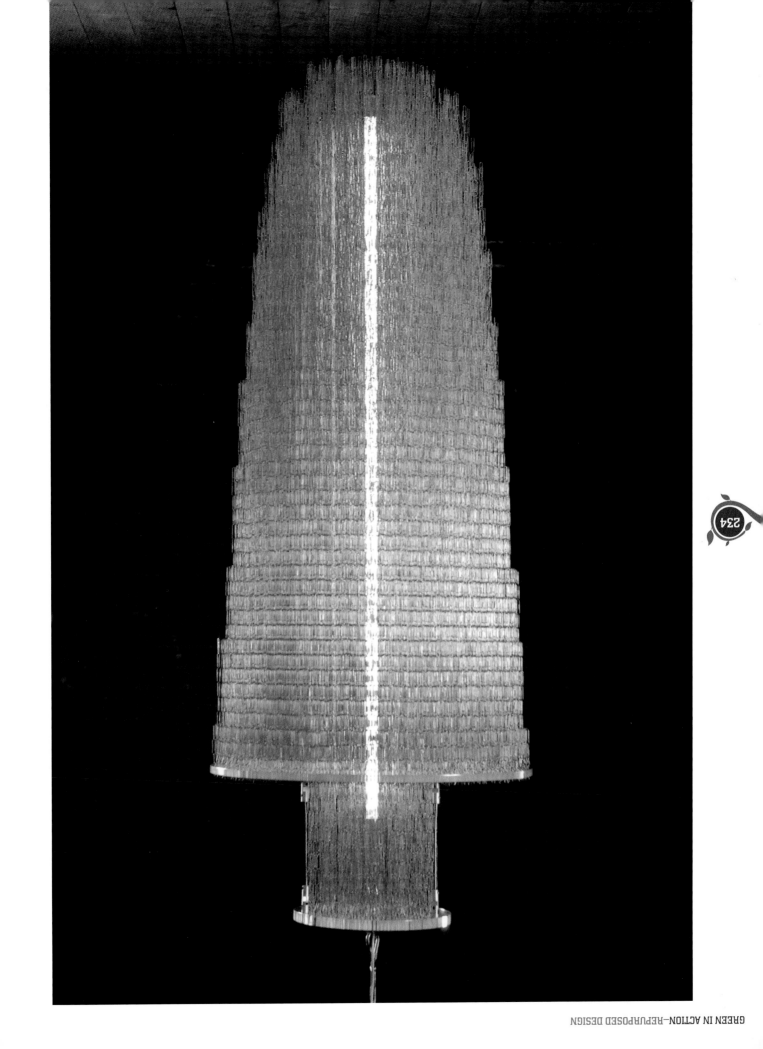

ALR DESIGN — RICHMOND, VIRGINIA
Creatives : Noah Scalin
Client : Better Housing Coalition

WHAT'S GREEN ABOUT THIS — Better Housing Coalition's first annual Leadership Awards ceremony was held in an old wood mill that is in the process of being transformed into a mixed-use community. In the spirit of the transformation, scavenged materials left over from the previous owners were used to create the trophies. They are entirely made from the reclaimed materials and finished with water-based stains and coatings. Titles and descriptions of each award were used as inspiration for the designs.

RE
DUCE
USE
THINK

environmentally driven design

SPONSORED BY MOHAWK PAPER

232

AIGA DC and Studio eg · 03.16.06

"Does this product have a right to exist? Does its existence cause more harm than good?"

Designers ask questions—it's part of the creative process. But given the state of the environment and our increasingly negative impact on it, some questions are more critical than ever before. On March 16th, AIGA invites you to meet Studio eg, a multidisciplinary California-based design firm that asks those two questions every day.

Studio eg is committed to ecologically smart design. Founded by industrial designer Erez Steinberg and graphic designer Gia Giasullo, Studio eg has been designing with recycled, reused, and non-toxic materials for over a decade. In 1995, Studio eg introduced Ecowork, a line of modular office furniture made up of 98% recycled materials that utilizes a low-energy manufacturing process. Studio eg has received many awards for this and other projects over the years, and has proven that ecologically smart design CAN be stylish and functional.

On March 16th, Studio eg will trace their journey of "inspiration to actualization" in successfully bringing an ecologically responsible product to market. Their presentation will focus on Studio eg's research, interdisciplinary collaboration, personal ethics and a fearless approach to ecologically inventive marketing and manufacturing. They encourage us not only to reduce waste and reuse materials, but to rethink our roles as designers and the impact we can play in mitigating environmental problems.

REUSE this invitation

Keep the spirit of the program going. Instead of throwing this invitation away, use the template above to make an A6 envelope.

ENVELOPE INSTRUCTIONS
- trim along the solid line
- fold in the two sides along the dotted lines
- fold up the bottom flap along the dotted line
- glue the bottom flap to the side flaps
- fold down the top flap along the dotted line
- enclose your mail, seal and send

WHAT'S GREEN ABOUT THIS — An invitiation to AIGA-sponsored discussion with Studio eg about their commitment to ecologically smart design is printed on 100% recycled paper, but the real hook is the built-in repurpose—a stylish envelope to trim, fold, glue, and send.

LOMANGINO STUDIO INC. — WASHINGTON, D.C.
Creatives : Betsy Martin
Client : AIGA

NOT JANE — WASHINGTON, D.C.
Creatives : Betsy Martin
Client : AIGA DC

WHAT'S GREEN ABOUT THIS — Washington, DC AIGA chapter board member Betsy Martin noticed they needed business cards. Since printing was not in the budget, she took advantage of materials that were lying around the studio, namely paper sample books, and repurposed them into business cards. They were virtually free (just the cost of the labels); they help reinforce the green initiatives of AIGA; and when handed out, they are a great conversation piece.

TWOINTANDEM — NEW YORK
Creatives : Sanver Kanidinc, Elena Ruano Kanidinc
Client : AIGA, Times Square Alliance, Worldstudio Foundation

WHAT'S GREEN ABOUT THIS — Banner Design for The Urban Forest Project. The design of the banner uses a metaphor of a tree to make a powerful visual statement and was displayed in New York's Times Square. They were then recycled into tote bags and sold at auction to benefit students of the visual arts.

235

JAM — LONDON, UNITED KINGDOM
Creatives : Jamie Anley, Astrid Zala
Client : Sothebys

WHAT'S GREEN ABOUT THIS — "In the context of 'Waste to Taste,' imagine the paperless office: What would we do with all the unwanted paperclips?" Design firm JAM proposed this question to Sotheby's 2003 "Waste to Taste" exhibition, then answered it by creating a "paperless" chandelier made from 50,000 paperclips. The chandelier was then auctioned off.

WHAT'S GREEN ABOUT THIS — Trashbags—hand-sewn purses made from recycled and scrap materials—were born in 2004 in an effort to give old shopping bags a second, more glamorous shot at life. In addition to shopping bags, materials include mat board and watercolor paper scraps, Ziploc bags, and soda-can tabs. Purse handles are adorned with thread scraps too small to use in regular sewing projects. Even the purse's tag is recycled, made of a piece of ripped shopping bag sandwiched between artwork printed on old paper samples from the artist's graphic design studio.

THE WHOLE PACKAGE — SAN FRANCISCO, CALIFORNIA
Creatives : Leila Singleton
Client : Leila Singleton

236

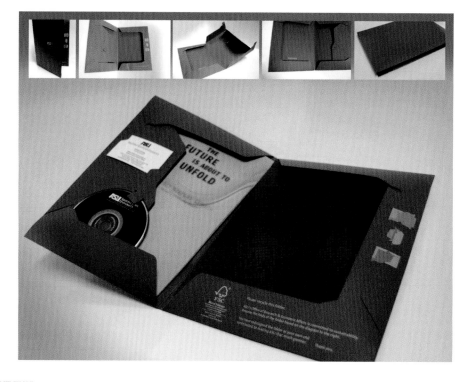

WHAT'S GREEN ABOUT THIS — Designed to be used both for external and internal communications of the Arizona State University Office of the Vice President for Research and Economic Affairs' message, "Sustainability Now," the folder needed to be recyclable and be able to be repurposed. Using a recyclable paper, four folders were laid out on one press sheet for minimal paper waste. A DVD/CD tab was built in to eliminate the need for a jewel case, and a business card slip was also included. The folder can be repurposed simply by reversing the folds—once it has been refashioned, all the branding is hidden from view. The user is empowered to redesign the folder.

ARIZONA STATE UNIVERSITY OFFICE OF THE VICE PRESIDENT FOR RESEARCH AND ECONOMIC AFFAIRS — TEMPE, ARIZONA
Creatives : Hoi Yan Patrick Cheung, Mai-Li Le, Sheilah Britton, Debbie Fossum
Client : Arizona State University Office of the Vice President for Research and Economic Affairs

MINE™ — SAN FRANCISCO, CALIFORNIA
Creatives : Christopher Simmons, Tim Belonax
Client : Sacred Heart Cathedral Preparatory

WHAT'S GREEN ABOUT THIS — These Open House posters were silk-screened by hand on otherwise landfill-bound "make-ready" press sheets recycled from the school's viewbook. By using reclaimed press sheets, the designers were able to save the client money and produce an environmentally benign promotion. The posters were so well received that many people kept them as a kind of memorabilia, adding yet another layer to the policy of reduce, reuse, recycle.

237

SCAMPER LTD — KENILWORTH, UNITED KINGDOM
Creatives : Tom Greenwood, Vineeta Greenwood
Client : Maple Rush

WHAT'S GREEN ABOUT THIS — Maple Rush is a small eco-friendly business, producing jewelry from recycled glass and reclaimed wood beads. For suitable, cost-effective packaging, necklaces and bracelets are packaged in small, recycled card boxes and colored a deep purple to match the brand's color scheme. A vegetable-ink logo is embossed on the top. For the 'earring cards', standard-sized business cards are punched in the top corner, and threaded with a loop of waste cotton cord from the necklace and bracelet production, which holds the earrings in place.

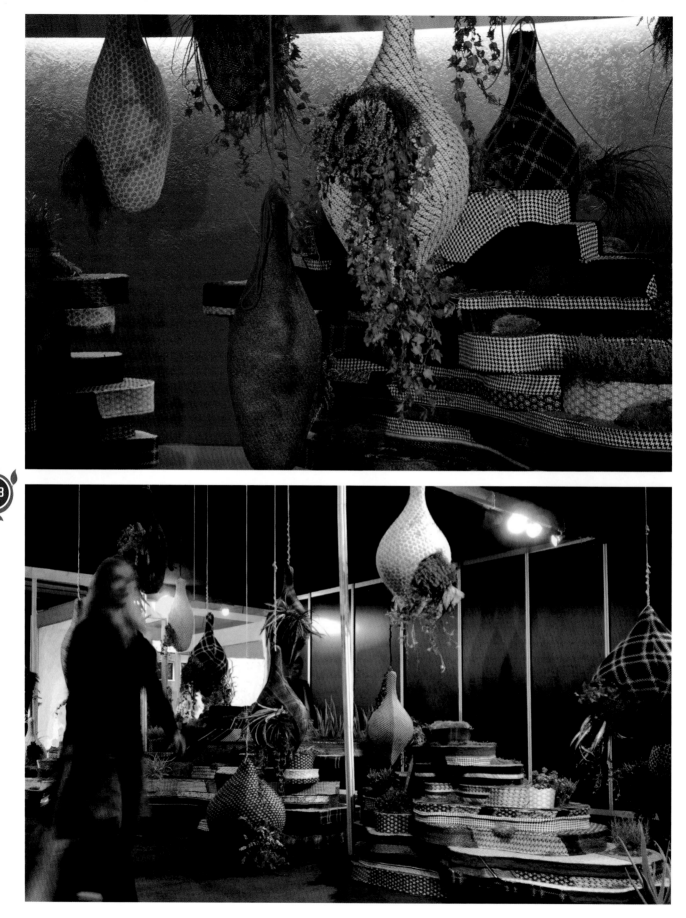

238

WHAT'S GREEN ABOUT THIS — UK branding agency JAM and fashion house Ted Baker collaborated on this fabric garden for an installation at 100% Design London 2008. Hanging vessels are made from reused lampshades and off-cuts of fabric from Ted Baker to reinforce the environmental focus of the project.

JAM — LONDON, UNITED KINGDOM
Creatives : Anna Marie, Stewart Pasescu, Lola Lely, Jamie Anley, Phil Nutley
Client : Ted Baker

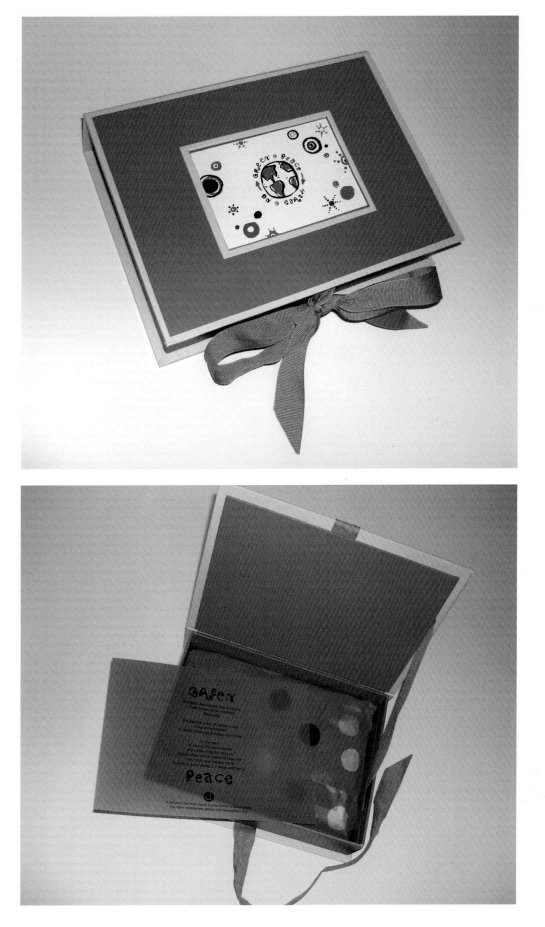

DESIGN NUT, LLC — KENSINGTON, MARYLAND
Creatives : Brent M. Almond
Client : Design Nut, LLC

WHAT'S GREEN ABOUT THIS — In years past, Design Nut designed and printed holiday cards to give to clients, colleagues, and potential clients. In light of economic pressures and in a desire to be more green, Design Nut collected a "greatest hits" of note cards and holiday cards from the last 6 years, bundled them together, and put them into photo boxes. The image on the top of the box and the card on top inside were printed digitally.

Green In Action
Anti-Packaging

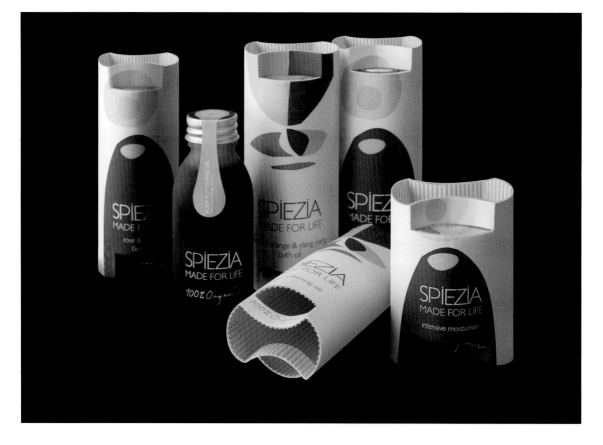

WHAT'S GREEN ABOUT THIS — Spiezia Organics, founded in 1999, had developed into a niche brand with a unique philosophy at its core. However, despite achieving accredited organic status, with its anonymous packaging, Spiezia struggled to gain momentum. Challenged with creating a difference whilst weaving sustainability into every aspect of the design, Jones Knowles Ritchie reduced secondary packaging by 12% and optimized digital printing methods to reduce waste.

JONES KNOWLES RITCHIE – LONDON, UNITED KINGDOM
Creatives : JKR Design Team
Client : Spiezia

242

WHAT'S GREEN ABOUT THIS — Earthpack supplies recycled bags and boxes to environmentally conscious retailers. Version-X is redesigning the Earthpack website and creating an E-commerce site for them that will make generic, recycled packaging and supplies available to the small business owner and general public.

VERSION-X DESIGN CORP — BURBANK, CALIFORNIA
Creatives : Chris Fasan, Adam Stoddard
Client : Earthpack

THRIVE DESIGN — EAST LANSING, MICHIGAN
Creatives : Kelly Salchow MacArthur
Client : Thrive Design

WHAT'S GREEN ABOUT THIS — This storage unit was sold in retail stores in Ohio. The entire unit is die-cut from one piece of sustainable, natural felt, and the packaging continues the concept. Recycled corrugated paper surrounds the unit and is secured without adhesives by using a simple combination of diecut (which exposes the color of the product) and ribbon (running through the grommeted hole of the storage unit). The only printing is on the hang-tag.

243

STUDIO ONE ELEVEN — CHICAGO, ILLINOIS
Creatives : Scott Jost, Tim Moyar, Tatyana Balte
Client : Cosmos Corporation

WHAT'S GREEN ABOUT THIS — Cosmos' TropiClean pet grooming products wanted to raise the bar on packaging sustainability. Both client and designer agreed that a more comprehensive overhaul of the brand itself was in order. The bottle shape and lid were redesigned to be user-friendly with one hand in a wet environment. The bottle and sleeve are made from Ingeo, an ingenious biopolymer made from plants, not oil; it's 100% natural and renewable.

WHAT'S GREEN ABOUT THIS — This design minimizes packaging and provides a second use for it as well. The wooden box holds sample bottles of various tequila flavors and comes with pour spouts and hardware to mount the package to the wall. Once mounted, the bottles can be turned upside down to create a pouring system. In order to cut down on ink use, the company logo is burned into the side of the package rather than printed.

THE FAMOUS STUDIO — WHITE STONE, VIRGINIA
Creatives : Ryn Bruce
Client : Anando

244

WHAT'S GREEN ABOUT THIS— Lionshead beer, a popular beverage in the Pennsylvania college scene, received a complete packaging makeover with authentic graphics, tongue-in-cheek neck labels, and "paw holes" on the six-pack. The smaller labels use 40% less paper than previous labels. The design allowed for the use of 47 lb paper, as opposed to the current 51 lb paper, as well as vegetable-based inks, without sacrificing quality. Unbleached kraft stock was chosen for baskets and cartons. Additionally, copy was added to the 6-pack, 12-pack and case to encourage recycling, "Your favorite lion encourages you to keep our natural habitat clean. Lionshead beer uses recycled bottles and recycled content materials. Do your part and practice recycling in your own den."

LITTLE BIG BRANDS — NYACK, NEW YORK
Creatives : John Nunziato, Phil Foster
Client : The Lion Brewery

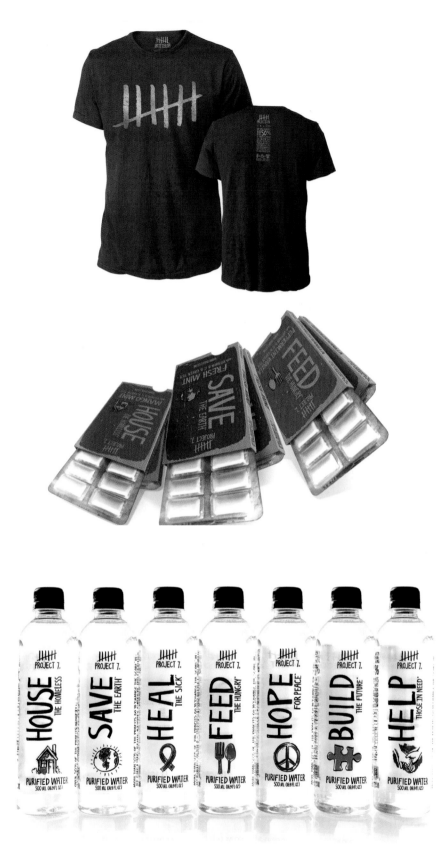

245

29 AGENCY — SOUTHLAKE, ALABAMA
Creatives : Tyler Merrick, Darren Dunham,
Jonathan Rollins
Client : Project 7, Inc.

WHAT'S GREEN ABOUT THIS — The water bottles are made from 100% recyclable PET and labels printed with water-based inks. The gum wraps are made from 40% post-consumer recycled material. Instead of traditional trays, Project 7 water is shipped in cases also made from recycled material. This allows the company to ship the same amount of water in four trucks that traditionally takes five – cutting energy and material consumption by an average of over 25%. Finally, to address the paradox of selling plastic bottles to promote environmental stewardship, Project 7 created a line of clothing made from 50% RPET (recycled PET) and 50% organic cotton. On average, five PET bottles are recycled and woven into each designer tee, and each shirt is branded with artwork created by 29 Agency, and printed with eco-friendly inks. www.29agency.com www.project7.com

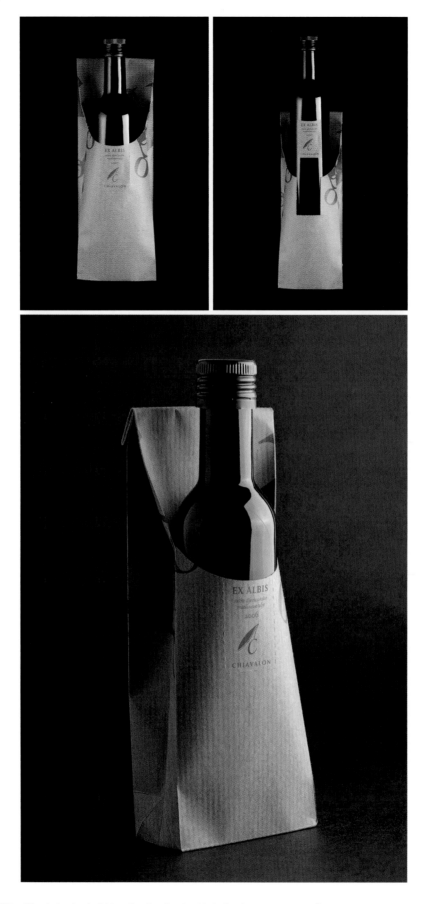

WHAT'S GREEN ABOUT THIS — Chiavalon is a brand of high-quality olive oil produced in the Croatian region of Istria, famous for its traditional olive oil production. The bottle, in addition to being a very nice souvenir, which encourages reuse, is packaged inside a bag made of recycled paper, which can absorb any oil dribbles.

BRUKETA&ZINC OM — ZAGREB, CROATIA
Creatives : Davor Bruketa, Nikola Zinic, Ruth Hoffmann
Client : Sandi Chiavalon

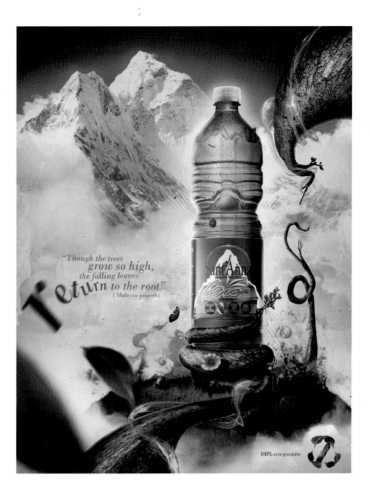

ISHBU.COM — MOSCOW, IDAHO
Creatives : David Walters
Client : Sant' Anna

WHAT'S GREEN ABOUT THIS — Sant'Anna is producing the first 100% biodegradable water bottle. The bottle is completely recyclable, and a used Bio Bottle can be recycled into a new Bio Bottle without any petroleum use or air pollution.

247

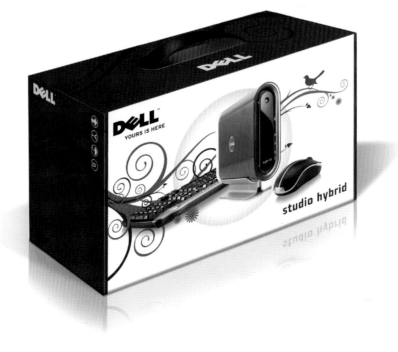

WALLACE CHURCH, INC. — NEW YORK, NEW YORK
Creatives : Stan Church, Rob Wallace, Marjorie Wood-Guthrie, Tom Davidson
Client : Dell

WHAT'S GREEN ABOUT THIS — Dell partnered with Wallace Church to launch its greenest consumer desktop PC. The Dell Studio Hybrid uses smaller packaging than other PCs and is made from 95% recyclable materials, including recycled bottles, plastics, and paperboard. It is 80% smaller than a standard desktop, so it fits anywhere, and it uses 70% less power than a typical desktop.

WHAT'S GREEN ABOUT THIS — This kit for Marvin Windows and Doors is more functional and environmentally friendly than most catalogs: it can have sections printed, replaced, or updated as needed instead of scrapping an entire catalog because of one change.

CHRISTIANSEN CREATIVE — HUDSON, WISCONSIN
Creatives : Tricia Christiansen
Client : Marvin Windows and Doors

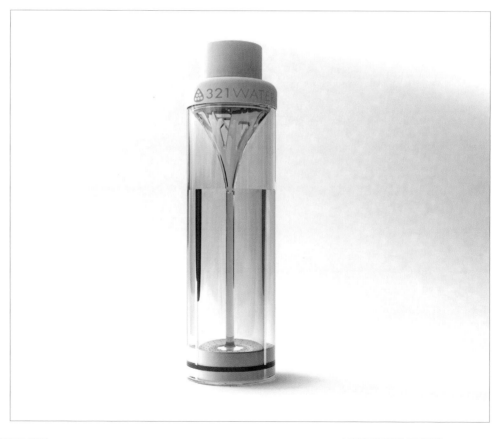

WHAT'S GREEN ABOUT THIS — This reusable water bottle has a '"French press"-style filtration system and was designed to discourage the use of throwaway water bottles. It uses BPA-free polycarbonate, a replacable carbon filter that effectively eliminates chlorine and metals from drinking water, and is dishwasher-safe for cleaning.

CHARLWOOD DESIGN — VIC, AUSTRALIA
Creatives : Gretha Oost, Paul Charlwood, Andrew Howley
Client : 321 Water

249

The Earth Friendly Wine
Pioneers in environmental responsibility.™

www.fetzer.com

We Make Our Wine Responsibly.
Please Enjoy It Responsibly.

FSC · 100% Recycled Paper
100% Minimum Post-Consumer Waste

©2008 Fetzer Vineyards, Hopland, Mendocino Co., CA
Fetzer is a registered trademark. Code # 000-0000

FETZER
VINEYARDS

Even The Bottle Is Earth Friendly.

Our New, Innovative Bottle Has 17% Less Glass For A Cleaner Today

By using less glass, our lightweight bottle cuts carbon emissions by 14%. That's the equivalent of:

- Saving 3,000 tons of greenhouse gases
- Or planting 70,000 trees – three times as many trees as in Central Park – and growing them for ten years.*

*Best Foot Forward , "Carbon Savings From 'Lightweighting' Fetzer Valley Oaks Bottles"

A Commitment To Sustainability Measured In Decades

For over 20 years, Fetzer Vineyards has been a leading pioneer in earth-friendly wine-making and business practices.

To learn more about our commitment to sustainability, visit Fetzer.com.

| BROWN-FORMAN AND PRICE WEBER MARKETING
(HANGTAGS) — LOUISVILLE, KENTUCKY
Creatives : Mike Haering, Maggie Peak, Rob Kaplan, Leigha Dorsey
Client : Brown-Forman

WHAT'S GREEN ABOUT THIS — Fetzer Vineyards lightweighted its entire line of wine bottles to reduce its environmental footprint. The new bottles reduce glass usage by 16% (more than 2,100 tons) by reducing the glass thickness and eliminating the punt, and they reduce the supply-chain greenhouse gas emissions (or carbon footprint) associated with glass bottles by 14% (3,000 tons of CO2e.) The bottom images are hangtags.

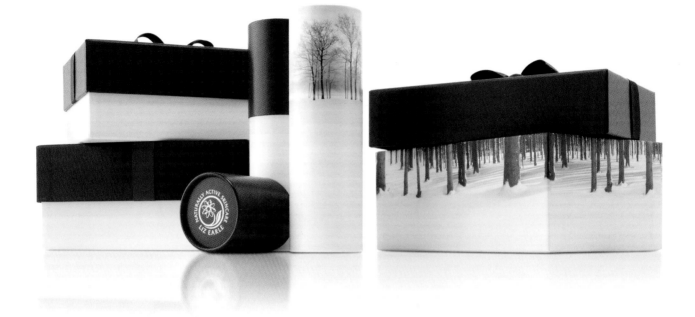

How They Did It
Liz Earle Cosmetics

"For many brands, Christmas is a time when good taste seems to go out the window," says Bruce Duckworth, founder and creative director for Turner Duckworth: London & San Francisco. It's also a time when millions of living room floors become littered with wrapping and packaging that only ends up in landfills.

Duckworth's team had these and more considerations in mind when they created the Christmas Gift Pack 2006 for Liz Earle natural body-care products.

"It's very important that every Christmas, the Gift Pack design looks different from the year before," Duckworth says. "Yet the design has to be very much in line with traditional brand values: beauty and natural ingredients."

Designer Jamie McCathie and artist/retoucher Neil McCall developed simple packaging that reinforced Liz Earle's brand. The Gift Packs came in stylish yet plain boxes.

"As you lifted the lid, it revealed a snowy Christmas scene underneath so you got this surprise and delight. We tried to make the recipient feel as though they were special and they'd discovered something new," Duckworth says.

Gift-packaging is a particular challenge for green designers. "It's usually superfluous and disposable," Duckworth says. "We used recycled and recyclable packing materials as well as non-solvent printing materials. The boxes were designed to be well constructed and the customer was carefully instructed to reuse it."

For example, recipients could store their favorite CDs in the boxes. The package was also designed without internal structure (usually plastic) to hold the product in place, thereby further reducing waste.

Liz Earle requested a key change. "They wanted it to look more gift-worthy," Duckworth says. "So, for example, we added ribbons."

Turner Duckworth doesn't necessarily specialize in earth-friendly design, yet it's doing more and more work along those lines. "Almost every client now is talking about reducing their environmental impact. They truly want to care for the environment. In addition, they want to reduce waste and therefore reduce the cost of packaging," Duckworth says. "In the end, it's both cheaper and altruistic."

TURNER DUCKWORTH: LONDON & SAN FRANCISCO — LONDON, UNITED KINGDOM
Creatives : David Turner, Bruce Duckworth, Jamie McCathie, Neil McCall
Client : Liz Earle Cosmetics

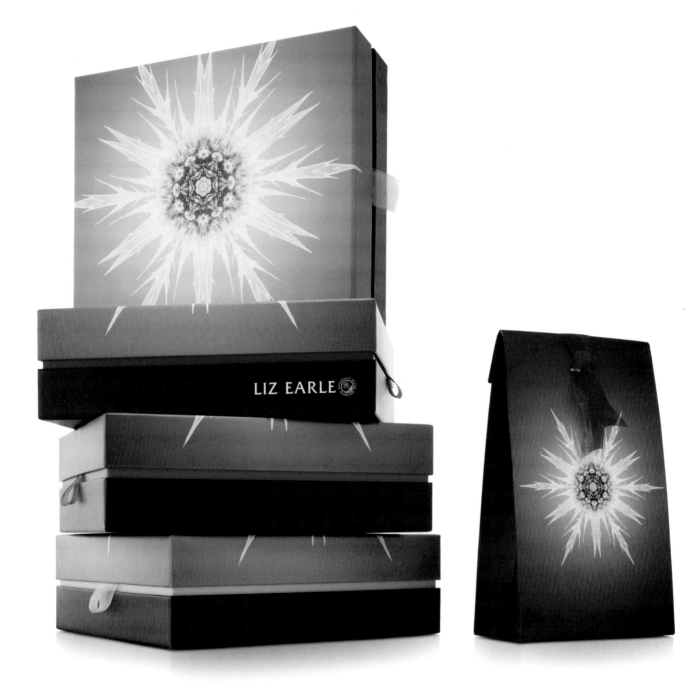

LIZ EARLE

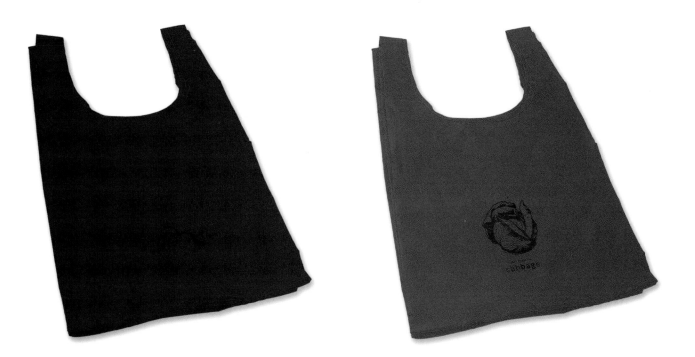

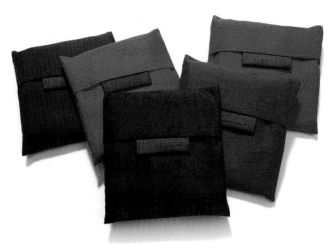

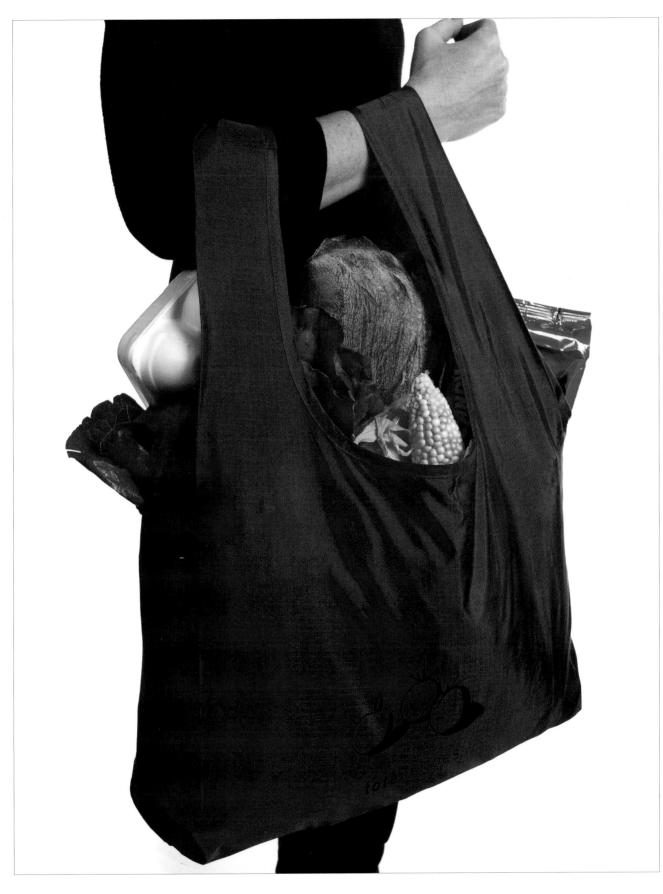

WILLOUGHBY DESIGN — KANSAS CITY, MISSOURI
Creatives : Ann Willoughby, Megan Semrick,
Janette Crawford, Nate Hardin, Nicole Satterwhite,
Becky Ediger, Luke Lisi
Client : Willoughby Design

WHAT'S GREEN ABOUT THIS — How many times have you gotten to the checkout counter and realized you've forgotten your reusable bags? Enter Willobag. This self-promotional product for Willoughby Design was designed to communicate their passion for innovation with good design that is also good for the world. Willobag folds up small and is easy to tuck in your purse, car, backpack or cargo pocket. They come in a variety of fruit and veggie puns and colors.

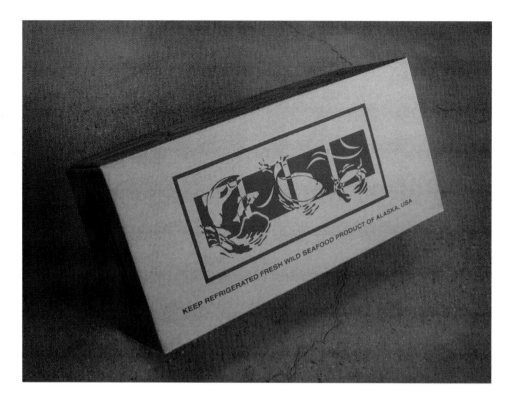

WHAT'S GREEN ABOUT THIS— West Coast Paper designed a new style of packing container for personal and commercial fish shipments. The box snaps together using a system of tabs, eliminating the need for staples or glue. Also, the box is free of the customary wax finish. The graphics reinforce the green qualities of the new container.

MAD DOG GRAPHX — ANCHORAGE, ALASKA
Creatives : Kris Ryan-Clarke
Client : West Coast Paper

254

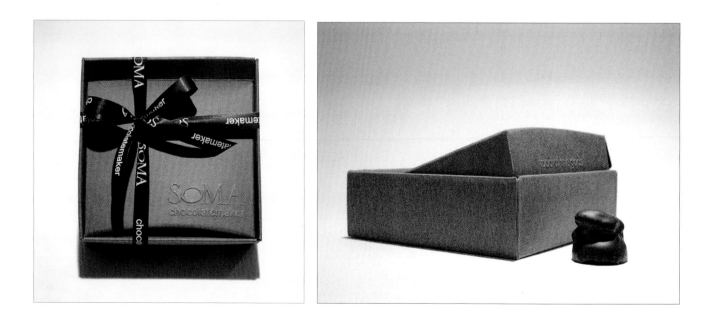

WHAT'S GREEN ABOUT THIS— SOMA is one of the few artisan chocolate makers in North America and the only chocolatier in Toronto that sources cocoa beans around the world, making chocolate in small batches directly from the beans. The owner desired new packaging boxes that were more ecologically sound than previous ones used by the company. While the well-proportioned box, minimum design, sculptured lid opening, and embossd logo all contribute to a strong identity for the brand and its artisan product line, recycled Kraft board, non-gluing processes, non-printing production reinforce the purity of the organic product.

STUDIO LIMING RAO — TORONTO, ONTARIO
Creatives : Liming Rao
Client : SOMA Chocolatemaker

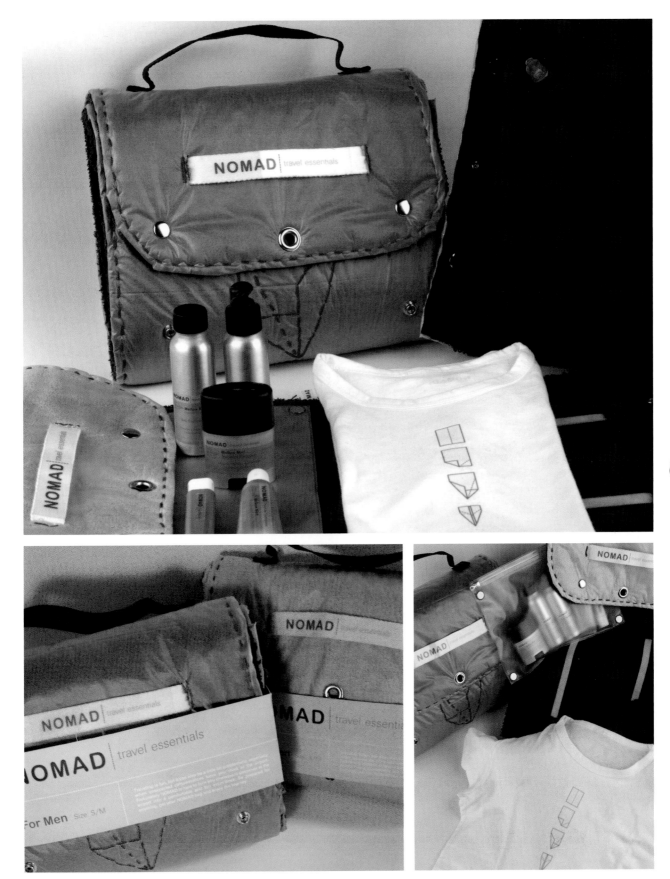

XIMENA MOLINA — SAVANNAH, GEORGIA
Creatives : Ximena Molina
Client : NOMAD (Student Project)

WHAT'S GREEN ABOUT THIS— With sustainability in mind, NOMAD is a travel emergency kit that was designed out of recycled and reused shower curtains and towels. It contains a fresh t-shirt, a built-in inflatable pillow and basic toiletries inside a package that serves as a handy and practical bag. The bag itself serves as the package and the belly band that it surrounds contains basic instructions to take care of the items.

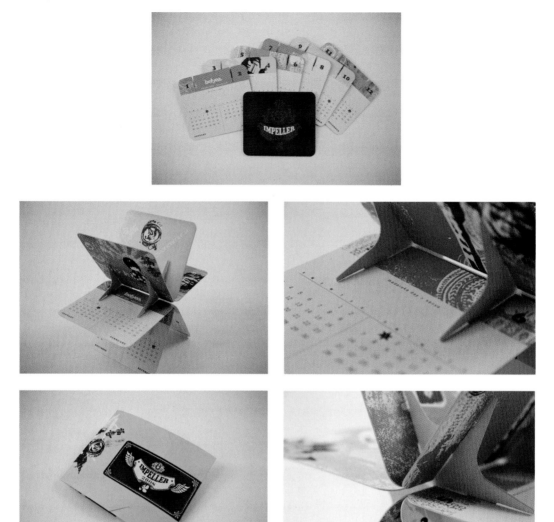

256

WHAT'S GREEN ABOUT THIS — Historically, Belyea produced an annual calendar that printed on three press sheets—one cover-weight and two text-weight parent sheets. The Impeller was produced on one sheet of sustainable cover-weight paper and laser die-cut to create a custom desktop calendar.

BELYEA — SEATTLE, WASHINGTON
Creatives : Patricia Belyea, Ron Lars Hansen, Nicholas Johnson, Aaron Clifford
Client : Belyea

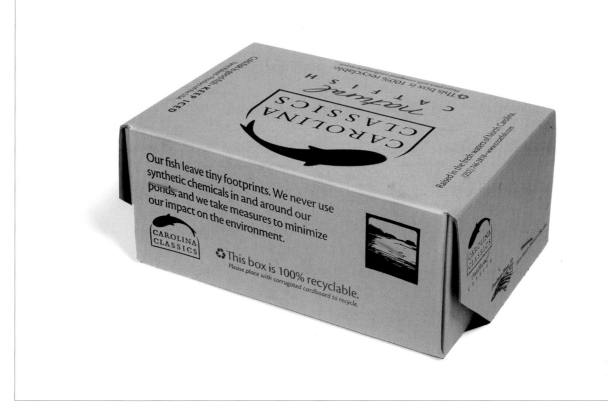

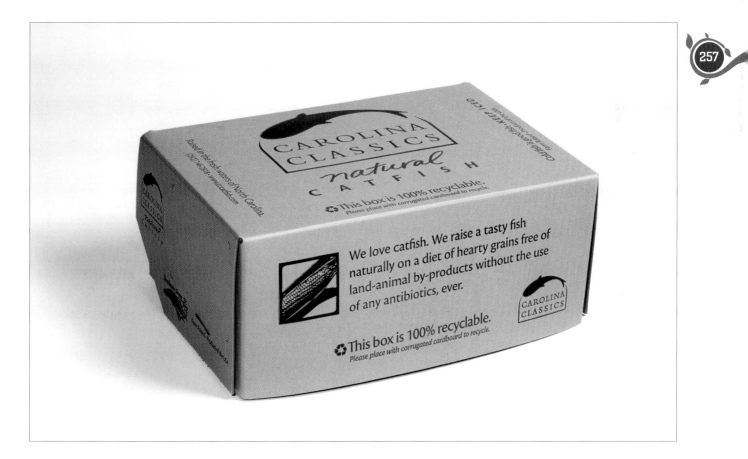

KABLE DESIGN + RESEARCH — GREENVILLE, NORTH CAROLINA
Creatives : Kate Ann B. LaMere
Client : Carolina Classics Catfish

WHAT'S GREEN ABOUT THIS — Carolina Classics Catfish is the first seafood producer in the United States to abandon wax-lined distribution boxes in favor of a sustainable alternative for its all-natural seafood product line. The new box is 100% recyclable and produced with approximately 95% recycled fibers.

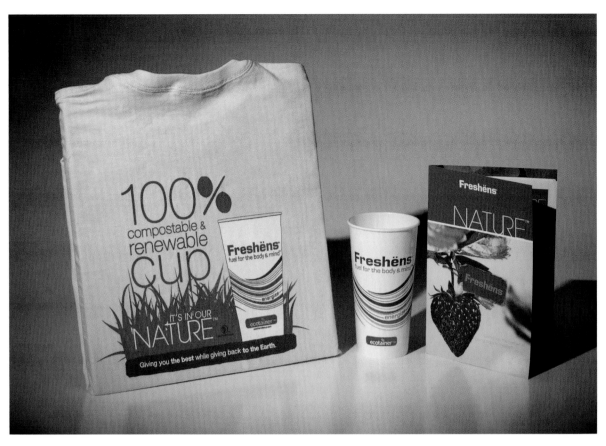

258

WHAT'S GREEN ABOUT THIS — Informational brochures and t-shirts increase awareness about Freshëns' ecotainer™ Paper Cold Cup. The fiber and coating in the cup are sourced from fully renewable resources. The trees used to make the paper cup come from a system independentally certified to adhere to SFI guidelines. The water-resistant lining is produced from corn grown in the United States and is processed in a greenhouse gas neutral manner. The brochure itself is printed at half the industry standard size, cutting paper use by 50%. Soy ink is printed on the 30% recycled stock.

ID8, INC. — MARIETTA, GEORGIA
Creatives : Kriston Sellier, Julie Cofer
Client : Freshëns Green Initiative

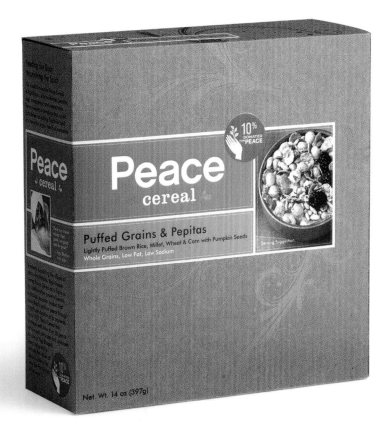

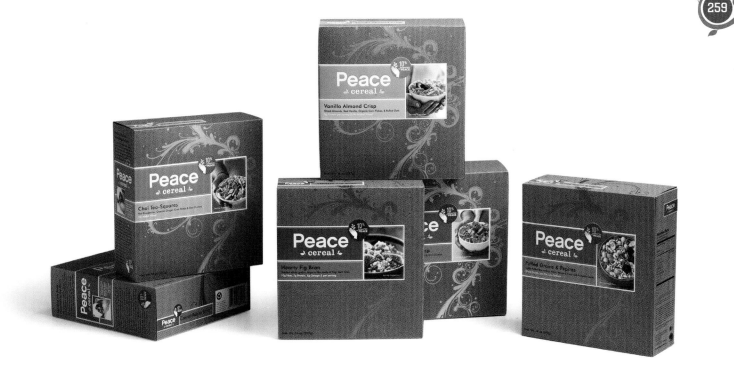

259

HATCH DESIGN LLC — SAN FRANCISCO, CALIFORNIA
Creatives : Katie Jain, Joel Templin
Client : Peace Cereal

WHAT'S GREEN ABOUT THIS — These cereal boxes are smaller than most, allowing more boxes to be packed per carton and displayed on shelf. This reduces the footprint of everything from fuel for shipping to retail space and eliminates the use of excess paper materials. Uncoated kraft paper was used as the base material.

Green In Action
Materials

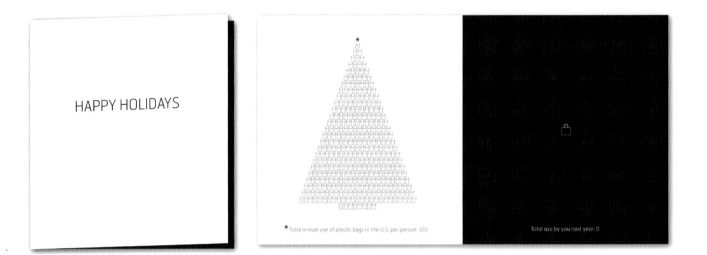

HAPPY HOLIDAYS

*

* Total annual use of plastic bags in the U.S. per person: 333

Total use by you next year: 0

IF I HEAR THE WORD 'GREEN'

ONE MORE TIME I SWEAR

I WILL SWITCH BACK TO

P L A S T I C

WHAT'S GREEN ABOUT THIS— This self-promotion piece was given to clients, vendors, and collaborators. The 100% Organic Cotton tote bags were shipped in time for the holidays, with a card showing a Christmas tree made of 333 plastic bags (the total annual used per person in the U.S.) Across the card was one tote bag, with the statement, "Total annual use of plastic bags by you: 0".

GEYRHALTER DESIGN — SANTA MONICA, CALIFORNIA
Creatives : Fabian Geyrhalter
Client : Geyrhalter Design

262

WEATHER CONTROL — SEATTLE, WASHINGTON
Creatives : Josh Oakley
Client : Eye Can Art

WHAT'S GREEN ABOUT THIS — Eye Can Art is a line of art kits for kids 5 and up It is a fundamentally green product. Each kit comes in a fully recyclable can which can also be used for storage and other creative purposes once the contents are used up. The labels are printed at Seattle's Olympus Press, which uses 100% post-consumer waste paper and high-definition printing for minimal environmental impact.

WHAT'S GREEN ABOUT THIS— Mugnaini Wood-Fired Ovens wanted to offer their customers a useful, beautiful thank-you gift filled with oven essentials. Design Source Creative created a reuseable, multi-purpose gift box made with pine from sustainable forests. The hinges were made from repurposed auto steel, and the brand wrapper was printed on recycled stock, using vegetable-based inks.

DESIGN SOURCE CREATIVE, INC. — APTOS, CALIFORNIA
Creatives : Cari Class, Stacey Boscoe
Client : Mugnaini Imports, Inc.

264

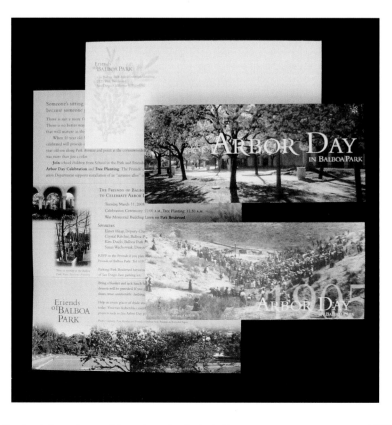

WHAT'S GREEN ABOUT THIS— There is no better way to engage future park supporters than to plant trees that will mature as they do. "Someone's sitting in the shade today because someone planted a tree a long time ago." This invitation (printed on recycled paper) invited the public to join children from School in the Park and the Friends of Balboa Park to celebrate their first annual Arbor Day celebration and tree planting.

CWA INC — SAN DIEGO, CALIFORNIA
Creatives : Calvin Woo, Sivlyly
Client : Friends of Balboa Park

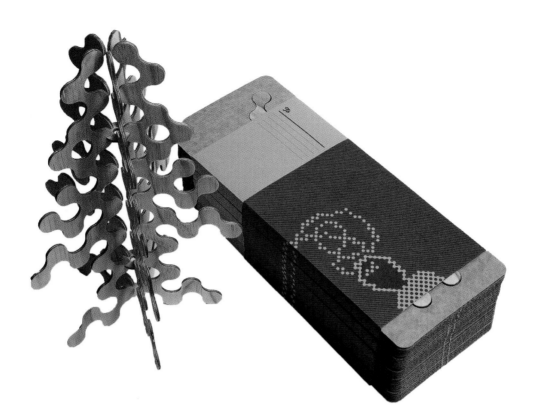

BÜRO NORTH — MELBOURNE, AUSTRALIA
Creatives : Soren Luckins, Sarah Napier,
Tom Allnutt, David Williamson
Client : Büro North

WHAT'S GREEN ABOUT THIS— Our 'green' tree is 80% more environmentally friendly than a traditonal pine X-Mas tree. Firstly, it is made with environmentally aware ingredients, it is CNC routered (a low-energy production technique) with waste material minimized by design. The flat-packed tree is emissions-efficient to transport and the most sustainable feature of the green tree is that you can use it for many Christmases to come.

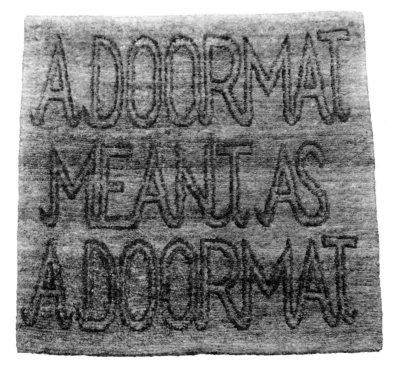

NETRA NEI — SEATTLE, WASHINGTON
Creatives : Netra Nei
Client : Ornamo

WHAT'S GREEN ABOUT THIS— Ornamo is a modern furniture showroom whose collection highlights the organic beauty of natural materials found in the designs of artisans and craftspeople from the Pacific Northwest as well as international designers. The doormat was designed for use in the store as well as for retail sale. Colored with natural dyes, the mat is made from the renewable resource hemp.

WHAT'S GREEN ABOUT THIS— The Urdd is a movement for children and young people which organizes activities across Wales to give children and young people the chance to learn and socialise through the medium of Welsh and to learn to respect each other and people around the world. Each year, youth groups come together to create a message that they would like to send to the world. In 2008, the group decided to send a message about the environment through a special song. The message is also represented in print, printed on recycled pulp board, using vegetable inks and a green ISO standard printer. Although the print piece reflected a CD wallet to reinforce a connection to music, the song was not mass-produced on CD but as a web download referenced in the print materials. The symbol of the tree was die cut out of the case to reveal the leaflet, hence avoiding print on the outer wallet.

ELFEN — CARDIFF, UNITED KINGDOM
Creatives : Guto Evans, Wayne Harris
Client : URDD

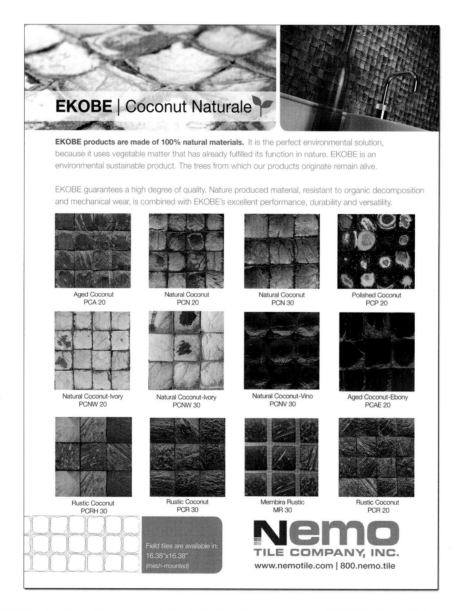

WHAT'S GREEN ABOUT THIS — Nemo Tile is a tile company based in New York City. They offer a diverse selection of tile material, in various size, color, and mosaic options. EKOBE is just one of their eco-friendly tiles. Made from 100% natural materials.

BULLDOG CREATIVE SERVICES — HUNTINGTON, WEST VIRGINIA
Creatives : Chris Michael, Christine Borders, Megan Ramey-Keelin
Client : Nemo Tile

ALR — RICHMOND, VIRGINIA
Creatives : Another Limited Rebellion
Client : Ma-Yi Theater Company

WHAT'S GREEN ABOUT THIS — A multi-purpose, folded self-mailer/poster. One item that does the job of two and being a self-mailer it also eliminates the need for envelopes. Printed on Rolland Enviro 100, 100% PCW.

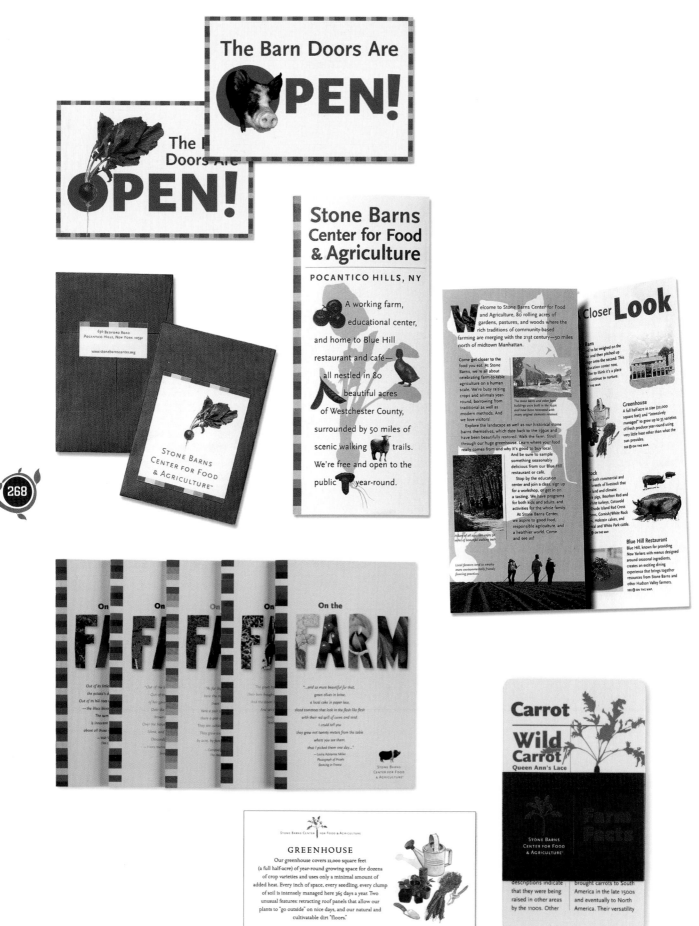

269

ALEXANDER ISLEY INC. — REDDING, CONNECTICUT
Creatives : Alexander Isley, Aline Hilford,
Tara Benyei, Cherith Victorino, Hayley Capodilupo
Client : Stone Barns Center for Food and Agriculture

WHAT'S GREEN ABOUT THIS— Stone Barns Center for Food and Agriculture is a new facility that will serve as an educational center, working farm, and restaurant devoted to farm-to-table sustainable agriculture. The Center is located on an eighty-acre parcel of land in Pocantico Hills, New York, on part of the Rockefeller family estate.

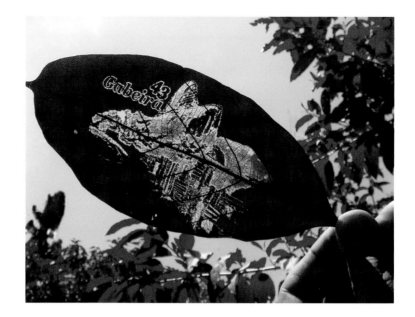

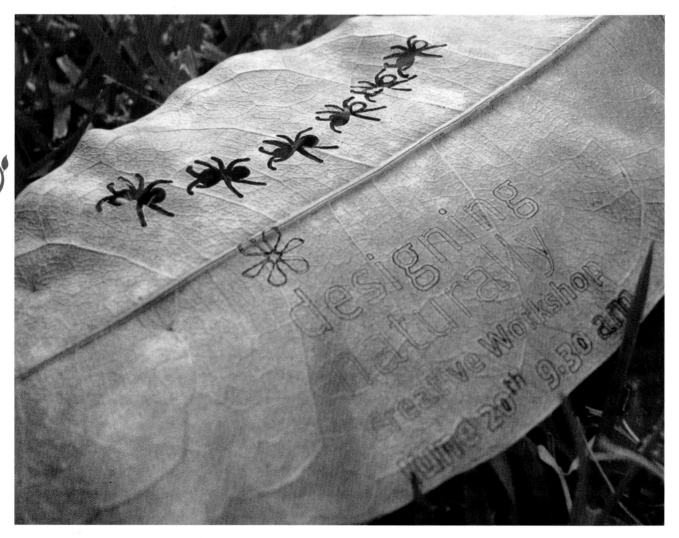

WHAT'S GREEN ABOUT THIS — Tatil Design wanted to invite people to their "Designing Naturally" workshop, part of the 55th Cannes Publicity Festival's program of creative workshops. The purpose of the workshop was to discuss the role of design as a tool to transform the future, giving examples of solutions with low environmental and high sensorial impact. That purpose informed the choice of the material for their invitations. They collected a few of the many fallen leaves on the streets of Rio de Janeiro, then asked the Tátil team to select images that were somehow linked to the theme "Designing Naturally." Images were laser-printed along with the information they had to convey: the time and date of the workshop. Simple, different, meant to be looked at against sunlight, their invitation became a new medium—a flyer that is actually supposed to be thrown away on the ground—paint-free, borrowed from nature for a purpose, and then returned to it.

TÁTIL DESIGN — RIO DE JANEIRO, BRAZIL
Creatives : Fred Gelli, Ana Camargo,
Luciana Moletta, Bruno Senise
Client : Tátil Design and Fernando Gabeira

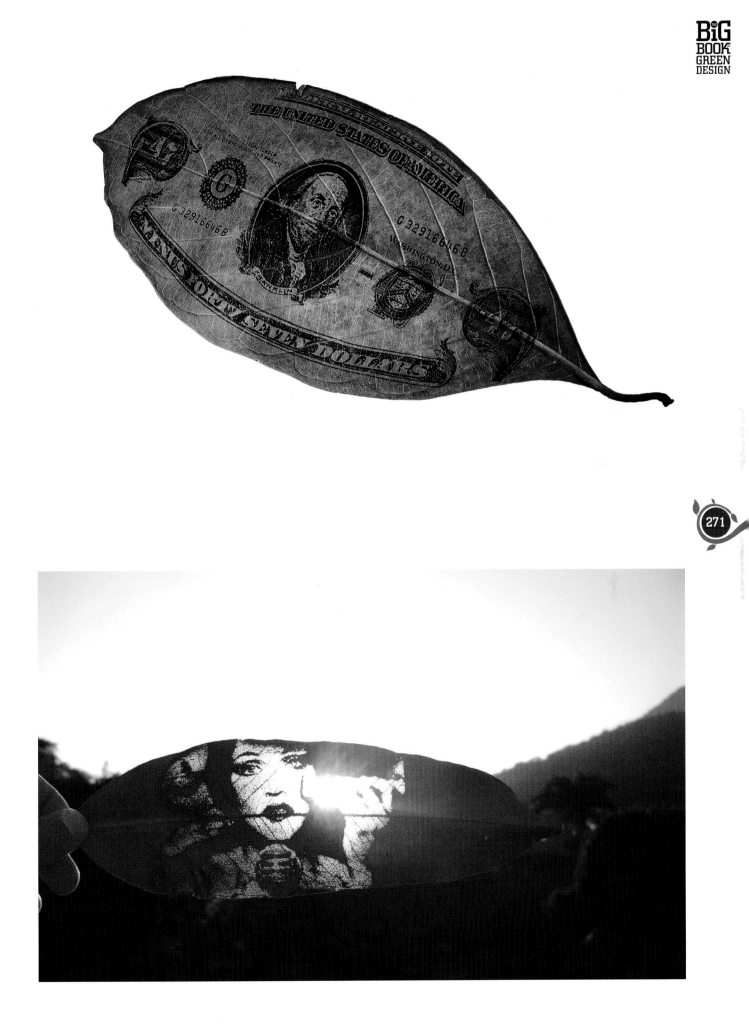

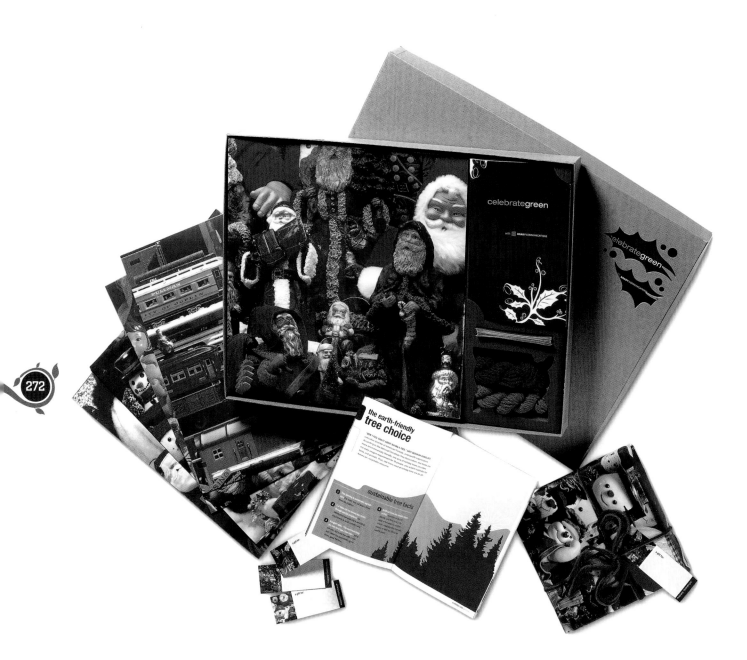

272

WHAT'S GREEN ABOUT THIS— To celebrate the holiday season, Brady Communications created a gift package with a sustainable theme. "Celebrate Green" consisted of a custom box containing gift wrapping and supplies. All of the contents were eco-friendly: recycled papers, soy inks, and biodegradable materials. A 12-page booklet containing information on sustainability accompanied each gift package.

BRADY COMMUNICATIONS —PITTSBURGH, PENNSYLVANIA
Creatives : John Brady, Corey Tiani, Dawn Patton, Janine Hochman
Client : Brady Communications

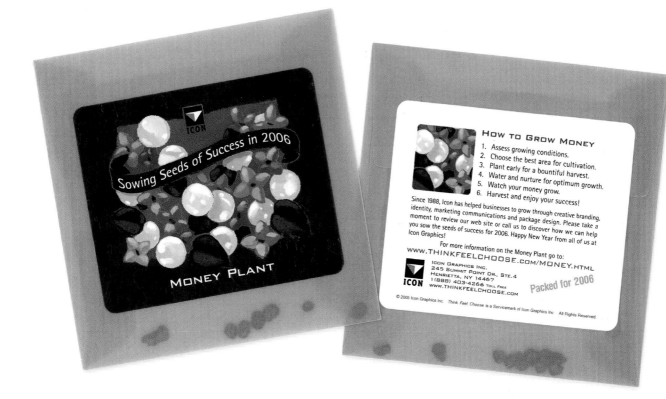

How to Grow Money

1. Assess growing conditions.
2. Choose the best area for cultivation.
3. Plant early for a bountiful harvest.
4. Water and nurture for optimum growth.
5. Watch your money grow.
6. Harvest and enjoy your success!

Since 1988, Icon has helped businesses to grow through creative branding, identity, marketing communications and package design. Please take a moment to review our web site or call us to discover how we can help you sow the seeds of success for 2006. Happy New Year from all of us at Icon Graphics!

For more information on the Money Plant go to:
WWW.THINKFEELCHOOSE.COM/MONEY.HTML

ICON GRAPHICS INC.
245 SUMMIT POINT DR., STE.4
HENRIETTA, NY 14467
1 (888) 403-4266 TOLL FREE
www.THINKFEELCHOOSE.com

Packed for 2006

© 2005 Icon Graphics Inc. *Think. Feel. Choose.* is a Servicemark of Icon Graphics Inc All Rights Reserved

273

ICON GRAPHICS, INC. — HENRIETTA, NEW YORK
Creatives : Icon Graphics, Inc.
Client : Icon Graphics, Inc.

WHAT'S GREEN ABOUT THIS— This self-promotional piece is full of money plant seeds. The parallel is that seeds grow and so can the client's business with the appropriate branding.

WHAT'S GREEN ABOUT THIS — This one-piece wedding invitation was printed on recycled paper. It is a self-contained piece; no separate envelope was used. The format size and barrel fold were developed to meet mailing guidelines. The invitation was closed with a wafer seal and the RSVP was perforated to create a postcard. The front and back panels have corresponding, complete information for the event (enabling this to be the only mailing that went out). Smaller cards (which guests brought to the event, in lieu of a guestbook) are held in place with die-cuts. These were printed on recycled stock, on an inkjet printer, quantity as needed. Placecards were created in the form of various abstracted leaf shapes, and the wedding program continued the system—with a simple die cut to secure an inserted twig, dividing the information.

THRIVE DESIGN — EAST LANSING, MICHIGAN
Creatives : Kelly Salchow MacArthur
Client : Kelly Salchow & James MacArthur

274

WHAT'S GREEN ABOUT THIS — This 50th Anniversary invitation is made using only environmentally responsible paper and inks by an FSC-certified printing-press facility. The invitation is also green in principle: All three elements of the invite, (the envelope, letter, and name tag), were printed on one sheet of recycled paper per invitation.

MINDS ON, INC. — LEWIS CENTER, ALABAMA
Creatives : Tom Augustine, Kaydee Blinn, Mike Campanaro
Client : Bruner Corporation

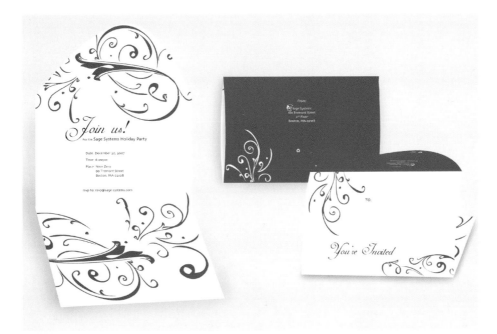

SAGE SYSTEMS — MASSACHUSETTS
Creatives : Sahba Fanaian, Yvette Perullo,
Boyds Direct Printer
Client : Sage Systems

WHAT'S GREEN ABOUT THIS — In-house invitation design for the Sage Systems annual holiday party. The goal was to reduce the environmental impact of this piece by designing the invitation as a self-mailer to minimize paper use. RSVPs were requested via email instead of a reply card to further eliminate the use of paper. This was a small two-color print run printed digitally for less waste during proofing. The paper is 30% post-consumer waste recycled stock.

275

AXIOMACERO — MONTERREY, MEXICO
Creatives : Mabel Morales,
Carmen Rodriguez
Client : AxiomaCero

WHAT'S GREEN ABOUT THIS — This marketing and design firm wanted their new image to convey their commitment to the environment as well as their creativity and to use only environmentally friendly materials. They chose recycled kraft paperboard as the base paper because its production eliminates the use of bleach and other chemicals that are hazardous both to the environment and to humans. Where white paper was needed, they chose ESSE Pearlized Papers, which are Green Seal-Certified and manufactured using all organic materials. No foils or metals are employed to create the pearl effect. The contrast of combining the two very different papers created a unique effect for their corporate identity.

WHAT'S GREEN ABOUT THIS — This graphic design firm decided to rethink traditional stationery systems to convey their corporate identity. They placed the firm's name only on the back of the letterhead, making use of what is typically a blank page. On an environmental and economic level, the tipped-in address label allows the printed stationery to extend its usefulness even if the firm's location is later changed. Soy inks and recycled paper were used.

SCOTT ADAMS DESIGN ASSOCIATES —
MINNEAPOLIS, MINNESOTA
Creatives : Scott Adams
Client : Scott Adams Design Associates

276

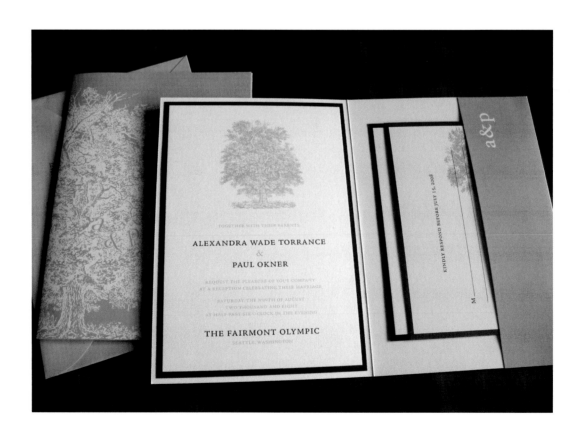

WHAT'S GREEN ABOUT THIS — These clients came to Brown Sugar Design seeking chic wedding stationery, but they were both concerned that everything associated with their wedding be environmentally conscious. Considering their style and concerns about the environment, Brown Sugar designed a custom pocket-style invitation suite printed on 100% post-consumer waste stock with soy inks. The envelopes are 30% post-consumer waste.

BROWN SUGAR DESIGN — KIRKLAND, WASHINGTON
Creatives : Jonathan Speir, Whitner Speir
Client : Allie Torrance and Paul Okner

NINE BRAND NEW STORIES

277

Some of the best work we do is for organizations that are either newborn or changing. Why do we favor these moments? Because that's when branding is more than a nice-to-have item; it's a business imperative.

We were fortunate to have many of these types of assignments in 2007. While the clients are diverse, our engagements were all focused on the brand. They included:

■ **brand extension**—helping emerging national law firm Mintz Levin become known in new markets

■ **brand alignment**—sharpening the market message of global players like SHRM (Society for Human Resource Management) and World Wildlife Fund

■ **brand expression**—articulating the value propositions of Sterne Kessler in *D.C.*, McAndrews in *Chicago* and Pierce Atwood in *Portland, Maine*

■ **brand leadership**—showing how Choate can succeed *by any measure* and how Nixon Peabody has turned its focus to being *legally green*.

The challenges our clients face may seem similar on the surface, but we've learned that every firm, every organization, every business is unique. Our job is to help the internal transformation, constant in every successful business, emerge and take flight.

— *Joe Walsh, Jeffrey Morgan and Burkey Belser*

GREENFIELD/BELSER LTD — WASHINGTON, D.C.
Creatives : Burkey Belser, Mark Ledgerwood, Joe Walsh, Gene Shaffer
Client : Greenfield/Belser Ltd.

WHAT'S GREEN ABOUT THIS — Greenfield/Belser's annual review was printed by Mosaic, a 100% wind-powered print communications solution provider, using 100% FSC-certified, post-consumer recycled paper.

WHAT'S GREEN ABOUT THIS — As NJ is known for its fine produce, Rizco Design borrowed an organic, apple-based identity from the state's reputation and developed a theme for the 2008 Art Directors' Club of New Jersey Awards Show. Building on that green theme, they made all their end products recyclable. They utilized gang runs, which minimize paper waste as well as running time, ink, and energy and require only one set of plates for the job. All components were offset-printed with limited ink coverage on FSC-Certified, 100% recycled, carbon-neutral, Green-e certified, windpowered, and Green Seal-Certified paper.

RIZCO DESIGN — MANASQUAN, NEW JERSEY
Creatives : Keith Rizzi
Client : Art Directors Club of New Jersey

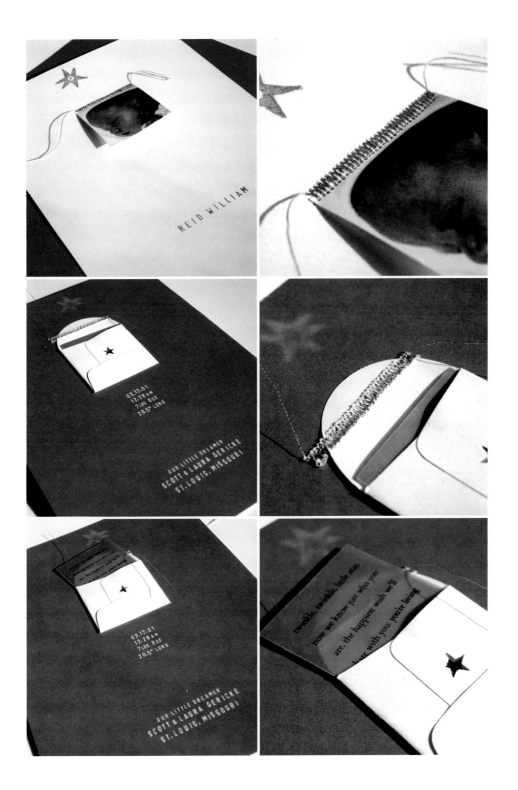

DESIGNLAB, INC. — ST. LOUIS, MISSOURI
Creatives : Scott Gericke, Laura Gericke
Client : Scott and Laura Gericke

WHAT'S GREEN ABOUT THIS — New parents and designers Laura and Scott Gericke made their own green birth announcements for the birth of their son, Reid. They printed his little photo which was cut and hand-sewn onto the card. The reverse side features a little envelope containing a poem printed on blue vellum.

How They Did It
Mr. Ellie Pooh Paper

It takes a brave and imaginative person to find inspiration in elephant dung but Karl Wald has done just that. First, a little backstory.

A few years ago Wald became tired of his 9–5 existence and began searching for alternatives. An avid animal lover, he was drawn to the plight of Asian elephants in Sri Lanka. Their population has been dwindling due to the overlap of their roaming territories and Sri Lankan agricultural fields. Wald wondered if the elephant's presence could potentially benefit indigenous farmers. That's when he learned that the Sri Lankan company Eco Maximus company had discovered a way to make paper from elephant droppings.

"Since an elephant's diet is all vegetarian, the waste product is basically raw cellulose," Wald explains. "Thoroughly cleaned and processed, it can be converted into a uniquely beautiful, textured paper." Wald brought the idea to the United States where he markets Mr. Ellie Pooh paper products. The papyrus-type paper is acid-free with a linen-like finish.

"Paper usually is not earth-friendly," Wald says. "Why not use a paper that is 100 percent earth-friendly? Our paper is 75 percent 'Ellie Poo' and 25 percent post-consumer recycled. There are no harsh chemicals used in the paper-making process, only natural vegetable products. Every use can make a difference: product tags, thank-you notes, wedding invitations, media kits. Anything you can use paper for."

Mr. Ellie Pooh costs more than conventional papers but is less expensive than designer or handmade papers. "Our paper is perfect for someone who wants to make a statement or wants to convey their organization's specialness," Wald says. The paper also benefits Sri Lankan farmers. The elephants that roam their fields each produce up to 500 pounds of dung a day. The farmers can sell this dung to the paper manufacturers. "It provides a way of converting a liability into an asset," Wald says. Wald now works with Eco Maximus to open paper manufacturing centers in Sri Lanka and to train Sri Lankans in the craft of paper-making. "We are attempting to save elephants by creating paper-making jobs in areas where people are killing wild elephants," Wald says. "If we can pay villagers more money to make paper than they would make growing a rice crop, they can buy rice elsewhere, thus preserving habitat, saving these noble beasts."

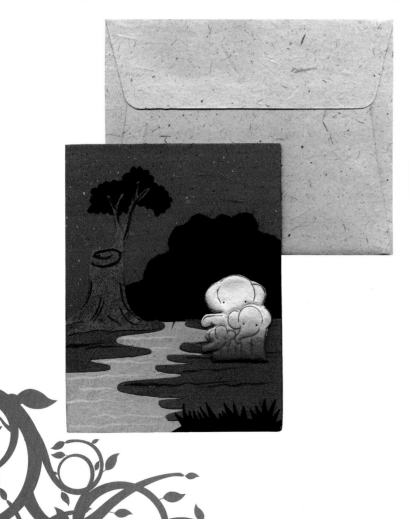

MR. ELLIE POOH PAPER — BROOKLYN, NEW YORK
Creatives : Karl Wald, Annika, DeMilo Design/Sustain and Heal, Dee and Lala, Mr. Ellie Pooh
Client : Mr. Ellie Pooh Paper

Jordyn and Diane Chace, Maryland 20854

With great pride, we invite you to share our joy when our daughter

Jordyn Zoe

is called to the Torah as Bat Mitzvah

Saturday, the twenty-fourth of January, two thousand nine

at half past five in the evening

reception to follow

Temple Beth Ami, 14330 Travilah Road, Rockville, Maryland 20850

Diane Belotin Chace and Richard Chace

"Unless someone like you cares a whole awful lot, nothing is going to get better. It's not." – Dr. Seuss, The Lorax

Please respond on or before December 30, 2008

M _____

accept with pleasure

decline with regret

Jordyn Chace
15 Old Creek Court
Potomac, Maryland
20854

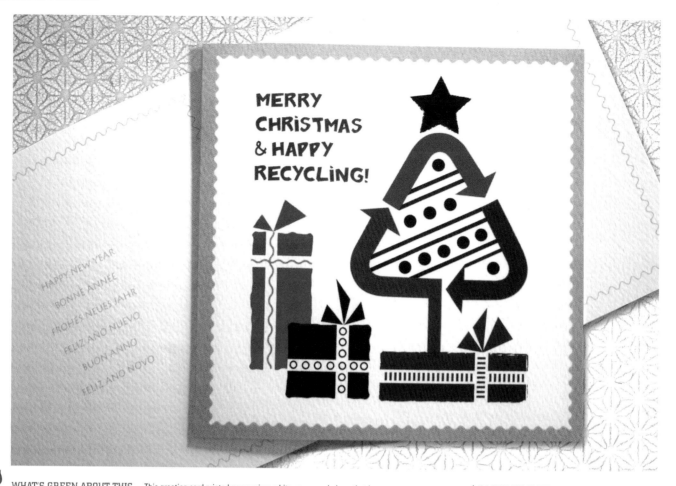

WHAT'S GREEN ABOUT THIS — This greeting card printed on premium white paper reminds us that by recycling wrapping paper, envelopes, and cardboard gift boxes we can save thousands of trees and keep our planet green. Even the shape of the Christmas tree represents the well known recycling sign.

DASHA WAGNER — STATE CENTER, IOWA
Creatives : Dasha Wagner
Client : Ooprint

WHAT'S GREEN ABOUT THIS — Every aspect of this education conference emphasized minimizing its ecological footprint. The production employed ecologically conscious materials and measures for minimal environmental impact. The designers worked with green printing facility Hemlock Printers and Mohawk Paper, using 100% post-consumer recycled stock, manufactured with 100% windpower. Throughout the production process, they monitored waste and consumption impacts with ongoing eco-audits—the results of which are reported in the back of the program guide book. Paper, water and other resources were saved by gang-running several of the pieces together and by reducing the size of the book from 8.5x11 to 4x6. Name-badge holders were collected for reuse after the event, and attendees were asked to bring their own canvas tote bags rather than producing an event-specific tote.

MINE™ — SAN FRANCISCO, CALIFORNIA
Creatives : Christopher Simmons, Tim Belonax
Client : Coalition of Essential Schools

Make the extraordinary happen.

BE A WINNER AT LS&CO.

GLOBAL PLAYER adopts and adapts
WORLD-READY
CONNECTED
OPERATES ACROSS BOUNDARIES
EMBRACES DIFFERENCES
CITIZEN OF THE WORLD
DRIVES FOR EFFICIENCY
SEEKS OUT BEST SOLUTIONS
GLOBAL PERSPECTIVE

GLOBAL MINDSET

protects the BRAND
COMPANY AND TEAM FIRST
proudly found elsewhere

BE A WINNER AT LS&CO.

perseveres
PRIORI
sets new standards
DELIVERS RESULTS WITH URGENCY
owns
DISSATISFIED WITH SECOND BEST
BEATS
THE PLAN

DRIVEN to WIN

adapts quickly
MAKES A DIFFERENCE
passionate BOLD
ACCOUNTABLE

BE A WINNER AT LS&CO.

283

Think beyond your boundaries.

BE A WINNER AT LS&CO.

THE VEGA PROJECT — SAN FRANCISCO, CALIFORNIA
Creatives : Jeff Caldwell, Danielle Gutherie
Client : Levi Strauss and Company

WHAT'S GREEN ABOUT THIS — The Vega Project collaborated with Levi Strauss and Company to brand and launch a new initative. The project included creating promotional and educational materials including a Flash™-based portal. All materials were printed on 100% post-consumer waste recycled paper from French Paper Company. They also created notebooks from the scraps of the project.

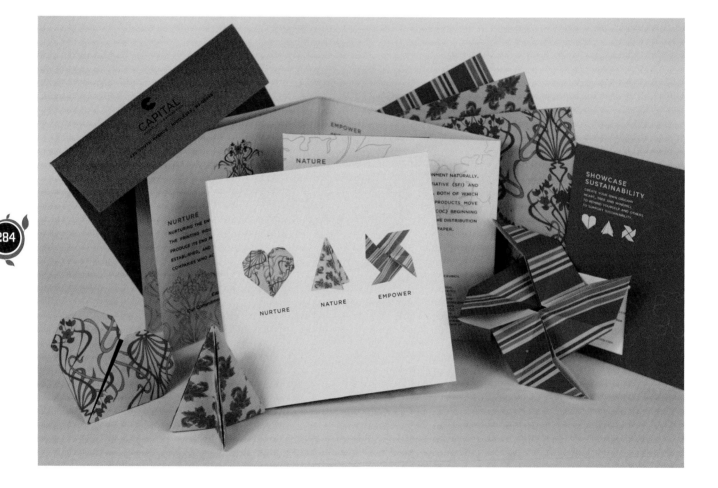

284

RIZCO DESIGN — MANASQUAN, NEW JERSEY
Creatives : Keith Rizzi, Jennifer Pesce
Client : Capital Printing Corporation

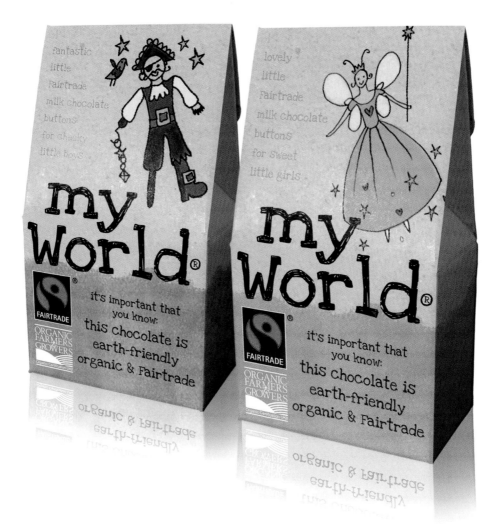

285

PURE EQUATOR LTD — NOTTINGHAM, UNITED KINGDOM
Creatives : David Rogers, Rhian Moore
Client : Winterbotham Darby

WHAT'S GREEN ABOUT THIS — The designer sourced compostable inner bags and 100% recycled card for the carton and ensured it was printed and produced in the UK to save transport miles. The chocolate is certified Organic and Fairtrade. They have supported this product with a website full of things to do, environment quizzes to educate, drawings to inspire, and a free downloadable children's book.

WHAT'S GREEN ABOUT THIS — 2020 Vision/Powershift Brochure designed alongside full event design for a certified carbon-free national tour for Environmental advocacy group, 2020 Vision. Printed on FSC-certified, post-consumer recyclable stock and printed with soy-based inks.

MATTHEW SCHWARTZ DESIGN STUDIO —
NEW YORK, NEW YORK
Creatives : Matthew Schwartz, Niall O'Kelly
Client : Acumen Fund

Capital +

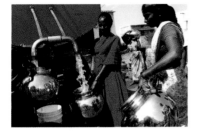

Our investment model values financial and social returns

Acumen Fund 2007 Investment Pipeline

	Country	Description	Investment
Health	Kenya	Fortified flour manufacturer looking to diversify its distribution to AIDS patients	$1,000,000
	Uganda	Pharmaceutical company seeking to distribute low-cost drugs for HIV and malaria on a large scale	$500,000
Water	India	Irrigation systems for rural farmers	$1,000,000
	India	Low cost water purification systems for small rural villages	$175,000
	India	Solar-based water distillation products with purification capacity of 1,500-2,000 liters per day	$55,000
	Kenya	High quality, environmentally-sound sanitation facilities	$250,000
	Pakistan	Affordable drip irrigation products marketed and sold to farmers	$400,000
	Pakistan	Treated water marketed & distributed through private & NGO channels	$400,000
	South Africa	Purified water for low-income household consumers	$500,000
	Uganda	Financial institution providing affordable credit to private water operators–resulting in an expanded water supply infrastructure	$250,000
Housing	India	New company that provides mortgages and home improvement loans to low-income people	$1,100,000
	India	Microfinance organization seeking to launch affordable home improvement loans for the urban poor	$1,250,000
	Kenya	Microfinance organization seeking to provide affordable mortgages for 2,090 households from the admit slums of Nairobi	$270,000
	Pakistan	Expanding microfinance provider that is increasing its membership base and diversifying its product offerings	$5,060,000
	Pakistan	Building affordable homes for low income people	$100,000
	Pakistan	Mortgage provider to low-income people without access to credit	$900,000
	Total Investment Pipeline		$14,790,000

The Model

Our investment model values financial and social returns. [illegible body text]

Our mainstay is philanthropic capital - patient capital that provides the flexibility to invest in very difficult environments. We typically invest in companies with a 2-3 year operating history, an established business model and revenue stream. We give active management support to help these enterprises grow.

Talent +

Building a new kind of leadership for the social sector

A Global Transfer of Entrepreneurial Knowledge

[illegible body text]

Case Study +

Our investment in A to Z helps fight malaria in Tanzania

A to Z Textile Mills is a family-owned maker of long-lasting insecticide-treated anti-malaria nets in Tanzania. [illegible body text]

Impact

[illegible body text]

Best Available Charitable Option Analysis for A to Z

	Acumen Fund Investment	Traditional Charity
Financial Cost	+ $325,000 loan (6% interest) in 2002 + $130,000 in-kind support + $402,500 loan payment + interest = $32,500 total cost	+ $325,000 grant = $325,000 total cost
Social Impact	+ 7 million long-lasting insecticide-treated nets produced annually + New technology transferred to A to Z + 4,000 jobs created	+ 92,857 traditional nets produced ($3.50/net)
Result	+ $0.02 to supply a person with a year of malaria protection	+ $0.84 to supply a person with a year of malaria protection

Join Us +

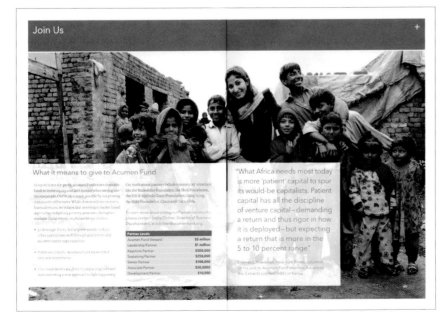

What it means to give to Acumen Fund

[illegible body text]

Our institutional partners include visionary organizations like the Rockefeller Foundation, the Skoll Foundation, the Bill & Melinda Gates Foundation, Google.org, the Nike Foundation, Cisco and Coca-Cola.

Partner Levels	
Acumen Fund Steward	$5 million
Leadership Partner	$1 million
Keystone Partner	$500,000
Sustaining Partner	$250,000
Senior Partner	$100,000
Associate Partner	$50,000
Development Partner	$10,000

"What Africa needs most today is more 'patient' capital to spur its would-be capitalists. Patient capital has all the discipline of venture capital–demanding a return and thus rigor in how it is deployed–but expecting a return that is more in the 5 to 10 percent range."

Thomas L. Friedman, New York Times columnist, on his visit to Acumen Fund investee Advanced Bio-Extracts Limited (ABE) in Kenya.

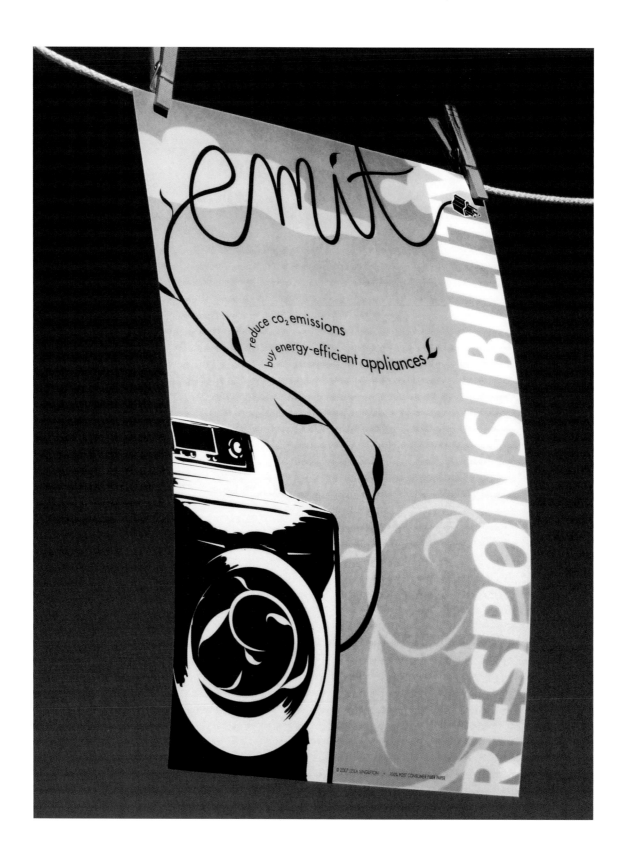

288

WHAT'S GREEN ABOUT THIS — Every two years, Graphic Responses—the Colorado International Invitational Poster Exhibition's digital satellite—calls for artists' visual responses to issues of international concern. "Emit Responsibility (not CO2)" was among the posters selected for 2007's electronic-only exhibition, addressing the issue of CO2 emissions from home appliances. The poster was produced in a limited edition of fifty 11" x 17" prints on an FSC-Certified stock manufactured using 100% renewable energy, chlorine-free processing, and 100% post-consumer fiber.

THE WHOLE PACKAGE — SAN FRANCISCO, CALIFORNIA
Creatives : Leila Singleton
Client : Graphic Responses 2007

HOUSEMOUSE™ — MELBOURNE, AUSTRALIA
Creatives : housemouse™
Client : The City of Glen Eira

WHAT'S GREEN ABOUT THIS — The concept behind the Glen Eira Annual Report 2007-08 was to incorporate the unique voices of the Glen Eira community, recycled elements, and of course the key data. The 280-page report was printed on environmentally friendly paper with vegetable-based inks and was printed by an FSC-Certified printer. The concept of the Glen Eira Community Plan 2008-2013 matches the concept of the annual report. The Glen Eira Community Plan is printed with vegetable-based inks on Options Recycled PC 100, a paper stock that is manufactured with non-polluting Green Power electricity generated from wind power and using 100% post-consumer waste fibers.

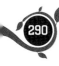

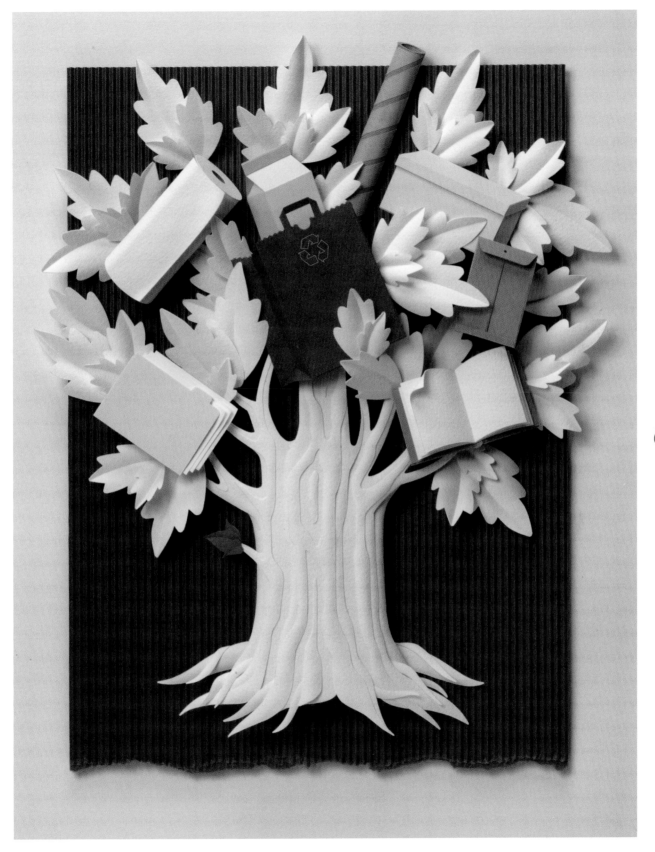

SALLY VITSKY ILLUSTRATION — RICHMOND, VIRGINIA
Creatives : Sally Vitsky, Gretchen Spears
Client : Sally Vitsky, American Forest & Paper Association

WHAT'S GREEN ABOUT THIS — All of these promotional pieces were created from sketches commissioned by the American Forest & Paper Association, for their sustainability program. All are 3-D paper sculpture art created with recycled papers, and additionally used for self-promotion.

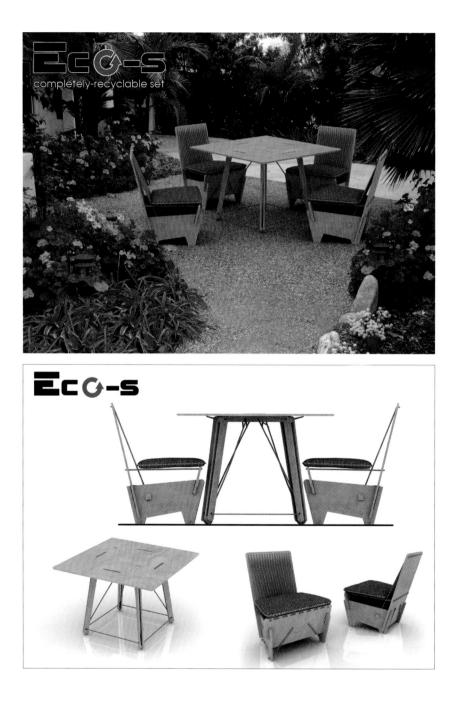

WHAT'S GREEN ABOUT THIS — The Eco-S is an economical, 100% recycled, do-it-yourself alternative outdoor furniture set of 4 seats and a table made from completely recycled materials without any production chemicals, metal components, pins, or bolts. Plywood sheets, natural jute and textiles are assembled by the user according to the directions. Production involves shaping the plywood (which is cut to minimize waste) and packaging the components. Minimal labor, material, and operating costs make the set economical to produce and affordable. All textiles use completely organic, natural fabric paints; cushion filling is made of processed corncobs. Plywood panels have a paraffin coating.

DESIGNNOBIS — ANKARA, TURKEY
Creatives : Hakan Gürsu Dr. Ind.
Client : designnobis

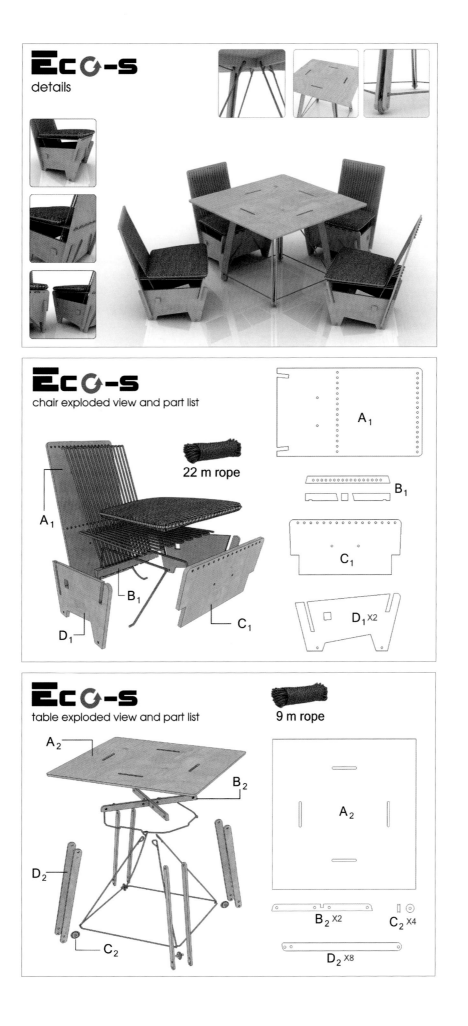

Ec⊘-s
details

Ec⊘-s
chair exploded view and part list

22 m rope

A_1

A_1

B_1

B_1

C_1

C_1

D_1

D_1 X2

Ec⊘-s
table exploded view and part list

9 m rope

A_2

B_2

A_2

D_2

B_2 X2

C_2 X4

C_2

D_2 X8

BiG BOOK GREEN DESIGN logo at top right, and "293" circular badge on right side.

BiG BOOK GREEN DESIGN

293

294

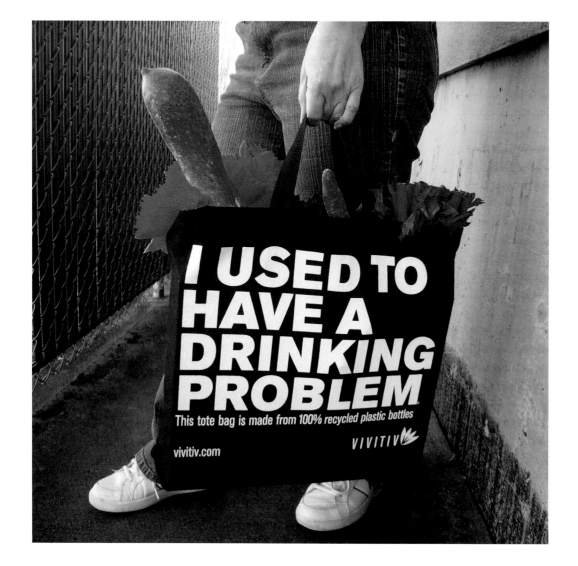

VIVITIV — SEATTLE, WASHINGTON
Creatives : Mark Kaufman, Jacqueline McCarthy
Client : Vivitiv

WHAT'S GREEN ABOUT THIS — Eight out of ten plastic bottles end up in the landfill—a real drinking problem. As a holiday promotion, Vivitiv sent out a tote bag made entirely of plastic bottles.

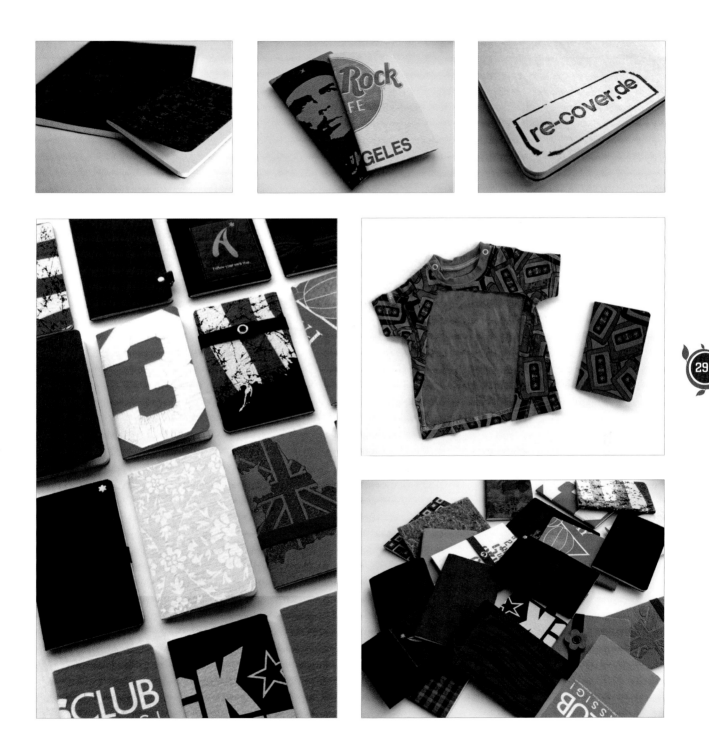

295

Y&R GERMANY — FRANKFURT AM MAIN, GERMANY
Creatives : Lea Perchermeier, Monika Spirkl, Helge Kniess, Daniel Tripp, Sarah Hirschhaeuser, Sandra Elm, Lothar Grim
Client : re-cover.de

WHAT'S GREEN ABOUT THIS — Everybody has a stash of old t-shirts they just can't bear to throw away: t-shirts from your first year at camp, t-shirts from your high-school play, t-shirts for your favorite environmental cause. They take up too much space, but they're full of memories and you don't want to add them to a landfill. www.re-cover.de takes your old t-shirts and turns them into covers for useful notebooks.

296

WHAT'S GREEN ABOUT THIS — WSN Environmental Solutions provides reliable and responsible recycling, resource recovery, and waste management services to the greater Sydney area and beyond. The Annual Report was produced on 100% recycled stock using vegetable oil-based inks in an alcohol-free printing process and is FSC-certified.

SPATCHURST — AUSTRALIA
Creatives : Steven Joseph, Sarah Magro
Client : WSN Environmental Solutions

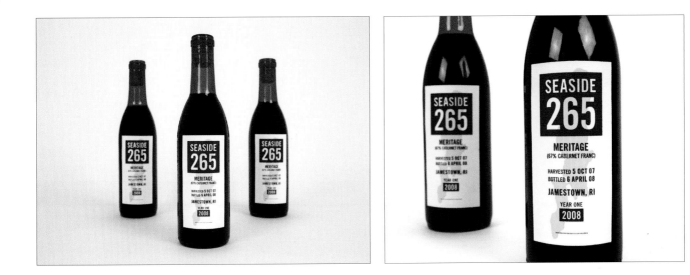

CITIZEN STUDIO — ATLANTA, GEORGIA
Creatives : Linda Doherty
Client : The Coustan Family

WHAT'S GREEN ABOUT THIS — The client, a private winemaker in Jamestown, Rhode Island, asked that the design for his first set of labels reflect both his mid-century modern taste and an artisan, hand-made feel. To solve the design problem with minimal waste, Citizen Studio created a clean, two-color design with letterpress printing. The labels were printed by hand at a local letterpress studio, with soy inks on 100% cotton printmaking paper. Non-toxic adhesive was added for applying the labels to bottles.

BAMBOO

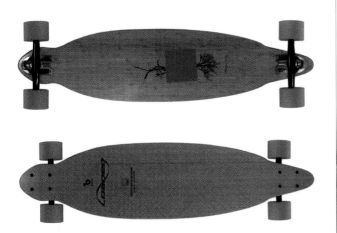

JANTONE — INDIANAPOLIS, INDIANA
Creatives : Jan Michael Bennett
Client : Loaded Boards

WHAT'S GREEN ABOUT THIS — Established in 1995, Loaded Boards produces and sells longboards out of California. Their innovative combination of cutting-edge technology and sustainable resources has made them a leading company in environmental responsibility and design. As part of their transition to using bamboo and soy- based inks in the construction of their longboards, Loaded sought nature-inspired graphics along with a logo indicating the materials used.

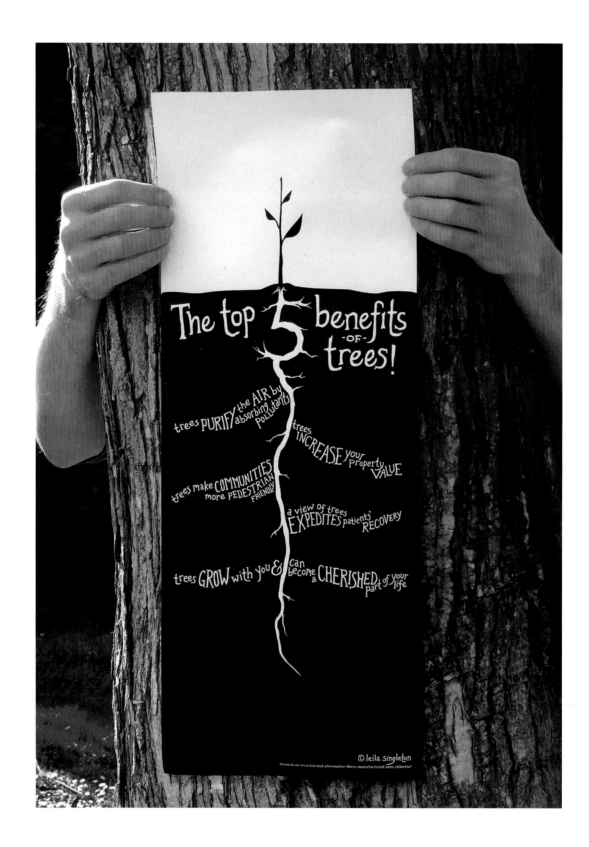

The top 5 benefits -OF- trees!

trees PURIFY the AIR by absorbing pollutants

trees INCREASE your Property VALUE

trees make COMMUNITIES more PEDESTRIAN friendly

a view of trees EXPEDITES patients' RECOVERY

trees GROW with you & can become a CHERISHED part of your life

© leila Singleton

Printed on recycled and alternative fibers manufactured sans chlorine!

298

WHAT'S GREEN ABOUT THIS — This self-promotional piece was refined from a favorite student project encouraging tree planting in urban areas. Naturally, the paper is earth-friendly, manufactured chlorine-free using only alternative and recycled fibers. The poster was screen-printed, by hand, by the good folks at Ape Do Good Printing in San Francisco.

THE WHOLE PACKAGE — SAN FRANCISCO, CALIFORNIA
Creatives : Leila Singleton
Client : Leila Singleton/The Whole Package

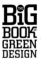

HOUSEMOUSE™ — MELBOURNE, AUSTRALIA
Creatives : housemouse™
Client : Australian Red Cross

WHAT'S GREEN ABOUT THIS — The calendar forms part of the Australian Red Cross humanity range, which supports the work of Red Cross. The 2009 Calendar was printed by an FSC-certified printer using 100% recycled paper.

WHAT'S GREEN ABOUT THIS — Designed using recycled and reclaimed materials and sustainable construction methods, this is one of the most sustainable permanent galleries in the UK. Your Ocean challenges visitors to confront the impact that their everyday actions can have on the health of the oceans. Backdrops for each area of the gallery are made of materials relevant to the subject. A large wall of beach litter introduces the section on Your Waste, and electrical cables salvaged from other gallery spaces undergoing renovation at the Museum were used to form a graphic backdrop for Your Energy. Object tags were made from reclaimed road signs to explain to visitors how they can help re-address the balance of our lifestyle and actions.

THOMAS.MATTHEWS LTD — LONDON, UNITED KINGDOM
Creatives : Kristine Matthews, Tara Hanrahan, Sophie Thomas
Client : The National Maritime Museum

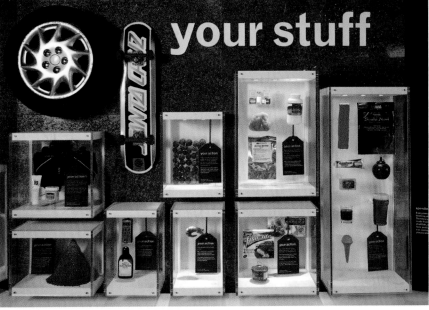

301

Green In Action
Events

Client : U.S. Green Building Council

304

ARE YOU READY? GO FOR EMISSIONS.

Get ready **to take on climate change.**
Get set **by learning how to help your company reduce its carbon footprint.**
Go to usgbc.org/carbon **to register for the Carbon Reduction Webinar
Series beginning October 10.**

Program partners

WORLD
RESOURCES
INSTITUTE

Global CLIMATE CHANGE

CTG

BUILDINGS

WHAT'S GREEN ABOUT THIS — Ad to encourage industry members and creative professionals to
sign up for the "Carbon Reduction Online Learning Webinar Series" and adopt greener practices.

TWOINTANDEM — NEW YORK
Creatives : Sanver Kanidinc, Elena Ruano Kanidinc
Client : U.S. Green Building Council

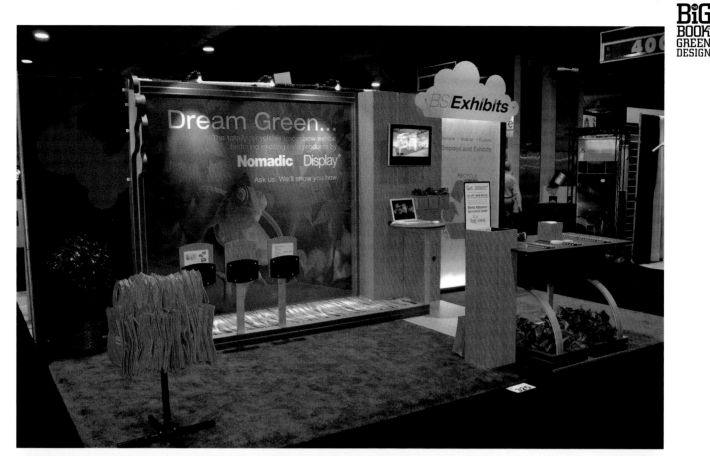

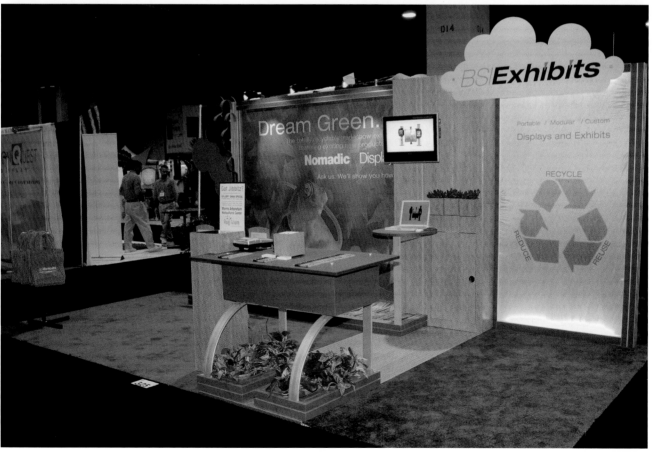

NOMADIC DISPLAY — SPRINGFIELD, VIRGINIA
Creatives : Kurt Kohl, Michael Dare
Client : Nomadic Display and Berm Studios TS2 Exhibits

WHAT'S GREEN ABOUT THIS — The display design features the following, "green" aluminum framework, counter tops laminated in recyclable thermoplastic material, panels that are covered with bamboo venee, recyclable polyester spandex fabric graphics printed with water, soluble inks, polyester carpeting made from 100% post, consumer plastic bottles.

BALTIMORE BIONEERS '08
CULTIVATING CHANGE, INSPIRING SOLUTIONS

2008 Conference Planning Committee

Leadership
Julie Galanski — Co-Chair
Susan Smith — Co-Chair
Peter Brown — Outreach & Exhibitions Chair
Ida Chenoman — Marketing Chair
Lesli Hill — Event Manager
Serafina Kraig — Coordinator
Erin Mitchel — Programming Chair
Kelley Ray — Media/PR Manager

Members
Jordan Faye Block
Tori Burns
Kristen Covey
Jennifer Downs
Bob Duggan
Tracy Ward-Durkin
Ian Hochberg
Phila Hoopes
Mimi Kaplott
Rebecca Ruggles
Cindy Norris
Ted Rouse
Keri Smith
Hannah Spangler
Pat Thomas
Susan Weis
Sharon Wright

Special Thanks
Lisa Ferretto
Prescott Gaylord
Hugh Pocock

"IT IS OUR COLLECTIVE AND INDIVIDUAL
RESPONSIBILITY TO PRESERVE AND TEND TO
THE ENVIRONMENT IN WHICH WE ALL LIVE."
DALAI LAMA

306

REBECCA MOORE

Rebecca Moore (earth.google.com/outreach) is a computer scientist and longtime software professional. At Google, she conceived and now manages the Google Earth Outreach program, which supports nonprofits, communities and indigenous peoples around the world in applying Google's mapping tools to pressing problems in areas such as environmental conservation, human rights, cultural preservation and creating a sustainable society.

KAVITA N. RAMDAS

President and CEO of the Global Fund for Women (globalfundforwomen.org), Kavita is one of the most effective international leaders working to empower women around the world by increasing girls' access to education, defending women's health and reproductive rights, preventing violence against women, and advancing women's political participation at all levels.

RICK REED

Rick Reed (reamp.org) is a senior advisor to the Garfield Foundation, leading its collaborative clean energy project. RE-AMP is a community of 10 foundations and 70 NGOs using system-mapping and shared learning to align their clean energy strategies across seven states in the upper Midwest. With a background in organic farming and molecular biology, Rick has been working in the fields of philanthropy and sustainability for nearly 20 years.

GREG WATSON

Greg Watson (masstech.org) is senior advisor for Clean Energy Technology within the Massachusetts Executive Office of Energy and Environmental Affairs and vice president for Sustainable Development at the Massachusetts Technology Collaborative. His long life of exemplary, cutting-edge public service has included serving as executive director of The Dudley Street Neighborhood Initiative, director of educational programs for Second Nature, director of The Nature Conservancy's Eastern Regional Office, commissioner of the Massachusetts Department of Food and Agriculture, and executive director of the New Alchemy Institute.

"WHAT YOU DO MAKES A DIFFERENCE,
AND YOU HAVE TO DECIDE WHAT KIND OF
A DIFFERENCE YOU WANT TO MAKE."
JANE GOODALL

"THERE CAN'T BE ANY LARGE-SCALE
REVOLUTION UNTIL THERE'S A PERSONAL
REVOLUTION, ON AN INDIVIDUAL LEVEL."
JIM MORRISON

2008 Baltimore Bioneers National Speakers

RAY ANDERSON

Ray Anderson (interfaceinc.com) is the most successful visionary "green business" leader in America, founder and chairman of Interface Inc., the world's largest manufacturer of modular carpet and a leading producer of commercial fabrics.

LUCAS BENITEZ

Lucas Benitez (ciw-online.com), a farmworker and co-director of the Coalition of Immokalee Workers, originally from Guerrero, Mexico, came to the U.S. on his own when he was 16 to help support his five brothers and sisters. By organizing fellow migrant farmworkers, Lucas helped secure the first wage increase for tomato pickers in 20 years, exposed and stopped two slavery rings, and launched a Labor Action Rights program that collected nearly $100,000 in back wages.

JANINE BENYUS

Janine Benyus (biomimicry.net) is a dazzlingly brilliant naturalist, co-founder of the Biomimicry Institute and the author of six books, including the groundbreaking Biomimicry: Innovation Inspired by Nature. Her company, the Biomimicry Guild, helps clients such as HOK Architects, Interface, Kohler, Seventh Generation and Herman Miller consult life's genius to create sustainable products and processes. Her latest book project is Nature's 100 Best, a look at what ingenious (and often endangered) species can teach us about becoming true natives.

ERICA FERNANDEZ

Erica Fernandez, 18, born and raised in Michoacán, Mexico till age 10, became a remarkable young environmental activist in Oxnard, California. Initially motivated to fight air pollution because of her asthma, she helped mobilize her whole diverse community, from Latino youth to the Sierra Club, to defeat the placement of a liquefied natural gas facility just offshore, successfully resisting a multinational billion-dollar corporation.

DUNE LANKARD

A native Athabaskan Eyak from the Copper River Delta of Alaska (redzone.org), Dune was a commercial fisherman in Prince William Sound when the Exxon Valdez disaster made him an activist and social entrepreneur, dedicating his life to protecting human rights and the environment. Selected by Time magazine as one of its "Heroes of the Planet," he is a co-founder of the RED OIL Network (Resisting Environmental Degradation of Indigenous Lands).

SUBSTANCE151 — BALTIMORE, MARYLAND
Creatives : Ida Cheinman, Rick Salzman
Client : Baltimore Bioneers

WHAT'S GREEN ABOUT THIS — The Bioneers Conference is a multidisciplinary forum of visionary innovators and thought leaders around the nation working to improve the health of our environment and human communities. Bioneers weaves together the concepts of environmental and social justice, including green building and alternative energy, education, green jobs, culture, art, science and technology.

WHAT'S GREEN ABOUT THIS — "Fueling Revolution" was the theme for the 2008 National Conference and Trade Show for the American Coalition for Ethanol. ACE is a national association that provides grassroots support for ethanol, a renewable fuel.

INSIGHT MARKETING DESIGN — SIOUX FALLS, SOUTH DAKOTA
Creatives : Doug Moss
Client : American Coalitional for Ethanol

308

WHAT'S GREEN ABOUT THIS — 83% of the Timberland booth is eco-conscious: 60% recycled materials; 4% reused; and 19% renewable. 82% of the booth is recyclable at the end of its five-year targeted life span. Translucent wall panels are constructed of the same material as postal carrying cartons. Roll-up galvanized steel receiving doors were intended as flexible dividers that open and close to create the "convertible" meeting rooms and assist in the transportation process between show appointments.

JGA — SOUTHFIELD, MICHIGAN
Creatives : Ken Nisch, Gordon Easton Company
Client : The Timberland

IT IS ESTIMATED THAT WE ARE LOSING 50 SPECIES A DAY. "WE ARE INTO THE OPENING PHASE OF A MASS EXTINCTION OF SPECIES. THERE ARE ABOUT 10 MILLION SPECIES ON EARTH. IF WE CARRY ON AS WE ARE, WE COULD LOSE HALF OF ALL THOSE SPECIES."
— PROFESSOR NORMAN MYERS

ENDANGERED EARTH

| TWOINTANDEM — NEW YORK
Creatives : Sanver Kanidinc, Elena Ruano Kanidinc
Client : Design Boom & Design Association of Japan

WHAT'S GREEN ABOUT THIS — Poster designed to celebrate Earth Day and raise awareness about the loss of biodiversity and dangers to the ecosystem.

| CWA INC. — SAN DIEGO, CALIFORNIA
Creatives : Calvin Woo, Sivly Ly
Client : Design Innovation Institute

WHAT'S GREEN ABOUT THIS — The Design Innovation Institute (Dii) held a series of one-day mini-workshops to expose the public to the importance of sustainable design. Workshops focused on such things as taking a used commodity, like rubber tire tubes, and transforming them into something functional. The best design solutions from the workshop were showcased in displays in San Diego public libraries and on Dii's website.

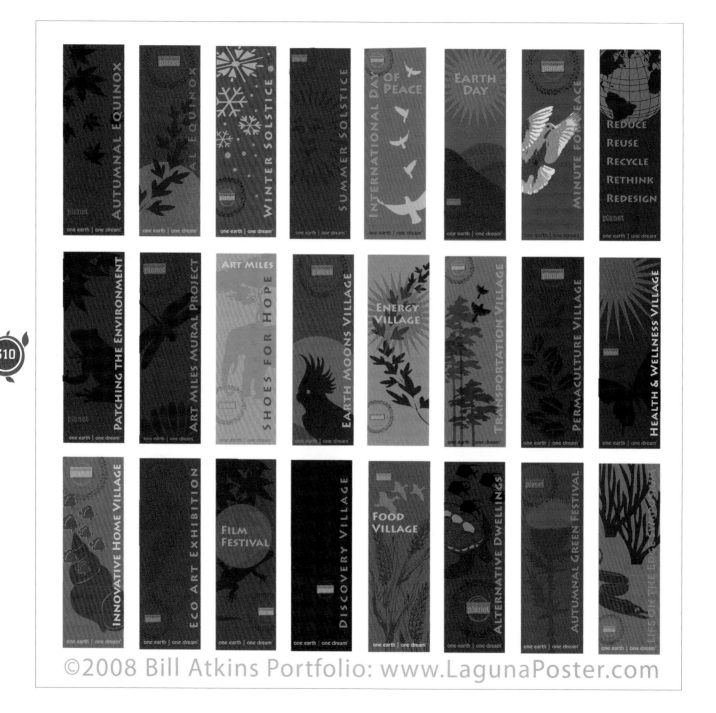

310

WHAT'S GREEN ABOUT THIS — The 24 Banners were created to identify participants of the event "One Earth/One Dream" October 3 - 5, 2008 held at Laguna Beach Festival of Arts, Laguna Beach, California.

BILL ATKINS DESIGN & ILLUSTRATION —
LAGUNA BEACH, CALIFORNIA
Creatives : Bill Atkins
Client : Charles Michael Murray

GUERRINI DESIGN ISLAND — BUENOS AIRES, ARGENTINA
Creatives : Sebastian Guerrini
Client : MAPO Argentine Movement for Organic Agriculture

WHAT'S GREEN ABOUT THIS — In 2008, Guerrini Design Island designed the branding and communications of the MAPO (*Movimiento Argentino para la Producción Orgánica*, the Argentine Movement for Organic Agriculture) (Buenos Aires, Argentina.) The brand was launched in Buenos Aires.

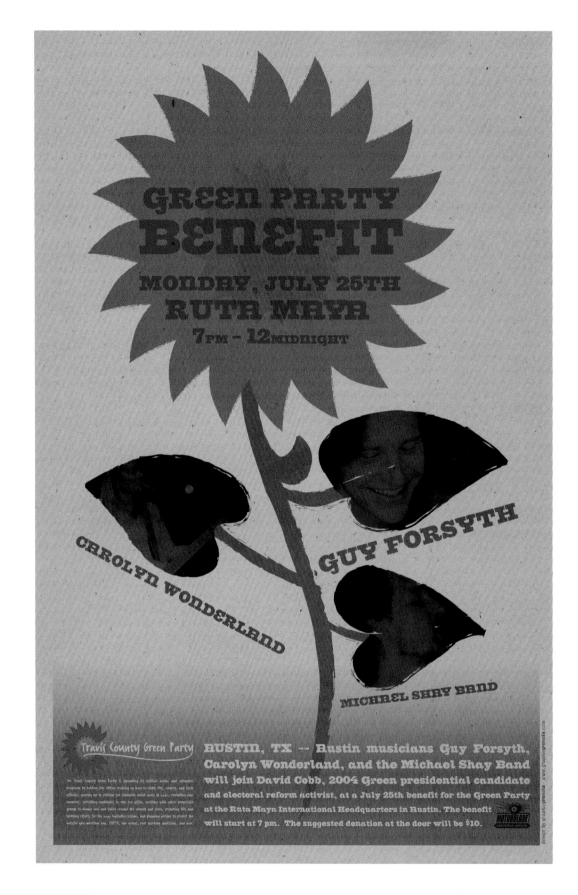

WHAT'S GREEN ABOUT THIS — These political action posters were created for different events for the Travis County Green Party.

GRAPHICGRANOLA — AUSTIN, TEXAS
Creatives : Kelly Blanscet
Client : Travis County Green Party

314

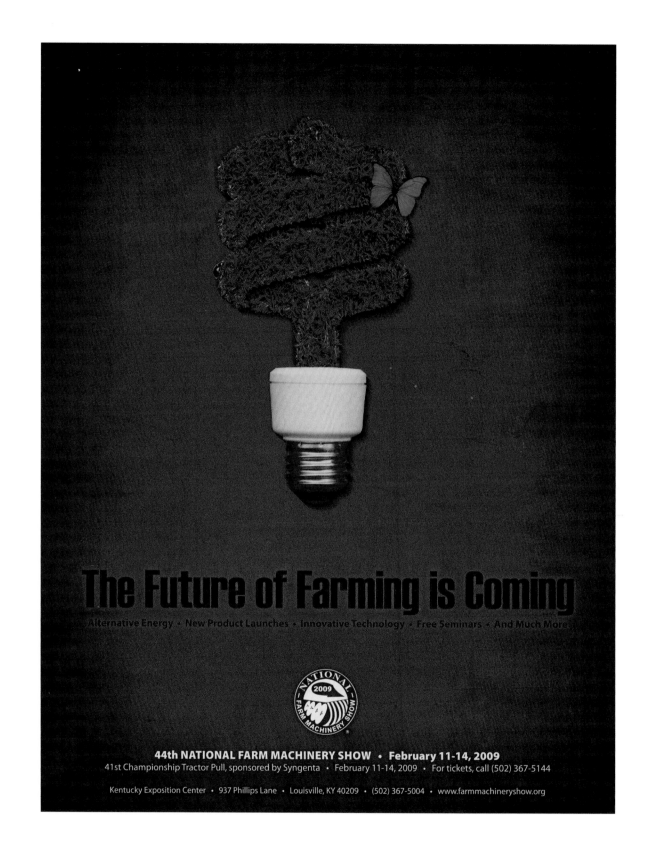

WHAT'S GREEN ABOUT THIS— As the largest indoor agricultural exhibition in the United States, the National Farm Machinery Show offers the latest in agricultural advancements designed to propel agricultural professionals across the globe into the future of environmental sustainability. As trends in farming progress toward a more environmentally sustainable future, the National Farm Machinery Show attracts clientèle, both exhibitors and attendees, who are looking to transform their business approach into one with an environmental focus. The ad's creative image visually displays a unique and well-established connection between agriculture and its effect on the environment through renewable energy.

KENTUCKY STATE FAIR BOARD — LOUISVILLE, KENTUCKY
Creatives : Mike Fryman, Sandra Kendall, Ryne Dunkelberger
Client : National Farm Machinery Show

I am not a virgin

I am 100% Post-Consumer waste.

I am not processed with any Chlorine.

I saved 1 tree, 27 gallons of water, 55,000

BTUs of energy, 6 pounds of solid waste and 10

pounds of greenhouse gases just by a designer

choosing me.

AIGA

315

UNIVERSITY OF ILLINOIS + RENOURISH —
CHAMPAIGN, ILLINOIS
Creatives : Kelly Stevens, Eric Benson
Client : AIGA Austin

WHAT'S GREEN ABOUT THIS — New Leaf Paper gave a presentation entitled "Pulp: Non-Fiction" for the AIGA Austin chapter about the growing sustainable-paper industry. This postcard let local AIGA members know about the event and embodied the message of sustainability in the card itself.

WHAT'S GREEN ABOUT THIS — Digital/electronic graphics were used in lieu of printed ones for a more environmentally friendly graphic solution. The exhibit structure used a tension fabric form as it is a sustainable/green material that helps to reduce the fuel consumption for shipping the exhibit as it is lighter in weight than typical hard wall construction. The flooring was also a green product— repurposed t-shirt material, carpeting, and recycled flooring.

3D EXHIBITS — ELK GROVE, ILLINOIS
Creatives : Nicole Genarella, Doug Schofield
Client : 3D Exhibits

Colour in one footstep for every Green Miles sticker that your class collects

IMAGINE — MANCHESTER, UNITED KINGDOM
Creatives : David Caunce, Paul Davis, Kathy Collins
Client : Manchester City Council—Transport Policy Unit

WHAT'S GREEN ABOUT THIS — Green Miles is an initiative to encourage school pupils to make greener and healthier travel choices. The competition is held annually in schools across Greater Manchester. Children are awarded stickers for good travel choices. No stickers are awarded for travel by car! The more stickers collected by a class, the more progress they make around the activity map. Prizes are awarded to classes who progress the furthest. All material is printed on recycled paper, mostly 9Lives silk.

319

How They Did It
Hoopla Headquarters for Dell, Inc.

The goal of this eco-friendly trade show environment was to capture the attention of industrial product designers and get them talking about what "green" means to design. The space was to spur the art of conversation, feature NO products, and include two primary zones. One zone was a place to stop, rest, sit, relax, and chat. The other offered interactive graffiti walls to launch conversations about green design.

Flooring: Marmoleum, manufactured by Forbo, is biodegradable, allergen-free, bacteria resistant, easy to clean, and durable. All ingredients are minimally processed and commonly available. Forbo also recycles all of its remnants back into the production process.

"Question Mark" Bench: The Maharam ledger fabric is made at an ISO 14001 certified facility. It is free of heavy metal dyes and is Greenguard indoor air quality certified (www.greenguard.org).

Waterwalls: Recycled and reused from a previous event, the water wall features inset 3Form panels. 3Form is engineered to incorporate 40% post-industrial reclaimed material, is free of any hazardous materials, and is Greenguard indoor air quality certified.

Illuminated graffiti walls: Reusable and recyclable, the sleek frames of the graffiti walls are made of aluminum. Plexiglas® insets have been refurbished and reused by Dell in subsequent events.

Turf Grass: Actual grass sod was used throughout the exhibit.

Eames Molded Plywood Chairs: Herman Miller, chair manufacturer, has purchased woods coming from only sustainable supplies since 1991. Water-based stains are employed on all standard veneers.

HOOPLA MARKETING — AUSTIN, TEXAS
Creatives : Ivy Oliver, Paige Neagle, Angela Oliver, Kyle Chesser
Client : Dell

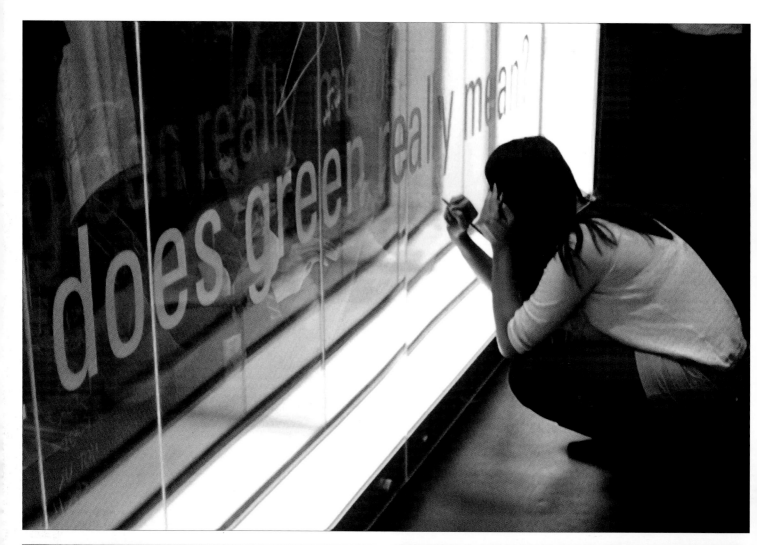

HOOPLA MARKETING — AUSTIN, TEXAS
Creatives : Ivy Oliver, Paige Neagle, Angela Oliver, Kyle Chesser
Client : Dell

324

WHAT'S GREEN ABOUT THIS — AIGA Detroit invited 35 Michigan designers to participate in the Urban Forest Project. After the sustainably-produced banners hung on the streets of Ann Arbor, they were converted into messenger bags and auctioned off. Proceeds went to The Ann Arbor Ecology Center.

THRIVE DESIGN — EAST LANSING, MICHIGAN
Creatives : Kelly Salchow MacArthur
Client : AIGA Detroit and The Ann Arbor Ecology Center

EARTH DAY
OMAHA ELMWOOD PARK
APRIL 19TH

FREE SATURDAY NOON-8PM MUSIC FOOD & BEER ROCK WALL CLIMBING & FAMILY FUN
Oxide Design Co. • The Big O 101.9 KOOO • The Reader • Papio Missouri River NRD • Whole Foods Market • WWW.EARTHDAYOMAHA.COM
RAIN LOCATION: Lewis & Clark Middle School HOST: EARTH DAY OMAHA COALITION

OXIDE DESIGN CO. — OMAHA, NEBRASKA
Creatives : Adam Torpin
Client : Earth Day Omaha

WHAT'S GREEN ABOUT THIS— Designed to promote Omaha's 2008 Earth Day event, these 18" x 24" posters were printed on various leftover paper stock that the printer had been planning to throw away.

WHAT'S GREEN ABOUT THIS — The 2008 session of The Kenan Writers' Encounters, "Earth: Writers and Artists Engage the Environment" chose worn river stones as an appropriate metaphor for humanity's harmony with the environment and coupled that image with subtle earth tones and a flecked paper with recycled content for their printed program materials. This poster folds up to be used as a mailer, and contains speaker and event information on the reverse side.

FIFTH LETTER — WINSTON-SALEM, NORTH CAROLINA
Creatives : Elliot Strunk, Ellen Rosenberg
Client : Kenan Writers' Encounters

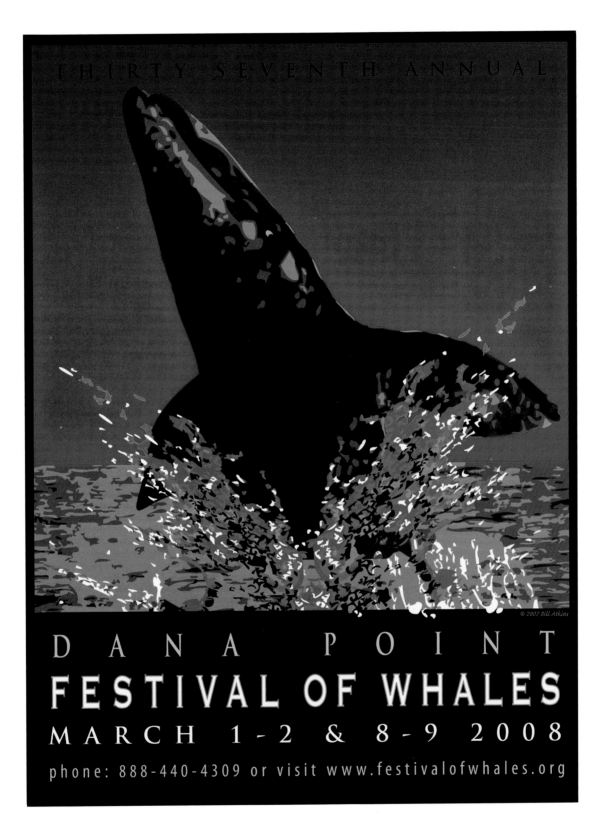

BILL ATKINS DESIGN & ILLUSTRATION –
LAGUNA BEACH, CALIFORNIA
Creatives : Bill Atkins, Penny Elia
Client : 2008 Festival of Whales, Dana Point, California

WHAT'S GREEN ABOUT THIS— 18" x 24" poster created to promote the Annual Festival of Whales in Dana Point, California.

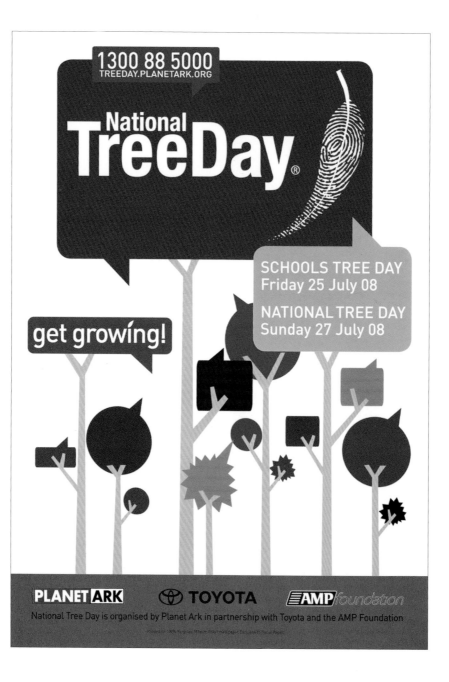

WHAT'S GREEN ABOUT THIS — Each year, Planet Ark encourages Australians to plant and maintain native trees and shrubs on National Tree Day. Volunteers plant 1.6 million trees in 3,500 locations. Spatchurst designed and produced the "Get Growing" print campaign for 2008. It included printed posters and brochures as well as downloadable files for the posters, brochures, and other campaign materials. The campaign resulted in a 49% increase in website visits from 2007.

SPATCHURST — AUSTRALIA
Creatives : Steven Joseph, Leah Procko
Client : Planet Ark

BILL ATKINS DESIGN & ILLUSTRATION —
LAGUNA BEACH, CALIFORNIA
Creatives : Bill Atkins, Marcia Beckett
Client : City of Irvine, Environmental Programs Department

WHAT'S GREEN ABOUT THIS — This 37" x 25" poster was created in digital media for the City of Irvine, California and displayed at an energy awareness festival.

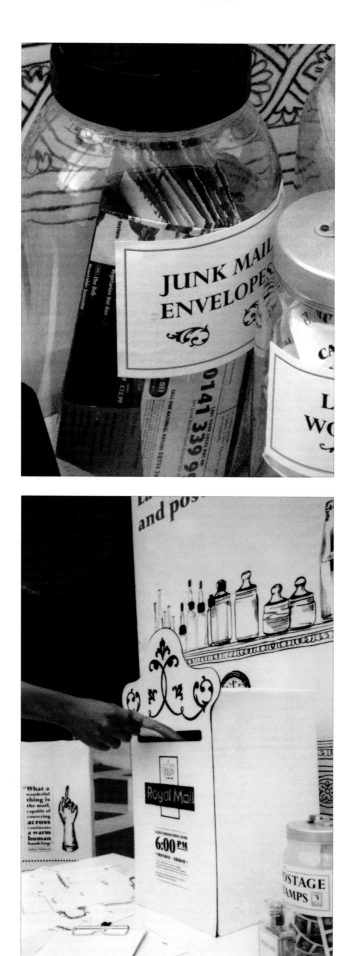

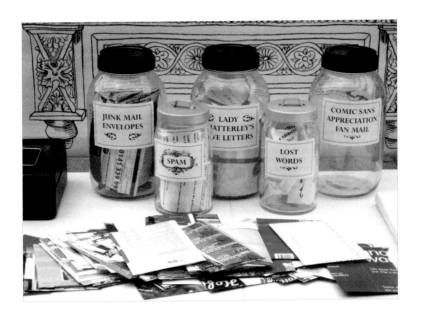

THOMAS.MATTHEWS LTD – LONDON,
UNITED KINGDOM
Creatives : thomas.matthews Ltd
Client : Wellcome Trust, Travelling Apothecary Event

WHAT'S GREEN ABOUT THIS— Thomas.matthews was invited to develop a project for the 'Travelling Apothecary' event: a showcase of 'remedies for modern illnesses', for the Wellcome Trust, it was held in the courtyard of the British Library. The RE:mail stall developed by thomas.matthews provided participants with strangely beautiful envelopes made out of junk mail collected in the lead-up to the event. In an age where most mail through your letterbox is junk-mail, and a keyboard is as personal as letter writing gets, participants were provided with pens, paper and stamps to write and post a slushy love letter, an overdue thank you or whatever took their fancy.

WHAT'S GREEN ABOUT THIS — These posters were designed for the Martin Luther King, Jr. Celebration campaign at Arizona State University. The concept was to think about what this influential man stood for in new ways. The goal was to get people to participate in student leadership in their communities, to help not only other people but their surrounding environment as well by going green.

ARIZONA STATE UNIVERSITY — ARIZONA
Creatives : Nicholas Winter
Client : ASU MLK Jr Celebration Committee

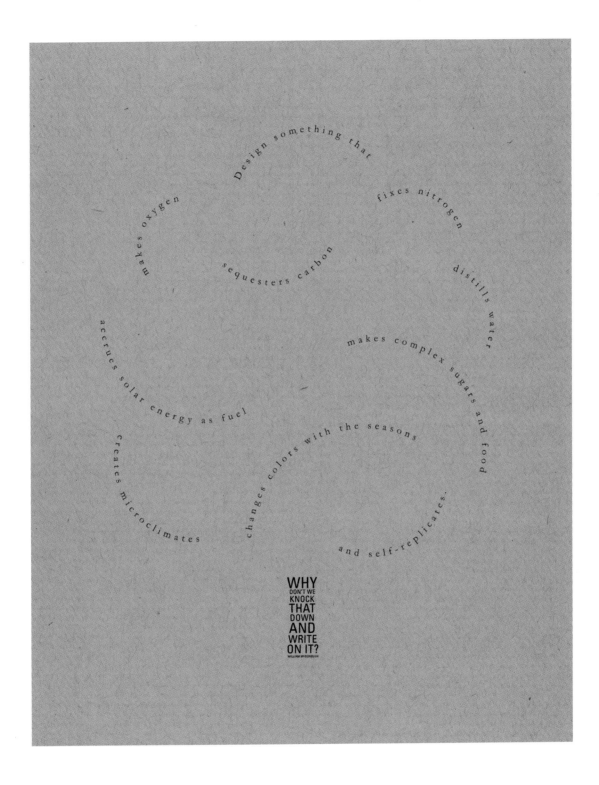

TYLER SCHOOL OF ART — PHILADELPHIA, PENNSYLVANIA

Creatives : Katie Hatz, Kelly Holohan

Client : AIGA Philadelphia Campaign 2 Sustain

WHAT'S GREEN ABOUT THIS — This poster illustrates a quote taken from the 2005 Ted Talk by William McDonough, green-minded architect, designer, and co-author of the book Cradle to Cradle (which is printed on fully recyclable polymer rather than on paper made from trees.) Dryly pointing out the absurdity of using trees to essentially create garbage, McDonough states, "Design something that makes oxygen, sequesters carbon, fixes nitrogen, distills water, accrues solar energy as fuel, makes complex sugars and food, creates microclimates, changes colors with the seasons, and self replicates. Why don't we knock that down and write on it?"

334

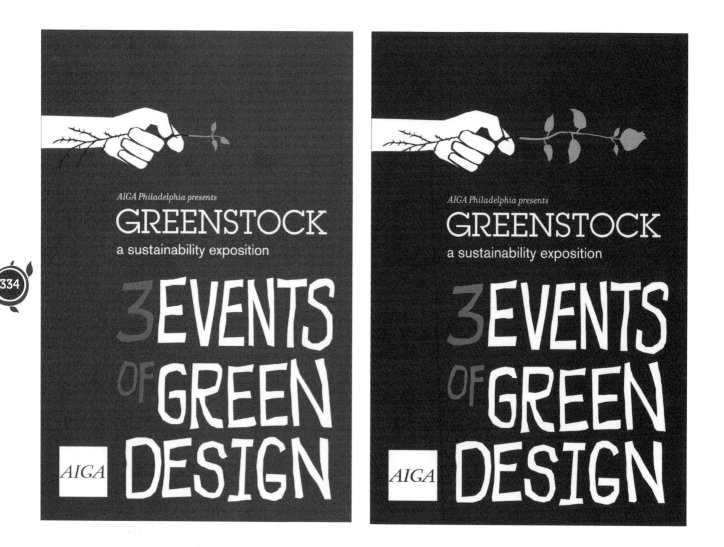

WHAT'S GREEN ABOUT THIS— Postcards designed to promote AIGA Philadelphia's Spring Lecture Series. Greenstock was a succesion of programs focusing on sustainability in design.

HOLOHAN DESIGN — PHILADELPHIA, PENNSYLVANIA
Creatives : Kelly Holohan, Alexander Zahradnik
Client : AIGA Philadelphia

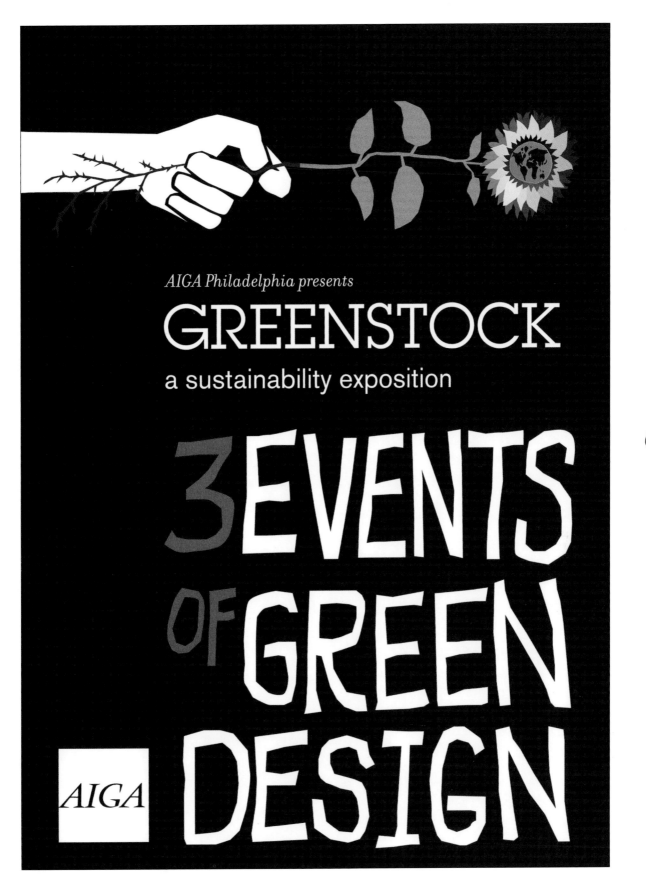

336

WHAT'S GREEN ABOUT THIS — Since 1999, the Design Center Stuttgart (Southern Germany) has been offering an annual prize dedicated to a specific motto. This year's criteria were sustainability and eco-friendliness. For the six-week exhibition, the design firm transformed the venue into a "green" oasis to put attendees in the right frame of mind.

DESIGN HOCH DREI GMBH & CO.KG — STUTTGART, GERMANY
Creatives : Susanne Wacker, Tobias Kollmann, Sandy Manig, Ioannis Karanasios
Client : Design Center Stuttgart

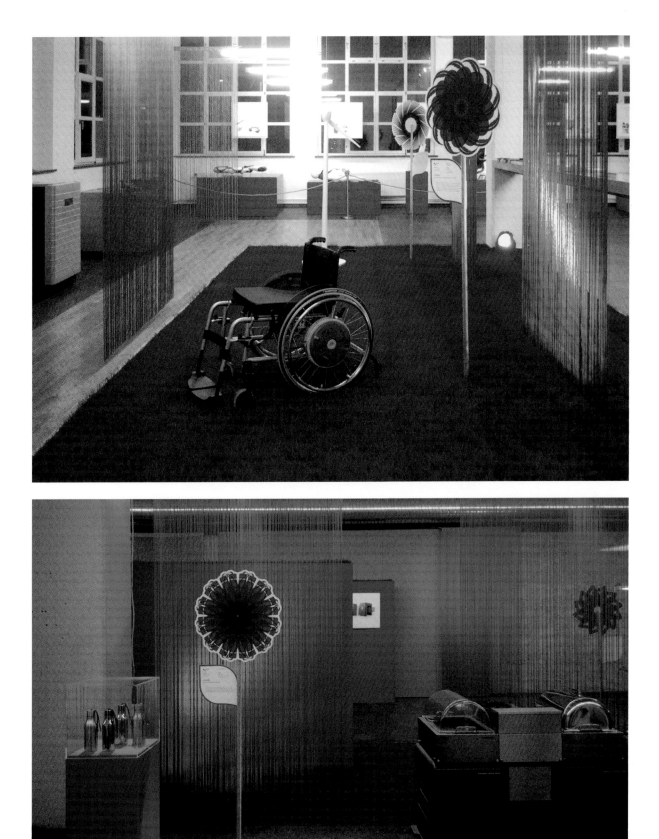

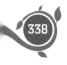
338

WHAT'S GREEN ABOUT THIS — TreeLife will be held in parks in New York, London, Sydney, and other cities in Europe, New Zealand, Canada, and Asia during 2009 and 2010. Established and emerging architects, designers, and artists will each be invited to design a tree-house for the event. TreeLife is a thoroughly green event, and tree houses will be crafted from sustainable or recycled materials. The participating designers will be briefed to design the tree houses as stand-alone structures that only appear to be suspended in the trees, so the exhibition does not impact on the trees or the environment.

ISHBU.COM — MOSCOW, IDAHO
Creatives : David Waters
Client : The Cool Hunter

WHAT'S GREEN ABOUT THIS — This series of stamps for Australia Post, promoting Earth Hour 2009, reprises the quirky style of the successful "Climate Change" series from 2007. The stamps are recognizable to Australia Post customers as a second environmental series. They focus on three simple actions for Earth Hour: Turning lights out; switching power points off; and saving energy by unplugging. The two local stamps featured illustrations of nocturnal animals to highlight the "lights out" message. The international stamp included an orang-utan, a species endangered by humanity's cavalier approach to the environment. The stamps raised awareness of Earth Hour and encouraged involvement in a positive way.

HOYNE DESIGN — MELBOURNE, AUSTRALIA
Creatives : Dan Johnson, Walter Ochoa, Huey Lau, Darren Rochford
Client : Australia Post

339

PLANET ADS & DESIGN PTE. LTD. — SINGAPORE
Creatives : Hal Suzuki, Patrick Jabillo, Suzanne Lauridsen
Client : Optique Paris Miki (S) Pte Ltd

WHAT'S GREEN ABOUT THIS — This concept was developed to raise awareness for Paris Miki's initiatives in honor of Earth Day. To mark the occasion, the eyewear chain offered storewide discounts plus a further discount upon donation of used spectacles for recycling. The headline "A World of Savings In Sight" alludes to both the monetary savings enjoyed by the customer and the environmental savings enjoyed by the planet from recycling.

Green In Action

Education

WHAT'S GREEN ABOUT THIS — This site includes resources and information on how and why to build green.

ANGELA WEBB - DESIGNS — TULSA, OKLAHOMA
Creatives : Angela Webb, Matt Means
Client : Landmark Resources

WHAT'S GREEN ABOUT THIS — Ethanol Today is the monthly publication of the American Coalition for Ethanol. ACE is a national association that provides grassroots support for ethanol, a renewable fuel.

INSIGHT MARKETING DESIGN — SIOUX FALLS, SOUTH DAKOTA
Creatives : Doug Moss, Clara Jacob, Mel Peterson
Client : American Coalition for Ethanol

| **LITTLEDOGDESIGN** — DAYTON, OHIO | **WHAT'S GREEN ABOUT THIS** — The Green Education Design Showcase features instructional, administrative, and service facilities for public, private, and parochial schools of all levels, up to and including technical, two-year, and four-year colleges and universities. The Green Education Design Showcase is a vehicle for sharing innovative yet practical solutions in planning, design, and construction to achieve the best possible learning environments for all students at all levels of education. |

Creatives : Matt Cole
Client : College Planning & Management

PARLIAMENT — PORTLAND, OREGON
Creatives : Chris Erickson, Aaron Noah, Jono Stark
Client : RecycleBank

WHAT'S GREEN ABOUT THIS — This interactive website for RecycleBank, a premier rewards and loyalty program that motivates people to recycle, explains the single-stream recycling process in an engaging way. From laser beams that shoot plastic bottles off conveyer belts to machines that wash ink right off the page, the whole process is explained in an animated, choose-your-own-adventure type of approach, encouraging the audience to participate in environmentally virtuous activities.

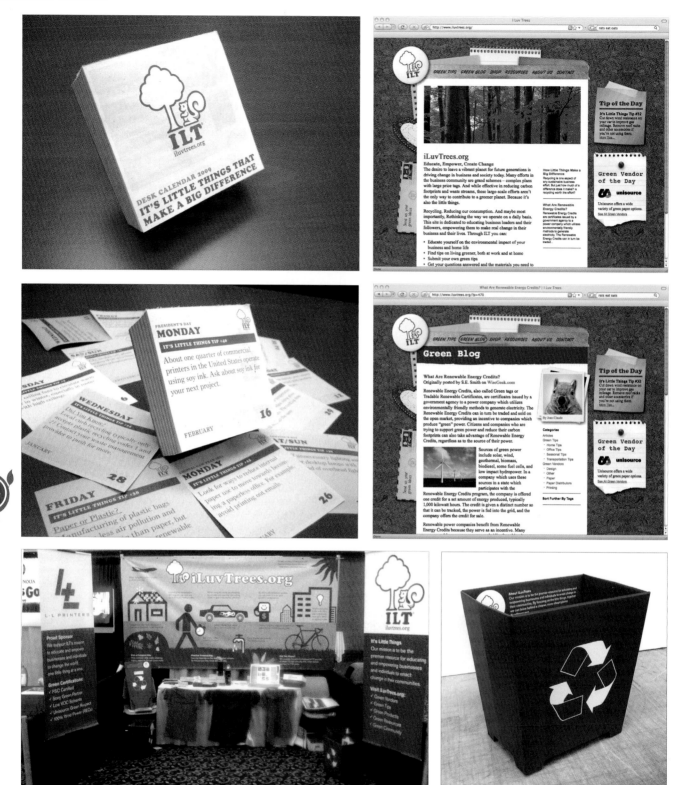

WHAT'S GREEN ABOUT THIS — iLuvTrees.org's mission is to be the premier resource for educating and empowering businesses and individuals to enact environmental change in their communities. By focusing on the little things, together they strive to leave behind a cleaner, more vibrant planet. This desk calendar, printed FSC on recycled paper with soy inks, is 100% recyclable and full of useful green tips and trivia. It was created for iLuvTrees.org, the green information website of L+L Printers, who are committed to green practices and sustainability.

INCITRIO — SAN DIEGO, CALIFORNIA
Creatives : Angela Hill, Dave Smith, Randy Fraser
Client : iLuvTrees.org

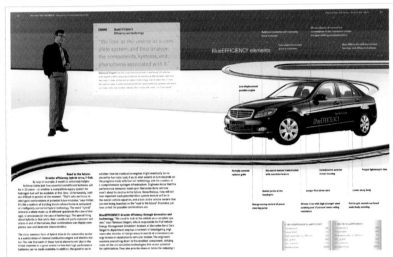

345

DESIGN HOCH DREI GMBH & CO.KG —
STUTTGART, GERMANY
Creatives : Wolfram Schäffer, Isabell Zirbeck,
Norbert Fasching, Bärbel Jördens
Client : Daimler AG

WHAT'S GREEN ABOUT THIS — The Daimler AG publishes a one-of-a-kind annual Sustainability Report under the label 360 DEGREES, a combination of consumer magazine and just-the-facts publication. In 2005, Daimler launched the integrated sustainability report that included the previously independent Social Commitment Report. The magazine now combines all dimensions of sustained economic activities in one report: the economic and ecological aspects as well as the social commitment, with regard to employees, customers and society.

346

Grounds for Knowledge

A GUIDE TO COLD SPRING HARBOR LABORATORY'S LANDSCAPES & BUILDINGS

Introducing the Bungtown Botanical Garden

LANDSCAPE PHOTOGRAPHY BY PETER STAHL

Elizabeth L. Watson

FOREWORD BY VINCENT A. SIMEONE
PREFACE BY JAMES D. WATSON

Cold Spring Harbor Laboratory Press, 2008

WHAT'S GREEN ABOUT THIS — Located in Cold Spring Harbor, New York, this arboretum welcomes visitors and provides educational programs regarding its extensive collection of native trees and shrubs. Its mission is to foster an awareness and appreciation of the role of plants in nature and in human affairs. *Grounds for Knowledge* is an invitation to notice the quiet interaction of all things natural—birds, trees, blossoms, harbor-edge grasses, and plantings. The design challenge was to bridge the desire for the book to be a coffee table quality publication, yet serve as a guidebook to the grounds for its buildings and its landscape. It was decided that a smaller book with no dust jacket would be not only economical, but also more ecologically friendly using less paper.

SMITH & DRESS LTD — HUNTINGTON, NEW YORK
Creatives : Frederick Dress, Abby Dress
Client : Cold Spring Harbor Laboratory Press

BiG
BOOK
GREEN
DESIGN

Before Bungtown,
there was a Harbor . . .

The north shore of Long Island first appeared as we might now almost recognize it after the retreat of the last glacier that had covered much of the Northern Hemisphere. This happened about ten thousand years ago, or less. The melting made the seas rise to today's level, leaving behind the Long Island we know today, with its shores, plains, hills, lakes, ponds, and rivers. Particularly on the north shore of the Island there were also innumerable springs which bubbled up close to the shorelines, from water sources trapped deep underground during the course of previous glaciations. Besides these tiny streams emptying into the harbor at Cold Spring, there was a river that originated several miles south of the village. Not surprisingly, the Native American

Cold Spring Harbor, ca. 1880. Looking north from St. John's Pond. Bung-town barrel factory (red) is at far left, with Inner Harbor and Sand Split middle distance. Inset, Hewlett-Jones grist mill (watercolor by Edward Lange; CSH Whaling Museum Collection).

15

347

on either side, blooming in big beautiful cups and "saucers" of rose and white.

The north side of de Forest Drive bordering the south garden of Airslie comes alive, again in the fall, with the bright orangey-red of recent plantings of a "burning bush" cultivar of **Winged Euonymus**, *Euonymus alatus*. This woody plant takes its name from the quartet of corky "wings" running parallel to each other up and down each and every stem. Maybe you can also spot at the back of the border more shrubby reminders of the estate era in the shape of **Rosebay Rhododendron**, *Rhododendron maximum*, with its extra large leaves and extra big pale pink blossoms that bloom extra late compared to today's hybrids. By the way, you might notice, across the road on its south side, now that spring is beckoning again, the interesting rhythm between the fragile white and pink Flowering Dogwood, young and not so young, and the tough old specimens of Eastern Redcedar with their stout rusty red trunks.

North along de Forest Drive:
from The Stables down to Ballybung

Just after the road turns a corner, you'll see TIFFANY and, if it's summertime, maybe you can spy the old **Goldenraintree** or **Japanese Lantern Tree**, *Koelreuteria paniculata*, bursting with pale puffy four-chambered seedpods that are even bigger than those of the Bladdernut (above), which they otherwise greatly resemble. (There is more recently planted Goldenraintree on the south side of Ballybung; see below.) In this same general vicinity of de Forest Drive, White Pine grow in profusion; there are younger ones deployed on the embankment west of the road and a number of weather-beaten old ones on the east, in the

Flowering Dogwood inset, Flowering Dogwood and Eastern Redcedar, en route to Mary D. Lindsay Child Care Center.

Snowy and American Egrets, Inner Harbor.

Appendix B

BIRD CHECKLIST –
COLD SPRING HARBOR LABORATORY
Bungtown Botanical Garden – *Choose your seasons and bring your binoculars!*

Forests & Meadows

Year-Round Residents
Blue Jay
Cardinal
Carolina Wren
Chickadee
Crow
Downy Woodpecker
English Sparrow
Flicker
Goldfinch
Housefinch
Mourning Dove
Red-bellied Woodpecker
Red-breasted Nuthatch
Red-tailed Hawk
Song Sparrow
Sparrow Hawk
Starling
Tufted Titmouse
White-breasted Nuthatch

Summer Residents
Baltimore Oriole
Barn Swallow
Black and White Warbler
Bluebird
Catbird
Chipping Sparrow
Cowbird
Kildeer
Kingbird
Mockingbird
Yellow Warbler

Migratory Visitors, Spring and Fall
Cedar Waxwing
Golden Crowned Kinglet
Myrtle Warbler
Palm Warbler
Ruby Crowned Kinglet

Winter Visitors
Junco
White-throated Sparrow

Shores & Waters

Year-Round Residents
Black Duck
Black-backed Gull
Canada Goose
Double-crested Cormorant
Great Blue Heron
Herring Gull
Kingfisher
Mallard
Mute Swan
Ring-billed Gull

Summer Residents
American Egret
Black-crowned Night Heron
Common Tern
Green Heron
Least Tern
Osprey
Snowy Egret
Spotted Sandpiper

Migratory Visitors, Fall and Spring
American Widgeon
Canvasback
Hooded Merganser
Northern Pintail
Red-breasted Merganser
Yellowlegs

Winter Visitors
Bufflehead
Goldeneye
Greater Scaup
Lesser Scaup
Old Squaw
Ringbilled Duck

Windvane, Banbury Center Meeting House.

Red-tailed Hawk on sculpture Transform.

Osprey leaving nest on Sand Split.

Mute swan, Inner Harbor.

194

WHAT'S GREEN ABOUT THIS — A government guide to waste disposal, recycling, and environmental programs for Lafayette, Louisiana.

THE RUSSO GROUP — LAFAYETTE, LOUISIANA
Creatives : Michael J. Russo, Gary LoBue Jr.
Client : Lafayette Consolidated Government

Discarded packaging represents over 30 percent of the solid waste buried in U.S. landfills each year.

CITIZENS FOR SUSTAINABLE DESIGN

DESIGN RESPONSIBLY

excerpt from Print Design and Environmental Responsibility (2003), The American Institute of Graphic Arts

LOUISIANA STATE UNIVERSITY — BATON ROUGE, LOUISIANA
Creatives : Courtney Barr
Client : Courtney Barr

WHAT'S GREEN ABOUT THIS — Letterpress poster printed on recycled paper; excerpt from "Print Design and Environmental Responsibility" by the American Institute of Graphic Arts.

How They Did It
Global Warming UNDO IT.

"People are confused these days," says Jimmie Stone, partner at Green Team. "We have to clarify issues."

Thanks to Green Team's campaign for the Environmental Defense Fund, people just might be a little less confused about global warming now. The Environmental Defense Fund approached Green Team to create a multi-pronged advocacy campaign. Green Team has concentrated on sustainability communications since 1993. "They came to us because of our expertise on these issues," Stone says. "They were trying to look for positive ways of communicating. We communicate with clarity, candor, and hope."

Hope was the key. "At that time, most of the communication was fear-based," Stone explains. "We wanted to concentrate on a positive, more pro-active direction. We weren't concentrating on the science of global warming. We wanted to change the paradigm."

Green Team found that some 75 percent of the American public was concerned about global warming, but few knew what to do about it. The "Global Warming UNDO IT" campaign was designed to give people direction. "Global warming was caused by humans," Stone says. "We wanted to convince them to do something about it. Our message would be, **If we did it, we can undo it.**"

Stone acknowledges that it's rare for a client to accept a marketing design idea without wanting it tweaked or even completely rethought. "But," says Stone, "The Environmental Defense Fund did! They went with it all the way. They even had donors who were concerned; they thought our message should have been stronger in the area of consequences, the fear factor. And the Environmental Defense Fund had a strong vision: **Come on, let's do it together.**"

Stone describes the campaign as "granular." Targeting numerous markets, Green Team created the undoit.org website, posters, TV and newspaper ads, viral videos, T-shirts, and petitions. "This campaign was very tactical. It was tough to reach all the different targets. We wanted to change the political climate in Washington. We even did a campaign for Middle America, for instance, telling hunters that global warming affects bird patterns. Of course, there may be no one more environmentally aware than a new mom. Students, activists, the media - all these people had different triggers," Stone says. Green Team played off the Undo IT message. For instance, one poster showed a woman's elaborately tattooed bare back. Part of the tattoo read, "There are things we can't undo." Another poster featured a toothbrush floating in a toilet bowl with the same line underneath the picture. In both cases, the kicker was, "Global Warming We Can."

Next, since the Environmental Defense Fund does not accept funds from corporations, Green Team recruited six progressive brands to carry the UNDO IT message in their existing communication channels. Stonyfield Farm, for one, printed the message **Cut the emission; sign the petition** on six million yogurt lids.

"We felt viral was going to be very key also," Stone says. So, the day after Janet Jackson's infamous "wardrobe malfunction," Green Team issued an email blast featuring a vidcap of the incident along with the ... **can't be undone** line.

All these instruments pointed the various markets in a single direction: Go to www.undoit.org.

The end result was that the Environmental Defense Fund was able to forward over 600,000 signatures on online and print petitions in an effort to convince US Senators to vote yes on the McCain-Lieberman Stewardship Act for carbon emissions cap-and-trade.

"We were trying to be positive, looking for humor and an optimistic approach," Stone says. "That's still what we believe today."

GLOBALWARMING UNDO IT.

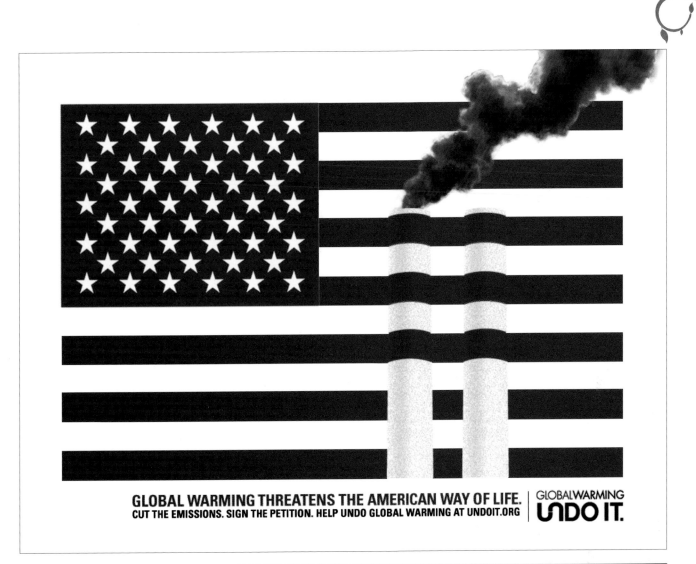

GLOBAL WARMING THREATENS THE AMERICAN WAY OF LIFE.
CUT THE EMISSIONS. SIGN THE PETITION. HELP UNDO GLOBAL WARMING AT UNDOIT.ORG | GLOBALWARMING **UNDO IT.**

GREEN TEAM — NEW YORK, NEW YORK
Creatives : Jimme Stone, Jeffrey Lin, Brian Hurewitz, Hank Stewart
Client : Environmental Defense Fund

There are things we can't undo.

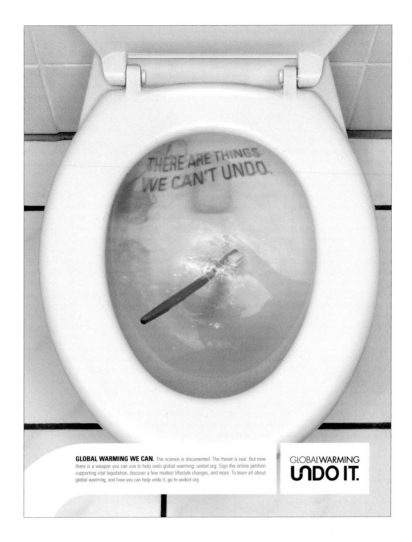

THERE ARE THINGS WE CAN'T UNDO.

GLOBAL WARMING WE CAN. The science is documented. The threat is real. But now there is a weapon you can use to help undo global warming: undoit.org. Sign the online petition supporting vital legislation, discover a few modest lifestyle changes, and more. To learn all about global warming, and how you can help undo it, go to undoit.org

GLOBAL WARMING
UNDO IT.

GREEN TEAM — NEW YORK, NEW YORK
Creatives : Jimme Stone, Jeffrey Lin, Brian Hurewitz, Hank Stewart
Client : Environmental Defense Fund

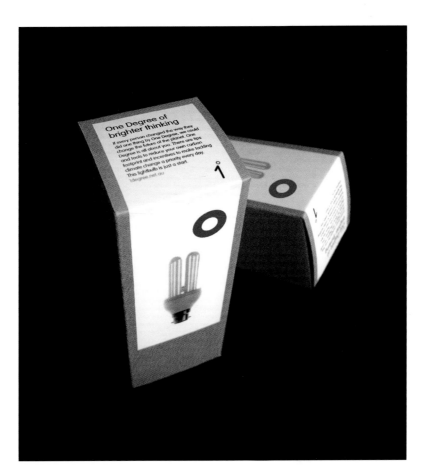

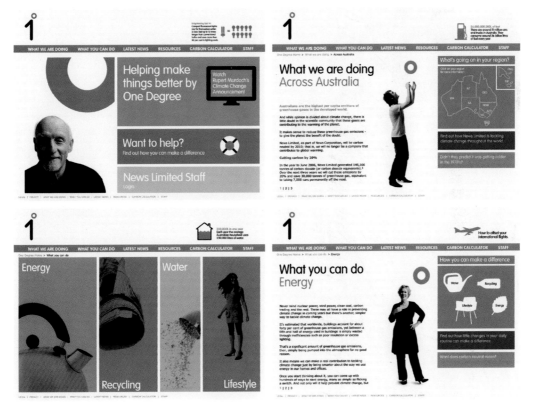

355

LANDOR ASSOCIATES — SYDNEY, AUSTRALIA
Creatives : Jason Little, Tim Warren,
Angela McCarthy, Mike Rigby
Client : News Limited

WHAT'S GREEN ABOUT THIS — The challenge was to create a brand for News Limited that would help drive employee, supplier, and public action on climate change. The new brand needed to inspire thousands of employees to make real, long-term change. The designer developed One Degree on a simple premise: that if everyone would change their behavior by just one degree, we can change the planet's future.

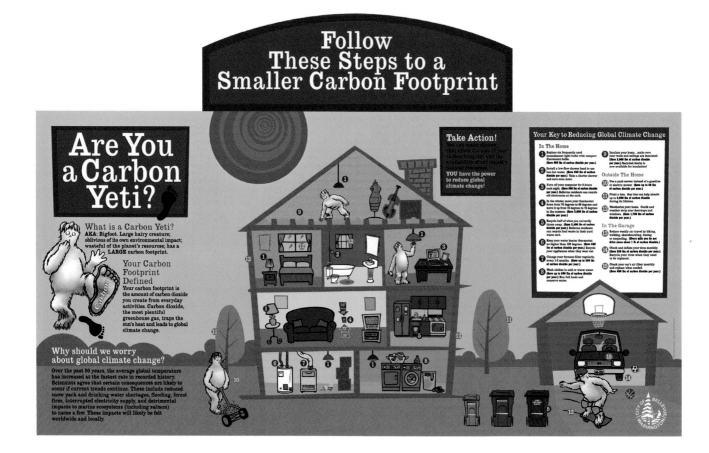

City of Bellevue

Smaller Footprint Pledge

A Resource Conservation Commitment For A Healthy Community

6. In the Yard

- Mow after 6 pm because gas vapors have less time to react with the sunlight.
- When it rains, pollutants such as oil, metals and pesticides are washed off lawns, roofs, driveways, streets and parking lots and enter our waterways untreated through the storm drain system.
- Every day more solar energy falls to the Earth than the total amount of energy the planet's inhabitants would consume in 27 years. Solar energy is a super-abundant resource.
- The air pollution from cutting grass for an hour with a gasoline-powered lawn mower is about the same as that from a 100-mile automobile ride.

Fact: Local King County stream samples turned up 23 common weed and bug killers at levels harmful to salmon and wildlife. Weed & feed chemicals found in local streams include 2,4-D, MCPP and dicamba. Over use of these products is bad for soil, fish and your family's health.

In the yard I pledge to...

A. Leave grass clippings on my lawn for free fertilizer and a healthier yard.
B. Think twice about using pesticides, quick-release fertilizers and weed & feed products. They can damage the soil, lawn health, and pollute our waterways.
C. Use a push mower instead of a gasoline or electric mower. **(Save up to 80 lbs of carbon dioxide per year.)**
D. Carry a bag when on walks with my dog, pick up after them, and dispose of the waste in the trash to protect local streams, lakes and wetlands.
E. Practice smart watering for healthier plants and to save limited summer water resources.

4. In the Bathroom

- In the United States, 27 percent of our water is used in bathing.
- The average North American consumes over 105 gallons of water a day compared to the average European's consumption of almost 53 gallons. The average person living in sub-Saharan Africa consumes only 2.4 – 5.3 gallons per day.
- A leaky toilet can waste over 100 gallons of water a day.

Fact: Showers account for 2/3 of all water heating costs.

In the bathroom I pledge to...

A. Install a water efficient showerhead so I use less hot water. **(Save 350 lbs of carbon dioxide per year.)**
B. Take 2 minutes off my shower time. **(Save 342 lbs of carbon dioxide per year.)**
C. Shave in the sink, not the shower. **(Save 50 lbs of carbon dioxide per year.)**
D. Repair leaky faucets knowing that they could leak up to 100 gallons of water per day.
E. Check my toilet(s) for leaks by putting 5-10 drops of food coloring into the toilet tank. If color appears in the bowl, I will know there is a leak that I need to repair.
F. Hang my towel to dry and use it more than once.

357

Are You a Carbon Yeti?

What is a Carbon Yeti?
AKA: Bigfoot. Large hairy creature; oblivious of its own environmental impact; wasteful of the planet's resources; has a LARGE carbon footprint.

Your Carbon Footprint Defined
Your carbon footprint is the amount of carbon dioxide you create from everyday activities. Carbon dioxide, the most plentiful greenhouse gas, traps the sun's heat and leads to global climate change.

Why should we worry about global climate change?
Over the past 50 years, the average global temperature has increased at the fastest rate in recorded history. Scientists agree that certain consequences are likely to occur if current trends continue. These include reduced snow pack and drinking water shortages, flooding, forest fires, interrupted electricity supply, and detrimental impacts to marine ecosystems (including salmon) to name a few. These impacts will likely be felt worldwide and locally.

Welcome!

You are invited to participate in the Smaller Footprint Pledge.

A community action program takes individual commitment. Each person or family can be part of the solution to reduce global climate change.

You may already include many of the practices listed in this book in your daily routine; perhaps you'll find a few new ideas to try. Everyday choices affect your personal carbon footprint and the future availability of our planet's natural resources. Working together we can make a difference.

You will be pledging to reduce your personal impact on climate change. Actions you choose to pledge in this booklet will reduce the carbon dioxide produced during your daily activities.

To take the Pledge, fill out the detachable card on the next page and mail it to us. We will send you a beautiful sun catcher* made of local recycled glass as our way of saying, "thank you."

*Limited to one per household in the Bellevue service area only, while supplies last.

Together we can make a difference. Take the Pledge TODAY!

VIVITIV — SEATTLE, WASHINGTON
Creatives : Jacqueline McCarthy, Mark Kaufman, Joyce Bergen
Client : City of Bellevue

WHAT'S GREEN ABOUT THIS — Vivitiv designed a campaign for the City of Bellevue to create carbon-footprint awareness among the city's young teen population. A booklet featuring "Carbon Yeti" invites them to pledge to reduce their carbon footprints and gives them specific steps to do so. A portable tabletop display featuring Carbon Yeti is used at city events, schools, farmers markets, and fairs. A series of ads informs city residents of the food recycling program: The city collects food scraps and food-soiled paper and turns them into compost for parks and local gardens. Collectively, these efforts have reduced carbon dioxide production as well as what goes into the landfill.

How They Did It
Plenty Magazine

Plenty magazine attempts to bring the green movement out of the stereotypes of the past and incorporate it with today's lifestyle and look. In late 2005, the publication wanted an evergreen full-page ad emphasizing that position for use in partner publications and the magazine itself.

A PR firm that worked with both firms recommended BBMG Branding and Integrated Marketing to Plenty. "BBMG is a little different," says Mitch Baranowsky, a founder of the firm and the Plenty account leader. "We view ourselves as a social change agency. We use branding and marketing to improve society. Our client base is a mix of green startups and non-profits as well as large companies that are moving to green."

BBMG developed three concepts for the ad. "Plenty was trying to stand out in a field that features an old hippie lifestyle. Plenty has a more edgy clientele," says BBMG creative director Scott Ketchum. The target was young, affluent, educated men and women. The tone would be smart, sexy, enriching, fun, upscale, and would reinforce the notion that saving the planet is easy. Ideally, the ad would help the magazine own a color—its own shade of green.

"We were very limited on the budget and photography we could use, so we needed to produce our own illustrations and photos," Ketchum says. For one concept, BBMG was inspired by Roy Lichtenstein, the pop artist heavily influenced by the comic book style. The concept—illustrated by Lou Brooks and which later went on to be a popular cover design for Plenty—depicts a young woman musing about her companion's green behavior. "He could be the one. He drives a hybrid, but does he compost?"

"It became a very successful cover for them," Ketchum says. "Mark Spellun (the magazine's founder) has used a slide of that cover in presentations to demonstrate what Plenty is all about."

Another concept contrasted the images of an old Volkswagen bus and a new Prius, with the line, "Green with envy," opposite. The question below read: "What shade of green are you?" Ketchum explains: "At the time, it seemed that most environmentally-conscious publications seemed to think you had to sacrifice your standards and lifestyle if you wanted to live green. We wanted to say you don't have to compromise."

The magazine had only published a few issues before BBMG designed the ads and the cover. It went on to grow in readership and has gained more optimal shelf placement in outlets such as Whole Foods Market, Barnes and Noble, Target, and Office Depot. The alliance of BBMG and Plenty was a natural. "Earth-friendly design is in our DNA," says Ketchum.

BBMG — NEW YORK, NEW YORK
Creatives : Mitch Baranowski, Lou Brooks, Mark Spellun, Scott Ketchum
Client : Plenty

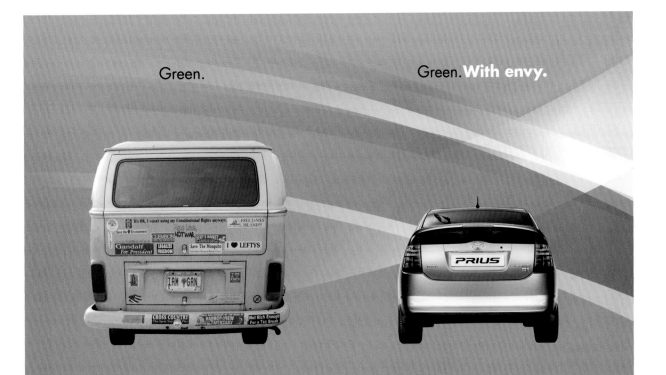

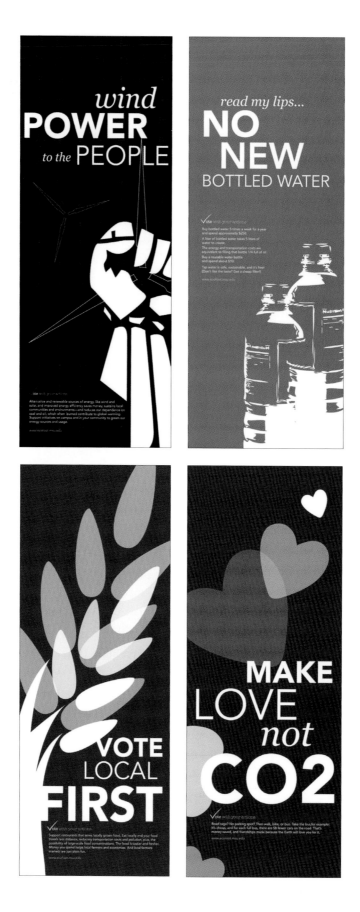

360

WHAT'S GREEN ABOUT THIS — To reduce waste, these posters replaced hundreds of brochures on the Michigan State University campus. Students were allowed to download PDFs of the files to print on demand, further emphasizing less waste. Each poster addresses an individual choice—or action—towards sustainable living.

THRIVE DESIGN — EAST LANSING, MICHIGAN
Creatives : Kelly Salchow MacArthur, Liz Levosinski, Caitlin Gallagher, Kali Sandberg
Client : Michigan State University

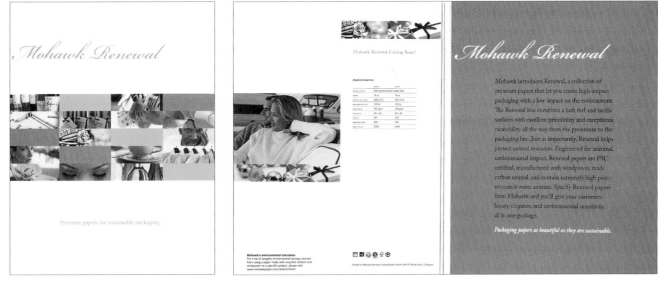

AURORA DESIGN — NISKAYUNA, NEW YORK
Creatives : Jennifer Wilkerson, Laurel Saville
Client : Mohawk Fine Papers

WHAT'S GREEN ABOUT THIS — Mohawk Renewal folding board is FSC-certified and made of 80% post-consumer waste fiber, carbon-neutral and manufactured with windpower. It is acid-free, archival, and process chlorine free.

361

EXECUTIONISTS, INC. — MARINA DEL REY, CALIFORNIA
Creatives : Richard Parr, Temy Gu, Erin Tozour, Manuel Y. Cabacungan
Client : Michael Warren

WHAT'S GREEN ABOUT THIS — The Million Lights Project was established with the goal of delivering one million Compact Fluorescent Light bulbs to homes across America by Earth Day, April 22, 2008. Among other things, their website explains the drawbacks of incandescent lightbulbs and the benefits of switching to fluorescent.

362

one
two
three
four
five
six steps
to sustainable
development
for housing
associations

WHAT'S GREEN ABOUT THIS — This 40-page report was printed in one color only, with the exception of the divider pages which were printed together in color. It was printed on 100% post-consumer recycled paper with vegetable-based inks. Each step is overprinted with the colors of the previous steps, reflecting the build-up of knowledge necessary to become truly sustainable.

THOMAS.MATTHEWS LTD — LONDON, UNITED KINGDOM
Creatives : Kristine Matthews, Tara Hanrahan, Sophie Thomas
Client : Beyond Green and The Housing Association

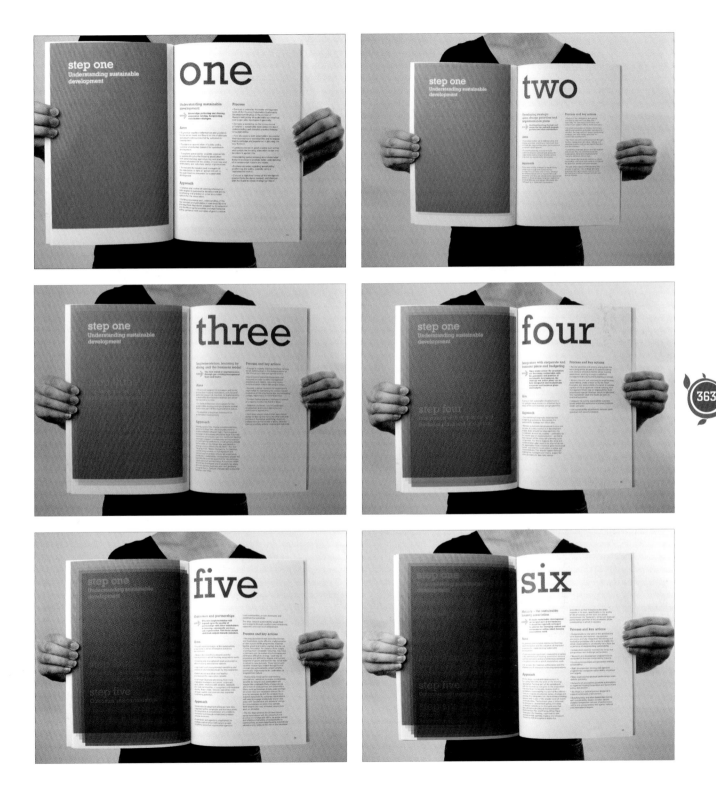

Make Coffee

Make Compost

After your morning coffee, don't throw the filter and grounds into the garbage—put them in your yard debris cart. Food scraps and food-soiled paper can go in with the yard debris. They'll stay out of the landfill and get recycled into a soil-enriching compost for gardens.

City of Bellevue Utilities
425-452-6932 or visit
www.rabanco.com/collection/bellevue

It's not garbage anymore

364

Stale Fruit Cake

Fresh-Cut Flowers

When family and friends won't eat the last of the fruit cake, put it into your yard debris cart! It will stay out of the landfill and get recycled into earth-friendly compost for flower gardens. And don't forget, food-soiled paper can go into the yard debris cart too.

If you live within Bellevue city limits and have yard debris service through Allied Waste Services, you can get a free bucket to carry food waste from your kitchen to the green yard debris cart. Call Allied Waste at 425-452-4762 to request your bucket.

Limited to one bucket per single-family residence.

City of Bellevue Utilities
425-452-6932

Pizza Party

Garden Party

You threw a great party, but don't throw that soiled pizza box into the garbage. Put it into your yard debris cart along with food scraps. They'll stay out of the landfill, get recycled into a soil-enriching compost, and grow delightful daisies.

Call City of Bellevue at
425-452-6932 or visit
www.rabanco.com/collection/bellevue

It's not garbage anymore

WHAT'S GREEN ABOUT THIS — These awareness advertisements were commissioned by the City of Bellevue, Washington for the "It's not garbage anymore" campaign.

VIVITIV — SEATTLE, WASHINGTON
Creatives : Jacqueline McCarthy, Mark Kaufman
Client : City of Bellevue

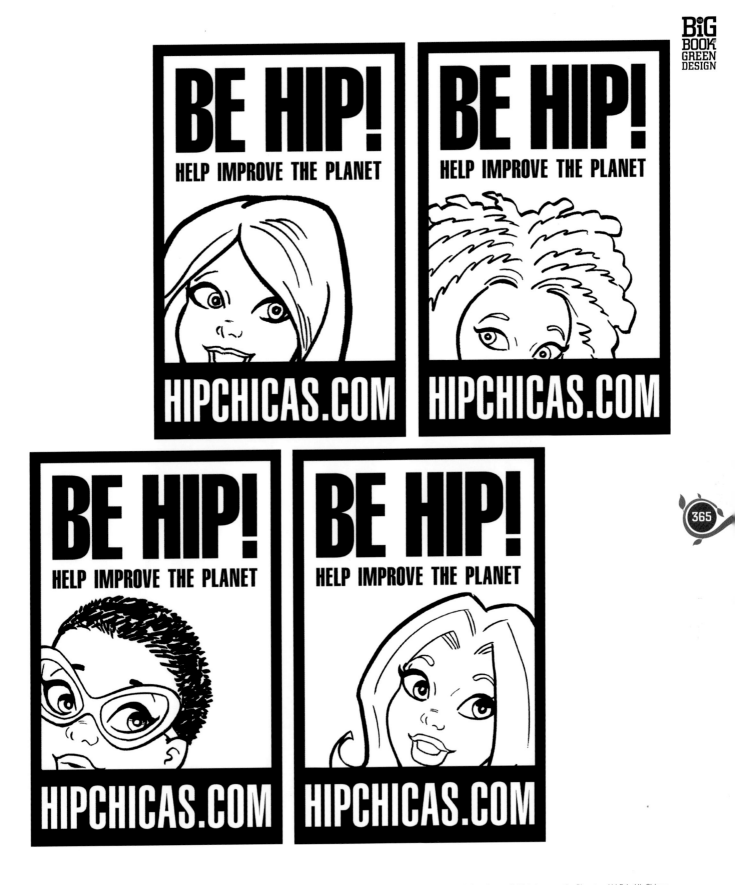

365

HIHO DESIGN — RIO RANCHO, NEW MEXICO
Creatives : Heidi Ames, Lázaro Fuentes, Dan Parent
Client : Lázaro Fuentes, Founder, CEO, HIP Venture Co., Inc.

WHAT'S GREEN ABOUT THIS — A website with one mission above all: Help Improve the Planet… H.I.P. In HipChicas. com users are the keepers of their environments. More than the typical decorating of a room as in other virtual worlds, users are planting trees, improving habitats, playing games where they protect whales or seed an ailing reef. They win points that convert to HipGreen with every improvement they make. They negotiate and trade with other players and they earn interest along the way. Members use alternative energies to light up their personal spaces and in order to watch their favorite videos or listen to music with friends on their friends list. Animals are not their pets but are the part of the habitat in each location so the more you improve their habitats the more they appear. Animals in the world include manatees, sea turtles, monkeys, whales, owls, dolphins, jaguars, and others native to each place - all endangered wildlife and all savable. That's hip!

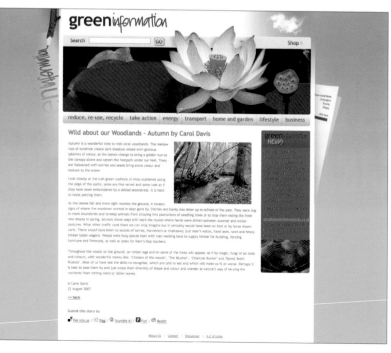

DESIGN ADVANTAGE — CANTERBURY,
UNITED KINGDOM
Creatives : Leon Hastwell
Client : Green Information

WHAT'S GREEN ABOUT THIS — Greeninformation.co.uk provides the public with information about sustainability, eco-products, and greener living.

thomas.matthews:
ten ways design
can fight
climate change

1.
re-thinking

We step back and think before we dive in to find a different way to communicate our clients' needs.

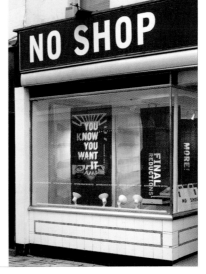

No Shop
Friends of the Earth
The client asked for a poster to encourage people to stop shopping – and consider their consuming habits – for the UK's first International No Shop Day. Instead we fought fire with fire, using the language of shopping – sale signs, shopping bags, a 'shop' stripped of goods – to form a No Shop brand and turn consumerism on its head. No Shop was reported over twenty networks and newspapers and has since appeared in many books, magazines and exhibitions.

8.
supporting
what
we believe

We work for clients who push agendas we care about: better recycling, fighting climate change, tackling hunger, raising money to make good things happen.

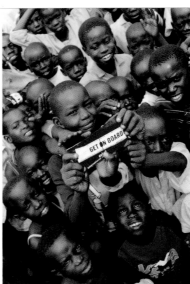

Get On Board
ActionAid International
We designed the identity and collateral for a campaign which highlighted third world debt to world leaders at the G8 Summit. A bus travelled from Johannesburg to the summit in Edinburgh, collecting thousands of personal messages on poverty along the way.

4.
saving
energy

We reduce our clients' carbon footprint by using sustainable energy sources. People power is best, or failing that, renewable energy is becoming more efficient. We design to minimise energy demand.

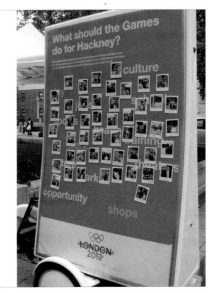

London 2012 Roadshow
Olympic Delivery Authority
A unique community consultation programme used a fleet of modified bikes, visiting venues across five East London boroughs. Public participation was encouraged using a kit of Polaroid cameras, stickers, pens, leaflets and other interactive materials. Using bikes gave out a positive message not only about sustainability but also about the Olympics and the role of sport and healthy living.

369

THOMAS.MATTHEWS LTD — LONDON, UNITED KINGDOM
Creatives : Sophie Thomas, Kristine Matthews, Mark Beever, Peter Clarkson
Client : thomas.matthews ltd

WHAT'S GREEN ABOUT THIS — For this publication, thomas.matthews used printer's make-ready sheets, which were printed on the reverse (plain) side. The size of each piece remained compact and small and each were printed with vegetable-based inks.

LÁZARO FUENTES
CEO

HIP VENTURE CO
1199 Park Avenue
New York, NY 10128
Tel: 212.722.7227
Cell: 917.822.1917
Fax: 877.572.7690
laz@hipventure.com
www.hipventure.com

WHAT'S GREEN ABOUT THIS — The Hip Venture Co. is a digital media company that will combine elements of popular culture, digital animation, and music to entertain children while instilling a shared sense of culture and responsibility for ourselves and our planet and empowering them with the ability to make positive changes online virtually and in their offline reality.

HIHO DESIGN — RIO RANCHO, NEW MEXICO
Creatives : Heidi Ames, Lázaro Fuentes
Client : Lázaro Fuentes, Founder, CEO, Hip Venture Co., Inc.

370

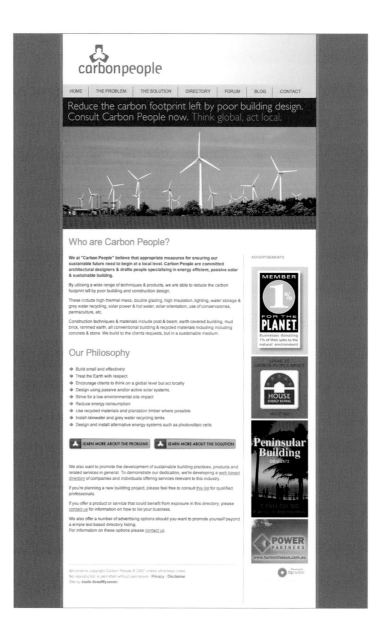

WHAT'S GREEN ABOUT THIS — Carbon People (www.carbonpeople.com.au) was developed in an attempt to bring those interested or involved in sustainable building design together online, so they can share ideas and knowledge. The site includes a community forum, blog, and business directory.

STUDIO THREEFIFTYSEVEN — ADELAIDE, AUSTRALIA
Creatives : Jason Porter
Client : Carbon People

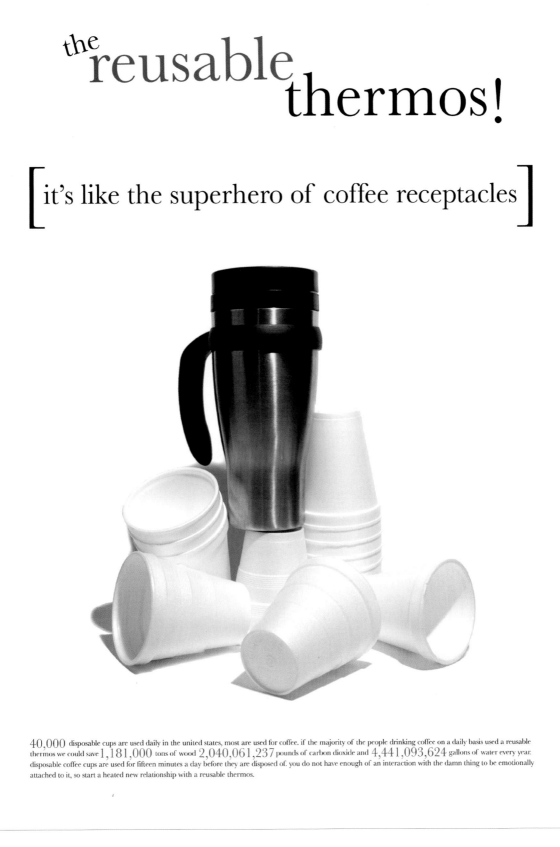

the reusable thermos!

[it's like the superhero of coffee receptacles]

40,000 disposable cups are used daily in the united states, most are used for coffee. if the majority of the people drinking coffee on a daily basis used a reusable thermos we could save 1,181,000 tons of wood 2,040,061,237 pounds of carbon dioxide and 4,441,093,624 gallons of water every year. disposable coffee cups are used for fifteen minutes a day before they are disposed of. you do not have enough of an interaction with the damn thing to be emotionally attached to it, so start a heated new relationship with a reusable thermos.

371

CALICO DESIGN — MAYS LANDING, NEW JERSEY
Creatives : Rebecca Fiedler
Client : Calico Design

WHAT'S GREEN ABOUT THIS — A poster displayed in a graphic design show about sustainability.

372

NO

NEVER pour or wash anything into a storm drain!

CLEANING UP?

NOTHING BUT RAIN DOWN THE STORM DRAIN

YES

Dispose of mop water in a utility sink that is properly connected to the sanitary sewer.

STORMWATER RUNOFF IS NOT TREATED and is the leading source of water pollution in our community. Runoff flows directly from the storm drain into local streams and lakes.

Many business activities can contribute to stormwater pollution. YOU can help keep pollutants out of our streams and lakes and reduce the hazards to people and fish!

Remember - Nothing But Rain Down The Storm Drain.

Call City of Bellevue Utilities at 425-452-6932 for more information

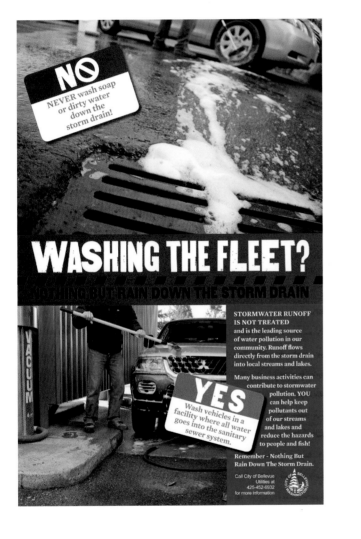

VIVITIV — SEATTLE, WASHINGTON
Creatives : Jacqueline McCarthy,
Mark Kaufman, Dale DeGabriele
Client : City of Bellevue

WHAT'S GREEN ABOUT THIS — Businesses often mistakenly dump dirty water or rinse spills into storm drains, thinking the waste water will get treated and toxins will be removed. This three-poster series was distributed to city businesses to encourage the proper disposal of mop water, soapy water, and spills. Reduction of pollutants to local streams and lakes lessens hazards to people and fish while improving water quality.

vama design(®)

EARTH'S TIME IS OVER.
WAKE UP!

♻ BE EARTH'S FRIEND. CARE FOR YOUR HOME. RECYCLE MEANS LIFE. ITS IN YOUR HAND.

VAMADESIGN — GREECE
Creatives : Vasilis Magoulas
Client : theÉcovoice

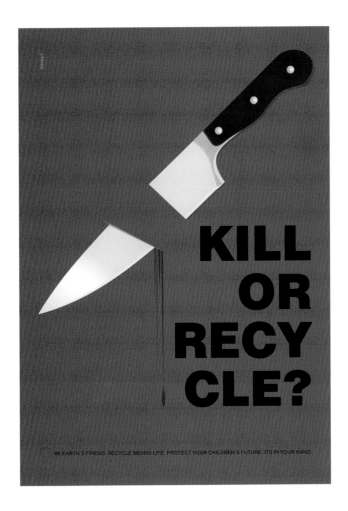

KILL OR RECY CLE?

BE EARTH'S FRIEND. RECYCLE MEANS LIFE. PROTECT YOUR CHILDREN'S FUTURE. ITS IN YOUR HAND.

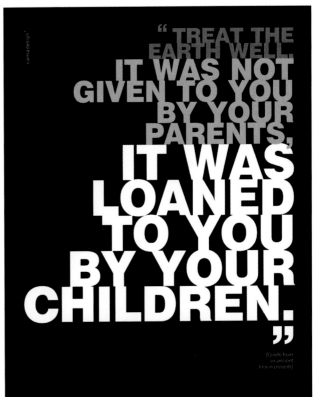

"TREAT THE EARTH WELL. IT WAS NOT GIVEN TO YOU BY YOUR PARENTS. IT WAS LOANED TO YOU BY YOUR CHILDREN."

[Quote from an ancient Indian proverb]

BE EARTH'S FRIEND. RECYCLE MEANS LIFE. PROTECT YOUR CHILDREN'S FUTURE. ITS IN YOUR HAND.

TERMINOLOGY

3Rs—Reduce, Reuse, Recycle.

Abaca—Species of banana plant. Its large leaves and stems are harvested for its fiber which is used in making clothing and textile goods. A sustainable alternative to cotton.

Bamboo—Fast-growing grass/reed that is generally more renewable than wood. Care should be taken when shopping for bamboo products because many cheaply-made items are coated with toxic finishes.

Biodegradable—Material that breaks down with the assistance of microorganisms.

Carbon Footprint—Total amount of carbon dioxide (and other greenhouse gases) emitted over the full life cycle of a product or service.

Certified—The acknowledgment that a product is genuine to what it claims, typically having gone through a process similar to obtaining a license.

Certified Wood—Referring to Forest Stewardship Council (FSC) certification. Wood-based materials used in building construction that are supplied from sources that comply with sustainable forestry practices that protect trees, wildlife habitat, streams, and soil.

Chain of Custody—The path that goods take from the forest to the consumer, including all stages of processing, transformation, manufacturing, and distribution.

Chlorine Free—Manufactured without chlorine or chlorine derivatives.

Compostable—A material that breaks down to become what is, effectively, dirt. The result of composted material contains no toxins and can support plant life.

CWMP (Construction Waste Management Plan)—A plan that diverts construction debris from landfills through recycling, salvaging, and reuse. Carefully monitored by the contractor, CWMP should also eliminate the packaging of materials.

Digital Printing—Method of printing from digital files direct to paper without the need for conventional films or plates. It requires less waste in terms of chemicals and wasted paper. Digital printing, or print-on-demand, gives the flexibility to print in quantities that would not be cost-effective with conventional litho printing.

Eco-Chic—Both eco-friendly and hip.

Eco-Friendly—Products made with the ecology and environment in mind.

Eco-Bag—Organically-made bag.

Eco-Savvy—One who is environmentally-aware.

Ecosystem—The physical and biological elements of an area that coexist to form a self supporting environment.

EMAS (Eco-Management and Audit Scheme)—Management tool for companies and other organizations to evaluate, report, and improve their environmental performance.

Energy Efficient—Products and systems that use less energy to perform as well or better than standard products. Some energy-efficient products have a higher purchase price than their traditional counterparts but they tend to cost less over their lifetime when the price of energy consumed is considered.

Fair Trade—Social movement that promotes standards for international labor through fair wages and good employment opportunities to economically-disadvantaged populations.

Flat-Pack—Product that is designed to be packed flat, thereby reducing shipping costs and fuel used in transportation. Flat-pack designs are ready to assemble by the customer right out of the box.

Forest Certification—Process by which the environmental, social, and economic integrity of a managed forest is inspected, measured, and certified by a credible third party.

FSC (Forestry Stewardship Council)—Nonprofit organization whose mission is to promote environmentally-appropriate, socially-beneficial, and economically-viable management of the world's forests. FSC-labeled wood products indicate that the wood is harvested from sustainably-managed forests.

FSC-Certified—Product, process, or service that has been certified by an FSC-accredited certification body as compliant with the applicable FSC standard.

Gang Printing—Using the maximum sheet size to print multiple images or jobs on the same sheet of paper.

Glass Recycling—A perpetual form of recycling. Unlike some other recycled products, a recycled bottle can be recycled into another glass bottle. And another, and so on forever.

Green Building—A building designed to conserve resources and reduce negative impacts on the environment with regard to energy, water, building materials, or land. Compared to conventional construction, green buildings may use one or more renewable energy systems for heating and cooling such as solar electric, solar hot water, geothermal, bio mass, or any combination of these.

Green Collar—A rapidly growing workforce devoted to sustainable, organic, or authentic industry.

Green Design: A term used in the building, furnishings, and product industries to indicate design sensitive to environmentally-friendly, ecological issues.

Greenwashing—Superficial nod to the environment that marketers and businesses, historically not interested in sustainable concerns, are doing in order to improve their public relations with the consumer.

Greywater—Effluent from the shower, bath, sinks, and washing machines.

Going Green—Phrase referring to the action a person consciously takes in order to curb harmful effects on the environment through consumer habits, behavior, and lifestyle.

ISO 14001—A standard for environmental management systems to be implemented in any business, regardless of size, location, or income. The aim of the standard is to reduce the environmental footprint of a business and to decrease the pollution and waste a business produces.

LEED (Leadership in Energy and Environmental Design)—Certification process by the U.S. Green Building Council that evaluates new buildings constructed to common green standards.

LOHAS (Lifestyle of Health and Sustainability)—Jargon that's becoming unfashionable in favor of the word "green".

Low-VOC—Term referring to reduced amounts of volatile organic compounds in paint and finishes. Low-VOC paints do not off-gas as much as conventional paints and contain less toxins that are harmful to the environment.

Multi-Functional—Something that serves more than one purpose. In product and furniture design, multi-functional pieces reduce the need for multiple products, thus using less raw resources and reducing clutter in modern homes.

Natural—A product that is made from materials and ingredients found in nature, with little or no human intervention. For example, wood is a natural material while plastic is not.

Non-Toxic—Not poisonous.

Organic—Of or relating to a product that is solely made from plants or insects. Organic materials and products often carry certifications according to the industry.

Organic Food—Plants grown without conventional pesticides, artificial fertilizers, or sewage. Organic food products from animals are not subjected to antibiotics or growth hormones.

PEFC (Programme for the Endorsement of Forest Certification)—Promotes an internationally-credible framework for forest certification schemes and initiatives in European countries.

PLA (Polylactic Acid or Polylactide)—Type of bioplastic. PLA can be made from corn starch or other starch-rich substances like maize, sugar, or wheat. Packaging made from PLA is biodegradable and reverts in less than 60 days in ideal conditions.

Post-Consumer—Refers to recycled material that was used first by a consumer. A high post-consumer content helps divert materials from ending up in landfills.

Pre-Consumer—Refers to recycled material that came from a manufacturing process. Pre-consumer recycling of scraps and discards diverts waste that may otherwise end up in landfills, and reduces use of raw materials.

Recyclable—Material that can be converted back into a similar material which can then be used in manufacturing new goods. Typically, recyclable materials (aluminum, steel, paper, etc.) must remain in a pure form. If too many adhesives are used, or a product is made from a composite, those materials may not be separated at the end of its life-cycle for recycling.

Recycle—Reprocess or use again.

Recycled Fiber—Fiber that has been reprocessed and incorporated into a new product. Sources of fiber for recycling may be reclaimed pre-consumer or reclaimed post-consumer material.

Renewable Energy—Energy harvested from sources that are not depleted when used, typically causing very low environmental impact. Examples include solar energy, hydroelectric power, and wind power.

Remanufacturing—Recycling concept by which an existing product can have its useful life extended through a secondary manufacturing or refurbishing process.

Renewable—Raw material that can be replenished within a reasonable amount of time. Bamboo and sustainably-harvested woods are renewable. Gold and precious stones are not renewable.

Repurpose—Using a thing or a material for a purpose other than its original use.

Re-Use—To use again, whether for the same purpose or reappropriated for another.

Soy Ink—Ink made from soybeans. It is more environmentally-friendly than traditional petroleum-based ink and is easier to recycle.

Sustainable—A broad term that often refers to actions and products meeting current needs without sacrificing the ability of future needs being met.

Sustainably-Harvested—Renewable resource harvested in a way that allows its inherent regeneration and continued ongoing supply.

Vegetable Based Ink—Ink made with vegetable oil, such as soybean or linseed oil. These inks significantly reduce the amount of ozone depleting (VOCs released into the air during printing.

Virgin Stock—Pulp obtained from wood, cotton, or another cellulose source not previously used in the papermaking process.

VOC (Volatile Organic Compounds)—Toxins commonly found in conventional paints, sealers, and finishes.

Waste Reduction—Process that reduces or eliminates waste at its source or reduces the amount of toxicity from waste.

Zero-VOC—Term used to indicate paint containing no volatile organic compounds.

DIRECTORY

3D Exhibits
2800 Lively Boulevard
Elk Grove Village, Illinois 60007
www.3dexhibits.com
847.238.4741

3rd Edge Communications
162 Newark Avenue • 3rd Floor
Jersey City, New Jersey 07302
www.3rdedge.com
201.395.9960

29 Agency
2485 E Southlake Blvd • Suite 180
Southlake, Texas 76092
www.29agency.com
817.488.9929

828 Design
32 Broadway • Suite 120
Asheville, North Carolina 28801
www.828design.com
828.254.9200

A3 Design
PO Box 43046
Charlotte, North Carolina 28215
www.athreedesign.com
704.568.5351

Addis Creson
2515 Ninth Street
Berkeley, California 94710
www.addis.com
510.704.7500

After Hours Creative
Phoenix, Arizona 85003
www.ahcreative.com
602.275.5200

Ainsworth Studio.com
705 S 9th Street • #301
Tacoma, Washington 98405
www.ainsworthstudio.com
253.534.9595

AkarStudios
1404 Third Street Promenade • Suite 201
Santa Monica, California 90401
www.akarstudios.com
310.393.0625

Alexander Isley Inc.
9 Brookside Place
Redding, Connecticut 06896
www.alexanderisley.com
(203) 544-9692

Aloof Design
5 Fisher Street
Lewes, East Sussex, BN7 2DG
United Kingdom
http://aloofdesign.com
44 (0)1273 470887

ALR Design (Another Limited Rebellion)
2701 Edgewood Ave
Richmond, Virginia 23222
www.alrdesign.com
804.321.6677

Alternatives
223 W 29th Street
New York, New York 10001
www.altny.com
212.239.0600

Altitude, Inc
363 Highland Avenue
Somerville, Massachusetts 02144
www.Altitudeinc.com

Ambient
Miller Place, New York
631.512.9515

Amcore Pet Packaging
10521 Highway M-52
Manchester, Michigan 48158
www.amcor.com/businesses/pet
734.428.9741

Angela Webb Designs
PO Box 691076
Tulsa, Oklahoma 74169
www.angelawebb-designs.com
918.794.4768

Anthem
35 S Park Street
San Francisco, California
415.896.9399

Arizona State University
University Drive and Mill Avenue
Tempe, Arizona 85287
www.asu.edu
480.276.8702

Aurora Design
Niskayuna, New York
www.auroradesignonline.com
518.346.6228

AxiomaCero
Padre Mier 1111
Monterrey, NL 64000
Mexico
www.euphorianet.com
811.257.1414

BBMG
200 Park Avenue South • Suite 1516
New York, New York 10003
www.bbmg.com
212.473.4902

Belyea
1809 7th Avenue • Suite 1250
Seattle, Washington 98101
www.belyea.com
206.682.4895

Better Image Company, The
7045 S Tamiami Trail
Sarasota, Florida 34231
http://thebetterimagecompany.com
941.926.8200

BHZ Design
Rua Ramiro Barcelos, 1.215/401
Independência - CEP 90035.006
Porto Alegre - RS ñ Brasil
www.bhzdesign.com.br
55.51.3024.8030

Big Fish Design Ltd.
11 Chelsea Wharf
15 Lots Road
London SW10 0QJ
United Kingdom
www.bigfish.co.uk
+44(0)20 7795 0075

Bill Atkins Design & Illustration
263 San Joaquin Street
Laguna Beach, California 92651
949.494.5899
bill@atkinsart.com

Boomerang Integrated Marketing
Level 2 • 7 Kelly Street
Ultimo NSW 2007
Australia
www.boom.com.au
02 9556 8999

BOUTIQUEGRAFICA
Viña del mar, Chile
www.boutiquegrafica.cl
(52)(32)2111486

Bowling Green State University
Bowling Green, Ohio 43403
www.bgsu.edu
419.372.2531

Brady Communications
Four Gateway Center
Pittsburgh, Pennsylvania 15222
|www.bradycommunications.com
412.288.9300

Brand Engine
80 Liberty Ship Way • Suite 1
Sausalito, California 94965
www.brandengine.com
415.339.4220

BrandLogic
15 River Road
Wilton, Connecticut
www.brandlogic.com
877.565.2255

Bremmer & Goris Communications
1908 Mount Vernon Avenue
Alexandria, Virginia 22301
www.goris.com
703.739.0088

Brown-Forman
Louisville, Kentucky
www.brown-forman.com
502.585.4559

Brown Sugar Design
Kirkland, Washington
http://bsdstudio.com
425.830.3680

Bruketa&Zinic OM
Zavrtnica 17
10 000 Zagreb
Croatia
www.bruketa-zinic.com
385.16064.000

Bulldog Creative Services
916 5th Avenue • Suite 305
Huntington, West Virginia 25701
www.bulldogcreative.com
304.525.9600

Büro North
L1/35 Little Bourke Street
Melbourne, Victoria 3000
Australia
www.buronorth.com
613.9654.3259

Burrows
5 Rayleigh Road • Shenfield
Brentwood, Essex CM13 1AB
United Kingdom
www.burrows.info
44(0) 1277 24666

B&Z Marketing Communications
5150 N Port Washington Road • Suite 260
Milwaukee, Wisconsin 53217
www.bzmarcom.com
414.332.1500

Calagraphic Design
523 Stahr Road
Elkins Park, Pennsylvania 19027
215.782.1361

Calico Design
Mays Landing, New Jersey
609.289.2543

Call Me Amy Design
PO Box 15804
Seattle, Washington 98115
www.callmeamy.com
425.444.4268

Camp Creative Group
Blue Ridge Summit, Pennsylvania
www.campcreativegroup.com
717.798.8373

Cannonball Studio
Placeta Montcada 1-3, principal
08003 Barcelona
Spain
www.cannonballstudio.com
34 93.269.01.89

Capers Design
166 Rivers Edge Drive
Middleboro, Massachusetts 02346
774.213.9566
lauren@capersdesign.com

Carbon Creative
2833 Irving Avenue South
Minneapolis, Minnesota 55408
www.carboncreative.com
612.870.8007

Cause and Affect Design Ltd.
301 - 21 Water Street
Vancouver BC V6B 1A1
Canada
www.causeandaffect.com
604.608.1366

CCO Inc.
13261 Venice Boulevard
Los Angeles, California 90066
www.craigcameronolsen.com
310.313.6000

Celery Design Collaborative
2115 Fourth Street • Suite C
Berkeley, California 94710
www.celerydesign.com
510.649.7155

Change, The
Chapel Hill, North Carolina
919.338.2129

Chapple Design
4224 Glenalbyn Drive
Los Angeles, California 90065
www.chappledesign.com
323.222.3111

Charlwood Design
50 Glasshouse Road
Collingwood Victoria 3066
Australia
www.charlwood.com.au
61 3 9416 1611

Chen Design Associates
649 Front Street • Third Floor
San Francisco, California 94111
www.chendesign.com
415.896.5338

Chrimmons
Brooklyn, New York
917.569.4891
http://chrimmons.com

Christiansen : Creative
PO Box 1022
Hudson, Wisconsin 54016
www.christiansencreative.com
715.381.8480

Church Logo Gallery
2530 Vista Way • Suite F164
Oceanside, California 92054
www.churchlogogallery.com
760.231.9368

Citizen Studio
886 Wildwood Road NE
Atlanta, Georgia 30324
www.citizenstudio.com
404.892.0560

CL Graphics, Inc.
134 Virginia Road • Suite A
Crystal Lake, Illinois 60014
www.clgraphics.com
815.455.0900

Compass Creative Studio
201-3228 South Service Road
Burlington, Ontario L7N 3H8
Canada
www.compasscreative.ca
905.331.1850

Conry Design
21234 Chagall Road
Topanga, California 90290
www.conrydesign.com
818.888.0977

Crabtree + Company
200 Park Avenue
Falls Church, Virginia 22046-4309
www.crabtreecompany.com

Creative Concepts
Newark, New Jersey
C.Cordaro@verizon.net
973.986.8575

Curious Design Consultants Limited
1 Turakina Street
Grey Lynn, Auckland 1021
New Zealand
www.curious.co.nz
64.9361.2591

CWA Inc .
4015 Ibis Street
San Diego, California 92103
www.cwaincsandiego.com
619.299.0431

D4 Creative Group
4646 Umbria Street
Manayunk, Pennsylvania 19127
www.d4creative.com
215.483.4555

Dasha Wagner
State Center, Iowa
http://www.dm-design-collection.com

Dean Ford Creativity
20 Westmoreland Road
Bromley BR2 0QL
United Kingdom
www.deanfordcreativity.com
020 7000 1055

Defteling Design
1848 NE 58th Avenue
Portland, Oregon 97213
www.defteling.com
503.234.5090

Design 446
2411 Atlantic Avenue • Suite 4
Manasquan, New Jersey 08736
http://design446.com
732.292.2400

Design Advantage
Richdore House • 11 Richdore Road
Waltham, Kent CT4 5SJ
United Kingdom
www.designadvantage.co.uk
01227.700009

Design Army
510 H Street NE • Suite 200
Washington, DC 20002
www.designarmy.com
202.797.1018

design hoch drei GmbH & Co.KG
Hallstraße 25a
70376 Stuttgart
Germany
www.design-hoch-drei.de
49.711.55037730

designlab, inc.
45 South Rock Hill Rd
St Louis, Missouri 63119
www.designlabinc.com
314.962.7702

designnobis
Kader Sokak 15/7 G.O.P Ankara
Turkey
www.designnobis.com
90.312.466.55.24

Design Nut, LLC
3716 Lawrence Avenue
Kensington, Maryland 20895
www.designnut.com
301.942.2360

Design Source Creative
1616 Chardonnay Ridge
Aptos, California 95003
http://designsource.biz
831.724.2400

Diver Logo Design
Saint-Petersburg
Russia
akulin@gmail.com

DK Design Studio, Inc
2121 Peralta Street • #121
Oakland, California 94607
www.dkdesignstudio.com
415.944.8541

Dotzero Design
208 SW Stark Street • Suite 400
Portland, Oregon 97204
www.dotzerodesign.com
503.892.9262

ecoLingo
Phoenix, Arizona
www.ecolingo.com
602.687.9803

ecoLOGIC Design, LLC
10 Vale Drive
Mountain Lakes, New Jersey 07046
www.ecologic-design.com
973.335.9133

ELFEN
20 Harrowby Lane
Bae Caerdydd
Cardiff Bay CF10 5GN
United Kingdom
www.elfen.co.uk

Elias-Savion Advertising
625 Liberty Avenue • 24th Floor
Pittsburgh, Pennsylvania 15222
www.elias-savion.com
412.642.7700

Enzo Creative
382 Springfield Avenue • Suite 408
Summit, New Jersey 07901
www.enzocreative.com
908.219.4703

Ewing Creative, Inc.
5741 E Hillcrest Drive
Port Orchard, Washington 98366
www.ewingcreative.com
360.769.2025

Executionists, Inc.
4134 Del Rey Avenue
Marina del Rey, California 90292
www.executionists.com
310.754.3807

Eyeprojector
Chattanooga, Tennessee

Famous Studio, The
White Stone, Virginia
912.596.7644

Fifth Letter
924 Burke Street
Winston-Salem, North Carolina 27101
www.fifth-letter.com
336.723.5655

Fleming Creative Group
128 8th Avenue West
Vancouver, British Columbia V5Y 1N2
Canada
www.flemingcreativegroup.com
604.669.2296

Flying Cow Design
217 O'Connor Street
Menlo Park, California 94025
www.flyingcowdesign.com
1.888.359.4642

Funk/Levis & Associates
1045 Willamette Street
Eugene, Oregon 97401
www.funklevis.com
541.485.1932

Futura Marketing
9531 West 78th Street • Suite 250
Eden Prairie, Minnesota 55344
http://futuramarketing.com
952.843.4878

Gee + Chung Design
38 Bryant Street • Suite 100
San Francisco, California 94105
www.geechungdesign.com
415.543.1192

Geyrhalter Design
2525 Main Street • Suite 205
Santa Monica, California 90405
www.geyrhalter.com
310.392.7615

Glass Egg Graphic Design
3005 New Natchez Trace
Nashville, Tennessee 37215
www.glasseggdesign.com
615.403.0681

Gouthier Design
Torrington, Connecticut
www.gouthier.com
212.244.7430

Graphic Communications Concepts
10 Sind Chambers • S Bhagat Singh Road
Colaba, Mumbai 400 005
India
091-22 2284 0206
dheergrd@vsnl.com

graphicgranola
1012 E 38th 1/2 Street
Austin, Texas 78751
www.graphicgranola.com
512.436.8222

Graphite Design Limited
2120 Celtic Crescent
Ellerslie, Auckland 1051
New Zealand
www.graphitedesign.co.nz
64 9 827 4616

Greenfield/Belser Ltd.
1818 N Street NW
Washington, DC 20036
www.gbltd.com
202.775.0333

GreenLeaf Media
2040 Winnebago Street
Madison, Wisconsin 53704
www.greenleafmedia.com
608.240.9611

Green Team
286 Fifth Avenue • 12th Floor
New York, New York 10001
www.greenteamusa.com
212.966.6365

Guarino Graphics Design Studio
345 Clay Pitts Road
East Northport, New York 11731
www.guarinographics.com
631.368.4800

Guerrini Design Island
Paraguay 754 4th • "B"
C.P. 1057 Buenos Aires
Argentina
www.guerriniisland.com
54 11 4315-8433

Hames Design
Mohegan Lake, New York
914.603.3093
hames@optonline.net

Hatch Design LLC
353 Broadway Street
San Francisco, California 94133
www.hatchsf.com
415.398.1650

Haugaard Creative Group
414 North Orleans • Suite 508
Chicago, Illinois 60654
www.haugaard.com
312.661.0666

Hiho Design
PO Box 44965
Rio Rancho, New Mexico 87174
http://hihodesign.com

Holohan Design
6760 Germantown Avenue
Philadelphia, Pennsylvania19119
www.holohandesign.com
215.621.6559

Hoopla Marketing
2101 East Saint Elmo Road • Suite 350
Austin, Texas 78744
www.hooplahq.com
512.804.0257

Hornall Anderson
710 Second Avenue • Suite 1300
Seattle, Washington 98104
www.hornallanderson.com
206.467.5800

housemouse™
Level 1 • 141 Flinders Lane
Melbourne 3000
Australia
www.housemouse.com.au

Hoyne Design
77a Acland Street
St Kilda 3182
Melbourne, Victoria
Australia
www.hoyne.com.au
03.9537.1822

Icon Graphics, Inc.
245 Summit Point Drive • Suite 4
Henrietta, New York 14467
http://icongraphicsinc.com
585.424.4266

Id8, Inc.
2865 Watchtower Approach NW
Marietta, Georgia 30064
770.428.8668
ks@sellierdesign.com

Ideal Design
PO Box 34794
Washington, DC 20043
www.idealdesignco.com
202.248.8291

I Imagine
Rotary Building International
1560 Sherman Avenue • Suite #306
Evanston, Illinois 60201
http://iimaginestudio.com
847.491.0308

Imagebox Productions Inc .
4933 Penn Avenue
Pittsburgh, Pennsylvania 15224
www.imagebox.com
412.441.0930

Imagine
The Stables Paradise Wharf
Ducie Street
Manchester M1 2JN
United Kingdom
www.imagine-cga.co.uk
0161 272 8334

Incitrio
10951 Sorrento Valley Road • Suite 2C
San Diego, California 92121
www.incitrio.com
858. 202.1822

Insight Marketing Design
401 East 8th Street • Suite 304
Sioux Falls, South Dakota 57103
www.insightmarketingdesign.com
605.275.0011

Ippolito Fleitz Group
Augustenstrasse 87
70107 Stuttgart
Germany
www.ifgroup.org
49 (0)711 993392 330

ishbu.com
Moscow, Idaho
509.951.5537

Jack Tom Design
1042 Broad Street • Loft 314
Bridgeport, Connecticut 06604
www.jacktom.com
203.579.0889

JAM
103 The Timber Yard • Drysdale Street
London
United Kingdom
www.jamdesign.co.uk
44 (0)20 7739 6600

Jantone
Indianapolis, Indianapolis
www.janmichael-b.com
317.460.6063

Jason Hill Design
Arizona
www.jasonhilldesign.com

J. Design Kommunikation AB
Roslagsgatan 60
113 55 Stockholm
Sweden
www.jdesign.se
46 70 312 37 00

Jenn David Design
5066 Saratoga Avenue
San Diego, California 92107
www.jenndavid.com
949.533.2359

JGA
29110 Inkster Road • Suite 200
Southfield, Michigan 48034
www.jga.com
248.355.0890

Jodesign LLC
101 S. Jennings • Suite 306
Fort Worth, Texas 76104
www.creativejo.com
817.335.0100

John Sposato Design & Illustration
179 Hudson Terrace
Piermont, New York 10968
845.365.1940

Jones Knowles Ritchie
128 Albert Street
London NW1 7NE
United Kingdom
www.jkr.co.uk
44 (0)20 7428 8000

Julia Reich Design
3370 Cork Street
Scipio Center, New York 13147
www.juliareichdesign.com
315.364.7190

Kable Design + Research
Greenville, North Carolina
http://kable.us

Karl Designs
19525 Vierra Canyon Road
Salinas, California 93907
www.karldesigns.com
831.663.6303

Kelsey Advertising & Design
133 Main Street
LaGrange, Georgia 30240
www.kelseyads.com
706.298.2738

Kenneth Diseño
S/N Fábrica San Pedro Centro
Uruapan 60000 Michoacán
Mexico
www.kennethdiseno.com.mx
52 452 523 1738

Kentucky State Fair Board
937 Phillips Lane
PO Box 37130
Louisville, Kentucky 40233
www.statefairboard.ky.gov
502.367.5157

Kollar Design | EcoCreative®
116 New Montgomery Street • Suite 830
San Francisco, California 94105
www.kollardesign.com
415.536.1536

Laf, Inc.
1500 Jackson Street • Suite 210
Fort Myers, Florida 33901
www.lafinc.com
239.939.3331

Lambiance Design and Multimedia
Room 2104C • 21/F
Admiralty Centre Tower 1
18 Harcourt Road
Hong Kong
http://lambiance-design.com/media/

Landor Associates
Level 11 • 15 Blue Street
North Sydney, NSW 2060
Australia
www.landor.com
61 2 8908 8700

Legacy Design Group
20226 New Kentucky Village
Hockley, Texas 77447
www.legacydesigngroup.com
713.907.0304

Liquidfly Designs
Carrollton, Texas
www.liquidflydesigns.com
972.948.3307

Little Big Brands
38 High Avenue • 4th Floor
Nyack, New York 10960
www.littlebigbrands.com
845.480.5911

LittleDogDesign
Dayton, Ohio

Lomangino Studio Inc.
1042 Wisconsin Ave NW
Washington, DC 20007
www.lomangino.com
202.338.4110

Louisiana State University
Baton Rouge, Louisiana70803
www.lsu.edu
225.769.9580

Mad Dog Graphx
1443 W Northern Lights Blvd • Suite U
Anchorage, Alaska 99503
http://thedogpack.com
907.276.5062

Magenta
West Los Angeles, California
310.893.4794

Marketability Group
611 Market Street • Suite 6
Kirkland, Washington 98033
www.marketabilitygroup.com
425.822.1482

Matthew Schwartz Design Studio
611 Broadway • Suite 430
New York, New York 10012
www.ms-ds.com
212.925.6460

McDill Design
626 North Water Street
Milwaukee, Wisconsin 53202
www.mcdilldesign.com
414.277.8111

Minds On, Inc.
8864 Whitney Drive
Lewis Center, Ohio 43035
www.mindson.com
740.548.1645

MINE™
190 Putnam Street
San Francisco, California 94110
www.minesf.com
415.647.6463

Moxie Sozo
1245 Pearl Street • Suite 212
Boulder, Colorado 80302
www.moxiesozo.com
720.304.7210

Mr. Ellie Pooh Paper
34 35th Street
Brooklyn, New York 11232
http://mrelliepooh.com
701.746.1489

Natalie Kitamura Design
30 Liberty Ship Way • Suite 3310
Sausalito, California 94965
www.nkdsf.com
415.289.0753

Nebraska Book Company
4700 South 19th Street
Lincoln, Nebraska 68501
www.nebook.com
800.869.0366

Nenad Dickov
Novi Sad
Serbia

Netra Nei
Seattle, Washington
http://netranei.com

Niagara Conservation
45 Horsehill Road
Hanover Technical Center • Suite 106
Knolls, New Jersey 07927
www.niagaraconservation.com
973.829.0800

Nine Ten Creative
Lakewood, Colorado
www.ninetencreative.com
303.885.2101

Nomadic Display
5617 Industrial Drive • Suite E
Springfield, Virginia 22151
www.nomadicdisplay.com
800.732.9395

Nora Brown Design
1911 S Racine Avenue • Apt 1
Chicago, Illinois 60608
www.norabrowndesign.com

Not Jane
Washington, DC
www.notjane.com

Off the Page Creations
20 Susie Wilson Road • Suite 7
Essex Junction, Vermont
www.offthepagecreations.com
802.879.3935

Ogilvy Group
Chervonoarmiyska, 5
01004 Kyiv
Ukraine
ogilvy.com
380 44 230 9520

Organic Design Works
2639 Cory Terrace
Silver Spring, Maryland 20902
www.organicdesignworks.com
301.942.1242

Oxide Design Co.
3916 Farnam Street
Omaha, Nebraska 68131
http://oxidedesign.com
402.344.0168

Parallel Practic LLC
14414 Detroit Avenue • #305
Lakewood, Ohio 44107
www.parallelpractice.com
216.533.1105

Parliament
107 SE Washington Street • #140
Portland, Oregon 97214
www.parliamentdesign.com
503.954.1230

Patrick Henry Creative Promotions, Inc.
11104 W Airport Boulevard • Suite 155
Stafford, Texas 77477
www.phcp.com
281.983.5500

Planet Ads & Design Pte. Ltd.
15 Martaban Road
Singapore 328641
www.planetad.com.sg
62504353

Plug Media Group
3614 Fern River Drive
Kingwood, Texas 77345
www.plugmediagroup.com
281.360.0480

Pryor Design Company
303 South Main Street • No.205
Ann Arbor, Michigan 48104
www.prydesign.com
734.769.1111

Pure Equator Ltd.
The Old School House
The Heritage Centre
High Pavement
The Lace Market
Nottingham NG1 1HN
United Kingdom
www.pure-equator.com
44(0) 115 947 6444

Range Design
2257 Vantage Street
Dallas, Texas 75207
www.rangeus.com
214.744.0555

Renourish
1007 South Victor Street
Champaign, Illinois 61821
www.re-nourish.com

ripe.com
1105 P Street NW
Washington, DC 20005
www.ripe.com
202.387.0404

Rizco Design
11 Parker Avenue
Manasquan, New Jersey 08736
www.rizcodesign.com
732.223.1944

Royal Society for the Conservation of Nature
PO Box 1215
Jubeiha 11941
Jordan
www.rscn.org.jo
962 6 5337931/2

Rule29
501 Hamilton Street
Geneva, Illinois 60134
www.rule29.com
630.262.1009

Russo Group, The
116 East Congress
Lafayette, Louisiana 70501
www.therussogroup.com
337.769.1530

Sabingrafik, Inc.
7333 Seafarer Place
Carlsbad, California 92011
www.tracysabin.com
760.431.0439

Sabrah Maple Design
530 South 5th Street
Jacksonville, Oregon 97530
www.sabrahmaple.com
541.601.9316

Sage Systems
101 Tremont Street • 2nd Floor
Boston, Massachusetts 02108
www.sage-systems.com
877.942.3338

Sagon Phior
2107 Sawtelle Boulevard
West Los Angeles, California 90025
www.sagon-phior.com
310.575.4441

Saint Dwayne Design
3240 Planters Ridge Road
Charlotte, North Carolina 28270
stdwayne.com
704.841.0871

Sally Vitsky Illustration
4114 Bromley Lane
Richmond, Virginia 23221
www.vitsky.com
804.350.0330

Sara Alway Design
Philadelphia, Pennsylvania
www.sarakalway.com
215.478.3473

Scamper Ltd.
PO Box 4756
Kenilworth, Warwickshire CV8 9BG
United Kingdom
www.scamperbranding.com
44 (0)208 1234590

Scott Adams Design Associates
290 Market Street • Suite 830
Minneapolis, Minnesota 55405
www.sadesigna.com

Simpatico Design Studio
529 East Bellefonte Avenue
Alexandria, Virginia 22301
www.simpaticodesignstudio.com
703.837.0584

Skaggs
305 Church Street
New York, New York 10013
skaggsdesign.com
212.966.1603

Sky Design
55 Allen Plaza • Suite 100
55 Ivan Allen Jr. Boulevard
Atlanta, Georgia 30308
www.skydesigngraphics.com
404.688.4702

Smith & Dress Ltd.
432 West Main Street
Huntington, New York 11743
www.smithanddress.com
631.427.9333

Spatchurst
C2.07 22 Mountain Street
Broadway NSW 2007
Australia
www.spatchurst.com.au
61 2 9212 1644

Spitfire Media Group
83 East Main Street
Buford, Georgia 30518
www.spitfiremediagroup.com
770.271.3001

Story Worldwide
360 Lexington Avenue • 19th Floor
New York, New York 10017
www.storyworldwide.com
212.481.3452

Studio 22
21 E. Main Street • Suite 102
Thurmont, Maryland 21788
www.studio20two.com
240.288.8116

Studio Liming Rao
551 Blackthorn Avenue
Toronto, Ontario M6M 3C7
Canada
www.studiolimingrao.com
001 647.343.4578

StudioNorth
1616 Green Bay Road
North Chicago, Illinois 60064
www.studionorth.com
847.473.4545

Studio One Eleven
444 North Wells Street
Chicago, Illinois 60654
www.studio111design.com
312.822.0111

studio threefiftyseven
The Church • 6 George Street
Stepney, South Australia 5069
Australia
www.threefiftyseven.com
61. 8.8132.1223

substance151
2304 East Baltimore Street
Baltimore, Maryland 21224
www.substance151.com
410.732.8379

Sudduth Design Co.
2201 Greenlee Drive
Austin, Texas 78703
www.sudduthdesign.com
512.236.0678

Symbo Design
401 2nd Street • Suite 200
Hudson, Wisconsin 54016
http://symbodesign.com
888.834.3060

Tátil Design
Estrada da Gávea, 712 • Lojas 101/104
São Conrado • Rio de Janeiro
CEP 22610-002
Brazil
www.tatil.com.br
55 21 2111 4200

Thinkhaus, A Socially Conscious Graphic
Design Firm
2621 Stuart Avenue • #11
Richmond, Virginia 23220
www.thinkhausdesign.com
804.484.4564

thomas.matthews ltd
8 Disney Street
London SE1 1JF
United Kingdom
www.thomasmatthews.com
44 (0)20 7403 4281

Thrive Design
East Lansing, Michigan
ksalchow@aol.com

Tomodesigns
New York, New York
http://tomodesigns.com
310.228.0050

Toormix
Bruc 91 • Planta 4
08009 Barcelona
Spain
www.toormix.com
34.93.486.90.90

Tread Creative
15495 Los Gatos Boulevard • Suite 1
Los Gatos, California 95032
http://treadcreative.com
408.358.3077

TURNER DUCKWORTH : London & San
Francisco
Voysey House
Barley Mow Passage
London W4 4PH
United Kingdom
www.turnerduckworth.com
44.(0)208.994.7190

Twointandem
New York, New York
www.twointandem.com
718.738.4909

TwolineSTUDIO
3001 Fox Street
Denver, Colorado 80202
http://twolinestudio.com
720.335.6069

Tyler School of Art
Temple University
2001 North 13th Street
Philadelphia, Pennsylvania 19122
www.temple.edu/tyler
215.777.9000

UNIT Design Collective
1416 Larkin Street
San Francisco, California 94109
www.unitcollective.com
415.409.0000

University of Illinois
143 Art & Design Building
Champaign, Illinois
www.faa.illinois.edu
217.333.6632

Urban Influence
3201 1st Avenue S • Suite 1110
Seattle, Washington 98134
www.urbaninfluence.com
206.219.5599

USA Today
McLean, Virginia
www.USATODAY.com

Valdes Design
8 Hedgehog Hill Road
Sumner, Maine 04292
www.valdesdesign.com
207.388.3432

vamadesign
Athens
Greece
www.vamadesign.com
30.694.261.3208

Vanpelt Creative
3425 Ridge Oak Drive
Garland, Texas 75044
www.vanpeltcreative.com
972.496.1744

Vega Project, The
375 Alabama Street • Suite 440
San Francisco California 94110
www.vegaproject.com
415.401.7221

Version-X Design
4131 West Vanowen Place • 2nd Floor
Burbank, California 91505
www.version-x.com
818.847.2200

Visionary+Flock
140 North La Brea Avenue
Los Angeles, California 90036
www.visionaryflock.com
310.779.0495

Vivitiv
4745 40th Avenue SW • Suite 101
Seattle, Washington 98116
www.vivitiv.com
206.623.9380

VKP Design
Leidsestraat 103
2013 xh Haarlem
Netherlands
www.vkpdesign.com
31 (0)6.4873 4590

Wallace Church, Inc.
330 East 48th Street
New York, New York 10017
www.wallacechurch.com
212.755.2903

Weather Control
Seattle, Washington
206.499.4464
oakjosh@gmail.com

Whitney Edwards LLC
16 West Dover Street
PO Box 3000
Easton, Maryland 21601
www.wedesign.com
410.822.8335

Whole Package, The
San Francisco, California
970.631.4281

Willoughby Design
602 Westport Road
Kansas City, Missouri 64111
www.willoughbydesign.com
816.561.4189

Ximena Molina
24 East Liberty Street
Apartment N 15-B
Savannah, Georgia 31401
www.ximenamolina.com
912.228.9499

Y&R Germany
Kleyerstraße 19
60326 Frankfurt am Main
Germany
www.yr-germany.de
49 (0)69.7506.1381

ZD Studios
111 S Hamilton Street
Madison, Wisconsin 53703
http://zebradogs.com
608.257.8400

zen kitchen, the
52 Hovey Street
Watertown, Massachusetts 02472
www.tzk-design.com
617.412.0585

Zero Design Limited
The Bond Building
13a Breadlabane Street,
EdinburghEH6 5JJ
United Kingdom
www.zero-design.net
0845 260 3 007

Z Factory
916 West Waveland Avenue • Floor 2
Chicago, IL 60613
www.zfactory.net
773.975.4280

INDEX

383

Why *The Big Book of Green Design* is not Printed on Recycled Paper

Nearly all printers, publishers, and consumers want to be more environmentally friendly in the book-making process. One frequently debated topic is the question of whether recycled paper is really more environmentally friendly than virgin paper. The complex answer depends on the kind of paper and the purpose for which it's used. Newsprint, packing cartons, and brown bags fall into a different category than the coated white paper used to print this full-color book.

While saving trees comes to mind first when thinking about recycling paper, there are other factors to be considered: energy consumption and associated greenhouse gas emissions, solid waste generation (including the sludge from de-inking paper), and utilization of valuable human labor.

According to statistics released by the American Forest and Paper Association (AFPA), more than 50% of all paper made in the USA is recovered for recycling. But, contrary to popular belief, the key environmental benefit lies not simply in saving trees, but in the reduction of solid waste destined for landfills and the conservation of energy used in obtaining paper fiber.

Interestingly, while virgin paper manufacturing depends primarily on greenhouse gas–neutral hydro and biofuel (wood-waste) energy sources, the collection, transportation, cleansing, and processing of recycled paper relies heavily on fossil fuel consumption, leading to increased greenhouse gas emissions. In addition, there is far more solid waste generated by recycling (ink, fillers, degraded fibers, and contaminants) than the virgin process, which utilizes 100% of the entire tree and reuses 95% of the pulping chemicals.

While adding recycled fiber to low-grade paper products makes sense both economically and environmentally, it would be a mistake to assume that higher levels of PCW in every product will necessarily benefit the environment. In fact, the National Energy Education Development Project found there are no savings in net energy consumption for recycled vs. virgin paper.

In particular, using recycled fiber in high-quality coated white paper incurs such a steep diminishing marginal return that using virgin fiber is indeed the more environmentally friendly choice. Good policy lies in protecting our old-growth forests and avoiding clear-cutting of trees. In forests where we do take selective cuts, we must replant seedlings for all the trees harvested and let the sun and soil do their job of regrowing them.

As a book producer interested in promoting environmentally sound graphic design and print, we chose to print *The Big Book of Green Design* on FSC-certified Korean Shin Moorin coated matt through our FSC-certified print partner, Everbest Printing Co., Ltd. We've proudly displayed the appropriate FSC logo on our cover.

—*Four Colour Print Group*

A Little Bit About…

Eric Benson is currently an Assistant Professor of Graphic Design at the University of Illinois at Urbana-Champaign. His work/research has appeared in *HOW Magazine, Creative Review, Communication Arts* and will be featured in *Blogs: Mad About Design* (Maomao Publications), *SustainAble: A Handbook of Materials and Applications for Graphic Designers and Their Clients* (Rockport Publishing) and *Reproduce and Revolt* (Soft Skull Press). He has lectured internationally on the topic of sustainable design and his work has appeared in various galleries from Portland, Oregon to Beirut, Lebanon.

Benson received his BFA in graphic and industrial design from the University of Michigan at Ann Arbor in 1998. His work professionally has been focused on creating enriching digital experiences on the web and environmentally friendly print and packaging material. In 2006 Benson received his MFA from the University of Texas at Austin with a concentration in design and social responsibility. His research is available at www.re-nourish.com, which provides a depository for practical information about sustainable materials and design theory.

Anthony and **Suzanna MW Stephens** are a husband-and-wife design team and principals of Designs on You! having a combined graphics tenure of 22 years. It's a successful partnership with Anthony's unfettered creativity balancing Suzanna's formal training.

Their portfolio is varied and includes, but is not limited to, logos, stationery, brochures, signs, t-shirts, DVD packaging…the usual graphic design stuff…but they are most proud of their experience in the publication market. Alone or together, the Stephenses (or is that Stephensi?) have been involved in the production of over 100 books. They are proud to say that the majority of these have been published by Collins Design an imprint of HarperCollins *Publishers*, and boast the professional design community as the target market.

They are currently preparing for *American Graphic Design & Advertising*, an annual design competition in its 26th year, which they own and manage. (www.americancorporteid.com)

Suzanna and Anthony live in a ninety-year old, three-story+basement home in frequent need of loving repair, where they share seven children, ages 8 - 27.